The Art of Describing

Svetlana Alpers

The Art of Describing

Dutch Art in the Seventeenth Century

THE UNIVERSITY OF CHICAGO PRESS

The University of Chicago Press, Chicago 60637
John Murray (Publishers) Ltd, London W1X 4BD

90 89 88 87 86 85 84 83 5 4 3 2 1

Library of Congress Cataloging in Publication Data

Alpers, Svetlana.
 The art of describing.

 Includes bibliographical references and index.
 1. Painting, Dutch. 2. Painting, Modern —17th-18th
centuries —Netherlands. 3. Visual perception. I. Title.
ND646.A72 759.9492 82-6969
ISBN 0-226-01512-2 AACR2

SVETLANA ALPERS is professor of art history at
the University of California, Berkeley. She is an
editor of *Representations* and of *The Raritan
Review* and is the author of *The Decoration of
the Torre de la Parada* and articles on northern
painting and on the study of art and its history.

To Paul

and

Benjamin and Nicholas

Contents

Illustrations

Preface

In the several years that this book has been in preparation I have incurred a number of debts. First, I have benefited from the invitations and hospitality of three institutions and their staffs. I began work on the book in 1975–76 as a fellow of the Center for Advanced Study in the Behavioral Sciences at Stanford. I was able to pursue research on native ground in 1979 during my six months as a visiting fellow at the Netherlands Institute for Advanced Study, in Wassenaar, with the support of the Humanities Research Committee of the University of California, Berkeley, and a fellowship from the American Council of Learned Societies. Finally, a major portion of the writing was done in 1979–80 when I was a fellow at the Institute for Advanced Study in Princeton, where Clifford Geertz made art welcome at the School of Social Science. Each of these institutions offered the challenge of new colleagues from a variety of disciplines and also the pleasure (not free from a certain pain) of being able to do one's work uninterrupted day after day. Finally, and more informally, the Warburg Institute of the University of London has long provided me with a scholarly home away from home.

As important as these times of retreat has been the time I have spent teaching at Berkeley. The questions, arguments, and work done by students in my seminars pushed me to clarify and develop my own. Their eagerness to take the study of art and its history seriously helped make the enterprise seem worthwhile. I shall thank particular people for particular points. Here I simply want to testify to how essential both the exercise of teaching at Berkeley and the students I have taught there have been to the writing of this book.

In the course of writing I have been helped by more individuals than it is possible to name. I am most grateful to Carol Armstrong, Celeste Brusati, Bob Haak, Anita Joplin, Susan Donahue Kuretsky, Walter Melion, Michael Montias, Johan Snapper, Pieter van Thiel, Eric-Jan Sluijter, Nicolette Sluijter, James Welu, Arthur Wheelock, Jr., and M. L. Wurfbain for their help with particular points of information or material. In venturing into fields far from my own, I have been fortunate to find a number of scholars willing to answer questions and offer the corrections necessary to someone new to and quite untrained in their special fields. I want to thank in particular Bruce Eastwood, Roger Hahn, Gerald Holton, and Helen Wallis. David Woodward's invitation to participate in the series of Kenneth Nebenzahl, Jr. Lec-

tures on art and cartography at the Newberry Library in 1980 offered the ideal occasion for working out my ideas about maps. Among those friends and colleagues who have been available on many occasions with their good talk and good writing I especially want to thank Paul Alpers, Michael Baxandall, James Cahill, T. J. Clark, Natalie Zemon Davis, Michael Fried, Stephen Greenblatt, Rosalind Krauss, Edward Said, and Edward Snow. I was fortunate to have begun studying Dutch art under Seymour Slive, Egbert Haverkamp-Begemann, and the late Horst Gerson. In a broader sense, I shall always remain the student of E. H. Gombrich. Since I first studied with him at Harvard years ago his work has been the example, his support a spur, to my own.

Finally, two remarks are in order about format and usage. Except where a standard English translation of a text exists, I have included the original, almost always preceded by an English translation. I want to thank Robert Hurley and Carole Newlands, who worked with me on the French and Latin passages respectively. The seven United Provinces that formed the Dutch Republic are commonly, though inaccurately, referred to in English as Holland, after the richest of them. For the sake of ease of reference I have followed this usage. Unless otherwise noted, Holland, then, refers not to the province bearing that name but to the entire Dutch Republic.

<div align="right">S. A.</div>

Introduction

Until recently it was the descriptive aspects of Dutch art that held the attention of viewers. For better or for worse, it was as a description of Holland and Dutch life that writers before the twentieth century saw and judged seventeenth-century Dutch art. Sir Joshua Reynolds, an antagonist, and Eugène Fromentin, an enthusiast, met in their agreement that the Dutch produced a portrait of themselves and their country—its cows, landscape, clouds, towns, churches, rich and poor households, its food and drink. The issue of what one could say, how one could convey the nature of such a descriptive art was felt to be a pressing one. Reynolds could only come up with an annotated list of Dutch artists and subjects in his *Journey to Flanders and Holland* of 1781. He acknowledges that it provides "barren entertainment" in contrast to the lengthy analysis he can give of Flemish art. Here are some excerpts from the list:

> Cattle and a shepherd, by Albert Cuyp, the best I ever saw of him; and the figure is likewise better than usual: but the employment which he has given the shepherd in his solitude is not very poetical: it must, however, be allowed to be truth and nature; he is catching fleas or something worse.

> A View of a church by Vander Heyden, his best; two black friars going up steps. Notwithstanding this picture is finished as usual very minutely, he has not forgot to preserve, at the same time, a great breadth of light. His pictures have very much the effect of nature, seen in a camera obscura.

> A woman reading a letter; the milk-woman who brought it, is in the mean time drawing a curtain, a little on one side, in order to see the picture under it, which appears to be a sea-view.

> Two fine pictures of Terburg; the white sattin remarkably well painted. He seldom omitted to introduce a piece of white sattin in his pictures.

> Dead swans by Weeninx, as fine as possible. I suppose we did not see less than twenty pictures of dead swans by this painter.[1]

The vulgar nature of the subject matter disturbs Reynolds, but he still concentrates his attention on what is to be seen—from white satin to white swans. The painters' interest in what Reynolds calls the "naturalness of

representation," combined with their repetitiousness (Ter Borch's inevitable white satin or Weenix's countless dead swans), makes for a boring, even inarticulate verbal account. Or as Reynolds himself explains:

> The account which has now been given of the Dutch pictures is, I confess, more barren of entertainment, than I expected. One would wish to be able to convey to the reader some idea of that excellence, the sight of which has afforded so much pleasure: but as their merit often consists in the truth of representation alone, whatever praise they deserve, whatever pleasure they give when under the eye, they make but a poor figure in description. It is to the eye only that the works of this school are addressed; it is not therefore to be wondered at, that what was intended solely for the gratification of one sense, succeeds but ill, when applied to another.[2]

It is hard for us, as heirs to the art of the nineteenth century, to get back to the frame of mind that made Reynolds disparage this descriptive art. We are after all convinced, as he was not, that a great painting can be made as Cézanne made it, for example, of two men playing cards, or a bowl of fruit and a bottle, or as Monet did of a patch of water lilies in a pond. But it is equally hard for us today to value Dutch art for the reasons given by a nineteenth-century enthusiast like Fromentin. In an often-quoted passage, Fromentin in 1876 argues, with reference to the 1609 truce with Spain and the founding of the new state, that "Dutch painting was not and could not be anything but the portrait of Holland, its external image, faithful, exact, complete, life-like, without any adornment."[3] He put the central issue succinctly at one point: "What motive had a Dutch painter in painting a picture? None."[4] The thrust of the professional study of Dutch art in our time has been to dig deeper than the naïve museumgoer who exclaims at the sheen of Ter Borch's satins, or at the clear, calm air of a Saenredam church interior, who is perhaps amused at the sunlit cow by Cuyp that rivals a distant church tower in size, or finally pauses in awe before the beauty and composure of a Vermeer lady in the corner of her room, her face echoed in the reflecting glass offered by the window.

Fromentin struggled to deal with how to separate the art as such from the world of which it was an imitation.

> We feel a loftiness and a goodness of heart, an affection for the true, a love for the real, that give their works a value the things do not seem to possess.[5]

But he was always on the verge of denying that which makes the art separate from, different from the life.

> We live in the picture, we walk about in it, we look into its depths, we are tempted to raise our heads to look at its sky.[6]

And Fromentin specifically contrasts Dutch painting in this regard with the art of the "present (French) school," the academic heir to the Italians.

> Here, you will perceive formulae, a science that can be possessed, an acquired knowledge that helps examination, sustains it at need, takes its

place, and, so to speak, tells the eye what it should see; the mind what it should feel. There, nothing of the kind: an art which adapts itself to the nature of things, a knowledge that is forgotten in presence of special circumstances in life, nothing preconceived, nothing which precedes the simple, strong and sensitive observation of what is.[7]

Significantly, and most appropriately as we shall see, Fromentin returns to a theme also enunciated by Reynolds, namely, that the relationship of this art to the world is like that of the eye itself.

In our time art historians have developed the terminology and trained their eyes and sensibilities to react rather to those stylistic features that compose the art—the height of the horizon on the panel, the placing of tree or cow, the light. All of these are spoken of as aspects of art as much if not more than they are as observations of the world seen. Each artist has his own relatively clear stylistic development and we can detail the influence of the artists on each other. Here, as in the interpretation of the subject matter, the study of Dutch art has taken on analytic tools first developed to deal with Italian art. The viewer who admires the sheen on a Ter Borch gown is now told that the woman in the shining gown is a whore being sought or bought before our eyes; the young sorrowing women who so frequently perch on the edge of a bed or chair attended to by a doctor are pregnant out of wedlock, and those looking at mirrors are sinfully vain. Vermeer's woman by the window reading a letter is engaged in extra- or premarital sex. Merry drinkers are gluttons, sluggards, or more likely the victims of the pleasures of the sense of taste, as music-makers are victims of the pleasures of the sense of hearing. The display of watchworks or of exotic flowers that fade is an exercise in human vanity. Iconographers have made it a principle of Dutch seventeenth-century picture-making that the realism hides meanings beneath its descriptive surface.

But there has been too great a price paid in visual experience in this current appeal to understanding verbal depths. Dutch art itself challenges such a view. The issue here is far from new. It has its source deep in the tradition of Western art.

To a remarkable extent the study of art and its history has been determined by the art of Italy and its study. This is a truth that art historians are in danger of ignoring in the present rush to diversify the objects and the nature of their studies. Italian art and the rhetorical evocation of it has not only defined the practice of the central tradition of Western artists, it has also determined the study of their works. In referring to the notion of art in the Italian Renais-sance, I have in mind the Albertian definition of the picture: a framed surface or pane situated at a certain distance from a viewer who looks through it at a second or substitute world. In the Renaissance this world was a stage on which human figures performed significant actions based on the texts of the poets. It is a narrative art. And the ubiquitous doctrine *ut pictura poesis* was invoked in order to explain and legitimize images through their relationship to prior and hallowed texts. Despite the well-known fact that few Italian pictures were executed precisely according to Alberti's perspective specifica-

tions, I think it just to say that this general definition of the picture that I have summarily presented was that internalized by artists and finally installed in the program of the Academy. By Albertian, then, I do not mean to invoke a particular fifteenth-century type of picture, but rather to designate a general and lasting model. It was the basis of that tradition that painters felt they had to equal (or to dispute) well into the nineteenth century. It was the tradition, furthermore, that produced Vasari, the first art historian and the first writer to formulate an autonomous history for art. A notable sequence of artists in the West and a central body of writing on art can be understood in these Italian terms. Since the institutionalization of art history as an academic discipline, the major analytic strategies by which we have been taught to look at and to interpret images—style as proposed by Wölfflin and iconography by Panofsky—were developed in reference to the Italian tradition.[8]

The definitive place of Italian art in both our tradition of art and our tradition of writing about it means that it has proved difficult to find appropriate language to deal with images that do not fit this model. Indeed, some innovative work and writing on images has come out of a recognition of this difficulty. It has been done on what might be called nonclassical, non-Renaissance images that would otherwise have been seen from the perspective of the Italian accomplishment. I have in mind writings such as Alois Riegl's accounts of ancient textiles, the art of late antiquity, post-Renaissance Italian art, or Dutch group portraits; Otto Pächt on northern art in general; Lawrence Gowing on Vermeer; or more recently Michael Baxandall on German limewood sculpture and Michael Fried on absorptive or antitheatrical (for which we may read anti-Albertian) French painting.[9] Though they differ in many respects, each of these writers felt the need to find a new way to look at a group of images, at least partly in acknowledgment of their difference from the norms provided by Italian art. It is in this tradition, if I can call it that, that I would like to place my own work on Dutch art. And if in the pages that follow I chart this art partly through its *difference* from the art of Italy, it is not to argue an unique polarity between north and south, between Holland and Italy, but to stress what I believe to be the condition of our study of all non-Albertian images.

There is, however, one pictorial distinction and a historical situation to which I will pay particular attention. A major theme of this book is that central aspects of seventeenth-century Dutch art—and indeed of the northern tradition of which it is part—can best be understood as being an art of describing as distinguished from the narrative art of Italy. This distinction is not an absolute one. Numerous variations and even exceptions can doubtless be found. And one must leave the geographic boundaries of the distinction flexible: some French or Spanish works, even some Italian ones can fruitfully be seen as partaking of the descriptive mode, while the works of Rubens, a northerner steeped in the art of Italy, can be seen in terms of the ways in which on various occasions he variously engages both these modes. The value of the distinction lies in what it can help us to see. The relationship between

these two modes within European art itself has a history. In the seventeenth century and again in the nineteenth some of the most innovative and accomplished artists in Europe—Caravaggio and Velázquez and Vermeer, later Courbet and Manet—embrace an essentially descriptive pictorial mode. "Descriptive" is indeed one way of characterizing many of those works that we are accustomed to refer to casually as *realistic*—among which is included, as I suggest at various points in my text, the pictorial mode of photographs. In Caravaggio's *Crucifixion of St. Peter*, Velázquez's *Water-seller*, Vermeer's *Woman with Scales*, and Manet's *Déjeuner sur l'Herbe* figures are suspended in action to be portrayed. The stilled or arrested quality of these works is a symptom of a certain tension between the narrative assumptions of the art and an attentiveness to descriptive presence. There seems to be an inverse proportion between attentive description and action: attention to the surface of the world described is achieved at the expense of the representation of narrative action. Panofsky put this particularly well about Jan van Eyck, another artist who worked in the descriptive mode:

> Jan van Eyck's eye operates as a microscope and as a telescope at the same time . . . so that the beholder is compelled to oscillate between a position reasonably far from the picture and many positions very close to it. . . . However, such perfection had to be bought at a price. Neither a microscope nor a telescope is a good instrument with which to observe human emotion. . . . The emphasis is on quiet existence rather than action. . . . Measured by ordinary standards the world of the mature Jan van Eyck is static.[10]

What Panofsky says of Van Eyck is quite true. But the "ordinary standards" that he calls on are none other than the expectations of narrative action created by Italian art. Although it might appear that painting by its very nature is descriptive—an art of space, not of time, with still life as its basic theme—it was essential to the Renaissance aesthetic that imitative skills were bound to narrative ends. The *istoria*, as Alberti wrote, will move the soul of the beholder when each man painted there clearly shows the movement of his soul. The biblical story of the massacre of the innocents, with its hordes of angry soldiers, dying children, and mourning mothers, was the epitome of what, in this view, pictorial narration and hence painting should be. Because of this point of view there is a long tradition of disparaging descriptive works. They have been considered either meaningless (since no text is narrated) or inferior by nature. This aesthetic view has a social and cultural basis. Time and again the hierarchy of mind over sense and of educated viewers over ignorant ones has been summoned to round out the argument for narration with a blast at an art that delights the eyes. Narration has had its defenders and its explicators but the problem remains how to defend and define description.[11]

Dutch pictures are rich and various in their observation of the world, dazzling in their display of craft, domestic and domesticating in their concerns. The portraits, still lifes, landscapes, and the presentation of daily life

represent pleasures taken in a world full of pleasures: the pleasures of familial
bonds, pleasures in possessions, pleasure in the towns, the churches, the land.
In these images the seventeenth century appears to be one long Sunday, as a
recent Dutch writer has put it, after the troubled times of the previous
century.[12] Dutch art offers a delight to the eyes and as such seems perhaps to
place fewer demands on us than does the art of Italy.

From the point of view of its consumption, art as we think of it in our time
in many respects began with Dutch art. Its societal role was not far from that
of art today: a liquid investment like silver, tapestries, or other valuables,
pictures were bought from artists' shops or on the open market as possessions
and hung, one presumes, to fill space and to decorate domestic walls. We have
few records of commissions and little evidence of buyers' demands. The
problem faced by a modern viewer is how to make this art strange, how to
see what is special about an art with which we feel so at home, whose
pleasures seem so obvious.

The problem is compounded by the fact that, unlike Italian art, northern
art does not offer us an easy verbal access. It did not occasion its own mode
of critical discourse. It differs both from the art of the Italian Renaissance
with its handbooks and treatises and from nineteenth-century realisms, which
were the subject of both extensive journalism and frequent manifestoes. It is
true that by the seventeenth century Italian words and texts had permeated
northern Europe and had even been taken up by a few artists and writers. But
this produced a split between the nature of the art being produced in the north
(largely by craftsmen who still belonged to craft guilds) and the verbal pro-
fessions of treatises as to what was art and how it ought to be made. It was
a split, in short, between northern practice and Italian ideals.

There are few significant signs among Dutch artists of the strain of living
in a native pictorial tradition while admiring, or being told that they should
admire, foreign ideals. There are those Dutch artists who began their careers
by producing history paintings (the architectural painter De Witte, Rem-
brandt's pupils, even Vermeer) but who then turned (commonly with more
positive results) to what are loosely classed as genre scenes. We read of the
figure cut by the group of Dutch artists in Rome.[13] They called themselves the
Bentvueghels (birds of a flock), took on comic names, and engaged in bac-
chanalian initiation ceremonies that simultaneously mocked antiquity and the
Church. They refused to abide by the regulations of the Italian painters and
they left their mark in the form of witty graffiti on convenient walls. In
providing entertainment of this sort for themselves and amusement for the
society around them they were reflecting, one might suppose, on the fact of
their difference. It was in the spirit of briefly triumphing over a sense of
inferiority that they played out their carnival capers. In a quite different sense
we can locate the strain in the very nature of Rembrandt's art. Though it is
arguable that he was out of sympathy with the pictorial aims of his coun-
trymen, he could not embrace the Italian mode as such. Rembrandt produced
his marvelous yet strange images partly out of this conflict. This fruitful

interplay between foreign ideals and the native tradition was rare. Utrecht artists such as Honthorst and Ter Brugghen are often classified as followers of Caravaggio. But they responded to an Italian artist who was himself deeply attracted to the northern European tradition: Caravaggio, it might be argued, led them back to their own northern roots.

Part and parcel of the difference felt between the art of Italy and that of the north was a sense of Italian superiority and Netherlandish inferiority. The Italian assumption about the rational authority and power of their art is made clear in the famous critique of the art of the Netherlanders attributed by Francisco de Hollanda to none other than Michelangelo himself:

> Flemish painting . . . will . . . please the devout better than any painting of Italy. It will appeal to women, especially to the very old and the very young, and also to monks and nuns and to certain noblemen who have no sense of true harmony. In Flanders they paint with a view to external exactness or such things as may cheer you and of which you cannot speak ill, as for example saints and prophets. They paint stuffs and masonry, the green grass of the fields, the shadow of trees, and rivers and bridges, which they call landscapes, with many figures on this side and many figures on that. And all this, though it pleases some persons, is done without reason or art, without symmetry or proportion, without skilful choice or boldness and, finally, without substance or vigour.[14]

The passage immediately following this one (one that has understandably not been quoted in studies devoted to northern art) seals and further grounds Michelangelo's severe judgment: "It is practically only the work done in Italy we can call true painting, and that is why we call good painting Italian." We shall want to return to Michelangelo's rich testimony again. For the moment I want to note that while reason and art and the difficulty involved with copying the perfections of God are on the side of Italy, only landscape, external exactness, and the attempt to do too many things well belong to the north. The contrast is between the central and definitive Italian concern with the representation of the human body (what Michelangelo engages when he speaks of the *difficultà* of art) and the northern concern with representing everything else in nature exactly and unselectively. The Netherlanders for their part did not really disagree. On those rare occasions when northerners attempt to state the special nature of their native art, they characteristically concur with the Italian distinction by laying claim to nature, rather than art, as the source of their artistic accomplishment.[15]

The Italian bias is still evident today in the writings of those art historians who are anxious to demonstrate that Dutch art is like Italian, that it too had its classical moment, produced its significant history paintings, that it too signified. Art history has witnessed powerful attempts to rework northern art in the image of the south. I think this can fairly be said to be part of the thrust of Panofsky's studies. He ranked the southern aspirations of Dürer over his northern heritage: in Panofsky's account the Dürer who depicted the nude and was intrigued with perspective is favored over the descriptive artist of the

Great Piece of Turf. But even Dürer's exercises in the nude and his architectural settings, which are often devious in their complexity, hardly reveal a southern sense of picture making. And his prints—including the meditative *Melencolia* in which Panofsky read the mood of the Renaissance genius—display the detailed observation and the descriptive surfaces characteristic of the north. Basing himself on an iconographical model of meaning first used to deal with Italian art, Panofsky in his *Early Netherlandish Painting* saw Netherlandish images as displaying disguised symbolism, by which he meant that they hid their meanings beneath realistic surfaces. Despite his Italian bias, Panofsky's analyses often achieve a balance between the claims for surface representation and for meaningful depth. This delicate balance has been disrupted by the recent rash of emblematic interpretations of Dutch art.

Many students of Dutch art today view the notion of Dutch realism itself as the invention of the nineteenth century. In the aftermath of the rediscovery of the relationship of a number of motifs in Dutch paintings to prints affixed with mottoes and texts in the popular emblem books of the time, iconographers have concluded that Dutch realism is only an apparent or *schijn* realism. Far from depicting the "real" world, so this argument goes, such pictures are realized abstractions that teach moral lessons by hiding them beneath delightful surfaces.[16] *Don't* believe what you see is said to be the message of the Dutch works. But perhaps nowhere is this "transparent view of art," in Richard Wollheim's words, less appropriate. For, as I shall argue, northern images do not disguise meaning or hide it beneath the surface but rather show that meaning by its very nature is lodged in what the eye can take in— however deceptive that might be.[17]

How then are we to look at Dutch art? My answer has been to view it circumstantially. This has become a familiar strategy in the study of art and literature. By appealing to circumstances, I mean not only to see art as a social manifestation but also to gain access to images through a consideration of their place, role, and presence in the broader culture. I begin with the example of the life and some of the works of Constantijn Huygens, secretary to the stadholder, a voluminous writer and correspondent and a leading cultural figure in the Netherlands. His early discovery of Rembrandt and his engagement with the arts have long been of interest to historians of art and of literature. In his autobiographical fragment about his youth, art appears as part of a traditional humanistic education retooled for him by his father. But in recounting his scientific, technological, or (as Huygens might say) philosophical education done in digression from his father's set program, Huygens binds images to sight and to seeing, specifically to new knowledge made visible by the newly trusted technology of the lens. Huygens testifies, and the society around him confirms, that images were part of a specifically visual, as contrasted with a textual, culture. The distinction between this seventeenth-century emphasis on seeing and representation and the Renaissance emphasis on reading and interpretation has been illuminated recently for us in the writings of Michel Foucault.[18] It was a general European phenomenon. But

it is in Holland that this mode of understanding the world is fully and creatively realized in the making of images. *(still)*

The Dutch present their pictures as describing the world seen rather than as imitations of significant human actions. Already established pictorial and craft traditions, broadly reinforced by the new experimental science and technology, confirmed pictures as the way to new and certain knowledge of the world. A number of characteristics of the images seem to depend on this: the frequent absence of a positioned viewer, as if the world came first (where we are situated as viewers is a question that one is hard put to answer in looking at a panoramic landscape by Ruisdael); a play with great contrasts in scale (when man is not providing the measure a huge bull or cow can be amusingly played off against a tiny distant church tower); the absence of a prior frame (the world depicted in Dutch pictures often seems cut off by the edges of the work or, conversely, seems to extend beyond its bounds as if the frame were an afterthought and not a prior defining device); a formidable sense of the picture as a surface (like a mirror or a map, but not a window) on which words along with objects can be replicated or inscribed; an insistence on the craft of representation (extravagantly displayed by a Kalf who repeatedly recrafts in paint the porcelain, silver, or glass of the craftsman along side the lemons of Nature herself). It is, finally, hard to trace stylistic development, as we are trained to call it, in the work of Dutch artists. Even the most naive viewer can see much continuity in northern art from Van Eyck to Vermeer, and I shall often look back from the seventeenth century to similar phenomena in earlier northern works. But no history on the developmental model of Vasari has ever been written, nor do I think it could be. This is because the art did not constitute itself as a progressive tradition. It did not make a history in the sense that art did in Italy. For art to have a history in this Italian sense is the exception, not the rule. Most artistic traditions mark what persists and is sustaining, not what is changing, in culture. What I propose to study then is not the *history* of Dutch art, but the Dutch *visual culture* —to use a term that I owe to Michael Baxandall.

In Holland the visual culture was central to the life of the society. One might say that the eye was a central means of self-representation and visual experience a central mode of self-consciousness. If the theater was the arena in which the England of Elizabeth most fully represented itself to itself, images played that role for the Dutch. The difference between the forms this took reveals much about the difference between these two societies. In Holland, if we look beyond what is normally considered to be art, we find that images proliferate everywhere. They are printed in books, woven into the cloth of tapestries or table linens, painted onto tiles, and of course framed on walls. And everything is pictured—from insects and flowers to Brazilian natives in full life-size to the domestic arrangements of the Amsterdammers. The maps printed in Holland describe the world and Europe to itself. The atlas is a definitive form of historical knowledge through images whose wide dissemination at the time we owe to the Dutch. The format of the Dutch atlas

is expanded by Blaeu in the seventeenth century to twelve printed folio volumes and then in the nineteenth it lends its name to entire collections of printed images. This involves questions of pictorial mode as well as questions of social function. While in another country a battle would be accounted for in a large history painting prepared for court and king, the Dutch issue a popular news map. Such different modes of representation also involve differing notions of history. One is bound to the heroic human actions of Italian painting and privileges unique events, while the other does not.

Having said so much about what the book will include, I should perhaps mention what it will not. On the subject of religion this book does not, directly, have much to say. Yet nothing I say about Dutch visual culture is inconsistent with Dutch religious views and, indeed, I think it can be used to help turn the current attention away from dogma to social practice. So far the art has been related to dogma or to rules governing behavior. On the other hand, I relate it to views of knowledge and the world, which are implicitly imbedded in a religious sense of order.

Although they flourished in a Protestant state, the pictorial phenomena I am concerned with in Holland in many respects predate the Reformation. Neither the confessional change, nor the confessional differences that existed between people in Holland in the seventeenth century seem to help us much in understanding the nature of the art. To the argument that secular subject matter and moral emblematic meanings speak to Calvinist influence, one must counter that the very centrality of and trust to images seems to go against the most basic Calvinist tenet—trust in the Word. Such a view is surely supported by the contrasting absence of images in Presbyterian Scotland or Calvinist New England. An appeal to religion as a pervasive moral influence in the society's view of itself and the larger world of Nature seems a more fruitful direction to take than to continue to check the art out against the tenets of the faith. We sorely need a social history of Dutch religion (and Dutch society). There one would have to consider such things as the extraordinary lack of religious prejudice or aggression in Holland (after the one outburst of the 1618 Synod at Dordrecht) compared to the rest of Europe. Issues of behavior and belief that produced strife, accusations, even executions in England are notable by their rarity in Holland. And when they occur they do not reverberate in powerful responses on the part of artists or writers. Dutchmen seem to have suffered much less than other Europeans from a sense of the threat posed by conflicting views of society or of God. A recent study locates this right in the art by pointing to the ecumenical nature of Saenredam's church portraits: he adjusts arches so as to blend different architectural styles and thus efface historical and confessional differences.[19] Toleration has its practical side. Like the merchants' insistence on trading with the enemy during the continuing conflict with Spain, it insures that business will continue as usual. Father Cats's immensely popular illustrated books of manners, which have attracted the attention of art historians and others as evidence of the Dutch absorption in moral questions of behavior,

can be understood better in this light. Cats is more distinctive as a taxonomist of social behavior than as the dogmatic moralist he is often taken to be. Dutch art is involved with this view. Pictures document or represent behavior. They are descriptive rather than prescriptive. A constant pressure is felt to make distinctions, to portray each thing—be it a person, a flower, or a type of behavior—so as to make it known. But along with this anxiety to define there is an ease with boundaries. Dutch art is notoriously subject to confusion with life. And those cultural and societal boundaries so basic to the definition of the urban West that mark off the city from the country, or the whore from the wife, can be curiously blurred.

After the first chapter on Constantijn Huygens, the book proceeds as follows: chapter 2 deals with the problem of what a picture is in Holland by turning to contemporary notions of sight and seeing, specifically to the model of the picture offered by Kepler's analysis of the eye; chapter 3 deals with the cultural role of images, in particular with the kind of authority that was attributed to their making and viewing. Here I turn to notions of education, knowledge, and craft found in the writings of Comenius and Bacon and in the programs of the English Royal Society. Often in these texts we find what the Dutch painted put into words. The mapping impulse, the subject of chapter 4, brings these results to bear on specific types of Dutch landscape views; and, turning the tables a bit on the visual culture so defined, chapter 5 considers the role of words in Dutch images.

Two final remarks which I hope will minimize any misunderstandings. To those who will protest that Italian art is not fully represented, or that I exaggerate differences within European art by slighting the continuous interplay between the art of different countries, I would reply that they are mistaking my purpose. I do not want either to multiply chauvinisms or to erect and maintain new boundaries, but rather to bring into focus the heterogeneous nature of art. Attending to the northern descriptive mode challenges the deeply imbedded tendency of our discipline to collapse all art-making under a general rubric provided by the viewing of Italian Renaissance art.

This book is not intended as a survey of seventeenth-century Dutch art. Certain artists and certain types of images will get more attention than others, some will receive little or no comment at all. I have concentrated on those artists and works that seem to me to show most clearly certain things that are basic to Dutch art. While I think that the emphasis on the art of describing is not of exclusive importance, it is essential to an understanding of Dutch art. And I think that any future study of, say, Jan Steen or the group portrait, to instance a major artist and a major genre with which I do not deal here, would benefit from taking it into account. To further locate and secure this way of seeing Dutch art, I turn briefly, in conclusion, to the two greatest artists of the time: to Vermeer, who reflected so deeply on, and to Rembrandt, who was in conflict with, the Dutch art of describing.

1

Constantijn Huygens and
The New World

It is a commonplace that few words were wasted on art in seventeenth-century Holland. If one wants to find out how the Dutch thought of the images they made, bought, and looked at one grabs at straws: Rembrandt's seven preserved letters compared to Rubens's hundreds; Vermeer glimpsed only indirectly through the legal documents involving his family; lists of home-town artists, sometimes amplified with a few extra remarks, that are part of the commemorative publications devoted to individual towns. Dutch theoretical treatises at least nominally subscribe to notions of art developed and practiced outside of the Netherlands in France and Italy. We have little information from the commissioning of works since the great majority were made for the market or, better, the markets. They were sold either out of the painter's shop, from kermis stalls, or, if they took the form of prints, at a bookseller dealing in maps, books, and prints. Works of art are recorded in inventories according to categories of subject matter (such as *landscape, kitchen, banquet,* or *company*) that give little sense of the way the art was perceived, used, or understood. The fact that Dutch art was so often independent of the texts that were the basis of history paintings made them also independent of commentary. Reynolds was right when he complained in effect that you cannot tell the story of a Dutch painting, you can only look at it. One reason the inscriptions in emblem books have appealed to modern interpreters is that, though at one remove, they give us some verbal access to otherwise silent works.[1]

One finds surprisingly rich testimony as to how the Dutch conceived of images in the writings of Constantijn Huygens. Art historians have long cited Huygens's *Autobiography* because of its early championing of Rembrandt and its taste for the Dutch artists of the day. But they have ignored a quite different kind of concern with images that is to be found elsewhere in the same text and in Huygens's other writings as well. Constantijn Huygens (1596–1687) was the son of the secretary to the first stadholder of the new Dutch Republic and succeeded his father in that position.[2] He combined service to

the state and religious orthodoxy with a variety of intellectual and artistic skills. The lute, globes, compass, and architectural plan on the table beside him in the portrait by Thomas de Keyser (fig. 1) refer to only a few of Huygens's interests and accomplishments. He was trained in the classics, was a writer, a poet, a translator of Donne, and had a library almost half the size of that of the king of France. He was well traveled and when still young was invited to perform on the lute before the English king. He was vitally interested in both art and contemporary science, and he directly encouraged the career of his famous son, Christian Huygens. Huygens was no ordinary Dutchman. But there is truth to Huizinga's claim that to understand Holland one must read Huygens. When one does, it is less the loftiness than the amplitude of the man that strikes one. It is an amplitude that enables Huygens to contain and reveal in his writing much of what was of the moment in his world.

In 1629, at the age of thirty-three, and but a third of the way through his long life, Huygens put himself to the task of setting down the course of his life to that time. This fragment of an autobiography is written in Latin and lay unpublished among his papers until its discovery at the end of the nineteenth century.[3] Huygens's family and his education, which his father cast in the international, aristocratic mold of the day, give shape to his account. Thus training in drawing takes its place beside languages, literature, mathematics, riding, and even dance. Huygens's text reads in some respects like an educational handbook. It differs from those contemporary autobiographies in which aristocratic authors like Sir Kenelm Digby give short shrift to education and devote themselves instead to the romance of life. But Huygens takes the opportunity afforded him by the educational theme for various personal asides and digressions that are among the most interesting parts of the fragment.[4]

Knowledge and love of art are mixed with chauvinism in the often-cited passage in which Huygens tells of his own artistic education and goes on to give an account of art and artists in the Netherlands of his time.[5] In writing of his own training, Huygens specifically complains that the artist of his choice, the old family friend and neighbor Jacques de Gheyn II, was unwilling to serve as his teacher. He was, therefore, not given the opportunity to learn the art of rapidly rendering the forms and other aspects of trees, rivers, hills, and the like, which northerners (as Huygens justly claims) do even better than the ancients. Huygens instead studied with Hondius, a printmaker whose hard and rigid lines were better suited to representing columns, marble, and immobile structures than moving things like grass and foliage, or the charm of ruins. In his assessment of Dutch artists, he acknowledges and praises in particular the skills of northern portraitists and landscape painters. He acutely says that they can even represent the warmth of the sun and the movement of breezes. But while praising the unique accomplishment of such lifelike representations, Huygens never calls into question the older, established tradition of art. And despite his fine "feel" for Dutch painters, he

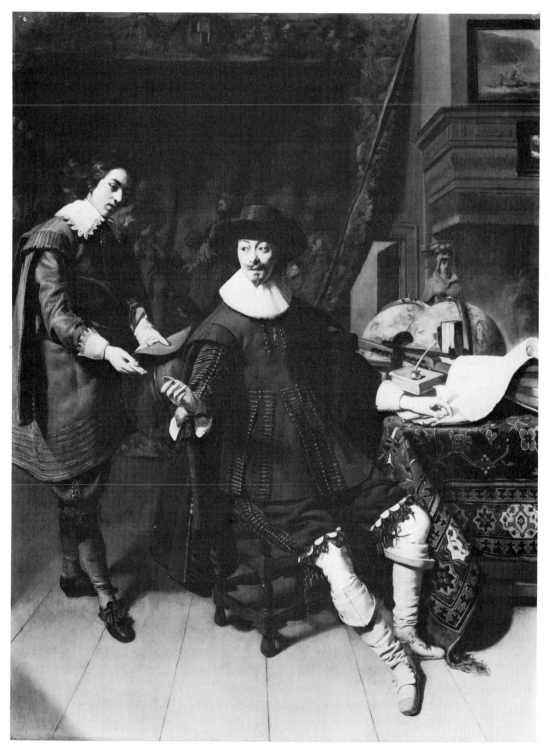

1. THOMAS DE KEYSER, *Constantijn Huygens and His Clerk,* 1627. By permission of the Trustees of the National Gallery, London.

awards the palm to Rubens as the greatest artist of the time.

It tells us something of the political outlook of the northern Netherlands that Rubens, who lived in Flanders, is claimed by a Dutchman as a native artist. Aside from revealing his taste for Rubens, it reveals Huygens's artistic outlook. He obviously rates what was known as history painting as the highest form of artistic achievement. It also is remarkable that Huygens singles Rembrandt out as a future great—remarkable both in view of the idiosyncratic nature of Rembrandt's talents and in view of his slow start: Rembrandt's earliest works hardly held forth such great promise. But this judgment is still consistent with a bias for history painting. Huygens's hyperbolic claim that ancient Greece and Italy would be outdone by a beardless son of a Dutch miller is made not to dispute but to accept the claims and achievements of the great tradition of art as it was viewed at the time. In keeping with this he recommended, though in vain, that Rembrandt go to Italy to see the likes of Raphael and Michelangelo. The trenchant distinction that Huygens makes between Rembrandt's expressiveness and the power of the figures as rendered by his studio-mate Lievens is couched in the very terms in which the great tradition was conventionally discussed. Huygens often acted on these beliefs. In the 1630s and 1640s he negotiated for the stadholder with Rembrandt for a series representing the Passion of Christ, and at mid-century he joined forces with the architect Jacob van Campen, a founding father of Dutch classicism, to work on the allegorical program of the decorations celebrating the House of Orange in the Huis ten Bosch.

This traditional view of art is maintained only in the passages that Huygens devoted to his art education and to contemporary artists. Art historians have not paid attention to the rest of the *Autobiography*. The long section on art was excerpted from the rest of the newly discovered manuscript and, accompanied by a Dutch translation, was the first part to be published. It was specially prepared for the benefit of art historians preceding the publication of the entire Latin text. The more recently published Dutch translation of the entire text included a special appendix on Huygens as a critic of art based once again on this particular section of the whole.[6] However, if we look at how images and their makers are invoked in other parts of the *Autobiography* we find surprising things. Huygens takes a quite different stance toward tradition in general and offers us a different understanding of the nature of Dutch pictures. It is just because Huygens is so well known as a classically oriented, humanistically engaged cultural figure that his other side is so striking. And if pictures are what interest us, it seems to me that the Dutch were preeminent in that aspect of picture-making that corresponded, broadly speaking, to Huygens's nonhumanistic, scientific concerns.

The *Autobiography* builds up to a passage of extravagant praise for the works of the two men whom Huygens salutes as the leading thinkers of his day, Francis Bacon and Cornelis Drebbel:

I have looked up in awe at these two men who have offered in my time the

most excellent criticism of the useless ideas, theorems, and axioms which, as I have said, the ancients possessed.

[Veterum, quae dixi, inanium notionum, theorematum, axiomatum censores praestantissimos duos aetate meâ suspexi.][7]

Huygens had met the English philosopher—whom he goes so far as to call a sort of saint—and the Dutch experimenter on one of his first three trips to England. Both were situated well outside the educational program planned for him by his father. At one point Huygens even had to defend Drebbel against his father's charge that he was a sorcerer. Drebbel, an inventor as well as a sometime entertainer to the English court, was indeed a curious figure.[8] He made microscopes, devised a machine with claims to perpetual motion, invented a self-playing clavichord, and constructed a submarine in which he submerged under the Thames to the delight and wonder of the court, but which proved useless when tried as a weapon against the French at the seige of La Rochelle. Part necromancer, part experimentalist of a type frequent at the time, he struck contemporaries as either devious and untrustworthy or as wondrous and inventive, in short, as either a deceiver or a discoverer. It is not irrelevant to our discussion of Dutch art that while Huygens found Drebbel admirable and his discoveries fascinating, Rubens was suspicious and dismissive. In a letter of 1629 to the celebrated scholar Peiresc, a friend with whom he shared interests in antiquity and science, the Flemish painter tells of having seen Drebbel on a London street. On the basis of his appearance and the nature of his work, Rubens smartly suggests that he might appear greater at a distance than at close range. Unlike Huygens, Rubens calls the perpetual motion apparatus nonsense and is totally uninterested in his microscope. But, always the gentleman, he stops short and says that one must be careful not to rely on public gossip to criticize someone one does not know. In a deep sense neither the type of man nor his experiments had any attraction for Rubens. Drebbel's technical and manipulative view of the world is in sharp contrast to the textual and historical concerns of Rubens.[9]

Drebbel's connection to the world of Dutch art was of long standing. In his youth he had studied in Haarlem with Goltzius, a leading artist of the previous generation, and he married his younger daughter. He made a map of his hometown, Alkmaar, in 1597, at the same time that he was turning to the design of clocks, water supply systems, and chimneys with improved drafts. Links between art and the attempts of the new experimental technology to control nature were well established in the Netherlands. The status of the efforts, however, was sometimes suspect. While praising Drebbel's experiments, Huygens was deeply critical of Goltzius's flirtation with what he called the "madness" of alchemy. Curiously, though, Huygens makes no mention of De Gheyn's interest in similarly questionable researches. Distinctions between truth and folly are not always easily made. In the works of De Gheyn we find juxtapositions of images that seem to expose this issue. A hermit crab, for example, drawn in all of its spiky detail beside a kind of

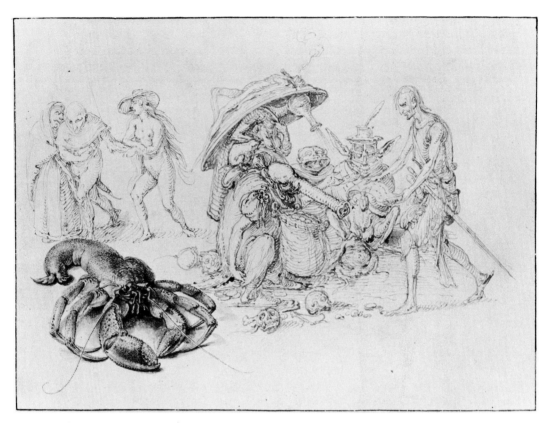

2. JACQUES DE GHEYN, *Hermit Crab and Witchcraft* (pen, ink, and watercolor). Städelsches Kunstinstitut, Frankfurt am Main.

witches' sabbath puts the complex relationship between curiosity and imagination in pictorial terms (fig. 2).

Huygens's promotion of Drebbel reaches its climax in his account of looking through Drebbel's microscope. He reports that people peering through the lens at first see nothing. (This is, in fact, a just account of what it is to look through the minute and imperfect lens of a seventeenth-century hand-held microscope.) They then cry out that they can see unbelievable things. It is a new theater of nature, indeed, another world. If only De Gheyn had lived longer, writes Huygens, he could have used his fine brush to depict the little things or insects seen in the lens. These drawings would then be engraved and the engravings collected into a book he would entitle *The New World.*

Indeed, material objects that till now were classified among atoms, since they far elude all human eyesight, presented themselves so clearly to the observer's eye that when even completely inexperienced people look at things which they have never seen, they complain at first that they see nothing, but soon they cry out that they perceive marvelous objects with their eyes. For in fact this concerns a new theater of nature, another world,

[handwritten margin note: on Drebbel's microscope: fascinated ppl: new theater of nature]

and if our revered predecessor De Gheyn had been allotted a longer life-span, I believe he would have advanced to the point to which I have begun to push people (not against their will): namely, to portray the most minute objects and insects with a finer pencil, and then to compile these drawings into a book to be given the title of the New World, from which examples could be incised in metal.

[Corpora nempe, quorum inter atomos hactenus aestimatio fuit, omnem humanam aciem longe fugientia, inspectanti oculo tam distincte obiecit, ut, cum maxime vident imperiti, quae nunquam videre, nihil se videre questi primo, mox, incredibilia oculis usurpare clamitent. Revera enim istud novo in theatro naturae, alio in terrarum orbe versari est et, si Geinio patri diuturnior vitae usus obtigisset, aggressurum fuisse credo, quo impellere hominem non invitum coeperam, minutissima quaeque rerum et in-sectorum delicatiore penicillo exprimere compilatisque in libellum, cuius aeri exemplaria incidi potuissent, Novi Orbis vocabulum imponere.][10]

Huygens looks into a lens and calls for a picture. In calling for a fine artist to record what he sees in a microscopic lens, Huygens assumes that picturing serves a descriptive function. It is not tied to received and hallowed knowledge but to new sights of a very individual kind. De Gheyn was an artist who had drawn both flora and fauna in minute detail (fig. 3), and Huygens seeks

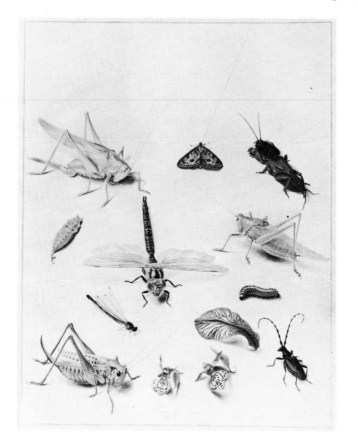

3. JACQUES DE GHEYN, page from a drawing book (watercolor on vellum). Fondation Custodia (coll. Frits Lugt), Institut Néerlandais, Paris.

to bind his skills to the new optical technology and the knowledge gained from it. What is interesting for us as viewers of pictures is the immediate connection that Huygens makes between the new technology and knowledge captured in a picture. This invocation of De Gheyn's skills is supported by a certain notion of picturing and of sight: we draw what we see and conversely to see is to draw. There is an assumed identity between seeing and the artifice of drawing that is realized in the artist's image.

In considering the kind of images that Huygens expects, we are calling attention to things about Dutch art that seem so obvious that we take them for granted. Art as the record of the image in the lens touches qualities that led commentators to consider Dutch art to be an extraordinarily and patiently crafted description of the world. The single instance of summoning De Gheyn to draw what is in the lens is not a sufficient basis for a general account of Dutch art. But this and other related passages in Huygens's writing suggest a certain cultural space that was occupied by Dutch images at the time.

Art, as Clifford Geertz has shown us, is part and parcel of a cultural system. Geertz argues that the kind of presence art has is not an absolute fact, evocable in some universally valid aesthetic terms, but is locally specific.

> The definition of art in any society is never wholly intra-aesthetic, and indeed but rarely more than marginally so. The chief problem is presented by the sheer phenomenon of aesthetic force, in whatever form and in result of whatever skill it may come, is how to place it within the other modes of social activity, how to incorporate it into the texture of a particular pattern of life. And such placing, the giving to art objects a cultural significance, is always a local matter; what art is in classical China or classical Islam, what it is in the Pueblo southwest or highland New Guinea, is just not the same thing, no matter how universal the intrinsic qualities that actualize its emotional power (and I have no desire to deny them) may be. The variety that anthropologists have come to expect in the spirit beliefs, the classification systems, or the kinship structures of different people, and not just in their immediate shapes but in the way of being-in-the-world they both promote and exemplify, extends as well to their drummings, carvings, chants, and dances. [11]

The absence of a special discourse about Dutch art may be a blessing in disguise, for it encourages us to look outside the art itself for clues as to its status, role, and meaning in the society. This is just where Huygens's *Autobiography* and his other writing can help us. They open up the possibility of defining the particular nature of a culture in which images play such a prominent role. In suggesting the new authority given to a visual as against a textual form of knowledge, Huygens suggests one reason for the peculiar primacy that images had at the time. But the variety of ways that images filled this role and the characteristics they exhibit in the process remain to be considered.

Huygens concludes his autobiographical fragment by looking into Drebbel's microscope and proclaiming the discovery of a new world. In his final

sentence he expresses the wish to continue their conversation, which was the most interesting that he had ever had. Huygens was still young when he wrote this and had a rich and various life ahead. But the interests revealed here are a far cry from those we expect of the educated humanist, commited to ancient languages, quoting established wisdom, and celebrating Rubens. The artist and his art are linked in this conclusion not to the noble tales, the beautiful bodies, and the expressive gestures of history painting, but quite simply to the world seen, the world known through seeing rather than through reading.

Neither here nor anywhere else in his writings does Huygens reveal that he feels any conflict between the aims of humanistic learning and the new natural knowledge, just as he sets up no conflict between history painting and what I call the art of describing. Immediately following his proclamation of the new world seen in Drebbel's lens he writes:

> Nothing can compel us to honor more fully the infinite wisdom and power of God the Creator unless, satiated with the wonders of nature that up till now have been obvious to everyone—for usually our astonishment cools as we grow familiar with nature through frequent contact—we are led into this second treasure-house of nature, and in the most minute and disdained of creatures meet with the same careful labor of the Great Architect, everywhere an equally indescribable majesty.

> [Infinitam Creatoris Dei sapientiam ac potentiam venerari nullâ re magis adigamur, quam si, satiati obviis cuique hactenus naturae miraculis, quorum, ut fit, frequenti usu ac familiaritate stupor intepuit, in alterum hunc naturae thesaurum immissi, in minimis quibusque ac despectissimis eandem opificis industriam, parem ubique et ineffabilem maiestatem offendamus.][12]

Huygens displays an extraordinary optimism about the entire enterprise of the new science for traditional theological reasons. He was certain that God's great plan was being more fully discovered in the lessons of the microscope and the telescope.

This confirming sentiment puts us in mind of Bacon, the thinker whom, next to Drebbel, Huygens admired most. Huygens is also a Baconian in the sense that he thinks of modern times as different from the past by virtue of knowledge and achievements unknown to the ancients. This theme is repeatedly touched on by Huygens in the *Autobiography*, whether with the example of the superiority of John Donne's preaching or the new technology of the lens. In spite of his classical education and his love for ancient authors, Huygens warns of the hold that the ancients have on men's minds. He quotes at some length from Bacon's *Great Instauration* on just this point:

> Except that under the influence of a unanimity that is firmly rooted in, so to speak, the judgment of time, we depend upon a system of thought largely deceptive and unsound, so that for the most part we do not know what has been noted in the sciences and arts at different periods and places

and what has been brought out into the open, much less what has been undertaken by individuals and studies in silence.

[Praeterquam quod consensu . . . iam inveterato tanquam temporis iudicio moti, ratione admodum fallaci et infirmâ nitimur, cum magnâ ex parte notum nobis non sit, quid in scientiis et artibus, variis saeculis et locis, innotuerit et in publicum emanârit, multo minus, quid a singulis tentatum sit et secreto agitatum.][13]

Huygens introduces the topic of the ancients versus the moderns in a surprisingly anecdotal way. He says that from the age of sixteen he has had to use eyeglasses in order to see clearly. Those wide-set, bulging eyes, so familiar to us from his portraits, were weak. To his delight, Huygens reports his discovery (which has since been confirmed) that the use of lenses is a strictly modern invention. We can praise antiquity, but this is something they did not know about. In a lengthy "digression on eyeglasses" in the humanist manner, Huygens recounts the history and use of lenses. Many other customs, arts, and sciences that were unknown to the ancients are just now, he points out, being discovered. On this note Huygens proceeds from his eyeglasses to a brief (though misleading) assessment of modern optics and geography. The contrast between the teachings of antiquity and the discoveries of modern technology and science is the same leitmotiv that sounds loud and clear in Huygens's praise of Bacon and Drebbel.[14]

Huygens, of course, was hardly alone at the time in arguing this way about the ancients and the moderns, but there is a further distinction to be made. In the complex turmoil of old and new, of craft and theory that make up what used to be called the scientific revolution of the seventeenth century, two strands are normally distinguished: the observational and experimental (in the original sense of experiential) practice promoted by Bacon, on the one hand, and the new mathematics on the other. However one judges the innovation or contribution of these two, it is clearly the former that Huygens invokes and with which he feels comfortable. In this he is in concert with his countrymen. His son Christiaan, who parted company with this tradition, did so abroad, in France.[15] This issue is not only intellectual but also social. It involves the kind of people you know and the world in which you live.

Huygens's interest in art is commonly related to his general cultivation. A leading study has argued that it is this that bound him most closely to England and things English. A. G. H. Bachrach says, "Sir Constantine [he was knighted already in 1622] . . . was one of the few equally at home in the two worlds in which England and Holland respectively excelled—the world of music and poetry and the world of painting."[16] While this Dutch scholar emphasizes the lofty, aristocratic, and traditional side of Huygens's culture, it was (appropriately) an American, the late Rosalie Colie, who exposed the other side, the Huygens who supported modern thinkers and the new technology against traditional learning and art, the Huygens whose world included Bacon but also Drebbel, "lower in rank but not in intellect," as he put it. Huygens had one of the great libraries of the time, but he also collected

lenses, brought a camera obscura back from England, and sponsored Leeuwenhoek with the Royal Society. These interests also bound Huygens to England and things English. Both countries excelled in a visually and technologically oriented culture, though the English contributed to it more through their texts and the Dutch through their images, as we shall see.

Huygens has no quarrel with art as a conveyor of traditional values. The long section of the *Autobiography* devoted to his own artistic education and to the inventory of Netherlandish artists testifies to this. However, he also thinks of images as bound in a most concrete way to the recording of new knowledge of the world seen. Images are thus tied to an advancement of learning, in Bacon's phrase, which Huygens specifically sets off against the inherited wisdom of the past.

The most extended statement of this is his great and moving *Daghwerck*, or *The Day's Work*.[17] It is a long and complex poem of over two thousand lines with a prose commentary. Huygens started it in 1630 in praise of, and dedicated to, his wife Susanna, as a record of his daily life with her. The *Daghwerck* offers an updated version of the education set forth in the *Autobiography*. This time, however, the education is of his own making, devised by Huygens for his wife. In it he brings the discoveries of the new science into his household for their common delight, education, and wonder. If Susanna had not died tragically following the birth of a child in 1637, Huygens intended to go on to set forth a poetic inventory of the day's occupations and pleasures, the sports, gardening, music, painting, and so forth of their life. The conversation Huygens looked forward to with Drebbel at the end of the *Autobiography* is taken up instead with his wife. As it is we are led through the world by microscope and telescope and through a survey of man's body and its medicines and then the poem abruptly ends in despair.

There is something very Dutch about a poet using the intimacy of his own house and his marriage as a central image of life, even as there is something Dutch about Huygens's equanimity toward the implications of the new science. The setting of Huygens's poem reminds us of the images of house, household, and family so frequent in northern art, from the homey dwelling of a Virgin of Van Eyck or Campin to the interiors of the seventeenth century. It is here in the comfortable, enclosed, private setting of one's own home that experience is received and literally taken in. This setting surely determines the definition and perception of what the nature of human experience is. While the *Autobiography* takes Huygens across the channel to England, tracing his experience of books and ideas, of men and events in the great world, the *Daghwerck* instead brings the world into his home. It domesticates cosmography—akin to the Dutch custom of decorating the walls of their rooms with maps of the world, as we shall see later.

A figure that Huygens employs to make an account of this to his wife says this and implies more:

> I have agreeable tidings which I shall bring you inside the house. Just as in a darkened room one can see by the action of the sun through a glass everything (though inverted) which goes on outside.

[Hebb ick aengename niewe tijdingen, ick salse u binnens huijs voor-
brenghen, gelijckmen in een duijstere Camer door een geslepen Glas bij
sonneschijn verthoont 'tghene buijtens huijs om gaet, maer aeverechts.][18]

This is Huygens's prose annotation to a passage of his poem in which he refers
to bringing news to his wife in the house even as a glass conveys the world
outside to those within. The annotation makes it clear that the glass referred
to is a camera obscura—literally a "dark room." This was the common name
given to a device that allows light to pass through a hole (often fitted with a
glass lens) into a box or darkened room to cast an image on a surface of the
world beyond (figs. 18, 23). The principle is the same as that of a camera, but
the image cannot be preserved. It is quite in keeping with what we know of
Huygens that he would call on the camera obscura to bring knowledge of the
world to his wife. It is "the new truth, new born into the clarity of midday's
light" ("de nieuw-geboren Waerheit / Niewgeboren inde klaerheit / Van des
middaghs hooghen dagh").[19] It is knowledge that takes the form of a picture.
Huygens's fascination with the camera obscura can be dated to his visit to
Drebbel during his London stay in 1622. The instrument, which had been
known in other forms for centuries, became a curiosity all over Europe in the
sixteenth and seventeenth centuries. While others had interests in it that were
astronomical and theatrical, Huygens's interests was purely pictorial—an
interest shared by his countrymen. Its picture-making capacity fascinated him
as it did the De Gheyns. The letter he wrote home to his parents exclaiming
on the beauty of the amazing image cast by Drebbel's device is an established
part of modern studies on the Dutch use of the camera obscura.

> I have in my home Drebbel's other instrument, which certainly produces
> admirable effects in reflection painting in a dark room. It is not possible to
> describe for you the beauty of it in words: all painting is dead in com-
> parison, for here is life itself, or something more noble, if only there were
> words for it. Figure, contour, and movement come together naturally
> therein, in a way that is altogether pleasing.

> [J'ay chez moy l'autre instrument de Drebbel, qui certes fait des effets
> admirables en peinture de reflexion dans une chambre obscure: il ne m'est
> possible de vous en declarer la beauté en paroles: toute peinture est morte
> au prix, car c'est icy la vie mesme, ou quelque chose de plus relevé, si la
> parole n'y manquoit. Car et la figure et le contour et les movements s'y
> recontrent naturellement et d'une façon grandement plaisante.][20]

The image is a direct challenge to the painter, but it also serves as a model for
his art. Although elsewhere Huygens suggests its utility as a valuable shortcut
to image-making, here it is its picturelike nature that fascinates him. Words
cannot do justice, he explains, to an image that is life itself or something in
even greater relief than life. This is the same point that Reynolds makes about
Dutch art when he despairs of writing an entertaining account of it. The
movement that Huygens praises recalls his praise for the Dutch skill in repre-
senting natural things. It is not human events or narrations, but the represent-

ation of the movement of nature herself that delights. It is not order, but the momentary, unfixed aspect of nature's passing show. Huygens's reception of the natural rendering of the world in the camera obscura can be persuasively related to his praise of the lifelikeness of contemporary Dutch landscape paintings. A circle is closed with this device, which offers technological confirmation of a taste we know he had.

We can learn much from the widespread Dutch fascination with the camera obscura as a maker of pictures like their own, and we shall return to this at greater length in the chapter that follows. Here, since it concerns Drebbel, I want to note a curious absence or exclusion: what the Dutch did *not* have in mind in their fascination with it. We are so accustomed by now to associating the image cast by the camera obscura with the real look of Dutch painting (and after that with photography) that we tend to forget that this was only one face of the device. It could be put to quite different uses. These uses significantly had no echo in Dutch pictures and we should consider why. One of the other wondrous devices that Drebbel produced was a magic lantern show, similar in construction to the camera obscura but with a human performance in view. Among Huygens's papers, in fact, is a letter of Drebbel's describing the transformation made possible by projecting himself in different ways:

> I take my stand in a room and obviously no one is with me. First I change the appearance of my clothing in the eyes of all who see me. I am clad at first in black velvet, and in a second, as fast as a man can think, I am clad in green velvet, in red velvet, changing myself into all the colors of the world. And this is not all, for I can change my clothing so that I appear to be clad in satin of all colors, then in cloths of all colors, now cloth of gold and now cloth of silver, and I present myself as a king, adorned in diamonds and all sorts of precious stones, and then in a moment become a beggar, all my clothing in rags.[21]

Drebbel changes from king to beggar and then, in a lighter vein, he proceeds to turn himself into a tree and then into a veritable menagerie of animals: a lion, a bear, a horse, a cow, a sheep, a calf, and a pig. These transformations also approximate art. But here Drebbel is closer to the masquing entertainments that delighted the English court than to the paintings of the Dutch. The camera obscura principle is employed to contrive a theatrical presentation, which is made up of Drebbel's transformations or narrations of himself. It differs from the presentation of recorded nature that is praised by Huygens in two respects: first, because it is performative or theatrical in character, and second, because the maker of the image, rather than standing by as a viewer, injects himself into its midst. By contrast, Dutch pictures avoid such a theatrical presentation in the interest of embracing the world described. Hence it is not surprising that Huygens and his countrymen were fascinated by the descriptive aspect of the camera obscura. A brief excursus on a related pictorial example can help us to clarify this point further in its relationship to Dutch art.

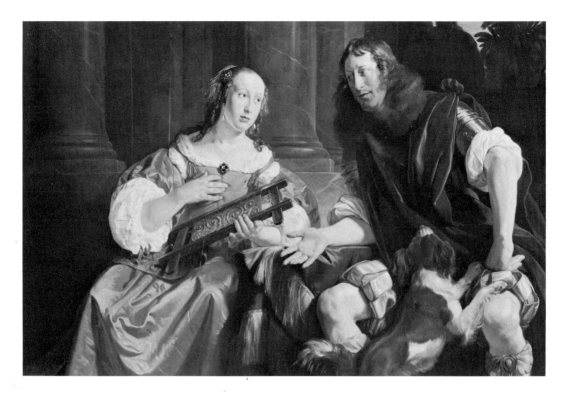

4. JAN DE BRAY, *A Couple Represented as Ulysses and Penelope,* 1668. Collection of the J. B. Speed Art Museum, Louisville, Kentucky. Photo: Prudence Cuming Associates Ltd., London.

A favored genre of portraiture in Holland was the so-called historiating portrait.[22] One might assume from the name that the Dutch, like Drebbel in England, played at transformation. It is often surprising today to see what historical identities the Dutch sitters wished to take on: a merchant and his wife as Ulysses and Penelope (fig. 4), Jan de Bray depicted a man and his wife as Antony and Cleopatra. But even more surprising than the choice of persona is the manner of presentation. And it is here that the contrast to Drebbel's use of the camera obscura will become clear. All such sitters for historical portraits, almost without exception, are distinguished by looking dressed-up rather than transformed. Unlike Drebbel, they could claim to fool no one. It is a collusion between portrayed and portrayer. It is as if the insistent identity of the Dutch sitters, present in the look of their faces and their telling domestic bearing, combines with the insistently descriptive mode of the artist representing them to make them unable to appear other than themselves. It is Rembrandt, unique in this way as in so many others, whose mysterious and probing portraits redeem the genre. A Rembrandt work of this type often poses the unanswerable question as to whether we have a portrait or a historical work before our eyes. The unresolved case of the so-called *Jewish Bride* (fig. 5) reveals the degree to which he can engage

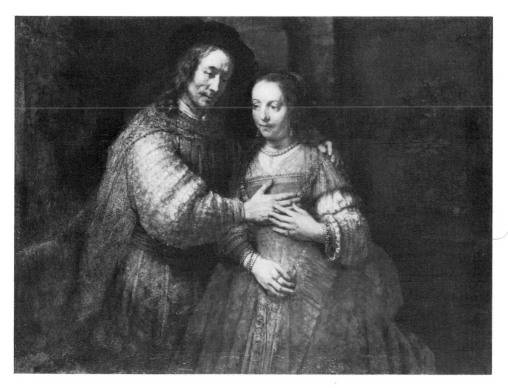

5. REMBRANDT VAN RIJN, *The Jewish Bride.* By courtesy of the Rijksmuseum-Stichting, Amsterdam.

contemporary individuals in the imagined life of other times and conversely grant presence and individuality to the imagined figures of history.[23] (A comparison of his awkward [early] *Saskia as Flora* with the splendid [late] *Hendrijcke as Flora* suggests that even Rembrandt is not always successful in this.) Such a sense of Rembrandt's dramatic (though notably nongestural) proclivities also gives us a way in which to understand the extraordinary variety of portrayals of self that he made in his lifetime. And this brings us back to Drebbel's letter and to his magic lantern. If we follow Rembrandt from his early, etched self-portrait as the beggar seated on a mound (fig. 6), in which he dresses himself in rags, to the royal demeanor that he takes on in the Frick *Self-Portrait* (fig. 7), we are surely witnessing Drebbel's magic lantern rather than Huygens's world described.

Let us return to where we left Huygens beside the camera obscura in his *Daghwerck.* A primary means to knowledge in the poem is the eye. It is praised as among the highest of God's gift to man.

> O you who give the eyes and the power,
> Give eyes through this power:
> Eyes once made watchful,
> Which see the totality of all there is to see.

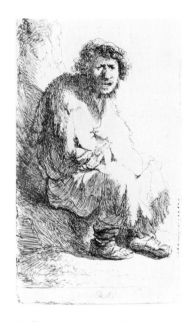

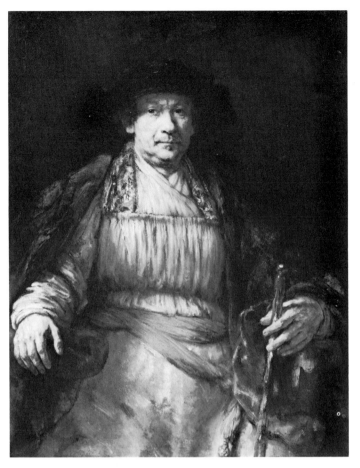

6. REMBRANDT VAN RIJN,
Beggar Seated on a Mound
(etching). Teylers Museum,
Haarlem.

7. REMBRANDT VAN RIJN, *Self-Portrait*, 1658. Copyright the
Frick Collection, New York.

[O, die d'oogen en 'tgeweld geeft,
Oogen geeft bij dit geweld:
Oogen eens ter wacht gestelt,
En die all' sien soo der veel' sien:][24]

The eye is the means by which Huygens reports new knowledge of the world.
He travels up to the heavens, then down into the earth where he looks at
flowers, gnats, and ants. The smallest things that were previously invisible
can now be seen with the help of the magnifying glasses:

From little Flowers, Midges, Ants, and Mites shall I draw my lessons.
With the aid of the microscope, parts of these the smallest of Creatures till
now invisible have at this time become known.

[Uyt Bloemkens, Muggen, Mieren ende Sieren sal ick mij lessen trecken.

Want der kleinste schepselen tot noch toe ongesiene deelen zijn nu bekent geworden, door hulp van onse korte vergroot-Brillen.][25]

Although people said you could not see them with your eyes, you now can—from the stars in heaven to the individual grains of sand on the shore. Huygens enthusiastically repeats the voyage with his eyes:

And discerning everything with our eyes as if we were touching it with our hands; we wander through a world of tiny creatures till now unknown, as if it were a newly discovered continent of our globe.

[Ende onderscheidende alles by onse ooghen, als oft wij 't met handen tasten, wandelen door eene tot noch toe onbekende wereld van kleine schepselen oft het een niew ontdeckt gedeelte van den Aerdbodem waere.][26]

We are truly as gods, concludes another poem, if we can see everything from this highest point of the heavens to the tiniest creatures on earth.

On the Telescope
At last mortals may, so to speak, be like gods,
If they can see far and near, here and everywhere.

In Telescopium
[Dijs, dicat, liceat tandem mortalibus esse,
Si procul et prope, et hic esse et ubique queunt.][27]

The tone of Huygens's utterance does not present a challenge but rather a tribute to God's devising. He takes a positive stance toward what was, to many at the time, an unnerving new view of man's place in the world. Perhaps Huygens suggest some uncertainty when he, like Milton after him, hands a telescope to the Devil:

On the Same Glasses [lenses]
Who is to say that the Tempter
Did not have the use of that lens,
Since he showed the Lord
All the Earth's Kingdoms?

Des Mesmes Lunettes
[Qui dira si le Tentateur
N'auoit l'usage de ce verre,
Des lors qu'il monstra au Seigneur
Tous les Roijaumes de la Terre?][28]

But the real issue was not the hands into which the glasses fell. This rhyme offers a rational explanation of how Jesus was enabled to see. The issue was rather man's place or, more specifically, his measure in this new world.

It followed, as part and parcel of the primacy granted to sight, that the issue of scale or the estimation of relative size became a pressing one. An immediate and devasting result of the possibility of bringing to men's eyes the minutest

of living things (the organisms viewed in the microscopic lens), or the farthest and largest (the heavenly bodies viewed through the telescopic lens), was the calling into question of any fixed sense of scale and proportion. The related problem of how we perceive distance and estimate relative size still exercises students of perception. Whatever the solution might be, there is general conclusion that the eyes cannot by themselves estimate distance and size. It is this that telescopes and microscopes made clear in the seventeenth century. To many it seemed a devasting dislocation of the previously understood measure of the world, or, in short, of man as its measure. The simple enthusiasm with which Huygens greets this dislocation of man is astonishing. Part of the passage praising Drebbel at the conclusion of the *Autobiography* reads as follows:

> If nothing else, let us learn this, that the estimation which we commonly make of the size of things is variable, untrustworthy, and fatuous insofar as we believe that we can eliminate every comparison and can discern any great difference in size merely by the evidence of our senses. Let us in short be aware that it is impossible to call anything "little" or "large" except by comparison. And then, as a result, let us firmly establish the proposition that the multiplying of bodies . . . is infinite; once we accept this as a fundamental rule then no body, even the most minute, may be so greatly magnified by lenses without there being reason to assert that it can be magnified more by other lenses, and then by still others, and so on endlessly.

> [Si non aliud, hoc sane edocti, quae magnitudinis rerum vulgo aestimatio est, fluxam, futilem et insanam esse, quatenus omissâ comparatione aliquo sensuum indicio absolute discerni creditur. Tandem hoc sciatur, nihil usquam parvi aut magni extare nisi ex parallelo; denique ex hoc statuatur, multiplicationem istam corporum infinitam esse et, his rei principiis traditis, nullum de minimis corpusculum tantopere vitris augeri, quin asserendi locus sit, in immensum aliis item atque aliis auctum iri.][29]

Huygens delights in offering specific examples of the loss of measure and proportion in his *Daghwerck* (I am quoting once more from the prose commentary that clarifies his points):

> For example: a city gate as we now see it is but a mere crevice, compared to a crevice as seen through the magnifying lenses, which looks like a huge gate. And if one viewed with such glasses one of the 360 degrees, one would find space in it for 1000 miles instead of 15.

> [Bij voorbeeld: Een' Stads poorte, soo wijse nu sien, is maer een splete, by een splete door het vergrootglas gesien, die sich als een onmatighe Poorte verthoont. Ende alsmen met sulcke Brillen eenen van de 360. graden besagh, men souder ruijmte in vinden voor 1000 mijlen in plaets van 15.][30]

The juxtaposition of a tiny crevice and huge town gate, or the expansion of the degree into a panoramic view, brings to mind characteristic features of

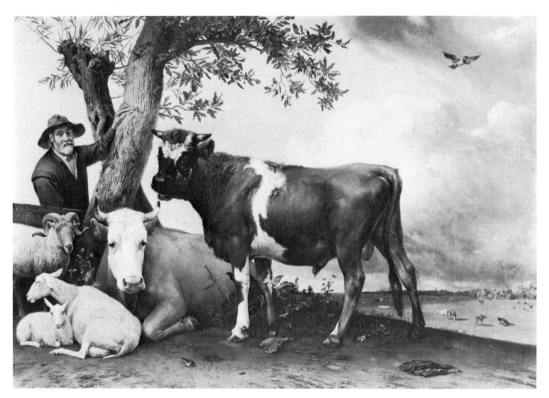

8. PAULUS POTTER, *The Young Bull*, 1647. Mauritshuis, The Hague.

Dutch art. Paulus Potter's famous *Young Bull* looms against a dwarfed church tower and sports a tiny fly on its extensive flank (fig. 8). Philips Koninck's panoramas extend the small reach of the Dutch land into an expanse that rivals the dimensions of the globe itself (fig. 86). The curious image of the artist is often reflected in miniature on the surface of a wine jug in Abraham van Beyeren's still lifes (figs. 9, 10). Equating through juxtaposition of near and far, or small and large, had occupied northern painters since at least Van Eyck. He had depicted himself in miniature reflected in his works (fig. 11) and had juxtaposed the hands of Chancellor Rolin against the towers of a distant town. Did artists in the north ever, one wonders, posit any fixed measure or proportion?

It is this question that forms the basis of that famous complaint against northern art attributed to Michelangelo. It is the final sentence of this passage that concerns us:

> In Flanders they paint with a view to external exactness or such things as may cheer you and of which you cannot speak ill, as for example saints and prophets. They paint stuffs and masonry, the green grass of the fields, the shadow of trees, and rivers and bridges, which they call landscapes, with many figures on this side and many figures on that. And all this, though it pleases some persons, is done without reason or art, without symmetry

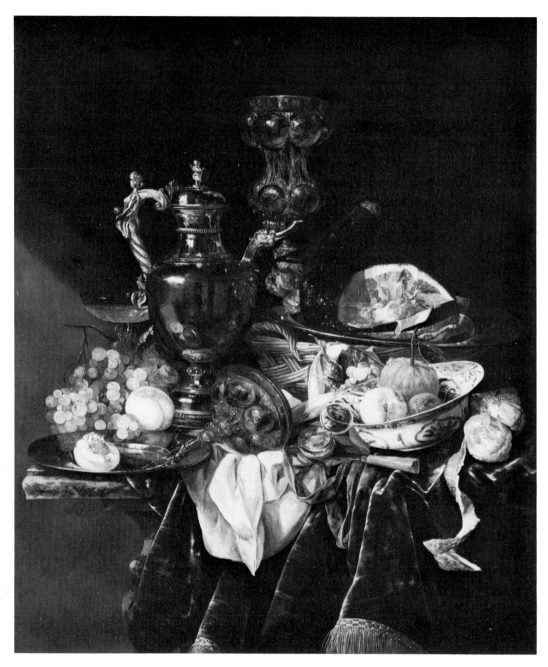

9. Abraham van Beyeren, *Still Life with a Silver Wine Jar and a Reflected Portrait of the Artist.* The Cleveland Museum of Art, purchased from the Mr. and Mrs. William H. Marlatt Fund.

10. ABRAHAM VAN BEYEREN, detail of fig. 9 (artist's reflection).

11. JAN VAN EYCK, *Madonna with the Canon van der Paele*, detail (artist's reflection). Musée Communal des Beaux Arts, Bruges. Copyright A.C.L. Brussels.

or proportion, without skilful choice or boldness and, finally, without substance or vigour.[31]

We usually remember the emphasis on detailed description from this passage. But the speaker significantly ties such detail to a lack of reason, art, symmetry, and proportion. Alberti had written that

> large, small, long, short, high, low, wide, narrow, light, dark, bright, gloomy, and everything of the kind, which philosophers termed accidents, because they may or may not be present in things,—all these are such as to be known only by comparison.[32]

But in the face of such relativism, he confidently asserted that man provides the measure in a way that determines and assures the nature of Italian pictures:

> As man is best known of all things to man, perhaps Protagoras, in saying that man is the scale and the measure of all things, meant that accidents in all things are duly compared to and known by the accidents in man.[33]

Huygens does not accept this reasoning. On the contrary, his celebration of the conjunction of small and large, and of near and far, accepts the absence of any fixed proportion or human measure. What had long been characteristic of northern art became the proven human condition in the seventeenth century. We shall see in the following chapters that this is not the only respect in which northern pictures anticipated certain seventeenth-century ways of understanding the world.

Accepting the relativity of size, as revealed to the eye strengthened by the lens, raises the question of the truth or status of vision. We see a crevice in one way when it is enlarged by a lens to the size of a city gate, and in another way when it appears much smaller than a city gate. Which view is the true one? How do we define the identity of things in the world when they are seen as so variable in size? Can we trust our eyes? (Lenses had been rejected before this time just because it was thought that they misled or distorted true vision.) Huygens's delight in the unresolvable question of size means that he accepts the fact that in making an image our sight plays tricks. To accept the deceptions of sight, and sight itself as a useful artifice, is, paradoxically, a condition of his single-minded concentration on sight and things seen. This surfaces particularly in his attention to the question of the truthfulness of lifelike images. The issue occupies Huygens at one point in his *Autobiography* and to a lesser extent in the *Daghwerck*. First of all, he gives evidence that he himself painted paintings to fool the eyes. He describes with pleasure his still life with hazelnuts, a pipe, a candle, and a large fly in the De Gheyn manner. With uneasy excitement he describes the fearful likeness of a head of Medusa by Rubens. It awakens so much uncertainty in the viewer as to its status—real or painted—that the friend who owned it kept it covered and as it were disarmed. Although Huygens uses the *Medusa* to discuss the relationship of beauty to ugliness or horror, the basic problem concerns the truth of such a

(?) TRUTH OF REPRESENTATION

representation. It is this theme that Huygens raises in his remarks on contemporary artists when he turns to portraiture and to the Dutch portraitist he considers the greatest of all, Michiel van Miereveld. In attempting to put his finger on the lifelike quality of his portraits, Huygens concludes that in the end, as Seneca had written, the likeness of art is inferior to reality. But he does not let the issue rest there. He proceeds to give examples of the tangled relationship between sitter and representation or between life and art. He adds a phrase from Tacitus to the effect that art borders directly on deception, "breve confinium artis et falsi."[34] Even when it is true, a human making borders on falseness. The "art" (in the sense of the human making) that Tacitus had characterized in this way was a prediction by certain astrologers that was believed but misunderstood.[35] Therefore, when it came true, it came true in unexpected ways and was thought to be false. This anecdote, like its motto quoted by Huygens, suggest how close to each other truth and error are.

It is Huygens's preoccupation with the problem of the truth of a representation that I wish to emphasize. It is a problem he raises when he comes to praise Drebbel's camera obscura in the *Autobiography*. It is in the nature of the device that it upends the world imaged in it: the image it casts is upside down unless something is done to right it. Though Drebbel himself claimed to be able to correct this imperfection, the falsification was disturbing to Huygens. The instrument whose image-making he extols is itself falsifying. In the midst of the evocation of the camera obscura as the bearer of new truths to his wife in the *Daghwerck*, Huygens interrupts himself to warn her of this danger. Indeed, from the figure of truth he turns to its opposite. Huygens proceeds to relate the camera obscura's reversal of the world to the reversal of truths or lies that are produced by men (historians among others) in the world.[36] The concern with the nature of this image is part of a continuing concern with the truth of images. The instance of a real-looking, but still in some aspects false, representation is situated right on the borderline between reality and artifice, which, on the evidence of their eye-fooling pictures, intrigued the Dutch. Far from minimizing the importance of images, it suggests how much they depended on them.

With his rare combination of public service, great learning, and diverse talents, Constantijn Huygens could be described as a Renaissance figure transported to seventeenth-century Holland. But in important respects he is completely at home in his time and place. He turned away from the established knowledge and texts of the past for the newest discoveries being made in the advancement of natural knowledge. His unbounded confidence in the technologies that strengthened human sight led him to value images and sights of all kinds as the basis for new knowledge. His enthusiasm took quite practical forms. The link between pictorial depiction and natural knowledge in the writings of Huygens is not based on mathematics or scientific theory, but rather on observations, experimental procedures, and their practical outcome. It was the medicine, land-drainage, mapmaking, and the little animals

pictorial depiction ~ natural knldg

mathematics; science

observation, experiment

based on

in Leeuwenhoek's lenses that interested him.[37] And therefore it was quite natural for Huygens to associate art, or image-making, with such practical tasks.

In the *Autobiography,* as part of his general discussion of the artistic training that his father planned for him, Huygens argues for the utility of a skill in drawing. He offers the example of the kind of record of one's travels that one can make if one knows how to draw. The *Autobiography* is of course an outline of a proper education. Drawing had already been considered a skill suitable to the wealthy in ancient times. Huygens establishes this by quoting Pliny, to which we can add the example of Castiglione's *The Courtier,* which also commends drawing. But perhaps because of the theoretical weight given internationally to *disegno* (the conceptual role of drawing in the invention of images), the craft and social utility of *tekening* (the Dutch word for drawing) has not been defined. There is much evidence from the sixteenth and early seventeenth centuries that art served as a pictorial record or description. Huygens tells us in his *Autobiography* how his great-uncle Joris Hoefnagel had traveled widely in Europe from the 1560s to the 1590s preparing drawings of cities for use in the great *Civitates Orbis Terrarum* of Braun and Hogenberg. Botanical description, maps, topography, and costume study all were tasks for the artist as illustrator at the time. Until recently, art historians have tended to separate high art, on the one hand, from image-making as a craft with utilitarian uses. The line is drawn so that what is considered to be a craft has not been considered to be art.[38] What happens to the practical images praised by Huygens? To the interest in mapping, archaeology, and botany that are present in a landscape by Van Goyen, a church interior by Saenredam, or a vase of flowers by Bosschaert? Artful images such as these make it hard to dismiss pictorial craft.

The pursuit of natural knowledge in the seventeenth century provides a model for the consideration of both craft and high art. Here the relationship between craft and theory is a recognized problem. Let us propose that the empirically based pursuit of natural knowledge, for which Huygens opts, contrasts with the classical, mathematically based studies, even as the craft concerns of Dutch artists do with the aims and ideals of high art. The so-called Merton thesis, which linked the Protestant ethic—a strong utilitarian strain, a work ethic and, a mistrust of system—with the development of science, has been much disputed. It attempted to explain more than it could. In a recent reconsideration, Thomas Kuhn wisely relates the Merton thesis not to the development of science in general but to the experimental, Baconian strain in particular. This was the form of science that was at its strongest in England and in the Netherlands. It is this experimental, Baconian strain to which Huygens implicitly binds Dutch art.[39]

The social history of the Dutch artist has yet to be written. But to the extent that we acknowledge art as a practical craft, we must reconsider our notion of the occupation of the artist as well as of his product. The advantage of drawing an analogy between the artist and the experimenter in natural knowl-

edge is that it encourages us to focus anew on what went into the making of Dutch images: an absence of any learned discourse and no connection with any institution engaged in it; the use of traditional skills; a renewed sense of purpose and delight in discovery.

There is a two-way street here between art and natural knowledge. The analogy to the new experimental science suggests certain things about art and artistic practice, and the nature of the established tradition of art suggests a certain cultural receptivity necessary for the acceptance and development of the new science. With the single exception of Galileo in Italy, northern Europe was the center for the use of the lens. The Dutchman Leeuwenhoek was amazingly the first, and for a while the only, man in Europe to pursue the study of what was seen in microscopic lenses. The fact that the country that first used microscopes and telescopes had Van Eyck and other works like his in its past is not just an amusing coincidence, as Panofsky once claimed.[40] Didn't northern viewers find it easier to trust to what was presented to their eyes in the lens, because they were accustomed to pictures being a detailed record of the world seen? Given the extraordinary articulateness and persistence of the pictorial tradition in the north—a tradition that neither the cultural movement of the Renaissance nor the crisis over religious confession managed to undo—one is hard put to assign precedence in these matters. The cultural space that images can be said to occupy in Huygens's world and writing raises but does not answer such questions.

2

"Ut pictura, ita visio": Kepler's Model of the Eye and the Nature of Picturing in the North

I want to turn from the general cultural role of images in the Netherlands to one specific aspect: their lifelike appearance. To deal with this I shall be introducing a new and concrete piece of evidence: the definition of the picture arrived at by Kepler in his description of the eye. Concrete though this is, its use requires some delicacy. I am not claiming a source for or influence upon the art, but rather pointing to a cultural ambiance and to a particular model of a picture that offers appropriate terms and suggests strategies for dealing with the nature of northern images. But before I continue a note on usage is in order. In the title of this chapter, as elsewhere in the book, I employ the word "picturing" instead of the usual "picture" to refer to my object of study. I have elected to use the verbal form of the noun for essentially three reasons: it calls attention to the *making* of images rather than to the finished product; it emphasizes the inseparability of maker, picture, and what is pictured; and it allows us to broaden the scope of what we study since mirrors, maps, and, as in this chapter, eyes also can take their place alongside of art as forms of picturing so understood.

It has become fashionable of late among some art historians to dismiss Dutch realism as an invention of the nineteenth century. Though we might agree to lay what is frequently referred to as the "concept" of realism at the door of the nineteenth century, when the term itself was first widely employed, the beguiling visual presence, the "look" common to so many Dutch pictures is part of their birthright, which is only evaded by the current attention to emblematic meanings. Henry James, as acute a commentator as any in this regard, placed the phenomenon I want to deal with in this chapter at the center of his sense of Dutch art.

> When you are looking at the originals, you seem to be looking at the copies; and when you are looking at the copies, you seem to be looking at the originals. Is it a canal-side in Haarlem, or is it a Van der Heyden. . . . The maid-servants in the streets seem to have stepped out of the frame

of a Gerald Dow and appear equally well adapted for stepping back again.
. . . We have to put on a very particular pair of spectacles and bend our nose
well over our task, and, beyond our consciousness that our gains are real
gains, remain decidely at loss how to classify them.[1]

Where is the art? When images are situated at the threshold between the world
and our perception of it how can they be considered as art? These are ques-
tions that puzzled Henry James as they have puzzled viewers before and
since. We have already touched on a number of pictorial features that conjoin
to produce this appearance of a world existing prior to us which we view. Let
me rehearse them once more: the absence of a prior frame—that rectangle or
framed window which Alberti offers as his initial definition of the picture—
so that the image spread out on the pictorial surface appears to be an un-
bounded fragment of a world that continues beyond the canvas (to frame such
a fragment, as Dou often does by painting one into the picture, is a decisive
act [fig. 12]); the world staining the surface with color and light, impressing
itself upon it; the viewer, neither located nor characterized, perceiving all
with an attentive eye but leaving no trace of his presence. We might take
Vermeer's *View of Delft* (fig. 13) as the consummate example. Delft is hardly
grasped, or taken in—it is just there for the looking. These features are
commonly explained by an appeal to nature. The Dutch artist, the argument
goes, adds actual viewing experience to the artificial perspective system of the
Italians. In this wide vista, which presumes an aggregate of views made
possible by a mobile eye, the retinal or optical has been added on to the
perspectival. An imitative picture, it is assumed, is perspectival and Italian by
definition and the Dutch add nature to it. Images made by the camera obscura
and the photograph have frequently been invoked as analogues to this direct,
natural vision. Thus Lord Clark has written (a bit crudely) of the *View of
Delft* that "this unique work of art is certainly the nearest which [*sic*] painting
has ever come to a coloured photograph."[2] But the appeal to nature (for that
is what Clark means this to be) leaves us justifiably uncomfortable. Nature
cannot solve the question of art—particularly in this post-Gombrichian age.
And this has now led to painstaking studies of the techniques of these realist
painters. Maybe, it is thought, if we look into exactly how Vermeer laid on
his paints we can locate and testify to the art in his art. But the craft and skill
that produced the Dutch pictorial illusion of life are curiously unassertive.
They do not call attention to themselves through the kind of admission to or
celebration of the primacy of medium that becomes a hallmark of realist
painting in the nineteenth century. With Dutch painting we are, as it were,
prior to such recognition. It was a particular assumption of the seventeenth
century that finding and making, our discovery of the world and our crafting
of it, are presumed to be as one. This assumption was common, as we shall
see in the following chapter, to the project of inventing a universal language,
to the experiments of Bacon's natural history, and to picturing. It was in just
this spirit that a Dutchman could refer to the image cast by a camera obscura
as a "truly natural painting."[3]

12. GERARD DOU, *A Poulterer's Shop*. By permission of the Trustees of the National Gallery, London.

It is in pursuit of just what this "truly natural painting" might be that there has understandably been much attention devoted to the camera obscura and its relationship to Dutch images.[4] There were basically two forms of this device at the time: one immobile, with a hole perhaps fitted with a lens in the wall or window shutter of a darkened room casting the image of sunlit things outside onto a paper or a wall (fig. 18), and the other a mobile version (fig. 23). This image-making device, found most commonly in America today in

13. Jan Vermeer, *View of Delft*. Mauritshuis, The Hague.

children's science museums, appears early on in the literature on Dutch art. Reynolds was the first who, with knowledge of the techniques used and effects created by the Italian *vedusti,* claimed that the paintings of Jan van der Heyden "have very much the effect of nature, seen in a camera obscura."[5] Reynolds defines this effect as great breadth of light combined with a very minute finish—an effect that led nineteenth-century commentators to compare Van der Heyden's work to photographs. Fromentin makes the same point about breadth—this time, however, of view—in his passage about Ruisdael's panoramic landscapes. He speaks of the "circular field of vision," of the painter's "grand eye open to everything that lives"; an eye, he adds, with "the property of a camera obscura: it reduces, diminishes the light and preserves in things the exact proportions of their form and coloring."[6] "He regarded the immense vault, which arches the country or the sea, as the actual, compact and stable ceiling of his pictures. He curves and spreads it, measures it, determines its value in relation to the variations of light on the terrestrial horizon."[7] Eye, world seen, and picture surface are here elided in

a manner that suggests that the world described—painting as we spoke of it in the first chapter—is none other than the world perfectly seen. Fromentin's example is drawn from landscape, the image of which was commonly cast by the camera obscura when the device was described and illustrated in the seventeenth century. But his characterization is continuous with his sense of other kinds of painting. Ter Borch, for example, he writes, produces an artless art "which adapts itself to the nature of things, a knowledge that is forgotten in presence of special circumstances in life, nothing preconceived, nothing which precedes the simple, strong and sensitive observation of what is."[8] It is the surfaces, the materials of the world that have caught the eye in Ter Borch. Fromentin catalogues for our eyes "the apparel, the satins, furs, stuffs, velvets, silks, felt hats, feathers, swords, the gold, the embroidery, the carpets, the beds with tapestry hangings, the floors so perfectly smooth, so perfectly solid."[9] It is as if visual phenomena are captured and made present without the intervention of a human maker. This is the rightness of the connection made to the eye or to its equivalent, the camera obscura. The geometrically calculated dimension of space and figures and the solidity of objects found in an art constructed according to linear perspective give way to this, Fromentin implies. He writes of there being "no science or technique" to be learned. When Reynolds and Fromentin and others appeal to the camera obscura it is by way of suggesting the difference of Dutch art—the difference from the established art of Italy or of the academy.

Since the nineteenth century with the advent of photography and the attention to Vermeer, his works have been prominent among those related to the tradition of mechanically made images. Some commentators continue to stress the familiar analogy of the camera obscura, as when Claudel describes Vermeer's *Soldier and Laughing Girl* (fig. 14) in the Frick collection: "Ce qui me fascine, c'est ce regard pur, dépouillé, stérilisé, rincé de toute matière, d'une candeur en quelque sorte mathématique ou angélique, ou disons simplement photographique, mais quelle photographie: en qui ce peintre, reclus à l'intérieur de sa lentille, capte le monde extérieur." Others begin to insist on the actual use of an instrument to achieve certain effects. The scale of these figures—the large man placed in the foreground before the small woman— was termed "a photographic scale" by Joseph Pennell in 1891 and suggested to him that Vermeer had employed an optical device.[10] This is only the first of many such comments on the striking formal organization and pictorial presence of Vermeer's paintings. The relationship to image-making devices shifts subtly from proclaiming lifelikeness to the aesthetic claims of art. The problem is that although many sixteenth- and seventeenth-century treatises that discuss the artistic use of the camera obscura recommend tracing its image, we have no evidence of cases in which artists actually did this. The argument from use, rather than from analogy, has had to proceed therefore by trying to establish specific phenomena present in paintings that are not seen by unaided vision and that, it is thus concluded, must result from the use of the camera obscura.

14. JAN VERMEER, *Soldier and Laughing Girl.* Copyright the Frick Collection, New York.

In the case of Vermeer, everything from spatial organization to the rendering of objects and the use of pigment—in short, much of what we think of as his distinctive style—has been at some time attributed to the camera obscura. But to prove the use of the camera obscura in this sense is in effect to distinguish the viewing device and its effects from nature. Instead of being tantamount to seeing the world, the camera obscura becomes a source of style. Further, the artist is seen attending not to the world and its replication in his image, but to copying the quirks of this device. Of the list of ten phenomena put forth by the most comprehensive study of this kind only one has been generally accepted. It would appear that those small globules of paint that we find in several works—the threads in the *Lace-maker,* the ship in the *View of Delft*—are painted equivalents of the circles of confusion, diffused

circles of light, that form around unfocused specular highlights in the camera obscura image.[11]

Practically speaking, from the point of view of the use of a device and the production of the entire image presented by each picture, the attempt to prove how Vermeer used the camera obscura has been disappointing in its results. The basic issues remain muddled, because rather than offering a solution to the problem posed by the nature of the painting, the analogy of the camera obscura has so far just mirrored that problem in all its complexity. On the one hand there is the suspicion—which we can trace from the seventeenth century up to the attacks on photography in our time—of the bad faith shown by an artist who is dependent on a mechanical instrument. This is particularly true in the case of the camera obscura, which is sometimes implicitly seen as the untutored (Dutch) craftsman's shortcut means to perspective. In other words, it is only if you cannot make a perspective picture (geometrically) like the Italians that you copy the picture in a camera obscura. Art is assumed to be that which is not due to an instrument but to the free choices of a human maker. There is an attempt to rescue the art in art from the encroaching machine. However, this point is in turn in some doubt because of uncertainty as to the nature and status of the camera obscura image itself. Seen by some as developing the image of perspective seeing, it is also seen—and today much more commonly—as offering an alternative to that. It offers what has often been called an "optical" versus a "perspectival" image. In this view, the camera obscura corresponds to the impetus and makings in Dutch art that strove, as a recent writer put it, "to overcome the limitations of linear perspective in a very innovative way." It supplies direct visual impressions to an empirical age and particularly to the Dutch who, as the same scholar suggests, "were using their eyes with fewer preconceptions than their predecessors."[12] Rather than serving as an access to a constructed image of the visible world, the camera obscura in this view supplies the visible world direct empirical evidence, as it were, which the artist then uses in his art. Mechanical guide, constructor of perspectival images, or mirror of nature: the uncertainty about how to specify the use or force of the camera obscura reflects a genuine uncertainty about the nature of the art it has been thought to evoke or to which it has so consistently been bound.

Though it is generally agreed that there is an important sense in which the camera obscura is paradigmatic of Dutch images, it is not clear what this constitutes as a notion of art. Let us look at the evidence again, but in a different way. The appeal to nature in the understanding of Dutch images is grounded in a specific cultural ambiance—the empirical interests of what is commonly referred to as the age of observation. The skies are scanned, land surveyed, flora, fauna, the human body and its fluids are all observed and described. But if we consider what all this empirical observation of nature entails, we are in for a surprise. Instead of finding a direct confrontation with nature, we find a trust to devices, to intermediaries that represent nature to us. The major example is the lens. Its images and those engendered by it take

their place beside the images of art, which are also, of course, representations. The artifice of the image is embraced along with its immediacy. The situation is summed up in the *Autobiography* of Constantijn Huygens who, as we have seen, praises his eyeglasses, marvels at the camera obscura image, and calls for De Gheyn to draw the new world made visible in the microscope.

Historians of science tell us that though the lens was long known, it had been considered distorting and deceptive. It was not until the seventeenth century that it was trusted. Indeed, empirical observation in Holland is made possible by a trust in a host of representations of the world. It is less the nature or use made of the camera obscura image than the trust placed in it that is of interest to us in understanding Dutch painting. And this is the relevance of Kepler, to whom we now turn. For in defining the human eye itself as a mechanical maker of pictures and in defining "to see" as "to picture," he provides the model we need for that particular binding of finding and making, of nature and art, that characterizes the picture in the north.

I

Kepler seems to have backed into the problem of the optical mechanism, and the way he did it has an interesting relationship to the early history of the camera obscura or its predecessor, the pinhole camera.[13] Since antiquity this device had been used as a method of making certain astronomical observations—in particular observing lunar and solar eclipses. It was a way of studying light rays. When we try to understand the use of the camera obscura as a maker of those pictures of the world that so fascinated Huygens and Hoogstraten, we must remember that though the mechanism was old, its picture-making function was quite new. In the past, the pinhole camera had made possible indirect and hence eye-saving observations of the sun, the moon, and their eclipses. This was Kepler's first interest in it.

There was, however, a problem, an enigma as he called it, about these observations: the lunar diameter as formed by the rays in the pinhole camera appeared smaller during a solar eclipse than at other times, although it was rightly assumed that the moon had not changed size nor moved farther away from the earth. It was this observation, made by Tycho Brahe in Prague when Kepler was serving as his assistant in 1600, that Kepler was able to explain. His radical answer was to turn his attention away from the sky and the nature of light rays to the instrument of observation itself: to turn from astronomy to optics. Kepler argued that what was at issue was the precise optics of the images formed behind small apertures in the pinhole camera. The apparent changing diameter of the moon is, so he argues in his *Paralipomena* —or additions to (literally "things omitted from") the work of the older astronomer Witelo—an inevitable result of the means of observation. The size and shape of the refracted ray bundles were related, so he argued, to the size of the aperture. The optical mechanism, in short, intersected the rays. To understand our view of sun, or moon, or world, we must understand the instrument with which we view it, an instrument, so Kepler argued, with distortion

or errors built in. In this 1604 publication Kepler went on to take the next step of recognizing the necessity of investigating our most fundamental instrument of observation, the eye, which he now in effect described as an optical mechanism supplied with a lens with focusing properties (fig. 15). It was by studying and defining the function of the parts of the eye, with some help from the discoveries of anatomists and an arguable relationship to the knowledge of cadavers, that Kepler was led to define vision as the formation of a retinal image, which he significantly called a picture:

> Thus vision is brought about by a picture [*pictura*] of the thing seen being formed on the concave surface of the retina.
>
> [Visio igitur fit per picturam rei visiblis ad album retinae et cauum parietem.][14]

But we are getting ahead of ourselves. For before we turn to the forming—the "painting" Kepler was to call it—of the picture itself, let us turn back to Kepler's initial strategy. First, note the words he chose in coming to terms with the contradictory observations of the eclipsed sun or moon in the pinhole camera:

116 LA DIOPTRIQUE

15. Illustration of the theory of the retinal image in RENÉ DESCARTES, *La Dioptrique* (Leiden, 1637). Courtesy, the Bancroft Library, Berkeley, California.

> As long as the diameters of the luminaries and the extent of solar eclipses are noted as fundamental by astronomers . . . some deception of vision [*visus deceptio*] arises partly from the artifice of observing . . . and partly just from vision itself. . . . And thus the origin of errors in vision must be sought in the conformation and functions of the eye itself.
>
> [Dum diametri luminarium et quantitates Solis Eclipsium, fundamenti loco annotantur ab Astronomis: oritur aliqua visus deceptio, partim ab artificio obseruandi orta . . . partim ab ipso visu simplici. . . . Erroris itaque in visu, occasio quaerenda est in ipsius oculi conformatione et functionibus.][15]

Kepler here attributes the enigma of the astronomical observations to the deception of vision, which consists of

two things: the artifice of observing (in other words, the aperture intersecting the rays in the pinhole camera) and vision itself, the eye. Thus the observation of the moon, the images of it on the retina, are necessary distortions. Two things are clear here: a definition of sight as distorting, and an acceptance of that fact. Far from raising doubts about the value or use of the deceiving instrument of sight (and this of course had been the case not only about the sense itself, but about lenses, which were known but not trusted for use in earlier times), Kepler seeks to give an account and to take the measure of its deception or artifice. We are justly reminded here of the enthusiastic trusting to the lens and picturing that we find among the Dutch—indeed, that we found at the center of Huygens's account of his life, his eyeglasses, and the new world seen through Drebbel's lens. But let us also remember the consuming Dutch interest in deception and the status of the image. Huygens's meditation on the nature of Miereveld's portraits summons up Tacitus's words on the thin line between the truth and falsehood of the astrologers. What fascinated Huygens was precisely the problem of the relationship between art(ifice) and nature. And we recall that his discussion of Miereveld ends by almost collapsing them into each other. In Miereveld, Huygens concludes, nature is art and art is nature. We might then consider Vermeer's *View of Delft* not as a copy done after a camera obscura or as a photograph (both of which claims have been made in the past), but as a display of this notion of artifice. A claim is made on us that this picture is at the meeting-place of the world seen and the world pictured. That border line between nature and artifice that Kepler defined mathematically, the Dutch made a matter of paint. And when we turn to works like the still lifes of Kalf we have to consider if, more often than scholars have been willing to admit, deception here engages not a moral but an epistemological view: the recognition that there is no escape from representation.

To speak of the *View of Delft* in this way is eccentric since it separates the picture as a "seeing object" from the world and the maker. We might attempt, as has been done, to locate a viewing device in a particular building over-looking Delft. But we only confirm that it is the eye, not a human observer of a certain size, that is at issue. The Dutch peep-box, which provides the viewer with an eye-hole through which to look at an interior illusionistically depicted on the inner surfaces of the box, also confirms this characteristic northern isolation of the eye.

And this is indeed just what Kepler did. In order to argue in this way, or more concretely, in order to address himself to the study of the eye in this way, he had to separate as his object of study the mechanism of the eye—what the eye considered as an optic system does with rays—from the person who sees, from the observer of the world, and from the question of how we see. It was to this question of how we see that studies of vision had historically addressed themselves. It was the power of Kepler's invention, then, to split apart the hitherto unified human field. His strategy was to separate the physical problem of the formation of retinal images (the world seen) from the

psychological problems of perception and sensation. The study of optics so defined starts with the eye receiving the light and ceases with the formation of the picture on the retina. What happens before and after—how the picture so formed, upside down and reversed, was perceived by the observer— troubled Kepler but was of no concern to him.

> I leave it to natural philosophers to discuss the way in which this image or picture [*pictura*] is put together by the spiritual principles of vision residing in the retina and in the nerves, and whether it is made to appear before the soul or tribunal of the faculty of vision by a spirit within the cerebral cavities, or the faculty of vision, like a magistrate sent by the soul, goes out from the council chamber of the brain to meet this image in the optic nerves and retina, as it were descending to a lower court.[16]

Neither the observer looking out into the world nor the process of perceiving the picture formed is Kepler's concern. The power of his strategy is that he deanthropomorphizes vision. He stands aside and speaks of the prior world picturing itself in light and color on the eye. It is a dead eye, and the model of vision, or of painting if you will, is a passive one. The function of the mechanism of seeing is defined as making a representation: representation in the dual sense that it is an artifice—in the very making—and that it resolves the rays of light into a picture. Visual perception is itself an act of representation in Kepler's analysis:

> Thus vision is brought about by a picture of the thing seen being formed on the concave surface of the retina.[17]

As he puts it in another passage, "ut pictura, ita visio";[18] or, sight is like a picture.

Despite differences of opinion about what part of his analysis of the eye is based on the analogy of the camera obscura, or as to whether his research is a perfection of or a break with medieval views, all modern commentators agree on one clear innovation: Kepler was the first person ever to employ the term *pictura* in discussing the inverted retinal image. As a recent study put it: "This is the first genuine instance in the history of visual theory of a real optical image within the eye—a picture, having an existence independent of the observer, formed by the focusing of all available rays on a surface."[19]

Two main things, among others, worked together to make this innovation possible. One is Kepler's physical reconstruction of the mechanism of the eye and the role of the refracting lens and retinal screen. The other is the distinction, which he is the first to make clearly, between the image of the world outside the eye (previously called *idola,* or visual species), which he called the *imago rerum,* and the picture of the world cast on the retinal screen, which he called the *pictura.* Because of insufficient knowledge of the refraction of light through the lens, all previous attempts to describe the picture in the eye had to imagine that the *idola* or species itself slipped through into the eye and thence to the brain. It was Kepler who for the first time turned away from the world to a representation of it, to the picture of it on the retina. In structural

terms, Kepler not only defines the picture on the retina as a representation but turns away from the actual world to the world "painted" there. This involves an extraordinary objectivity and an unwillingness to prejudge or to classify the world so imaged. Kepler's strategy and the resulting privileging of the world pictured on the eye helps us understand the particular justness of Gowing's evocation of Vermeer:

> Vermeer seems almost not to care, or not even to know, what it is that he is painting. What do men call this wedge of light? A nose? A finger? What do we know of its shape? To Vermeer none of this matters, the conceptual world of names and knowledge is forgotten, nothing concerns him but what is visible, the tone, the wedge of light.[20]

Gowing is describing a common experience we have in looking at Vermeer's works. If we concentrate on a detail—the hand of the painter, for example, in the *Art of Painting* (fig. 16; pl. 2)—our experience is vertiginous because of the way the hand is assembled out of tone and light without declaring its identity as a hand. My point is not that Vermeer is painting retinal images— though even Gowing makes this not too helpful suggestion—but that his stance toward the world pictured can be called Keplerian. Gowing might have had Kepler's strategy in mind when, in the sentence preceding the passage just quoted, he writes: "[Vermeer's] detachment is so complete, his observation of tone so impersonal, yet so efficient."

Kepler does not employ the simile of the picture lightly. In later studies, in which he develops its implications further, he effectively enriches its appropriateness as a model of Dutch pictures. Having first defined vision in the *Paralipomena* of 1604 as "brought about by the picture of the thing seen being formed on the concave surface of the retina," Kepler goes on in the *Dioptrice*

16. JAN VERMEER, *The Art of Painting*, detail (the artist's hand). Kunsthistorisches Museum, Vienna.

of 1611 to refer to the retina as painted with the colored rays of visible things. The word that he chooses for what does the painting is *pencilli*—or little brushes—the very little brushes that Huygens called on De Gheyn to use in replicating the view in the microscopic lens.[21] Artists' brushes paint a picture of the world outside the eye on the opaque screen of the retina in the back of the eye:

> The retina is painted with the colored rays of visible things.
>
> [Retiformis tunica pingitur à radijs coloratis rerum visibilium.][22]

In its formation the picture evokes that peculiar absorption into each other of drawing and painting that is characteristic of Netherlandish artists. Many drawings are situated on the very border of painting: the colored drawings favored by De Gheyn, whose sheets dazzle the eye (or would if one saw the original) with the colors of the flora and fauna of the world (fig. 3), or Saenredam's church portraits drawn in pen and brushed with fine washes or chalks, which his paintings emulate in oil. (This northern practice is confirmed in the works of that northern internationalist Peter Paul Rubens. The preparatory studies that he executed in colored oils on panel and that we refer to as sketches were commonly called drawings at the time.) Colored drawings call attention to the double aspect of a pictorial representation: they document *what* appears and also render *how* it appears. This is also called attention to by another Dutch borderline medium—pen-painting or *penschilderij* (fig. 17). Delicately drawn works are executed in pen on a prepared board to document a particular sea-battle or, in one case, the dwellings of a rich Haarlem merchant. While the colored drawing adds attributes of painting to drawing, the pen-painting presents drawings as if they were paintings. There is, finally, the notable absence of any drawings at all by a number of Holland's leading artists—Hals, De Hooch, Vermeer—an absence shared by other artists of the time commonly perceived to share northern sympathies (Caravaggio and Velázquez, for example). This suggests that for such artists—and this is most self-consciously true of Vermeer—representation takes place directly in color and therefore in paint.

The attitude that informs these phenomena is corroborated by the Dutch artist and writer Samuel van Hoogstraten in a passage of his 1678 handbook on painting, in which he refers to drawing as "imitating things after life even as they appear."[23] Hoogstraten introduces this formulation at the end of giving an account of Michelangelo's well-known criticism of Titian's works for revealing a lack of knowledge of *disegno*. In criticizing the famous Venetian colorist, Michelangelo, according to Vasari, had introduced the common Italian distinction between drawing (*disegno*) as the basis for rendering things selected from nature with an eye to beauty, and that interest in following nature exactly that is related to the use of color (*colore*). Without ever using the word *disegno*, Hoogstraten subtly alters Vasari's terms. He directs the issue instead toward two different notions of one thing, which he refers to as *teykenkunst*. Hoogstraten presents Michelangelo as arguing for a

17. JACOB MATHAM, *The Brewery and the Country House of Jan Claesz. Loo* (pen on panel), 1627. Frans Halsmuseum, Haarlem.

teykenkunst concerned only with the beautiful, while Titian presumes that it means drawing all things after life just as they are seen. In Hoogstraten's text, as in Dutch images, we find that there is no fruitful grasp of what the Italians called *disegno* —the notion of drawing that refers not to the appearance of things but to their selection and ordering according to the judgment of the artist and in particular to the ordering of the human body. Therefore, in what is a characteristic alteration of the very Italian attitudes that he cites, Hoogstraten surprisingly praises Titian as a draftsman. To render things after life as they appear is tantamount to drawing well. Though he does speak for ordering, Hoogstraten manifests none of Michelangelo's concern about the dangers for an artist who starts to draw after life when young. Indeed, this is just what he recommends to the Dutch. In another reversal of Italian priorities, which posit drawing as the basis for painting, Hoogstraten is moved to assure the artist he is addressing that painting will not hinder but will indeed actually help his drawing!

With the emphasis on replication of the world, northern art engages yet another kind of absorption—that of the maker into his work. We have already noted Fromentin's remark on the lack of any perceived manner of drawing by Dutch artists because they produce an art "which adapts itself to the nature of things."[24] The point is not that one cannot tell the drawings by Dutch artists apart, but that they do not seem to be practicing a notion of correct drawing as much as capturing or receiving what is seen. This attitude is reiterated by Dutch spokesmen, who specifically urge against artists having

a manner of their own. One author went so far as to write that the artist must follow life so closely that one cannot see any manner at all.[25] The Italian writers on art, at least since Vasari, has of course argued against a *mannered* style, but they argued this significantly in the name of a better, more natural *style.* The Dutch, by contrast, sidestep the issue of style or manner almost completely to put *nature seen* before personal style or self. We are reminded once again of the model provided by Kepler's eye.

As we move between the model of the eye, Dutch images, and Dutch texts about images, we are charting a territory in which the representation of appearance—Kepler's *ut pictura, ita visio* —not only defines images to the exclusion of distinctions between drawing and painting, but also dominates the artist's sense of self and invades his very mind. While the Italians moved— as Panofsky skillfully demonstrated—to distinguish between what we can simply refer to as the real and the ideal, or between images done after life and those also shaped by judgment or by concepts in the mind, the Dutch hardly ever relaxed their representational assumptions.[26] This is as true of their texts as it is of their images. Their term *naer het leven* (after life) and *uyt den geest* (from the mind or spirit), as employed by Van Mander and other northern writers who came after stinctions between real and ideal, between physical distinguish between different sources of visual percep *en* refers to everything visible in the world, *uyt den geest* refers to images of the world as they are stored mnemonically in the mind. Certain surprising formulations both verbal and pictorial result from this. First, unlike their Italian counterparts (and unlike the entire academic tradition that followed), the Dutch did not restrict *naer het leven* to the notion of drawing after the live model, but used it to denote drawing after anything in the world presented to the eyes. A drawing after an antique statue, as it is casually recorded, for example, in the inventory done of Rembrandt's belongings, could be done "nae't leven."[27] Perhaps we have in this an explanation of the making and high appreciation accorded those curious northern works such as Goltzius's prints after Dürer's *Meisterstücke,* in which the artist mimics deceptively the works of an earlier master. These prints, like Rubens's remarkably deceptive painted copies after other masters, are renderings of *art* done, as it were, "after *life.* "

Goltzius's prints could, however, have as well been done *uyt den geest,* because working out of the mind was itself considered not a selection process or a matter of judgment, but a matter of mirroring. Goltzius is reported by Van Mander to have left Rome with no drawings after the great Italian paintings but instead with the paintings "in his memory as in a mirror always before the eyes."[28] Indeed, the self of the artist, which was sacrificed for the world seen, finds itself here: the self is identified with the images of the world stored in the mind. In what is a peculiarly circular argument, Dutch commentators considered that working out of one's store of visual memories, working *uyt den geest,* constituted working out of oneself, or *uit zijn zelf doen,* as the phrase went.[29] The most famous description of this notion of selving out of memories of things seen is the description of Pieter Bruegel offered by a

fellow northerner. Bruegel is said to have drawn the Alps *naer het leven* so that when people saw his later works they said that he had swallowed up the Alps and spit them out onto his canvas.[30]

The concept of the mind as a place for storing visual images was of course a common one at the time. But it was in the north of Europe that artists *pictured* such a state of mind. For better or for worse, depending on one's view, the general lack of what we might call an ideal or elevated style and the tendency toward a descriptive approach to the representation of even elevated subject matter are due to this representational practice.

<div align="center">II</div>

Kepler was, of course, not the first to yoke together painting and the study of vision. If, as has been suggested, his decision to call the retinal image a picture is based on the previous connections that were made between picture-making and vision, it must be carefully distinguished from them. Though his work confirmed the principle of rectilinear propagation of light in homogeneous media assumed by the perspectivists and installed in artificial or linear perspective, he invokes or defines a picture differently.[31] The diagram that Descartes offers of Kepler's eye is less helpful to us in this regard than the illustration used to demonstrate the operation of the eye in a Dutch medical handbook of the later seventeenth century (fig. 18).[32] Two gentlemen are in a dark room equipped with a light-hole fitted with a lens. They hold out a surface on which is cast the image of the landscape beyond—people, trees, boats on a river are all brought inside, represented for their delectation. Van Beverwyck tells of having set this device up in the tower of his Dordrecht house, where it cast on a wall or paper the image of people walking along the Waal and boats with their colorful flags. This is the way, he claims, that sight gets into the eye (though he goes on to puzzle about how the inverted scene is righted). There is no awkwardness for Van Beverwyck about making the invisible image in the eye visible. "In a small circle of paper," as della Porta had written earlier of his eyelike camera obscura, "you shall see as it were the Epitomy of the whole world."[33] Van Beverwyck's illustration is a kind of domestic reenactment of the forming of the Keplerian image as well as a model of Dutch painting. This could be a view of Delft. Kepler's eye and Vermeer's image are both evoked in this unframed image of the world compressed onto a bit of paper with no prior viewer to establish a position or a human scale from which, as we say, to take in the work. The gentlemen standing by, detached observers, also remind us that such an image, rather than being calculated to fit our space, provides its own.

Alberti's picture, by contrast, begins not with the world seen, but with a viewer who is actively looking out at objects—preferably human figures—in space, figures whose appearance is a function of their distance from the viewer:

> In the first place, when we look at a thing, we see it as an object which occupies a space.[34]

18. Illustration of the working of the eye in JOHAN VAN BEVERWYCK, *Schat der Ongesontheyt* (Amsterdam, 1664), vol. II, p. 87. In *Wercken der Genees-Konste* (Amsterdam, 1667). Courtesy of the Royal Library, The Hague.

We can let Dürer's rendering of a draftsman at work (fig. 19) represent certain aspects of the Albertian picture. The picture is not claimed to be part of vision but is indeed the artist's construction, an expression in paint, as Alberti says, of the intersection of the visual pyramid at a given distance from the observer:

> First of all, on the surface on which I am going to paint, I draw a rectangle of whatever size I want, which I regard as an open window through which the subject to be painted is seen; and I decide how large I wish the human figures in the painting to be.[35]

It is Alberti who instructs the artist to lay down a rectangle on the model of the window frame. It could be argued that Alberti's great invention was this picture itself. James Ackerman has pointed out that Italian picture frames were once designed like window surrounds, to which one might respond that in the Netherlands in the seventeenth century, as a painting by Metsu clearly records (fig. 144), picture frames resemble instead the frames placed on mirrors.[36]

Bound to the Albertian view is a privileging of man, for it is in the name

19. ALBRECHT DÜRER, draftsman drawing a nude (woodcut), in *Unterweysung der Messung* (Nuremberg, 1538). Kupferstichkabinett, Staatliche Museen Preussischer Kulturbesitz, Berlin (West).

of the *istoria,* the representation of significant human actions, that this picture is made. In the face of the admitted relative size of all things Alberti, following Protagoras, claims that man, as the best known of all things to man, is the measure. The prior viewer is confirmed once again. So many aspects of Renaissance culture, its painting, its literature, its historiography are born of this perception of an active confidence in human powers. And so much are we heir to this view of man, or perhaps more particularly so much are art historians heir to this view of artistic representation, that it is hard to see it as a particular modality and not just the way representational art is. Although Alberti's treatise cannot fairly be said to propose the famous simile, it implicitly builds "ut pictura poesis" into its definition of the relationship between the picture and vision.

The perspectival confirmation offered by both modes of picturing confuses or masks the distinction that we must draw between them. The distinction lies not in the realm of the nature of vision but in its mode of visualization, its mode of representation. What continue to be major problems posed by photography—is it art, and if so what kind of art is it—are related to this issue. This is not properly a conflict between art and nature but between different modes of pictorial making. Many characteristics of photographs— those very characteristics that make them so real—are common also to the northern descriptive mode: fragmentariness; arbitrary frames; the immediacy that the first practitioners expressed by claiming that the photograph gave Nature the power to reproduce herself directly unaided by man. If we want historical precedence for the photographic image it is in the rich mixture of seeing, knowing, and picturing that manifested itself in seventeenth-century images. The photographic image can, like Dutch painting, mimic the Albertian mode. But the conditions of its making place it in what I call the

20. JAN VAN EYCK, *Madonna with the Canon van der Paele.* Musée Communal des
Beaux Arts, Bruges. Copyright A.C.L. Brussels.

Keplerian mode—or, to use a modern term, among Peirce's indexical signs.[37]

A comparison of the proposed pictures of Kepler and Alberti touches on
what is a textbook contrast between Renaissance art in the north and south
of Europe. If we go back to the fifteenth century we can contrast Van Eyck's
Van der Paele altarpiece with the Saint Lucy altarpiece of Domenico
Veneziano (figs. 20, 21). We might summarize the well-established contrast
between north and south in the following ways: attention to many small
things versus a few large ones; light reflected off objects versus objects mod-
eled by light and shadow; the surface of objects, their colors and textures,
dealt with rather than their placement in a legible space; an unframed image
versus one that is clearly framed; one with no clearly situated viewer com-
pared to one with such a viewer. The distinction follows a hierarchical model
of distinguishing between phenomena commonly referred to as primary and
secondary: objects and space versus the surfaces, forms versus the textures of
the world.[38] Whether the Italian perspective system is taken as visual truth or
as a convention—and both claims have an arguable basis depending on the
force with which one makes a claim for truth—the litany of qualities sets up

21. Domenico Veneziano, *Madonna and Child with Saints*. Galleria degli Uffizi, Florence. Alinari/Editorial Photocolor Archives.

a duality.[39] As James Ackerman, speaking for Italian art, has put it; "If the artist wants to communicate as precise a record of fact as he can he should follow Alberti; if he wishes to communicate the way things look to him he is not obliged to follow anyone."[40] Modern students of northern art have been moved to speak of artists who are "fully aware of the differences between artificial perspective and natural vision" and to compliment them for "using their eyes with fewer preconceptions than their predecessors."[41] With Kepler's assistance I think we can better suggest that the issue is not "record of fact" versus the "look" of things, it is not different ways of perceiving the world, but two different modes of picturing the world: on the one hand the picture considered as an object in the world, a framed window to which we bring our eyes, on the other hand the picture taking the place of the eye with the frame and our location thus left undefined.[42]

As we make and pursue distinctions between pictorial modes the reader is probably aware that philosophical issues, and psychological ones as well, threaten to take over from the pictures. It is inevitable, I think, that the nature or status of the picture as knowledge is an issue because we are considering

pictures produced in a culture that employs a perceptual metaphor for knowledge. By this I mean a culture that assumes that we know what we know through the mind's mirroring of nature.[43] Our problem, then, is how to deal with actual pictures given their assumed overlap with mental or visual ones. One strategy is that of E. H. Gombrich, who has attempted to ground Western pictorial representation in the nature of human perception. (This strategy has been adopted recently, and for similar reasons of proof, in the psychological interests of advanced analytic philosophy.) While I differ from Gombrich in that I do not assume that art must necessarily be defined by the perceptual model of knowledge, I have accepted this as the interpretive bias in this book and have even tried to differentiate modes within that model. My aim is to work within the framework offered by the time to understand how the Dutch in the seventeenth century produced and validated their images.

There is probably no artist or writer who meditated as continuously and as deeply on the relationship between seeing, knowing, and picturing the world as did Leonardo da Vinci. For that reason, though he is geographically and chronologically removed from the center of our concerns, to turn to him is to consider more deeply the problems at hand. Leonardo, who was fascinated by the eye as an instrument (he was one of the first to propose the camera obscura as its model) and by its powers of observation, testifies poignantly in his writing and in his picturing to the dilemma presented by the choice between these two pictorial modes—what I am calling southern and northern. His praise of the eye as the road to knowledge of the world is as total as we shall find anywhere in Europe at the time. All the more so because Italian culture was so preoccupied with the question of the comparative value of text and image. In defending and defining the eye he is also defending and defining the painter versus the poet, the image versus the word:

> Whoever loses sight, loses the beautiful view of the world and is as one who is shut alive in a tomb wherein he can move and live. Now, do you not see that the eye embraces the beauties of all the world? It is the master of astronomy, it makes cosmography, it advises and corrects all human arts, it carries men to different parts of the world, it is the prince of mathematics, its sciences are most certain, it has measured the heights and the dimensions of the stars, it has found the elements and their locations. It has predicted future events through the course of the stars, it has created architecture, and perspective, and divine painting.[44]

Leonardo gives himself over to the eye most totally in those passages in his writing where he recommends the mirror as a model for an art striving to attain the condition of total reflection.

> The painter's mind should be like a mirror, which transforms itself into the color of the thing that it has as its object, and is filled with as many likenesses as there are things placed before it. Therefore, painter, knowing that you cannot be good, if you are not a versatile master in reproducing through your art all the kinds of forms that nature produces—which you

will not know how to do if you do not see and represent them in your mind.[45]

The argument here has three parts. They remind us of the condition of Kepler's picture even as they do of the objections to northern art on the part of the south: first, the mind not only is *like* a mirror, but, colored by the objects it reflects, it is actually transformed *into* a mirror; second, the image so produced is unselective—every form produced by nature is imaged, so man has no privilege; finally, in his concluding phrase Leonardo clearly distinguishes the mirrored representation in the mind from the sight of the world itself. In this view of picturing, the mirror is the master or guide and Leonardo in this spirit advises the artist to check his art against mirrored nature. We are reminded of the visual catalogue of observations contained in his notebooks and introduced—in the flowers and the rocks of the first *Madonna of the Rocks* —into his works. In this view a picture opens itself up to the representation of appearances such as atmospheric perspective (the perceptual fact that contours appear softened, shapes rounded off at a distance from our eyes) or curved space. But if the picture takes the place of the eye then the viewer is nowhere.[46] Though fascinated with appearances, Leonardo fears giving himself over to such demands of total absorption and fears the sacrifice of rational human choices that this notion of picturing assumed. The conflict is one between passive self-absorption and active making. The tension it produces is evident in the psychological demeanor of figures like his Saint John or Saint Anne, where it contributes to what we perceive as their power-ful and disturbing presence. These figures are suspended between action and rest, or between active self-assertion and passive receptivity (fig. 22). So on occasion Leonardo turns against this mirror view:

22. LEONARDO DA VINCI, *The Virgin and Child with St. Anne.* Musée du Louvre. Cliché des Musées Nationaux.

The painter who draws merely by practice and by eye, without any reason, is like a mirror which copies every thing placed in front of it, without being conscious of their existence.[47]

Offering us the improbable hybrid of a selective mirror, Leonardo at one point attempts to negotiate, as he did in his works, between two models of art—a mirrorlike reflection and the making of a second world:

The painter should be solitary and consider what he sees, discussing it with himself, selecting the most excellent parts of the appearance of what he sees, acting as the mirror which transmutes itself into as many colors as exist in the things placed before it. And if he does this he will be like a second nature.[48]

How can a mirror reflect choice or reason? The answer is found in the injunction to the artist—spoken by Leonardo as it was earlier by Alberti—to use the mirror as the judge of his own pictures. The mirror then becomes a witness not to life but to art. By distancing the artist from his art, it serves, as Alberti says, to judge the faults of things taken from nature and thus corrects art.

It would seem that the mirroring, the giving-over to the nature of things that he instinctively pulls away from, is more closely related to the sources of Leonardo's inventive genius than is his appeal to reason. For in his oft-cited recommendation that one rouse the mind by looking at crumbled walls, glowing embers, speckled stones or clouds, Leonardo turns the artist himself into the creator. Rousing the mind to inventions in this way exposes us to the crowded indeterminancy of things. But in Leonardo's view, rather than giving over to the makings of nature, he takes that making, Prospero-like, upon himself. Everything then becomes a creature of *his* eye. Northern mirroring is thus turned on its head, which is why it is finally impossible to fix Leonardo in this scheme.[49]

The distinction that Leonardo makes between simple mirroring and selective or rational mirroring is related to a distinction that was commonly made at the time between two kinds of vision. The *locus classicus* in art historical literature is a passage in a letter of Poussin's in which he is seeking to defend the replacing of some earlier decorations in the Long Gallery of the Louvre with works of his own. He sets forth the basis of his works by offering a distinction between "deux manières de voir les objets." The terms Poussin offers us are *aspect* on the one hand and *prospect* on the other. There are, he writes,

two ways of viewing objects: simply seeing them, and looking at them attentively. Simply seeing is merely to let the eye take in naturally the form and likeness of the thing seen. But to contemplate an object signifies that one seeks diligently the means by which to know that object well, beyond the simple and natural reception of its form in the eye. Thus it can be said that mere aspect is a natural operation, and that what I call *Prospect* is an

office of reason which depends on three things: the discriminating eye, the visual ray, and the distance from the eye to the object.

[deux manières de voir les objets, l'une en les voyent simplement, et l'autre en les considérant avec attention. Voir simplement n'est autre chose que recevoir naturellement dans l'oeil la forme et la ressemblance de la chose veûë. Mais voir un objet en le considérant, c'est qu'outre la simple et naturelle réception de la forme dans l'oeil, l'on cherche avec une application particulière les moyens de bien connoistre ce mesme objet: Ainsi on peut dire que le simple aspect est une opération naturelle, et que ce que je nomme le Prospect est un office de raison qui dépend de trois choses, sçavoir de l'oeil, du rayon visuel, et de la distance de l'oeil à l'objet.][50]

The final clause, with its reference to the visual ray and the distance of eye from object, clearly reveals that by *prospect* Poussin refers to nothing other than seeing according to perspective theory. Indeed, this entire passage, like others of this theoretical kind in Poussin's works, has been traced back to a well-known Italian treatise. It is not surprising that Poussin would define and defend his own art in terms of *prospect.* Nor is it surprising that he presents an argument about the nature of painting in terms of notions of seeing. The identity assumed between seeing and picturing—with the resulting confusion that picturing has been thought of as a way of seeing rather than a visualization of it—was after all laid down in the perspective construction. But the argument is not a symmetrical one. While seeing in a prospective way implicitly corresponds to perspective picturing, seeing in an aspect way is left as just that—simple seeing with no related kind of picturing. With Kepler's *ut pictura, ita visio* before us, Poussin's evocation of aspect has a familiar ring and leads us back to a by-now familiar definition. "Voir simplement n'est autre chose que recevoir naturellement dans l'oeil la forme et la ressemblance de la chose veûë." What else is this but a description of that replicative picture cast on the retina to which Kepler devoted his studies? It is an "operation naturelle," as Poussin calls it, which corresponds to that natural painting that the Dutch spoke of as cast by the camera obscura. It was Kepler, as we have seen, who demonstrated that the retinal picture is itself a representation.

The problem inherent in appealing to the world seen "aspectively" is that no one ever sees the picture on the retina. The appeal risks that mindless identity of eye and world that Leonardo feared. But the picturing of this picture was a major concern in the seventeenth century in the north. Kepler himself did it.

III

Let us return once more briefly to Kepler. In a field near his house in Austria he set up a device—presumably like the one found today in a drawing among his papers (fig. 23)—to observe the rays of the sun.[51] He also used it to make a landscape image. Kepler's landscape is an established part of the camera obscura literature. But we tend to forget that he set up his device in

a field not for picture-making but for astronomy. In attending to the picture it made, and in subsequently tracing it off on paper, Kepler re-creates for us his radical redefinition of the eye as a picture-making optical instrument. His use of the camera obscura to make a landscape picture makes visible the invisible picture he had located in the eye.

23. Drawing of an optical device from the papers of JOHANNES KEPLER. Manuscript Archive of the U.S.S.R. Academy of Sciences, Leningrad.

Many strands of our account come together in the well-documented visit of Sir Henry Wotton to Kepler in Linz in 1620. Wotton's social connections reconfirm that community of concerns which we have described: as English ambassador to The Hague in 1615 he had been a neighbor of the Huygens family and was, so Huygens tells us in his *Autobiography,* a companion to them in music-making. The letter he wrote home on the Kepler picture was sent to none other than Francis Bacon, the philosopher so admired by Huygens, whose views and programs for human makings educated and confirmed his own. Wotton writes to Bacon of his excitement about a landscape drawn on a piece of paper that he saw in Kepler's study. When he asks Kepler how he did it, Wotton is finally told that the drawing was traced from a camera obscura image made "non tanquam pictor, sed tanquam mathematicus" by the device set up in the field. Here are Wotton's words:

He hath a little black tent (of what stuff is not much importing) which he can suddenly set up where he will in a field, and it is convertible (like a windmill) to all quarters at pleasure, capable of not much more than one man, as I conceive, and perhaps at no great ease; exactly close and dark, save at one hole, about an inch and a half in the diameter, to which he applies a long perspective trunk, with a convex glass fitted to the said hole, and the concave taken out at the other end, which extendeth to about the middle of this erected tent, through which the visible radiations of all the objects without are intromitted, falling upon a paper, which is accommodated to receive them; and so he traceth them with his pen in their natural appearance, turning his little tent round by degrees, till he hath designed the whole aspect of the field. This I have described to your Lordship, because I think there might be good use made of it for chorography: for otherwise, to make landscapes by it were illiberal, though surely no painter can do them so precisely.[52]

Though Wotton echoes Kepler's disclaimer about the art of the picture, the account nevertheless tells us something about the image that bears on notions of picturing.

Wotton writes that the device that Kepler used was made to turn around like a windmill. The drawing or drawings that resulted must have been a series of discrete views taken one by one, in succession, of the entire field around the camera obscura. Each view was, as Wotton testifies a "tracing" in pen of the "natural appearance" of the "visible radiation of all objects without." The series of views so taken would add up to what Wotton then terms the "whole *aspect*" of the field. The word *aspect,* though employed casually, reminds us not inappropriately of the distinction made by Poussin that we have just discussed. It is hard to figure out what this might produce by way of a single image—a long strip of paper or a series of pieces. But I want to call attention to that fact that clearly the world so pictured is an assemblage or aggregate of partial aspects, and that world is itself but part of a larger whole. Is there a way for a draftsman to capture the extent of his vision on a flat surface? This is not idle speculation but indeed speaks to the circumstances and intent of many Dutch pictures. It was with this end in view that Hoogstraten titled a chapter "How Visible Nature Presents Herself in a Particular Fashion."[53] Northern artists characteristically sought to represent by transforming the extent of vision onto their small, flat working surface. This is true of the sweep of a panoramic landscape that continues beyond the arbitrary rectangle of the canvas, or the multiplication of rooms that are assembled for our view in a Dutch peep-box.

It is the capacity of the picture surface to contain such a semblance of the world—an aggregate of views—that characterizes many pictures in the north. A source of confusion in looking at and writing about Dutch art is due to the fact that in the north the very word perspective, or *deurzigtkunde,* rather than referring to the representation of an object in respect to its spatial relationship to the viewer, is taken to refer to the way by which appearances are replicated

on the pictorial surface. Perspective in this sense is concerned with the representation of what Poussin called *aspect*.

Let us now consider some pictorial examples of this phenomenon. Despite their striking idiosyncracies, perhaps indeed because of them, the architectural portraits of Pieter Saenredam have repeatedly been chosen as examples of certain deeply rooted and pervasive characteristics of Dutch images.[54] We shall, however, get much farther in understanding them if we start with this notion of the picture rather than assuming that Saenredam is indulging in a free handling of the linear perspective mode. We might summarize the look of his paintings as follows: for all their interest in architecture—which normally we consider under the rubric of architectural space—it is the surface of the works that is remarkable. The delicate linear patterns—arch laid on arch with doors folded over, trimmed by pillars thick and thin and bound by walls of the palest tones of wash—have reminded many contemporary viewers (and not without reason) of the surfaces of a Mondrian *in nuce*. What is further distinctive about these as patterns is that they are notably asymmetrical. The works often display a wide-angle view. A drawing from the north aisle looking across the nave of the Buur church in Utrecht (fig. 24) clearly assembles two views on one surface. From a point marked on the central pillar the artist looked left and right and then combined these two views. Without moving one's head and eyes a viewer in the church, situated at the eye point noted by Saenredam, could not at once see to the left and to the right. The work therefore does not present a fictive, framed window through which we look into the church interior.

In further disregard of a prior frame, Saenredam proceeds to divide this image in two. He makes one painting that corresponds to the left half, and one to the right half of this drawing with the central pillar eliminated (figs. 25, 26). Saenredam does not redesign the halves during this cropping operation. We end up with two very different-looking works, each displaying another characteristic—an extreme, oblique view. In making two images out of one, Saenredam preserves the eye position from which the architecture was originally viewed in the first work. The left panel is thus viewed from off the right edge, the right obliquely from off the left. This explains the looming pillars opposite each obliquely situated viewpoint. What remains constant in these works is not the frame and an externally posited viewer, but rather what was seen by the viewer or viewing eye within the image. Saenredam accords such privilege to the view seen that, in a quite unprecedented fashion, he annotates his drawings done in churches when, sometimes years later, he makes or (takes) a picture *from* them. As testimony to the world seen, the drawing is not preparatory to anything but is the thing, or the representation of the thing, itself. We are looking at architecture the seeing of which was already recorded within the representation. We might justly say—with reference to the notion of picturing with which we started—that such pictures are not properly architecture viewed, in which an external viewer is presented with a view of architecture, but rather views of architecture viewed.[55]

My attempt to define represented seeing in painting is parallel in certain respects to some recent attempts to define what is known as represented thought and speech in written language. I am referring to the grammatical study of what is familiar to most readers in the stream of consciousness technique of the novel: speech is represented as perceived or experienced expression whose communicative function is removed.[56] Each of these phenomena—represented seeing and represented thought and speech— manifests extraordinary attentiveness, without, however, acknowledging that interplay between sender and receiver—be it world and viewer or two speakers—that normally characterizes pictures in the Italian mode or language when spoken. What one writer acutely described as "that remarkable mixture of distance and absorption" which characterizes Saenredam and other Dutch images is a symptom of such a pictorial state.[57]

Perhaps the best way of explicating the phenomenon is by considering for a moment the special northern tradition of perspective construction to which Saenredam's works belong: that so-called distant point construction long considered the northern draftsmen's answer to Alberti. While Alberti's text on painting was all words with no illustrations, his northern counterparts offered, by contrast, annotated pictures. They offered a geometric way to transform the world onto a working surface without the intervention of viewer and picture plane, without, in other words, the invention of an Albertian picture. If we start with the first northern treatise on perspective, *De Artificiali Perspectiva* (1505) by the French priest Jean Pélerin, known as Viator, we find that he assumes that representation replicates vision, which he defines in terms of a moving eye reflecting the light it receives like a burning mirror or *miroir ardente*.[58] (The reference is to a curved mirror that can cause fire by concentrating rays of light.) Alberti, by contrast, explicitly states that the operation of the eye itself is of no consequence to an understanding of his pictorial construction. Viator then proceeds to locate the eye point not at a distance in front of the picture, but rather on the very picture surface itself, where it determines the horizontal line that marks the eye level of persons in the picture. The eye of the viewer (who in Alberti's construction is prior and external to the picture plane), and the single, central vanishing point to which it is related in distance and position, have their counterparts here *within* the picture. The first eye point located by Viator is joined on each side, at equal distances, by two so-called distance points from which the objects in the work are jointly viewed. The points are functions of the world seen rather than prior places where a viewer was situated. It is solely to people and objects in the work, not to the external viewer, that these three points refer. Placed side by side, the two constructions appear confusingly similar and, indeed, they have been claimed to be different constructions with the same aim and identical result of offering artists a geometric means of representing objects in space. The difference is clearly exposed in the diagrammatic comparison between the two perspective systems (figs. 27, 28) offered some years later by the Italian architect Vignola.[59] We might say that, in Italian terms, there is no

24

25

24. PIETER SAENREDAM, *Interior of the Buur Church, Utrecht* (pen and chalk on blue paper), 1636. Topographical Atlas, Municipal Archives, Utrecht, Ja 4.1.

25. PIETER SAENREDAM, *Interior of the Buur Church, Utrecht,* 1644. Location unknown.

26. PIETER SAENREDAM, *Interior of the Buur Church, Utrecht,* 1644. By permission of the Trustees of the National Gallery, London.

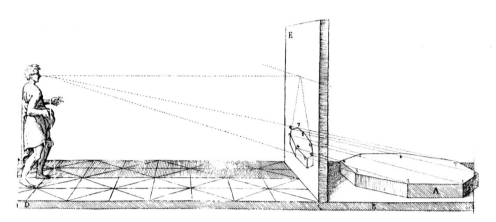

27. The first "regola" or the "costruzione legittima," in GIACOMO BAROZZI DA
VIGNOLA, *Le due regole della prospettiva practica* (Rome, 1683), p. 55. University of
Chicago Library.

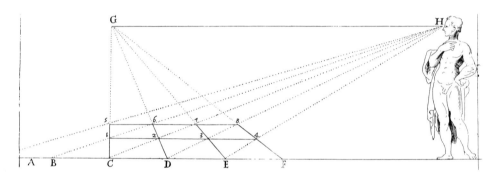

28. The second "regola" or the distance-point method, in GIACOMO BAROZZI DA
VIGNOLA, *Le due regole della prospettiva practica* (Rome, 1683), p. 100. University of
Chicago Library.

picture in the distance point construction, for there is no framed window pane
to look through. Viator's picture is not separate from and related to an
external viewer. It is itself identified with pieces of the world seen. The
representation of figures in proportion to the pictorial architecture is put in
terms of *their* view: "ainsi qu'il sera vu par les figures." Although the model
of the eye is not Kepler's, Viator's impulse to identify the picture with the
eye, rather than with the world seen by a man situated before it at a certain
place, is like Kepler's. Viator's praise of works that employ his mode of
perspective not surprisingly echoes the Keplerian picture we have been defi-
ning: "[the artists] representent les choses dépassées et lointaines comme
immédiates et présentes et connaissables au premier coup d'oeil."[60] It re-
mained for followers to articulate this in pictures.

The distant point method *can* be manipulated to produce the unified central
perspective favored by Alberti. Vignola, who in 1583 introduced this method
to the Italians, did just that with it since he was no more able than most

modern commentators to imagine away the viewer and the picture plane. But the distance point method does not favor this choice. It easily produces oblique and multiple views. While Viator did produce a number of illustrations that mimic the centralized view, successors in the north emphasized its more native peculiarities. Vredeman de Vries, the Flemish artist-engraver and designer of architecture on paper, reiterated Viator's identification of the eye, perspective, and picture surface when he subtitled his *Perspective* 1604–5 "that is the most famous art of eye-sight which looks upon or through objects painted on a wall, panel or canvas."[61] The first two plates (figs. 29, 30) beautifully illustrate the basic terms of Viator's visual geometry. The first plate shows the circular arc transcribed by the turning eye, and the second the section of this which, when laid out flat, is the horizon line crossing the

29. JAN VREDEMAN DE VRIES, *Perspective* (Leiden, 1604–5), plate 1. Courtesy, the Bancroft Library, Berkeley, California.

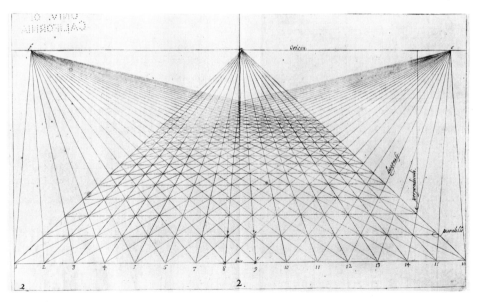

30. JAN VREDEMAN DE VRIES, *Perspective* (Leiden, 1604–5), plate 2. Courtesy, the Bancroft Library, Berkeley, California.

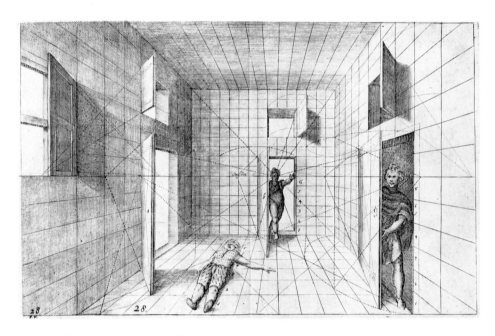

31. JAN VREDEMAN DE VRIES, *Perspective* (Leiden, 1604–5), plate 28. Courtesy, the Bancroft Library, Berkeley, California.

pictorial surface. In a later plate a multiplication of distant points leads the eye to a variety of views up and down, in and out of an empty room. The effect is that adding-on of views of the moving eye suggested by Viator. When figures enter they are captives of the world seen, entangled Gulliver-like in the lines of sight that situate them (fig. 31). The many eyes and many things viewed that make up such surfaces produce a syncopated effect. There is no way that we can stand back and take in a homogeneous space.

Before we return to Saenredam's versions of this tradition, let us look at one more bit of evidence that confirms, but also complicates, our understanding of this special northern notion of perspective. It is not surprising, given the title and ambitions of Vredeman's *Perspective,* that some seventy years later another Netherlander, Samuel van Hoogstraten, would commend it in the chapter on perspective in his theoretical handbook, the *Academy of Painting.* Although he speaks of it with traditional respect, Hoogstraten gives perspective rather short shrift. But rather than dismiss it completely, he presents it in such a manner that it is transformed to articulate the northern preoccupation with optical illusion.[62] What is surprising and most telling is the company that Vredeman keeps. His representation of open doors and inner rooms, as Hoogstraten describes it, is grouped with two rather unlikely examples of perspective in art—a famous lost nude by Giorgione and an engraving of Venus by Goltzius (fig. 32). The Giorgione nude was depicted with its back toward the viewer and the other sides of the figure were visible

by means of the ingenious use of reflections: one side was imaged in a mirror, another in shining armor, and the front turned away from the viewer in the surface of a pool of water. The strategy, chosen by Giorgione to demonstrate painting's ability to outdo sculpture, has, like Giorgione's works in general, a decidedly northern flavor. Van Eyck had done a similarly constructed work showing a woman at her bath. But what is northern about it goes beyond an attraction for reflecting surfaces. Giorgione achieves a comprehensive view of the figure by addition, as it were, by putting together separate views. Although a view of the whole is assembled, the result does not confirm the unity of a body in space, as the Italians wished. It rather deconstructs it. A single prospect, to use the relevant term, is sacrificed for an aggregate of aspects. And yet it is just this that Hoogstraten offers as an example of perspective.

Vasari, on whose account of Giorgione's nude Hoogstraten based his own, gives special praise to Giorgione for having the viewer enabled to see all around the figure in a single glance.[63] But he does not remark how different this is from the devices traditionally employed by Italian artists to achieve a comprehensive view of a figure. Italian artists were normally unable or else unwilling to sacrifice either the authority of the individual viewer or the unity of the figure viewed. One strategy, therefore, was to double a figure. We find the device known as *figure come fratelli* in Pollaiuolo's *Martyrdom of St. Sebastian* (fig. 33), in which the back and front of crossbowmen are displayed in two paired figures. Or the device of the *figura serpentinata*, a figure twisted around itself like Bronzino's *St. John the Baptist* (fig. 34), is used in such a way as to reveal more sides to view. We can trace the history of this Italian manner of picturing right up to Picasso (fig. 35). In combining different views to make one face or one body, Picasso elected to go so far as to distort or to reconstruct the human anatomy. He paints, to paraphrase Leo Steinberg's felicitous phrase, as if to possess, rather than relinquishing the authority of the single viewer or the solidity of the figure viewed.[64]

Any doubts that we might have about Hoogstraten's understanding of the Giorgione nude are dispelled in the third of his perspective examples. He cites the print after Goltzius that shows Venus looking at herself in a mirror while a painter is painting her (fig. 32). There are three views of Venus: in the flesh, in the mirror, and on the painter's canvas. We are not in fact shown all sides of the figure, as we were by Giorgione. The Goltzius print does not answer the challenge for a comprehensive view of the figure, but rather demonstrates that what Hoogstraten calls a perspective picture is made up of a sum of representations. We know Venus in pieces just as we know the churches of Saenredam. Putting it this way, we can perhaps better understand why the figures represented by Giorgione and Goltzius are related by contiguity in Hoogstraten's text to the additive spaces of Vredeman's architectural views.

Like others of its genre, Hoogstraten's handbook is a patchwork of traditional examples plus some new ones of his own collected to illustrate established topics. Since it provides the best testimony to what the Dutch could say about images at the full maturity of their own tradition, and since I shall be

32. Jan Saenredam, after HENDRICK GOLTZIUS, *An Artist and His Model* (engraving). By permission of the British Museum.

33

34

33. Attributed to ANTONIO AND PIERO DEL
POLLAIUOLO, *The Martyrdom of St.
Sebastian*. By permission of the Trustees of
the National Gallery, London.

34. AGNOLO BRONZINO, *St. John the Baptist*.
Galleria Borghese, Rome. Alinari/Editorial
Photocolor Archives.

35. PABLO PICASSSO, *Seated Woman*, 1927.
Collection, the Museum of Modern Art,
New York. Gift of James Thrall Soby.

35

referring to it again in the course of this book, it is important to establish the nature of reading his text. The difficulty in reading it is that the assemblage, more often than not, does not present a linear argument but rather an associative display. In this respect it might be said to be curiously related to the pictures it describes. Although the examples taken individually are often traditional ones (by which I mean ones commonly set forth in Italian treatises), we must always be alert to the unstated interplay of associations that leads Hoogstraten to group them together as he does. The sum of this interplay is different from each example taken individually. In the present passage the three examples of perspective that we have discussed are bracketed by traditional examples of illusion. The peep-box (referred to here in Dutch as *perspectifkas*) and the grapes of Zeuxis clearly belong to a discussion of illusion. But placed here they appear in a rather specific light. It is the accumulated nature of the picturing of the world fit into a peep-box that is emphasized and conjoined with the examples of Giorgione's picturing of the nude and Goltzius's *Venus* that follow. The peep-box, Hoostraten suggests, presents a structure not unlike Vredeman's buildings—an unframed sequence of rooms or vistas successively viewed. Such an experience of sequential viewing is confirmed in Hoogstraten's own peep-box (now in the National Gallery in London) by the unusual addition of a second peep-hole and by the addition of a man visible outside the far window who is looking in (figs. 36, 37). Similarly, the example of the deceptiveness of Zeuxis's grapes plays back on our understanding of the accumulative representations of Giorgione and Goltzius and assimilates them (unlikely thought this might seem) to illusion. Zeuxis's grapes define the nature of what has been put together before our eyes by Giorgione, Goltzius, or Vredeman: representation as replication instead of spatial devising is confirmed as the basis of pictorial illusion. If we sense that Hoogstraten here is of a like mind with Kepler we are right. On the previous page, where he defines art as an imitation of appearance (at issue is the picturing of Seneca's famous line of pillars, which deceptively blend together when seen a certain way), Hoogstraten takes the stance toward art's pictures that Kepler had taken toward the pictures on the retina. Let us put the two side by side.

Kepler:

> As long as the diameters of the luminaries and the extent of solar eclipses are noted as fundamental by astronomers, [it needs to be understood that] some deception of vision arises partly from the artifice of observing. . . . And thus the origin of errors in vision must be sought in the conformation and functions of the eye itself.[65]

Opposite page:

36. SAMUEL VAN HOOGSTRATEN, peep-box, detail. By permission of the Trustees of the National Gallery, London.

37. SAMUEL VAN HOOGSTRATEN, peep-box, detail. By permission of the Trustees of the National Gallery, London.

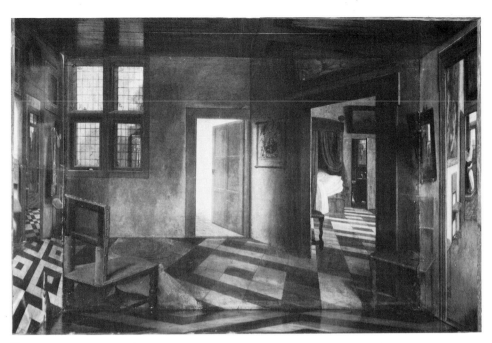

36

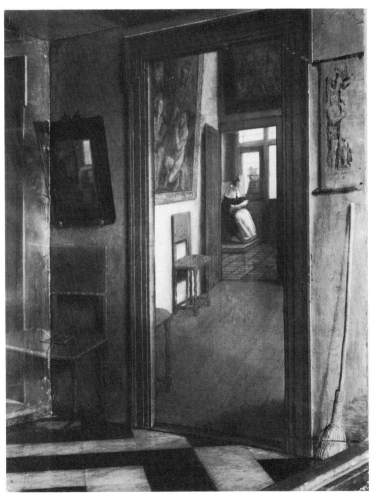

37

Hoogstraten:

> But I say that a painter whose work it is to fool the sense of sight, also must have so much understanding of the nature of things that he thoroughly understands by what means the eyes are fooled.

> [Maar ik zegge dat een Schilder, diens werk het is, het gezigt te bedriegen, ook zoo veel kennis van de natuur der dingen moet hebben, dat hy grondig verstaet, waer door het oog bedroogen wort.][66]

Of course there is a significant difference: what Kepler accepts as the necessary condition of retinal picturing Hoogstraten presents as the artist's task.

After this extended digression let us now return to Saenredam as a prime example of painting done in this northern mode. Far from rejecting the aggregate views assembled by Vredeman de Vries, Saenredam clearly accepts them. The apparent stylistic differences between what is commonly referred to as Vredeman's mannerism and Saenredam's realism blind us to this continuity. We might compare Saenredam's view before the library entrance of Saint Lawrence at Alkmaar (fig. 38) with Vredeman for diversity of views that enable us to see more. The eye passes low through two doors and through free space to the left, and is stopped by a high, lean slice of space behind the pillar at the right. In turning his attention to actual churches, Saenredam grounds or applies this kind of picturing in a new and surprising way. The small figures at the right are markers, at their eye level, of the horizon line. There is a certainty displayed in what the surface can contain. There are the few decorations of the white-washed church: the painted organ case, the hanging that ends with the truncated image of a man's head, and a death shield. And finally, though not in this work, figures concurrent with the artist's viewpoint in the church make their object of sight into ours. In many of his studies Saenredam marks the eye point, which locates the horizon line and also a point on that line from which the building was viewed. We find the *oog* point, for example, on the bottom of the pillar at the right foreground of a drawing of the great Saint Bavo in Haarlem (fig. 39). It is from here that the view could be seen across the nave into the complex of space beyond and also up into the vault with the painted shutters of its great organ. One could see this, that is, if one adjusted one's gaze. Once again the surface traversed by the eyes is the field of vision that the panel lays out for us. The definitive gaze of the human eye is then fortified with the figure of a man. In a painting that follows (fig. 40), Saenredam introduces (slightly to the left and on the horizon line itself) a small figure, a viewer who directs our eyes to the organ, which in this painting is the end in view. Saenredam's major innovation is to use his upward gaze to establish the view of the organ. Like Vredeman's figures he is, in turn, literally a captive of that view.

In the rendering of the organ, its decoration, and its accompanying inscription, as in the frequent notation of place and date of excution that Saenredam enters on the surface of his works, he documents in image and in word the

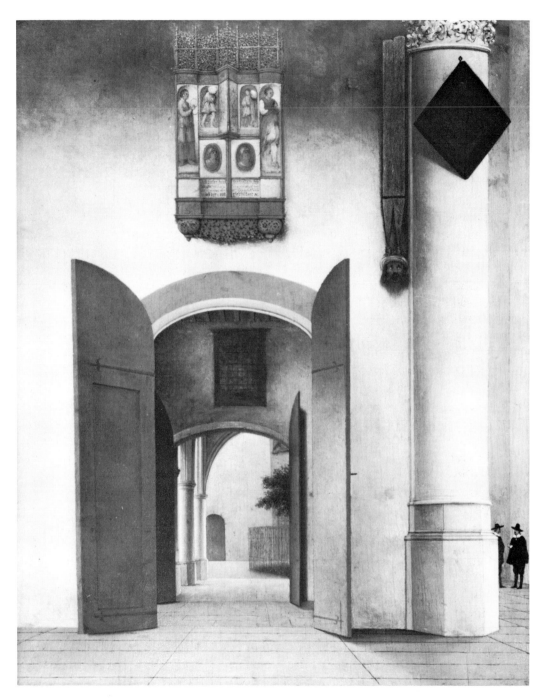

38. PIETER SAENREDAM, *Interior of the St. Laurens Church at Alkmaar,* 1661. Museum Boymans-van Beuningen, Rotterdam.

39. PIETER SAENREDAM, *Interior of the Church of St. Bavo in Haarlem* (pen, wash, and
black chalk heightened with white on blue paper), 1635. Kupferstichkabinett,
Staatliche Museen Preussischer Kulturbesitz, Berlin (West).

40. PIETER SAENREDAM, *Interior of the Church of St. Bavo in Haarlem*, 1636. By
courtesy of the Rijksmuseum-Stichting, Amsterdam.

41. Jan van de Velde, after PIETER SAENREDAM, *St. Bavo, Haarlem* (etching). Municipal Archives, Haarlem.

experience of the viewer that the work represents. It has been argued persuasively that the organ, whose role in the Protestant service and in society was a matter of great public dispute in the Netherlands at the time, is the proper subject of this picture. Its clearly visible inscription, a common one on organs at the time, argues approval for the organ's appropriate use. The picture represents such approval.[67] But it is characteristic of Dutch art and of the visual culture of which it is part that something seen, not performed, bearing witness rather than dramatizing an event, makes for significance. The rare instance in which Saenredam presents a single, central vanishing point, thus identifying the church viewed with our own external view, is due to special circumstances. It is the design for an etching of Saint Bavo that was published in a book as part of a tribute to the artist's native Haarlem (fig. 41). A hortatory inscription specifically urges us to look at the beautiful church "if your eyes can see." Here the entire church seen is made the object of *our* view in order to honor the craft of its making, the city in which it stands, and God.[68]

Saenredam's "lookers" within the picture (I use the word here to distinguish them from viewers external to the work) do not look out of the picture at us. That would indeed be a contradiction, since the picture does not assume our existence as viewers prior and external to it in the Albertian mode. (The frame establishes the window relationship, for the mode of art itself does not.) To look out from such a replication of the world seen would be to contradict it or to call into question the very nature of the picture. We would

not know whether to take it as the world we see (Albertian) or as the world that is seen (northern or Keplerian). In fact, Velázquez's *Las Meninas* (fig. 42), one of the most subtle and powerful experiments in representation in all of Western art, can be understood as being ambiguous in just this way. It seems appropriate to close our discussion of this aspect of Dutch images with a brief look at this great work.

In *Las Meninas* the "looker" *in* the picture—the one whose view it is—is suitably none other than the artist himself, Velázquez, who, however, turns from his canvas to look out at the viewer (at us and the royal couple) in front of the picture. Like so many of Velázquez's works that present powerful

42. DIEGO VELÁZQUEZ, *Las Meninas*. Museo del Prado, Madrid.

human figures through elusive surfaces, this is a conflation of the northern mode (the world prior to us made visible) and the southern mode (we prior to the world and commanding its presence). What is extraordinary about this picture as representation (apart from what I would want to say about the poise, power, and fullness of its portrayal of the Infanta, her royal lineage, the court and its expectations) is that we must take it as at once a replication of the world *and* as a substitute world that we view through a window frame. The world seen has priority, but so also do we. Paradoxically, the world seen that is prior to us is precisely what, by looking out (and here the painter is joined by the princess and her retinue), confirms or acknowledges us. But if *we* had not arrived to stand before this world to look at it, the priority of the world seen would not have been defined in the first place. Indeed, to come full circle, the world seen is before us because we (and the king and queen as noted in the distant mirror) are what commanded its presence. *Las Meninas* confounds a single reading because it depends on and holds in suspension two contradictory (but, to Velázquez's sense of things, inseparable) ways of understanding the relationship of a picture, and of the viewer, to the world. The attempts to make a single sense out of it are mistaken. As Foucault has best set forth, it is a picture born out of and defined by a trust in representation. But even in the seventeenth century representation is not, as Foucault claims, a thing unto itself. It has its disparate modes, by which I mean it is dependent on notions of human measure, at least two of which Velázquez works to reconcile in a particularly heightened way in his masterpiece.[69]

<center>IV</center>

A leading historian of science has written recently of Kepler: "We know now that the passive, camera-like features of the eye that took such intellectual efforts to discover and are so fundamental to its optical system, nevertheless raise the least interesting questions about vision."[70] This explains why the relationship between Dutch art and Kepler's optical discoveries have not been noted by students of science and perception. But how do we explain the general absence of concerted attention by art historicans? I think because the model of the art-science link has long been linear perspective and optics in the Renaissance. In Italy, knowledge of nature was appropriated by practitioners of art as a move to legitimize and elevate picture-making to the status of a liberal art. Indeed, the desire for art to be up-to-date and scientifically true in order to acquire status has also repeatedly been offered as the model of the art-science link in later centuries.[71] This model clearly does not obtain with Kepler and the northern artists. The artists and the few theorists were either unaware of Kepler or, if they were, did not accept his analysis of vision. We have commented that Huygens is on record as doubting his findings, and Hoogstraten argued (against Kepler) that light rays were emitted from the eye.

Instead it was established concerns of artists in the north that were in effect taken up by Kepler. He turned his attention not only to the camera obscura, but also to lenses, mirrors, and even to glass urinary bottles filled with clear liquid, all of which served him as models of refracted light. Contemplating these models, we cannot help but be struck that these are phenomena that had traditionally fascinated northern artists. The reflecting jewels, various textures, light, glass, glass vials, and eyeglasses are, as Gombrich once wrote, all done with mirrors.[72] Viewed from the vantage point of Kepler's optical studies, we could say that the image-making property of light had long been a concern in the north. Van Eyck shows us in the Van der Paele altarpiece that each illuminated, shiny, reflecting surface makes an image. The nature of representation is thus already being pursued. In the centuries preceeding Kepler, lenses and mirrors were not objects of study but were the product of craftsmen and part of the studio equipment and delight of painters in their works. A number of Dutch painters were the sons of glassblowers. Jan van der Heyden in the seventeenth century made and sold mirrors. It is a case of traditional crafts and skills eventually becoming the subject of natural knowledge.

The relationship between art, craft, and natural knowledge has been much debated. In the case of perspective it has been suggested that artists' workshop practice moved in the direction that was then confirmed, mathematicized as it were, in the perspective construction. A similar process, I think, took place in the north in the seventeenth century, but it has gone largely unremarked. It would seem to have been not innovating artistic practices but the established practices of the craft, its age-old recording of light and reflecting surfaces, its commitment to descriptive concerns in maps or to botanical illustrations, in short, its fascination with and trust in the representation of the world, that in the seventeenth century helped spawn new knowledge of nature.

In the north natural knowledge, rather than emphasizing the forces of change in the art, was itself part of the past. It based its findings, modern and mathematical though they often were in their working out, on the new technology born of the old established craftsmanly concerns of an earlier age. (It is as if in Italy it had been Pisanello, not Masaccio, who was linked to experimentation and thought.) In playing a significant role in the new world of the seventeenth century, northern art did not change its old habits, but rather became newly confirmed in them. We can say that in this respect northern art never took part in the Renaissance in spite of the struggle of the Italianizers. (Though, of course, insofar as intellectual accomplishments are claimed for artists in the north they are those claimed in the south— humanistic learning, the nude, and perspective.) We have a case of traditional crafts and skills sustaining or keeping alive certain interests that eventually become the subject of natural knowledge.[78] Northern art came of age, came into a new age, by staying close to its roots. In Kepler's study of the eye, natural knowledge caught up with the art.

3

"With a Sincere Hand and a Faithful Eye": The Craft of Representation

To appear lifelike, a picture has to be carefully made. Indeed, a second feature of northern art is its extraordinary display of craft. Here, too, the contemporary interest in the eye, in particular in its active use, is an appropriate way to comprehend the nature of Dutch picturing. Attentive looking, transcribed by the hand—what might be called the observational craft—led to the recording of the multitude of things that make up the visible world. In the seventeenth century this was celebrated as giving basic access to knowledge and understanding of the world. The phrase from Hooke's *Micrographia* that heads this chapter is meant to suggest that it is in this arena that we shall discover the language and the societal circumstances in which to locate some crucial aspects of Dutch art. Nowhere was this program more powerfully expounded than in the writing of Francis Bacon, and nowhere more persistently carried out than in the annals of the Royal Society for the Pursuit of Natural Knowledge and in separate but related educational projects of Johann Comenius. The various subjects set forth by Bacon in his *Preparative toward a Natural and Experimental History,* like the pictured words of Comenius's *Orbis Pictus* and the objects familiar to us in the still lifes of the Dutch, all treat knowledge as visible and possessible. We are dealing here, I hasten to add, with what is properly termed a Dutch reading of Bacon. Bacon's dreams of surveillance and power as the fruit of man's knowledge of nature were not taken up in the Netherlands, where it was rather the experimental program and its taxonomic format that attracted followers.

As we turn our attention to the crafting of pictures, we shall find that the visual analogy once again introduces (appropriately, I think) a certain elusiveness to our analysis. Once again we find ourselves faced with the problematic question of the nature of representation. But now the terms are not perceptual, as they were in the previous chapter, but rather involve areas of experience that we might best collect under the heading of *praxis.* By praxis I mean to refer to that curious seventeenth-century obsession with the craft-

ing of Nature, of language, of the human trades or arts. If in the last chapter the model for pictorial representation was presented by the artifice of sight, = Ch.2 in the present chapter it is presented rather by the skills of craft. I want to = Ch.3 define the new emphasis that was brought to bear in the seventeenth century on the exercise of the traditional representational skills of the Dutch artist. The chapter has four sections: the first deals with the attentive eye and what a commitment to this means for those using microscopes as well as for those wielding a brush; section two considers the picture as an instrument of language learning and as a form of language in the works of Comenius; section three turns to Bacon's interest in *technē* as a model for art's pursuit of knowledge through experiment; and the conclusion apeaks to those social circumstances that encouraged the Dutch artist to consider himself as supreme among the craftsmen of the day. My argument will move back and forth between the intellectual and social circumstances and the images themselves in an attempt to suggest the manner in which these phenomena were interwoven at the time.[1]

<p style="text-align:center">I</p>

When Robert Hooke published his *Micrographia* in 1664 he claimed to be contributing to what he termed a "reformation in Philosophy." The eye, helped by the lens, was a means by which men were able to turn from the misleading world of Brain and Fancy to the concrete world of things. And the recording of such visual observations, which were the subject of his book, was to be the basis for new and true knowledge. As Hooke put it himself, his studies would be by way of

> Shewing, that there is not so much requir'd towards it, any strength of *Imagination,* or exactness of *Method,* or depth of *Contemplation* (though the addition of these, where they can be had, must needs produce a much more perfect composure) as a *sincere Hand,* and a *faithful Eye,* to examine, and to record, the things themselves as they appear.[2]

Hooke's preface, from which this passage is taken, articulates the binding of the attentive or, as he calls it, faithful eye to the manual craft of the recording hand. He binds sight to crafted description and, further, places this activity in the context of the greater Baconian project. Hooke's book was published under the auspices of the fledgling Royal Society, which in 1663 asked Hooke to contribute one of his microscopic observations to each weekly meeting. His study was central to the wave of Baconianism that flourished in publications after Bacon's death and that was finally confirmed in the founding of the Royal Society. That "reformation in Philosophy" to which Hooke allies himself is the casting out of the intellectual authority granted to those false notions or "Idols," as Bacon termed them, that had previously captured men's minds. Observation and recording things seen and set forth in words and pictures is to be the basis of new knowledge. Hooke's interest in right seeing and its record embraced the camera obscura as well as the microscope.

In a report to the Royal Society of 1694, he argues that the camera obscura is a device that can be used to produce truthful drawings of foreign places to counter the false images then circulating in the form of travel literature.[3] This suggestion does not seem to have been practical and did not gain acceptance. But its aim—to achieve a true picture—surely accorded well with the interests of the Dutch. We have already seen that they were fascinated with the camera obscura. As we shall find in the chapter to follow, they were also among the most dedicated world-describers (to take "geographer" literally, as it then was) of the time.

At the conclusion of his preface to the *Micrographia*, however, Hooke's frame of reference becomes distinctly more practical and commercial than Bacon's:

> But that that yet farther convinces me of the *Real* esteem that the more serious part of men have of this *Society*, is, that several *Merchants*, men who act in earnest (whose Object is *meum & tuum*, that great *Rudder* of humane affairs) have adventur'd considerable sums of *Money*, to put in practice what some of our Members have contrived [T]heir attempts will bring Philosophy from *words* to *action*, seeing the men of Business have had so great a share in their first foundation.[4]

Despite Hooke's claim, there was a nagging sense that while England had the Royal Society with its commercial connections, Holland lacked the Society but had the trade. This was the respect in which Dutch Baconianism was recognized. Thomas Sprat returns to this theme several times in the course of his *History of the Royal Society* of 1667. He is a bit puzzled by the lack of institutionally supported experimentation in Holland (though the lack of a real monarchy and aristocratic sponsorship is an obvious explanation), but he is full of praise for the proverbial industriousness, inventiveness, and trade of the Dutch. The Hague, Sprat writes with reference to Bacon, "may be soon made the very Copy of a Town in the *New Atlantis.* "[5] Social factors present in Holland and sadly absent in England are basic to this success. Sprat's comparison of England with Holland could stand in good stead even today:

> The *English* [are] avers from admitting of new *Inventions,* and shorter ways of labor, and from naturalizing New-people: Both which are the fatal mistakes that have made the *Hollanders* exceed us in *Riches* and *Trafic:* They receive all *Projects* and all *People,* and have few or no *Poor.*[6]

But the activities of the English Baconians had other reverbations in Holland. Constantijn Huygens was not alone in his enthusiasm for Bacon's writings. Their popularity is testified to not only by the good number of editions of his works that appeared in Holland, but further by the very early date at which his ideas and, most significantly, his practical procedures were discussed. Isaac Beeckman, the head of the Dordrecht Latin school, a leading student of nature and a friend and correspondent of Descartes and Mersennes, was already testing the experiments compiled by Bacon in 1628, the year after the publication of *Sylva Sylvarum.* Beeckman's enthusiasm for Bacon led him

to try to correct the many mistakes that he found in specific experiments and in their results. The precision, even fussiness, of his undertaking seems temperamentally Dutch. Others among his countrymen joined him in the task of offering corrections of this sort to Bacon. Beeckman clearly did not take issue with the plan Bacon set forth, he simply wanted to bring it up to snuff so that it could fulfill its great promise. He approvingly copied into his notebook the well-known passage from the *Novum Organum* that defines and assails the Idols. The record of Beeckman's own thought and experiments suggests that Holland was well prepared to receive Bacon's message.[7]

Beeckman was an ordained minister with a medical degree from Caen who kept a detailed diary on his intellectual and scientific interests.[8] The diary is on the one hand a kind of commonplace book in which he could copy down truths such as Bacon on the Idols, but it also gave him the chance to set down wonderful and telling scenes from his intellectual life. Though Beeckman was an educated man who corresponded with and visited the leading thinkers of his day, he lacked the public opportunities to promote his ideas that were common for his English contemporaries. In this respect his situation was not unlike that of the uneducated microscopist Leeuwenhoek. The account of his experiments was only brought to public notice in his correspondence, instituted with the London Royal Society upon the advice of Constantijn Huygens. Baconian attitudes inform the making of Dutch images, but they never had the institutional support in Holland that they gained in England.

Beeckman's diary records a play of mind that he appropriately refers to as his sensible imagination. He sits with Johan van Beverwyck (the author of the standard medical handbook of the time, whom we met in the last chapter exhibiting his eyelike camera obscura) and Jacob Cats (the man whose writings provided the moral touchstone for the Netherlands, where families put Father Cats on the shelf beside the Bible). As the three men sip their wine together they note the way a lump of sugar sucks up the liquid and a lively discussion of capillary action ensues.[9] Or, coming home from sitting in his appointed pew at church, Beeckman regrets that he could not prevent his mind from drifting away from the sermon to take up the mathematical problem presented by the disposition of panes in the window just over his seat. He questions the movement of clouds, the flicker of a candle, the fact that books are normally higher than they are wide. In an extraordinary act of observation, he even turns to the body of his brother, on which he performs an autopsy to determine the cause of his untimely death.[10] It is the appearance and in that sense the nature of the world that rouses Beeckman's interest. His curiosity makes no distinction between man and his makings and Nature and hers. Beeckman's bent is practical. Though his diary is written in both Dutch and Latin, he favored starting a school to educate common craftsmen in physics that would be conducted entirely in Dutch. Whatever the subject, it is not meditation as such that Beeckman prizes, but results. He wants to get things clearly into focus. Everything visible in the world (and everything that

is important can be seen) is to be arranged in a Baconian way as part of a great taxonomy that constitutes knowledge.

In recording his observations, Beeckman compiles the bits and pieces of a program for Dutch art. Dutch artists shared a passion for visual attentiveness with this kind of experimenter and savant. Indeed, their works attend to many of the same things that he does: Ruisdael's billowing clouds lifted high over the land (fig. 88); the swaying of the candle and the curled pages of piled books captured for our eyes in Leiden still-life paintings; the cadavers depicted by portraitists, to whom death presents itself in the form of a surgeon's lesson in anatomical observation. Like the painters of his land, Beeckman had a predilection for proverbs and other common sayings. Why is it, he wonders, that people can sing together but not speak together? Why is it said that when the sun is hot it will rain?[11] Beeckman treats verbal commonplaces as observations of the natural world, and as such they too are subject to his attentive eye. He puts forth verbal truisms and grants them something akin to the presence they assume on the printed pages of Dutch emblem books and in the paintings that are their counterparts. One reason for the popularity of pictured proverbs such as we find in the works of Jan Steen (fig. 163) is that instead of opening up human behavior to the uncertainties of interpretation, they categorize it and make it plainly visible to the eye.

Dutch Baconianism rested on an extraordinary trust in the attentive eye. This is the active form of the concern with the appearance of things that we discussed in the previous chatper. If we look for textual evidence of this in the literature on art, the most articulate account is by Samuel van Hoogstraten. Although drawing "after life" was an established procedure in the making of images in Renaissance art in the West, Hoogstraten's emphasis on the attentive eye is distinctive. In the chapter following that on "How Visible Nature Presents Herself in a Particular Fashion," he addresses the need of using much attention (*opletting*) in drawing, to the point that a measure is, as it were, built into one's eyes.[12] Getting used to observing (*opmerken*) serves the eye as well as the hand. Almost any part of nature, Hoogstraten continues, can feed or sharpen the eye.(His expression "de scherpte des oogs te wetten" is what one would use of a knife.) Therefore, while advising that the eye be used keenly, he adds none of the strictures commonly found in treatises of this kind about what one ought to look at. Hoogstraten's concentration on the use of the eye in the making of pictures appears to be almost a function of the Dutch language. He entitles the chapter in which he defines what painting is "Van het *oogmerk* der Schilderkonst" or, literally, the aim or "eye-mark" of the art of painting. He proceeds to argue that painting is a study that represents all the ideas of the visible world with the aim of fooling the eyes. With the exception of the particular emphasis given fooling the eyes, the sentiments expressed are traditional ones. But the words chosen have a particular resonance: represent is *verbeelden* or repicture, ideas are "ideen ofte denk-beelden," which introduces a word for ideas referring to them specifically as mental pictures, and "*oog* te bedriegen," or fooling of the eyes, echoes the

oogmerk of the chapter title. In the brief passage, Hoogstraten is engaged in a common kind of Dutch word play that lends a material presence to abstract terms such as aims, ideas, and representation itself. Let us look at the entire passage now in this light:

> *Concerning the aim of the Art of Painting; what it is and what it produces.* The Art of Painting is a science for representing all the ideas or notions which the whole of visible nature is able to produce and for deceiving the eye with drawing and color.

> [*Van het oogmerk der Schilderkonst; watze is, en te weeg brengt.* De Schilderkonst is een wetenschap, om alle ideen, ofte denkbeelden, die de gansche zichtbaere natuer kan geven, te verbeelden: en met omtrek en verwe het oog te bedriegen.]

In calling for an attentive eye, Hoogstraten professes not only a notion of drawing, but also a notion of the world that is seen and drawn. He cautions the young artist against taking on a mannered style by appealing to him to humble his brush and his hand to the eye so that the diversity of the individual things in the world can be represented.[13] This is very much the world as seen through a microscope. When Hooke looks at the seeds of thyme, he testifies to the way in which each is different from the other "both as to the eye and light. . . . They seemed each of them a little creas'd or wrinckled, but E [indicated on the engraving] was very conspicuously furrowed" (fig. 45).[14] Even in tiny seeds the attentive viewer perceives the differences. An art conceived of in this way is indeed an unending mirroring, as Hoogstraten calls it elsewhere.

If the world is looked at in this way, it is not the differences between things but their resemblance that is most problematic. Apparent resemblances can produce confusions in our perception of the separate and distinct identities of things. This attitude explains a number of passages in which Hoogstraten disputes the attribution to pictures of meanings, interpretations, or what he considers to be confused identities. Although he is an advocate of what we call trompe l'oeil images, he assails the inexcusable magic of the Italian church ceilings that pretend to represent heaven. In a similar vein he also chides those who (Leonardo-like, perhaps) read meanings into the clouds in the sky.[15] When Hoogstraten encourages the painter to use his eyes to see clouds as clouds, he confirms the nature of Ruisdael's pictures and of Beeckman's pursuit of natural knowledge.

This fixation on discrimination between things and on individual identity explains a curious and unprecedented chapter that Hoogstraten devotes to resemblance.[16] In a world in which each face is marvelously created to be different from every other one, it is all the more remarkable, he observes, when two people happen to look so exactly alike that they cannot be told apart. Hoogstraten focuses on the confusions—sometimes comic—that can be brought about by people like identical twins who look alike to all but their families. In his customary manner he assembles examples from both texts and

life, but one instance from his own life is most suggestive. Hoogstraten tells of having seen a nobleman riding through the streets of London who attracted such a crowd of followers that he scarcely knew where to hide.[17] The reason for the pursuit was that, unbeknownst to him, he was a likeness or double for the king. Mistaken for the ruler, he was followed as if he were the king. The radical demystification of the basis of royalty implied by the tale does not occur to Hoogstraten. The incident of mistaken identity does not suggest to him that kingliness is only a function of appearance. It never enters Hoogstraten's mind that the "king's clothes" might be an example of mere appearance sustained by belief. In fact, quite the reverse, the tale suggests to him that even the recognition of the king is a function of individual identity. A king, in this essentially leveling view, is but one individual among all the others and the problem is how to tell him apart as an individual. Identity (in this case of an individual man) is valued over and even opposed to resemblance (in this case to a kingly look).

Hoogstraten does not make clear what conclusion he draws for the making of art from this consideration of resemblance and identity. And indeed, given the way in which his own text, as we have already seen, is delicately poised between the rhetoric of the south and the pictorial practice of the north, a clear conclusion is hardly to be expected. There is, however, I think, a link between the problem Hoogstraten raises and the idea and practice of art. Put simply, one could say that Italian art was based on an intentional turning away from individuality in the name of general human traits and general truths. In such an art *resemblance* to certain ideals of appearance or of action, and thus resemblance between things, was constitutive of truth. This not only helped give the art a certain ideal cast, it also encouraged the differentiation between kinds of works. Portraiture, since it must attend to individuals, was considered inferior to works that engaged higher, more general human truths. The Dutch trust to and privileging of portraiture, which is at the center of their entire pictorial tradition, is connected on the other hand to a desire to preserve the identity of each person and each thing in the world. At the heart of Hoogstraten's chapter on resemblance is this alternative notion of art and of truth.

The anecdotes in Hoogstraten's chapter on resemblance locate in the visible world those phenomena that Bacon put in more abstract, philosophical terms. It is the meeting and passing of people in the streets of London, or the relationships within a family that serve Hoogstraten as examples of mistaken identity. But his concern is consistent with Bacon's concern about mistaken identities that are of the mind's making:

> The human understanding is of its own nature prone to suppose the existence of more order and regularity in the world than it finds.[18]

As we saw in our discussion of Kepler's study of vision, what had long been a basis for northern art came into its own as a generally accepted way of understanding the world in the seventeenth century. Hoogstraten, like Bacon, takes part in that seventeenth-century mode of constituting knowledge

which Foucault has—to my mind somewhat confusingly—called classical. Foucault, in *The Order of Things*, persistently argues that this new order of understanding is in effect a rejection of the established Renaissance tradition of interpretation through resemblance. His analysis provides an appropriate summary and coda to our discussion of Hoogstraten's chapter on resemblance:

> Resemblance, which had for long been the fundamental category of knowledge—both the form and content of what we know—became disassociated in an analysis based on terms of identity and difference. . . . The activity of the mind . . . will no longer consist in *drawing things together* . . . but, on the contrary, in *discriminating,* that is, in establishing their identities, then the inevitability of the connections with all the successive degrees of a series.[19]

Foucault opens his book with his remarkable viewing of Velázquez's *Las Meninas,* but otherwise his materials are textual in nature. Because he offers examples and arguments from literature, philosophy, natural knowledge, linguistics, and economics, the centrality of the image to this new mode of knowing the world is never made clear. To the extent that my work owes a measure of its impetus to Foucault's formulation, it also offers a supplement to it as far the place of the image is concerned.

Bacon, as far as I know, does not employ the example of images. But within his circle I have found at least one occasion that testifies directly to the relationship between the nature of images and the sea-change in the notion of knowledge at the time. It concerns a common Renaissance dispute about the manner in which to make an image: Does one model art after nature or after previous art? In the prefatory ode commissioned from him for Sprat's *History of the Royal Society,* Cowley invokes this artistic dispute as a way of clarifying his exposition of Bacon. The famous passage in which Cowley hails Bacon as a second Moses is preceded by less famous lines that counsel a rejection of high art and a return to nature. First, Cowley questions the masters:

> Who to the life an exact Piece would make,
> Must not from others Work a Copy take;
> No, not from Rubens or Vandike.

He then proceeds to warn against resorting to one's own fancy:

> Much less content himself to make it like
> Th' Ideas and the Images which ly
> In his own Fancy, or his Memory.

And concludes with the same formula, or one close to it, that is put forth by Hooke and that serves as the title of this chapter:

> No, he before his sight must place
> The Natural and Living Face:
> The real Object must command
> Each judgment of his Eye, and Motion of his Hand.[20]

For him who pursues natural knowledge, as for the maker of images, Cowley says, it is necessary to choose between the true testimony of sight and misleading interpretations. Most Dutch images, I would maintain, can be said to support this view, but there is one in particular that declares it outright.

I have in mind an odd occasional print after Pieter Saenredam (fig. 44).[21] This etching of 1628 represents, so the lengthy inscription tells us, several cross sections cut through an old apple tree growing on a farm just outside of Haarlem. This image was made to repudiate an earlier one that had represented the widespread belief that the dark core of the apple tree represents the miraculous appearance of Roman Catholic priests (fig. 43). In a Holland still

43. Miraculous images found in an apple tree. Municipal Archives, Haarlem.

at war with Catholic Spain, with troops not far off, the religious issue was a lively one. But Saenredam's print speaks to the nature of images as well as to issues of faith. He shows us the shape and thickness of the cuts through the tree and then isolates the dark cores for our view. He carefully names the date it was found and the location of the tree. This print, published, as the inscription says, out of the love of truth, seeks to replace a false picture with a true one. Its strategy is to separate the object seen from those beliefs or interpretations to which it had given rise. It argues, in effect, that the miracle is bound to a mistake in image-reading or to a mistake in interpretation. Saenredam's image of the tree replaces man's fancy, to recall Cowley's words,

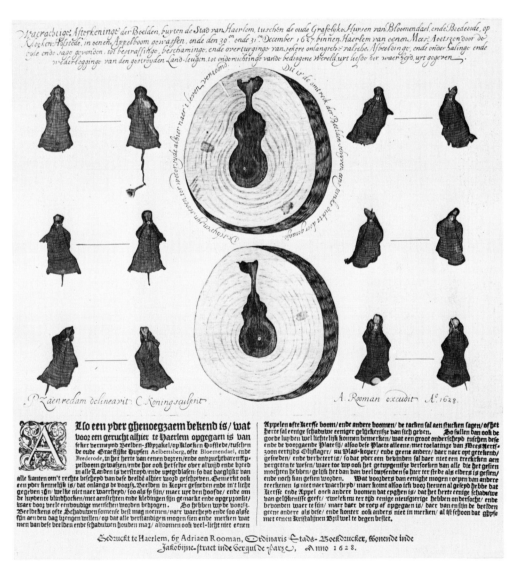

44. Cornelis Korning, after PIETER SAENREDAM, *Print to Belie Rumors about the Images Found in an Apple Tree* (etching), 1628. Municipal Archives, Haarlem.

with the real object seen. The core of an apple tree is not much to look at. Having denied any resemblance between these dark shapes and priests, is there anything left to see? Saerendam has no doubts. At the conclusion of the commentary he says: "There are no other images except these and they could not find any others. Although it is beautiful when you have a good look at them with a crystal glass." Dispensing with interpretation, Saenredam calls attention to the beauty of the particular thing seen in itself. Significantly, he looks through the newly accepted and newly popular lens. Unlike Saenredam's churches, the apple tree print does not convince us of the beauty of the things seen. But the inscription has the advantage of articulating a common intent: understanding is located in representing what is seen.

An illuminating contrast is offered by the quite different reception Rubens gave to the original print that recorded the miracle. As luck would have it, a copy of the engraving fell into his hands. In a letter written from Antwerp in March, 1628, he reports what he refers to as "the nonsense [bagatelli] from Holland": a vision has been reported of a bishop walking on the Haarlem Meer and an engraving has been widely distributed of an apple tree with nuns and monks.[22] Rubens quickly fills in what is to him an obvious context: the imperial Spanish army is nearby and fears have been raised among the Dutch that these are both omens of a Catholic resurgence. He then generalizes as follows: "How great an impression the dread or fear of something new will make upon the minds of men." It is the nature of human feelings and reactions, not the status of the tree, that Rubens attends to. And to give the event further grounding, Rubens predictably turns to antiquity. He cites a passage in which Pliny had referred to readings done on the basis of defects in the wood of a lemon tree. This, Rubens implies, is how people behave under certain circumstances, and defects in trees have traditionally been an object of interpretation. We can imagine Rubens representing the worship of false omens as a narrative picture: a crowd falls down or lifts its arms to honor the tree. He would find an antique counterpart to represent the modern errors. A painter's access to truth, as Rubens's works amply demonstrate, is through the depiction of human actions. Saenredam differs from Rubens in the nature of his understanding of the way images mean. Of course these things are linked. While Rubens's letter appeals to human nature and historical precedent, Saenredam offers instead to correct our sight.

The contrast offered us by these two reactions to the small instance of the apple tree outside Haarlem resounds in the program Bacon outlines in his *Great Instauration*. Bacon in effect sets Saenredam's view over and against that of Rubens by basing his plan of the natural histories on the belief that

> all depends on keeping the eye steadily fixed upon the facts of nature and so receiving their images simply as they are. For God forbid that we should give out a dream of our own imagination for a pattern of the world.[23]

But what is it to know nature through attentive looking? Or to put the question differently, what does one know if this is knowledge? There were a number of kinds of answers to this question at the time, one of which—the

microscopic model—is introduced by Saenredam himself in his invocation of the crystalline lens. His procedure and his claims about looking at the apple tree are familiar to us from the reports of others who were viewing the world through a lens. Leeuwenhoek, for example, repeatedly uses his microscope to disprove previous interpretations. When people think that a fever they have contracted is due to the fiery red color that their shoes pick up from meadow grass, Leeuwenhoek decides to look into it. He walks out to the meadow, studies the grass to discover what makes it red, and describes in detail the structure of the stalks.[24] Like the shapes in the apple tree, the feverish nature of the grass is put aside in face of what is seen. The red grass, like the apple tree, then has the status of a deconstructed wonder. This speaks to a general problem about the status and use of observations such as Leeuwenhoek's: to what extent does description take the place of other kinds of explanation? The example of the red grass is magnified by the larger one of his discovery and careful description of protozoa and bacteria—his animalcules. One is struck by the almost indiscriminate breadth of Leeuwenhoek's attentiveness—he turns his microscope on his sputum, feces, and even his semen as easily as he did on the flowers of the field.

Leeuwenhoek combines absorption in what is seen with a selflessness or anonymity that is also characteristic of the Dutch artist. Indeed, the conditions of visibility that Leeuwenhoek required in order to see better with his instruments resemble the arrangements made by artists. He brings his object, fixed on a holder, into focus beyond the lens. He adjusts the light and the setting as the artists were to do. To make the object of sight visible—in one case globules of blood—Leeuwenhoek arranges the light and background (in a way that is still not completely understood) so that the globules will, in his words, stand out like sand grains on a piece of black taffeta.[25] It is as if Leeuwenhoek had in mind the dark ground favored by Dutch still-life painters. From Bosschaert early in the century to Kalf later, Dutch painters understood that the visibility of surface (as contrasted with solidity of volume) depends precisely on this effect of relief (fig. 59). In keeping with the domestic mode of Dutch art, Leeuwenhoek's diaries describe with infinite care the household settings required for his observations: his study, its source of light and air, and the glass of water in which the animalcules are observed.[26] But there is another, more special sense in which his work, like that of the painters, acknowledges the conditions of sight. Leeuwenhoek was possessed by a fascination with the eyes of insects and animals. He looked not only at them but through them. In describing what animal or insect eyes see, he repeatedly calls attention to the fact that the world is known not through being visible, but through the particular instruments that mediate what is seen. Size, for example, is relative and dependent on the seer. Leeuwenhoek observes the church tower that artists recorded, but he looks at it through the eye of a dragon fly: "When I looked at the Tower of the New Church which . . . I found to have a height of 299 feet and from which my Study, as I guessed, is 750 feet distant, through the Cornea a great many Towers were presented, also upside down, and they appeared no bigger than does the point

of a small pin to our Eye."[27] When Paulus Potter or Aelbert Cuyp juxtaposes a bull (fig. 8) or a looming cow against a tower made tiny by its distance, he similarly acknowledges the conditions of sight.

This common interest is summed up in Leeuwenhoek's posthumous gift to the Royal Society. A contemporary account of the bequest, itself sadly long since misplaced, records that it, "consists of a small *Indian* cabinet, in the Drawers of which are 13 little Boxes or Cases, each containing two Microscopes. . . . They seem to have been put in Order in the Cabinet by himself, as he design'd them to be presented to the Royal Society each Microscope having had an Object placed before it." Leeuwenhoek not only bequeathed his instruments but, as the commentator goes on, methodically determined "those Minute subjects, that may in a particular Manner deserve his attention."[28] Three of the microscopes offered a view of eyes: the eye of a gnat; the eye of a fly, and the crystalline humor from the eye of a whale. To the end Leeuwenhoek played with questions of scale.

I shall not take up here the interesting problem of the nature and role of illustration in the works of the Dutch naturalists. Leeuwenhoek himself employed a pictorial scribe to note down in a simple form what he saw. Other Netherlandish students of natural knowledge such as the entomologist Joannes Goedart, and Maria Sibylla Merian, known for her splendid botanical images, made their own images. But I want to consider at least three useful terms of comparison between the activity of the microscopist and the artists, terms that are based on notions of seeing held in common and posited on an attentive eye. First and second, the double cutting edge of the world seen microscopically is that it both multiplies and divides. It multiplies when it dwells on the innumerable small elements within a larger body (Leeuwenhoek's animalcules in a drop of liquid) or the differences between individuals of a single species. It divides when it enables us to see an enlargement of a small part of a larger body or surface—as Leeuwenhoek studied the grain in wood or Hooke the weave of a bit of taffeta. Third, it treats everything as a visible surface either by slicing across or through to make a section (as Leeuwenhoek was one of the first to do) or by opening something up to expose the innards to reveal how it is made.

We know seeds of the thyme plant, Hooke assumes, by looking carefully at a number of individual seeds. A page illustrates this with nine greatly magnified seeds, each one distinct in its furrows, creases, or wrinkles, but having in common a very conspicuous part where they had been joined to a stem (fig. 45). Reflecting on the magnified forms, Hooke instinctively construes them as a Dutch picture: "the Grain affords a very pretty Object for the *Microscope,* namely, a Dish of Lemmons plac'd in a very little room."[29] This is similar to the way in which De Gheyn knows a mouse: he draws one seen four times from different views (fig. 46). Or it is the way in which we know a skull as we are shown by one Abraham van der Schoor, who made an unusual painting with multiple views of a number of skulls (fig. 47). There is a common interest. Whether the strategy is to see multiple views of one

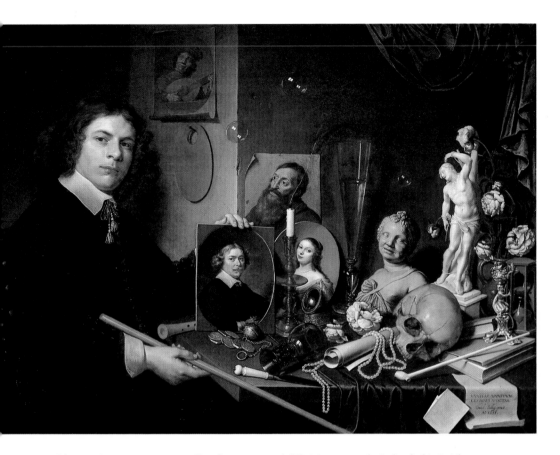

Plate 1. DAVID BAILLY, *Still Life*, 1651. Stedelijk Museum "de Lakenhal," Leiden.

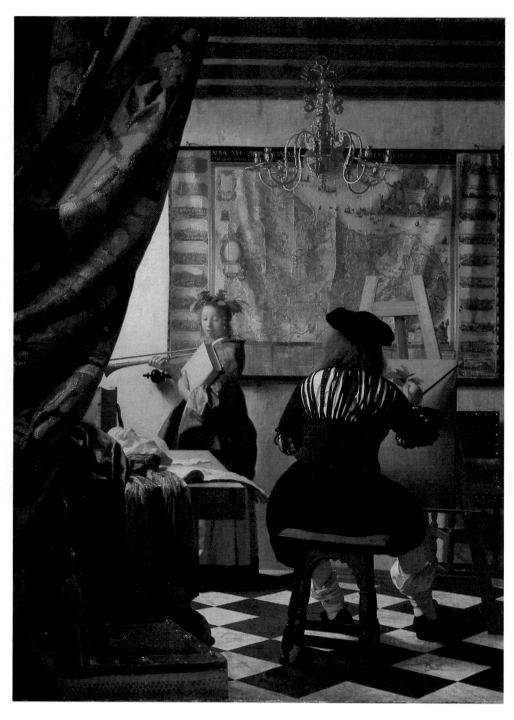

Plate 2. JAN VERMEER, *The Art of Painting*. Kunsthistorisches Museum, Vienna.

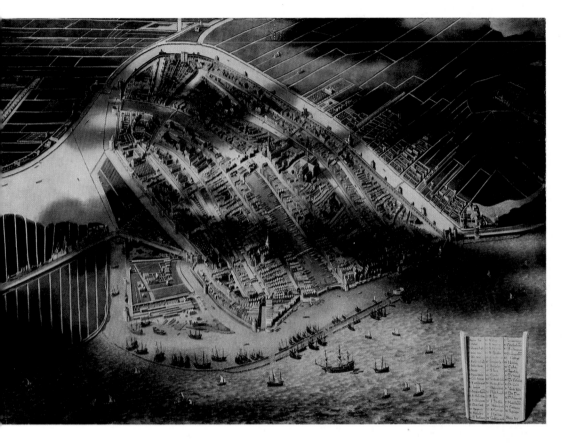

Plate 3. JAN CHRISTAENSZ. MICKER, *View of Amsterdam.* Collection Amsterdam Historical Museum, Amsterdam.

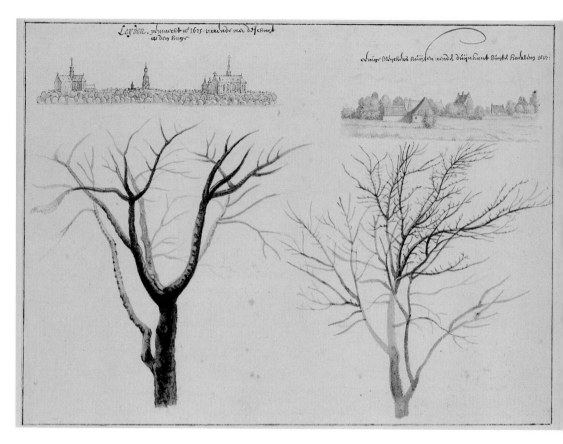

Plate 4. PIETER SAENREDAM, *Profile Views of Leiden and Haarlem and Two Trees* (pen, wash, and watercolor), 1617 and 1625. Kupferstichkabinett, Staatliche Museen Preussischer Kulturbesitz, Berlin (West).

individual (the mouse), or to multiply the number of individuals seen (the skulls), the aim is to draw our attention to the various features of mouse or skull. It is a fragmenting approach. Fragments are prized. We saw this already in an earlier chapter in Saenredam's additive approach to architectural space, which corresponded to Hoogstraten's additive understanding of perspective. This is the attitude expressed by Saenredam when he praises the beauty of the bit of the apple tree core seen through a crystalline lens. No need is felt to pull together, assemble, or in some way resolve individual views into a unified sense of a whole. The attitude is conditional on a double fragmentation: first, the viewer's eye is isolated from the rest of his body at the lens; second, what is seen is detached from the rest of the object and from the rest of the world. A contrast can be made between such fragmentary beauty, a function of infinite attentive glances, and a notion of beauty that assumes the just proportion of a whole and thus admits to a prior notion about what makes an entire object beautiful. The prime example for Renaissance picture-makers of beauty so conceived was the justly proportioned human body—constructed or imagined, but never seen. In Italy human proportions were also identified with those of buildings in order to confirm the symmetry of the body and to confer anthropomorphic presence on architecture. The scale of architecture is also related to the human scale. The ideal nude did not win general understanding or acceptance in the north. Architecture often featured complexly worked surfaces that had to be scanned by the eye. And architecture viewed by the disembodied eye placed at the viewing hole of a Dutch peep-box is denied that relationship to the viewer's scale that Italian pictures deemed necessary. The eye of the northern viewer inserts itself right into the world, while the southern viewer stands at a measured distance to take it all in.

Early in the century, De Gheyn manifests this restless, attentive eye with more persistence than any other Dutch artist. He strives to show the multiplicity of what is seen.[30] A drawing in Berlin represents nine views of the head of a youth with tousled hair (fig. 48). If we feel that the mouse was brought close, intimately viewed, we feel curiously distanced here from the look, character, feeling, or stance that we expect would attract us to the head of a youth. De Gheyn's fascination with the quality of the youth's hair is comparable to Hooke's absorption in the marked surface of the seeds of thyme. What is surprising is that De Gheyn's attentive eye does not credit the head with any human inwardness that would distinguish it from the seed of the plant.

This helps us perhaps to make some sense of a powerful but curious sheet of his drawings in Berlin (fig. 49). Two grapevines executed in pen and ink are placed diagonally across the upper part of the sheet, their finely cut leaves and spiraling tendrils reaching out over the paper's surface. At one place they meet the unlikely figure of a woman, small, round, firm of form, present only to her hips, the red-chalk flesh of her face and hands standing out from the black chalk of her dress. Below rests a plump melon with ample leaves whose firm contours echo the woman above and which, like her, is executed in the

45

46

45. Illustration of seeds of thyme in ROBERT HOOKE, *Micrographia* (London, 1665), plate 18.

46. JACQUES DE GHEYN, *Four Mice* (pen, ink, and gray wash with watercolor). By courtesy of the Rijksmuseum-Stichting, Amsterdam.

47. ABRAHAM VAN DER SCHOOR, *Vanitas Still Life*. By courtesy of the Rijksmuseum-Stichting, Amsterdam.

48. JACQUES DE GHEYN, *Studies of a Head* (drawing). Kupferstichkabinett, Staatliche Museen Preussischer Kulturbesitz, Berlin (West).

47

48

49. JACQUES DE GHEYN, *Old Woman and Vine* (black and red chalk).
Kupferstichkabinett, Staatliche Preussischer Kulturbesitz, Berlin (West).

soft chalk. De Gheyn's serious descriptive care deals equally with plants and with the human form. It adjudicates between disjunctive shifts in scale: the woman is made small by the vine while her rotund form is strengthened by the presence of the melon. Even if, as it appears, the sheet was executed in stages at different times, and is a set of jottings, not a single invention, this does not contradict our sense that it represents De Gheyn's sense of the world viewed. The most curious feature of the sheet, I think, confirms this. For at the right, nestled among the central leaves, and once again just above this at the right edge of the sheet, an eye is drawn with a sight line marked out across the page. It is a mark of the place of the attentive eye in the making of the sheet.

Whatever Dutch art might engage, an attentive eye can surely be said to be a factor in the making of a majority of seventeenth-century Dutch images. It can further be said to be a major theme of De Gheyn's picturing: he often elects to make attentiveness itself the object of representation. A surprising number of his drawings present people looking at or reading books. But the key work is a remarkable painting now in Ham House, Richmond, that depicts the unprecedented subject of Caesar dictating to his scribes (fig. 50).

50. JACQUES DE GHEYN, *Caesar Dictating to His Scribes*. Richmond, Ham House. Victoria and Albert Museum Crown copyright.

De Gheyn loosely follows the account in Plutarch's *Lives,* which praises
Caesar for being able to dictate two or more letters at once while on horse-
back.[31] The picture is a most eccentric gesture toward an antique world in
which De Gheyn otherwise seems to have had no abiding interest. (Aside
from the wreathed head of Caesar, his name inscribed at the upper left, and
the trophy within the tent, one would not even guess that this work depicts
the ancient world.) The emperor, seated on his horse at the right, dips his pen
into the ink held up by his groom and prepares to write a letter while he
glances to our left, where two scribes are at their work and a third reads a
completed letter. Each of the other three young men attends either to the
dictating, the writing, or to the reading that is going on. The figures are all
cut off at the waist to intensify our concentration on the heads and hands that
crowd the canvas—inscribing, listening, reading.

The story told of Caesar's dictation became in later times an emblem of
attention itself. No less a student of the subject than William James, in a
section of *The Principles of Psychology* entitled "To How Many Things Can
We Attend at Once," refers to what is in his view the futile attempt on
Caesar's part to attend to multiple directions:

> Where, however the processes are less automatic, as in the story of Julius
> Caesar dictating four letters whilst he writes a fifth, there must be a rapid
> oscillation of the mind from one to the next and no consequent gain of
> time.[32]

In many respects James's discussion of attention fits what we learn from the
Dutch pictorial example: its reflective and passive nature, its selectivity, the
need to hold attention by rolling a topic over and over incessantly to consider
different aspects of it. The major and significant difference is that the roots of
attention for James lie in consciousness of self, while De Gheyn (and the
Dutch artists in general) seem to let attention stand *for* the self. It is not really
Caesar's powers that interest De Gheyn as much as the multiplication of
attentive behavior manifested in his servants and scribes. In De Gheyn's
picture Caesar—like the artist himself—is the source of attentiveness in oth-
ers. And it is not only those within the picture, but also the viewer without
who is presented with a detailed assemblage of heads (and hands) not unlike
the youth drawn nine times on the sheet in Berlin.[33]

Finally, in the category of the microscopic taste for displaying multiple
surfaces, we should consider the common Dutch practice of opening, in order
to reveal to our sight, the makings of the objects in their still lifes (fig. 51).
Whether it is edibles such as cheese, a pie, herring, fruit, and nuts, or col-
lectibles such as shells, vessels, and watches, we are offered the inside, or
underside, as well as the outer view. Cheeses are cut into, pies spill out their
fillings beneath the shelter of crust, herring are cut to reveal flesh as well as
gleaming skin. Shells and vessels of precious metal or glasses topple on their
sides (occasionally we even see the jagged edge of a broken goblet), and
watches are inevitably opened to reveal their works. Objects are exposed to

the probing eye not only by the technique of flaying them, but also by reflection: the play of light on the surface distinguishes glass from metal, from cloth, from pastry, and also serves to multiply surfaces. The underside of a vessel's foot is doubled by its reflection in the adjacent pewter plate. Each thing exposes multiple surfaces in order to be more fully present to the eye.

Consider the lemon, one of the favored objects of Dutch vision. Its representation characteristically maximizes surface: the peel is sliced and unwound to reveal a glistening interior from which a seed or two is frequently discarded to one side. In the hands of Willem Kalf, particularly, the lemon offers a splendid instance of what I have termed division (fig. 59). The representation of the wrinkled gold of its mottled surface, with the peel here pitted, there swelling, loosened from the flesh and sinously extended, totally transforms the fruit. We have never seen a lemon in this way before. Modern interpretations notwithstanding, Kalf's lemons are subject not to the ravages of time but to the probings of the eye.[34] Compare the lemons of Kalf to the lemons of Zurbarán (fig. 52). Here is the familiar significant shape: bumpy ovals slightly drawn in at one end and pulled out to a pointed protruberance at the other, the entire form a steady yellow. What is more, Zurbarán's lemon is a solid object. It would fit into the hand, is graspable, and is piled with others of its kind to confirm its solid nature.

Whatever other aspects there are to such works, it is clear that they are devised as a feast for the attentive eye. "But to resolve nature into abstractions is less to our purpose than to dissect her into parts," writes Bacon in the *Novum Organum*.[35] The motto applies to Dutch still lifes. It suggests further what they are willing to sacrifice—the selection of a single, prime, or privileged view ("abstraction," in Bacon's terms) that is empowered to summarize knowledge. In a memorable passage written some years later, John Locke specified the disturbing potentiality of the microscopic view:

> If that most instructive of our senses, seeing, were in any man a thousand, or a hundred times more acute than it is by the best microscope, things several millions of times less than the smallest object of his sight now would then be visible to his naked eyes, and so he would come nearer to the discovery of the texture and motion of the minute parts of corporeal things . . . but then he would be in a quite different world from other people: nothing would appear the same to him and others.[36]

Far from acknowledging that their vision engaged the sublime—for that is the "different world" that Locke's remarks suggest—the Dutch greeted their new sights with wonder and delight as offering new and concrete knowledge of our common world.

II

The interest in the view through the lens was hardly an isolated phenomenon at the time. It was supported by a ground swell of views about knowledge and language, and in a somewhat more practical vein by schemes of

51. WILLEM CLAESZ. HEDA, *Still Life,* 1634. Museum Boymans-van Beuningen, Rotterdam.

52. FRANCISCO DE ZURBARÁN, *Still Life with Lemons, Oranges and a Rose.* The Norton Simon Foundation, Pasadena.

education. If we are to understand the kinds of presence, and thus the kinds of meaning, that Dutch descriptive paintings had at the time, it is useful to consider the nature of this support. We might start with the definition offered by Comenius, the leading Protestant theorist of education:

> If you demand what it is to be a good scholar, take this for an answer: to know how one thing differeth from another, and to be able to [note, or] marke out everything by its owne name.[37]

We are by now familiar with this sentiment in favor of discriminating between the identities of things. Comenius considers the kind of discrimination with which we have just been concerned in terms of naming. And by defining this as the purview of the scholar, he clearly plays off naming against the inherited body of texts associated with scholarship. It is not said of microscopy, but it is clear that it might have been. Hooke acknowledges the Adamic nature of his project in a passage of the *Micrographia*. But when he does this, in what he calls a "digression about Nature's method" at the conclusion of the chapter on the seeds of thyme, he invokes another, older notion of naming that his own project had superseded. It had been an established view in the previous century, articulated notably by Paracelsus in his doctrine of signatures, that a name itself was significant of a creature's or an object's nature. Therefore, our job was to read the "True Book of Nature" inscribed in both names and in the things that they resembled. Hooke ends his chapter by questioning the idea that Adam's names "had any significancy in them of the creatures nature on which he impos'd them." But then, echoing Paracelsus, he courts just what he has disputed: "The Creator may in those characters have written and engraven many of his most mysterious designs and counsels and given man a capacity to read and understand them."[38] Though he turns away from the authority of texts to nature herself, Hooke still wants nature to be not only visible, but also readable. But the vanguard of language studies at the time had led away from names redolent with meaning to the things themselves and to what Bacon variously referred to as "the creator's own signature and marks" or "footprints" or "stamps" on them. God creates by imprinting himself (as in the imprinting of a coin or a seal) in things rather than by writing texts. Adam, it would seem, did not have to decipher what he named, he simply saw. Names are not essentially created by God, as things are, but are part of a conventional system, A representation referring to real objects in the world. While it would be too reductive to refer to this simply as a picture theory of language, it is true that it was a notion of language that treated pictures as one of its possible modes or manifestations.

It was such an understanding of the nature of language that led to the invention and printing of the first illustrated school book for teaching language to children (fig. 53). Comenius, from whose view of education we quoted just above, is a central figure in the history of educational theory and reform. His *Orbis Sensualium Pictus* or *The Visible World Pictured* of 1658 is still recognized as a landmark in the history of education. Though the

extent of his contribution to the study of language is frequently questioned, his proposals for educational reform have been saluted from the Baconians to Goethe (who used the *Orbis Pictus* as a child) to Piaget (who edited a modern selection of his works).[39] But because he took no independent interest in pictures as such, Comenius has never figured in an investigation of images. The evidence that he should is provided not only by his use of pictures but by the invocation of visual attention and the craft of the painter we find in some of his major works.

First let us locate him in his time. Comenius was active and celebrated in the northern European Protestant world with which we are already familiar. A persecuted Moravian (Czech) prelate who was forced to flee his homeland, he devoted his life in exile to educational reform as part of a program of Protestant universalism known as pansophy. He promoted this cause in a steady stream of publications. He was living in Poland in 1631 when he published his first great success, the *Janua Linguarum Reserta* or *The Gates of Languages Unlocked.* It was the first of a graded series of texts that proposed a new way of teaching Latin. Comenius proposed shifting the entire emphasis from instruction in words to instruction in things—the things to which the words referred. Comenius wished to replace the previous emphasis on language as rhetoric with language as description. Bacon's *Great Instauration* was a central text for him, and he acknowledged that his manner was Baconian. All teaching must be achieved, he argued, not from books and traditions but from things. This material emphasis, and the schemes in which he ordered it, were recognized by Baconians in England, who in 1641 persuaded Comenius to come and join them in a plan to create an institution to further their common aims. Through the intervention of the Dutch entrepreneur De Geer, Comenius left England for Sweden during the revolution of 1642. He appears to have turned down an invitation from Cotton Mather to take up the presidency of a forward-looking institution of higher learning just being set up in Cambridge, Massachusetts. But Harvard, demonstrating a faith in education equal to Comenius's own, apparently employed his methods to teach Latin and some Greek to its few American Indian students. Only near the end of a lifetime of wandering did Comenius finally join the many exiles who found refuge in the Netherlands. He is buried just south of Amsterdam in the town of Naarden. Given his intellectual interests and the nature of his writings, it was most fitting that Comenius's collected works were published in Amsterdam (1657), bearing a dedication to the Dutch East India Company and to the city counselors of Amsterdam, the city that subsidized its publication.[40]

My interest in not in his educational schemes as such, but in the specifically visual basis that he gives to them. In the *Great Didactic* of 1641, his detailed program for school reform, Comenius argues that "seeing is believing." The Baconian (or Dutch) example he offers is *seeing* an actual dissection in contrast to *reading* about one in a treatise in anatomy:

Whoever has once seen a dissection of the human body will understand and remember the relative position of its parts with far greater certainty than if he had read the most exhaustive treatises on anatomy, but had never actually seen a dissection performed. Hence the saying "Seeing is believing."[41]

In this early text, Comenius dissects visual attention itself. Here is the passage in which he explains how to take in or understand things in the world through looking:

> We will now speak of the mode in which objects must be presented to the senses, if the impression is to be distinct. This can be readily understood if we consider the processes of actual vision. If the object is to be clearly seen it is necessary: (1) that it be placed before the eyes; (2) not far off, but at a reasonable distance; (3) not on one side, but straight before the eyes; (4) and so that the front of the object be not turned away from, but directed towards, the observer; (5) that the eyes first take in the object as a whole; (6) and then proceed to distinguish the parts; (7) inspecting these in order from the beginning to the end; (8) that attention be paid to each and every part; (9) until they are all grasped by means of their essential attributes. If these requisites be properly observed, vision takes place successfully; but if one be neglected its success is only partial.[42]

This concentration on the act of visual attention, the drive toward what is termed "successful" seeing, and the seriousness with which fruits of such attention are treated as an end of education, can help us to define the attentiveness demanded by much Dutch painting. I think, in particular, of the way in which still lifes isolate and attend to objects. Each object is displayed not for use, or as a result of it, but for the attentive eye.

We are so accustomed to think of picture books as appropriate for children that it is as hard to imagine when they were not in use as it is to think that they need a rationale. Comenius appeals not just to the appropriateness of pictures for children—though he did that—but to their appropriateness given the nature of language, perception, and our knowledge of the world. The argument might be put in two parts: perceptual and linguistic. First, the path to understanding is through the senses (with sight prime among the rest). Since we store what we have seen in mental images, the stirring up of visual attention is basic to education. Second, language is essentially denotative. One must learn the names given to things and engage in acts of pointing or reference rather than acts of expression or statement. Since words are man's (not God's) to fashion, language is a representation of all the things in the world. Images clearly have a paradigmatic place in a view such as this, which privileges vision and presents language as a representation.

Comenius's *Orbis Pictus* is an assembly of 151 pictures of things juxtaposed with their names. It is more precisely described as a table, since the named and pictured objects are arranged in a sequence of (undesignated) groups or

categories—elements, vegetables, animals, man, arts, crafts, and so on—which are further broken down into subcategories. The first, perhaps the major step in comprehending the world is to indicate the order of things. Understanding is thus composed of words or other marks referring to this order. The tree, for example, is placed in the category of the vegetable kingdom (fig. 53). It is distinguished from plants and shrubs, and then its parts—roots, trunk, branches, leaves—are enumerated. A felled tree is depicted exhibiting its core and its stump. The names and numbered parts of the picture to which they correspond represent the world as we know it, as Adam originally knew it. Comenius uses Genesis 2:19, 20 (the Lord bringing to Adam every beast of the field) as the epigraph for his book. The juxtaposition of pictures of things and names of things makes manifest Hoogstraten's claim that drawing is a second form of writing, or indeed a language. (Comenius's title, *The Visible World Pictured,* testifies to its common ground with Hoogstraten's Visible World.) John Evelyn put the matter directly when he praised Comenius's *Orbis Pictus* for showing that a *"picture* is a kind of *Universal Language,"*[43]

Though it was originally published in Polish and Latin, the *Orbis Pictus* was translated into English within a year of its publication and thence into many other languages. The spur to this process of translation was the new ambition to consider words as names, or as arbitrary or conventional characters with a real reference. It was not the generation of grammar, but the nomination of objects in the world that encouraged this process. Stability was sought not in the nature of the words in any one language, but in reference to the system of things that were named. Comenius's pansophic ambitions went hand in hand with the efforts of men such as John Wilkins and Leibniz to invent a new, artificial, universal language. The great (and vain) hope was that such knowledge could bind all men together in peace. Bacon had at one time flirted with the "Characters Real" of China only to reject them in favor of the more wieldy alphabetic writing. Though they did not adopt the pictographic mode, his followers tried unsuccessfully to invent a new system of notation. It was dubbed "real characters," to bring out the indissoluble links between its reference to the real world and its status as sign. The process was one of invention, but it had all the earmarks of discovery, as if indeed a notational system could be found that would at once be an artifice and also truly referential.

The idea that pictures are a form of language and hence a way to acquire knowledge of the world seems to be the assumption of a drawing by De Gheyn in Berlin (fig. 54). The woman and the child who lean over a book of pictures could be promoting Comenius's *Orbis Pictus.* The child looks and points at the image of a tree while the woman, probably his mother, clearly takes the role of a patient and encouraging teacher. De Gheyn offers us an image of instruction or education with the tools of the writer's craft—quill, ink, candle for light—casually yet prominently displayed on the table surface. The evidence is that illustrated school books were not in general use in

53. "A Tree," in JOHANN AMOS COMENIUS, *Orbis Sensualium
Pictus* (London, 1685), pp. 28–29. Courtesy of the John M.
Wing Collection, the Newberry Library, Chicago.

54. JACQUES DE GHEYN, *Woman with Child and Picture-book* (pen with brown wash).
Kupferstichkabinett, Staatliche Museen Preussischer Kulturbesitz, Berlin (West).

Holland or anywhere else at the time.[44] Though children did learn to draw,
De Gheyn's drawing tells us not about school practice but about an interest
in the acquisition of what we might call visual literacy. The images of the tree
and cow in the book are the instruments of education. The drawing is De
Gheyn's way of reflecting for himself and for us on that attentive viewing of
the world that his pictures provide and on the knowledge he assumes they
convey. Like so many of his works, it is a remarkably self-conscious man-
ifestation of concerns common to Dutch images. It is no revelation to claim
that Dutch art in general bears out the nominative and representative impulses
attributed to language at the time. But the relationship gives us further reason
to fix our gaze, as the Dutch artists fixed theirs, on the representation of the
stuffs and makings in the world rather than searching beneath their surfaces.[45]

To know is to name is to describe, but it is also to make. The simple plates
to Comenius's *Orbis Pictus* cannot begin to match the delving into the mate-
rial making of an object that we find in the art of the Dutch. But the gleam
of silver and its worked surface, the pearly wetness of the filling of a pie, and
the intricately tooled workings of a watch are all accounted for by Comenius
under the rubric of art or, more specifically, craft.

One of the major groups of things represented in the *Orbis Pictus* are those
objects made not by nature but by man. The subtitle to the entire text
accounts for them as "all the chief things that are in the world and Men's
Employments therein." Weaving, spinning, shoemaking, cooking, and glass-
blowing follow the tree and other artifices of nature. The plates often depict
the workshops where these products were made (fig. 55). This was not a new
idea for Comenius. In the *Great Didactic,* in which he first set forth his
general program for school reform and education, Comenius's strategy was
to juxtapose a prime example of Nature's art—the birth and nurturing of a
bird by its mother—with four human trades: gardening, carpentry, painting,
and printing. The argument is that "to place the art of intellectual discipline
on a firm basis" one must "assimilate the processes of art as much as possible
to the processes of nature." Comenius guides us through the principles of
eduation by taking us through the conception, birth, and nurturing of a bird
and the preparation of the canvas, choice of colors, drawing, finishing, and
protection of a painting:

> *Nature prepares the material, before she begins to give it form.*
> For example: the bird that wishes to produce a creature similar to itself first
> conceives the embryo from a drop of its blood; it then prepares the nest in
> which it is to lay the eggs, but does not begin to hatch them until the chick
> is formed and moves within the shell.
>
> *Imitation.* —In the same way the prudent builder, before he begins to erect
> a building, collects a quantity of wood, lime, stones, iron, and the other
> things needful, in order that he may not have to stop the work later on from
> lack of materials, nor find that its solidity has been impaired. In the same

55. "Cookery," in JOHANN AMOS COMENIUS, *Orbis Sensualium Pictus* (London, 1685), pp. 112–13. Courtesy of the John M. Wing Collection, the Newberry Library, Chicago.

way, the painter who wishes to produce a picture, prepares the canvas, stretches it on a frame, lays the ground on it, mixes the colours, places his brushes so that they may be ready to hand, and then at last commences to paint.[46]

A conclusion is then drawn for procedures in school:

> *Rectification.* —It follows, therefore, that in order to effect a thorough improvement in schools it is necessary: That books and the materials necessary for teaching be held in readiness.

Pictures in Comenius's scheme of things serve, like words, as representations of the concrete world of things. But they also serve as models of making. We are back again where we began this chapter, with Hooke's pairing of the faithful eye and the sincere hand. But we are also plunged right into the middle of Bacon's program for the advancement of learning, and it is there that we must now look for a further sense of the nature of Dutch pictures.

III

Bacon's program in *The Advancement of Learning* can be seen as a major philosophical enterprise with practical or technological ambitions. This is not the place to try to sort out its complex history within Bacon's own writings and those of his followers, or its blurred and often competing aims. My point

here is to suggest the ways in which aspects of his enterprise, in particular his definitive interest in the mechanical arts and its later implementation in a history of trades, can provide a background for understanding certain central impulses in Dutch picturing.[47] There seems no question that in the seventeenth century the traditional craft role and concerns of the Dutch artists were given a new rationale or at least a new lease on life. In the very face of a humanistic definition of art and what would later be called academic training, the Dutch painters instead developed and employed the craft aspect of their art. Far from abandoning their traditional craft skills, Dou, Mieris, Kalf, Vermeer, and others pushed it to new heights. It will not do, of course, to claim Bacon as a cause for the effect of Dutch painting, in spite of the Dutch enthusiasm for his writings. However, in arguing for craft or human artifacts and their making, Bacon, who lived in a country without any notable tradition of images, can help deepen our understanding of the images produced in Holland, a country notable for its lack of powerful texts. The utilitarian emphasis and commercial direction given by his followers to his philosophical venture neatly parallels the Dutch mixture of trade with art. In Holland this comes to replace the earlier concern with visual literacy as we saw it in De Gheyn. By mid-century, Dutch still lifes move beyond questions of visual literacy to attempt to mediate between high artistic craft and a tremendous pride in possessions.

Bacon first put forth his program in the *Advancement of Learning* of 1605. He reiterates and develops it in the *Novum Organum* of 1620 with its separate introduction, and the *Great Instauration* and its appended *Parasceve* (or *Preparative toward a Natural and Experimental History*). Bacon specifically turns to nature and away from the interpretation and learning offered in books: away, he writes in 1620, with antiquities, and citations or testimonies of authors, away with all superstitious stories. The state of human knowledge, as the prefatory note to the *Great Instauration* states, is dismal:

> That the state of knowledge is not prosperous nor greatly advancing; and that a way must be opened for the human understanding entirely different from any hitherto known, and other helps provided, in order that the mind may exercise over the nature of things the authority which properly belongs to it.[48]

Bacon's solution, one with which we are by now familiar from many sources, including Huygens, Saenredam, and Comenius, is to turn to facts in order to dissect:

> Those however who aspire not to guess and divine, but to discover and know; who propose not to devise mimic and fabulous worlds of their own, but to examine and dissect the nature of this very world itself; must go to facts themselves for everything.[49]

The way out is to be found in the generally neglected notion of natural (versus civil) history, which Bacon refers to as the primary or "mother" history.[50] Natural history in its turn is divided into three parts: the history of the works

56. ANONYMOUS, Northern Netherlandish School, *Radish*, 1626. By courtesy of the Rijksmuseum-Stichting, Amsterdam.

of nature, the histories of aberrations in nature (monsters), and the history of man's manipulations of nature, which is the history of the arts. Bacon's categories immediately suggest interesting connections to Dutch images. There are, for example, a number of Dutch pictures that surprise us by their unlikely subjects: a portrait of a giant radish (fig. 56), or a large kidney stone. Like Saenredam's apple tree, these images represent a category of oddities in nature. They are like those aberrations to which Bacon devoted special attention. Only a few decades before, such images would have been part of the encyclopedic collections of princes. These resembled modern ethnographic collections in many ways. But far from calling into question the norms by which men expect to live, as ethnographic collections have in our time, even the oddities were thought to expand knowledge of God's creation and confirm man in his ability to encompass it. About this Bacon and the Dutch artists agreed.

Bacon's innovation, as he sees it (though indeed earlier precedents have been found), is to insist on the essential oneness of the study of nature and man's arts or what he calls mechanical and experimental history. As in Comenius, man's crafts and his alteration of nature are made an essential part of the study of nature. The gardening, building, and painting of Comenius's *Great Didactic* is included in the list of projected particular histories that Bacon publishes at the end of the *Parasceve*. There are 130 topics in all: twenty are concerned with nature (both ordinary and extraordinary), eighteen with man, and the great majority (seventy-two) with man's interference

with or accomplishment in the field of nature. The subcategories in the list are a bit fluid as we move among examples from the mechanical arts, the practical part of the liberal arts, and areas of practical knowledge not yet systematized. Painting, music, cooking, baking, wool manufacture, weaving, dying, glass-making, architecture, gardening, even games are included as basic forms of human making deserving serious study and attention. Given Bacon's odd and characteristic combination of a few ordering principles and multifarious ex-amples, the categories enunciated in his introductory text remain un-delineated in the flood of examples that he sets forth.

Bacon's list is notable not only for adding human arts on to Nature's, but also for including within the list of the human arts a large number of non-mechanical arts—skills without a mathematical basis, which are engaged in by an otherwise uneducated segment of society. It is interesting for students of Dutch art that painting, which appears directly under the study of vision in the *Parasceve,* is also included with this kind of craft. Much can be learned from this. One would be correct to protest that many if not most Dutch artists did not simply identify themselves socially or professionally with craftsmen of this type. In the hierarchial structure of their own guild they put them-selves clearly on top. But it is equally true that they did not follow the Italian Renaissance model of the artist-engineer. He had received a new professional status in society through a relationship with both established literary tradi-tions and established scientific ones, namely, with the so-called classical (mathematical) science—astronomy, harmonics, mathematics, optics, and statistics. Italian artists emerged from the world of craft and artisans by contributing their mathematical expertise to the needs of society. War ma-chinery, fortifications, water supplies—all of these came within their purview and also significantly shaped their pictorial worlds. By contrast, if we want to consider the relationship of the Dutch arts to human knowledge, the project of the Baconian histories is instructive. The Baconian program sug-gests that the artist's own craft, like those crafts that occupied them within their pictures, was itself considered at the time to constitute a significant form of acquiring knowledge. The distinction between the two forms of knowledge parallels the distinction between two modes of seventeenth-century scientific thought as it has recently been articulated anew by Thomas Kuhn. As I suggested at the conclusion of my introductory discussion of Constantijn Huygens, the nonmathematical, observational bias of the Baconian project, with its lack of ancient precedent, corresponds to the model of Dutch art; the mathematical, less empirical, and ancient bias of the classical sciences fits Italian art.[51] The comparison between a science based on observation and one based on mathematics, like the comparison between the art of the north and that of the south, has not been treated as a comparison of equals. A sense of the inferiority of observation and experiment has persisted. An anecdote about the teaching of botany at the Jardin du Roi in France in 1770 is relevant. It tells of the conflict between the professor who lectured and the *demon-strateur* who followed him with appropriate experiments. The inferior *dem-*

onstrateur introduces his demonstration by declaring that all that the professor has just said is ridiculous. The eye, he claims, is proof against the word.[52] There is also, not unexpectedly, a gender aspect to the differences between the genres of science. Goethe concluded his *Theory of Colours* by pointing out, as experimentalists long had, that accidents or momentary observations could lead to discoveries. But his tone is condescending:

> Hence no one perhaps ought to be reluctant to offer his contributions. . . . All who are endowed only with habits of attention, women, children, are capable of communicating striking and true remarks.[53]

The marginality of those groups of people whom Goethe designates as observers is consistent with the Italian sense of the inferior nature of an observational art like that of the Dutch.

It is true that historians of science disagree over the ability and significance of the Baconian project and especially about whether it could proceed without an admixture of the alternative "classical" tradition. But these issues (which find analogies in discussions of Dutch and Italian art) need not be resolved to recognize the fruitfulness of a comparison between modes of art and modes of science at the time. It allows us to value more justly the established alliance of the Dutch artist with those craftsmen—goldsmiths, tapestry weavers, glassblowers, and geographers—whose products became the crafted objects in their representations.[54]

It is time that we turned from such general points to a specific artistic example: a still life by David Bailly, an exemplary work made in mid-century Leiden, provides extraordinary testimony to the Dutch painters' embrace of craft (fig. 57; pl. 1).[55] A young artist, identified as such by the maulstick resting in his hand, sits beside a table on which is strewn a crowded offering of objects. We can call it an assemblage of materials made by nature and worked by man. It is a catalogue: wood, paper, glass, metals, stone, plaster, clay, bone, hide, earthenware, pearls, petals, water, smoke, and paint. What is more, these are materials worked to reveal or, in Bacon's terms, to betray their nature: wood is shaped, paper curled, stone is carved, pearls polished and strung, cloth is draped, hides (as vellum) are treated to provide smooth cover for a book. Several materials betray their multiple natures: glass is solid and shaped, as in the overturned goblet, but it can contain liquid or sand and it reflects light even as it offers us a view through its transparent surface; metal is imprinted in coins, fashioned into links of chain, sharpened to form a knife blade, turned to a candlestick, or molded into the sprightly putto supporting the glass holder at the far right. Such fashionings fulfill Baconian ambitions. They squeeze and mold nature in order to reveal her. This for Bacon was a working definition of art or of craft:

> Seeing that the nature of things betrays itself more readily under the vexations of art than in its natural freedom.[56]

Bacon's is a modest, one might even say a utilitarian view of art. But it does make art essential to an understanding of the world. Art does not simply

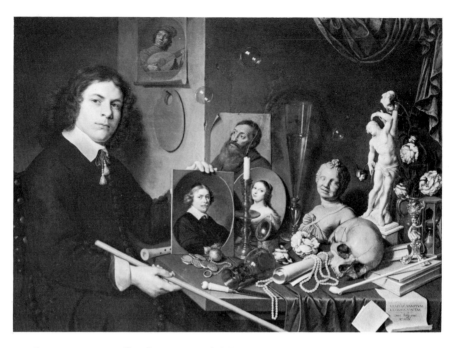

57. DAVID BAILLY, *Still Life*, 1651. Stedelijk Museum "de Lakenhal," Leiden.

imitate nature, nor is it a play of the imagination, but rather it is the *technē*
or craft that enables us, through constraint, to grasp nature. Man, humbled,
made equal and childlike through the purgation of the idols of understanding,
it at once the servant and the interpreter of nature and the prophet of a
technology that will bring mastery. In a subtle yet powerful instrumental
manner, art can lead to a new kind of knowledge of the world. Like the
Baconian program, Bailly's pictorial assemblage resists summation or closure.
Crafted objects themselves are subject to replication: the string of pearls
discarded on the table reappears around the painted woman's neck; the gath-
ered drapery of her painted dress is sculpted in stone at the breast of the bust
beside her and also hangs over head in a swatch that frames our view; the
leaves and petals of the rose are wrought in the metal of a tiny box. Such
transformations also work through corresponding shapes: the painted lute is
hung above an empty palette whose oval shape mimics it only to be repeated
in the pair of portraits on the table and the cover of the small box. Colors also
correspond: a subtle gradation of tans relates the sculpted body of Sebastian,
the skull, and the vellum of the book; the youthful bust is gray as is the female
face faintly visible on the wall, and both are played off against the ruddy flesh
tones of the young artist and the portrait. Set off against bodies of plaster,
stone, and metal, the bony skull, and the images in paint, Bailly (for the man
in the oval portrait is the painter himself) and the attendant youth appear as
living flesh. But as we withdraw from this painted world we must acknowl-
edge that the youth, though realer again than the portraits, is himself an image
fashioned out of paint. X-rays reveal that in this picture Bailly laid painted

forms upon completed ones beneath: the shadow visage on the wall and the portraits placed before it were in turn fully executed before further objects were placed over them. The layered design of the picture thus expresses or mimics the manner of its execution or craft. Bailly shows us art emerging into crafted objects from the shadowy female face against the wall. (Is this perhaps a reference to one version of the origin of painting as found in Pliny?)

By all these intricate devices, Bailly calls attention to various dimensions of craft and produces a dazzling mixture of making and deceit. His work could serve as an illustration of the definition of craft given by John Moxon in *The Mechanical Exercises* of 1677, his pioneering handbook on trades:

> Handycraft signifies Cunning or sleight or Craft of the Hand which cannot be taught by words, but it is only gained by Practice or Exercise.[57]

Moxon's book is famous for offering the first account of the printer's trade, but it contains much more. Characteristically, he includes a number of trades in what he calls the "Doctrine of Handycrafts": smithing, founding, drawing, joinery, turning, engraving, printing books and pictures, globe- and map-making, mathematical instruments, and so on. But it is his quite casual linking of craft to deceit that calls to mind Bailly's *Still Life*.[58] It is a nexus that is fully explored by seventeenth-century painters. Bailly's painting belongs in the company of the other great seventeenth-century pictorial meditations on the relationship of craft and art, picture-making and deceit: Velázquez's *Water-seller*, his *Spinners* and *Las Meninas*, Vermeer's *Art of Painting*, and even Dou's *Quack*. Rather than calling such works pictorial meditations, we should follow Bacon's lead and call them pictorial experiments. Let us see why.

"I admit nothing," Bacon writes at one point in the *Great Instauration*, "but on the faith of the eyes."[59] But for all his trusting to the eyes, he suspects the failure of the senses. The eyes can give no information (if trained on things too small) or they can give false information (since man is not the measure of the universe).[60] The solution Bacon recommends is to employ experiments. The study of Nature squeezed or pressed, the vexations of art, are what he means by experiments. There is a double thrust to this argument, relating as it does to both nature observed and back to the observer: on the one hand nature is vexed and thus better reveals itself, on the other hand the vexing of nature helps or assists man's imperfect senses. It is puzzling, perhaps, that weaving, dyeing, glassmaking, bread-baking, and painting are considered experimental. The problem is one of definition. Recent studies have reminded us that in the sixteenth and seventeenth centuries *experiment* was not intended in the sense that we think of it today—as a conscious attempt to test a particular theory or hypothesis by devising specific experimental or observational situation. It was rather synonymous with the notion of experience.[61] Its aim was not thought, but accurate circumstantial reporting. By experiment, then, Bacon means experiential observation of situations deliberately sought by the investigator as a source of experience. There is an important

sense in which all the mechanical human arts are experimental. They vex nature and, through substitution and rectification (to use Bacon's words), distance the world from the confusions of our senses.

Bacon's treatment of the human arts serves remarkably well as a definition of Dutch pictorial art. This is despite the fact that Bacon does not of course refer to art in the specific sense of painting. But in the world of Dutch pictures, rather than claiming that the notion of experiment is indistinguishable from experience, one would rather want to say that human experience is dealt with in terms of pictorial experiments. What this means will become clear if we now consider the manner in which David Bailly inserts himself and his life into the objects of his still life.

Bailly painted his *Still Life* in 1651 when he was already sixty-seven, and shortly after he rose to become dean of the newly extablished guild of Saint Luke in Leiden. The work is a celebration of the artist's craft while also serving as a personal memorial and a legacy. It is possible that Bailly suffered a serious illness at about the time he painted this work. He is unaccountably marked "dead" in the guild records, though he was to live until 1657. It is appropriate to call the picture a memorial because instead of producing a self-portrait at his easel—a common Dutch format—Bailly introduces himself in the form of a portrait. He is one representation among others. The crafting of art and of self is presented as a seamless whole. (We should keep this model in mind later when we look at Vermeer's *Art of Painting* [pl. 2]. Instead of doing a traditional portrait of himself at work, or including himself in the form of a portrait, Vermeer disappears into the very act of observing and painting. It is another way of absorbing the artist into his art.) Bailly's life and work are assembled in the objects on and around this table: the status of the youth and, indeed, the format of the still life with human actor (a format common in Antwerp) recalls his family's roots; the copy of a Venetian statue of Saint Sebastian recalls his Italian journey; the central rose, rolled paper, female portrait, the copy after Hals's *Lute-player*, the hourglass and skull were all objects previously crafted by Bailly for earlier works and represented here. Other objects as well might have ties to the artist's life. Bailly married at a late age, remained childless, and seems to have intended this work as a legacy to a student. He puts himself and his art into the hands of the youth of serious demeanor—a younger artist, it has been suggested—who supports Bailly's portrait with one hand while taking up the maulstick with the other. X-rays show that the maulstick was once pointing in the direction of the woman who is now but a dim shadow on the wall. The comparison that has been suggested with Sadeler's engraving after Spranger's tribute to his dead wife (fig. 58) confirms the memorial aspect of Bailly's work, but serves to bring out the tremendous difference between artistic modes.[62] The Spranger is a work that engages a richly inventive allegorical mode, while Bailly's is one that instead displays craft.

It is time that we dealt with an insistent feature of this work: the traditional reference made by almost every object (candle, bubbles, hourglass, skull,

58. Aegidius Sadeler, after BARTHOLOMÄUS SPRANGER, *Memorial to the Wife of Bartholomäus Spranger* (engraving), 1600. Kupferstichkabinett, Staatliche Museen Preussischer Kulturbesitz, Berlin (West).

jewels, coins, books) and the inscription at the lower right to vanity and hence to the transience of all human endeavor and particularly of life itself. Bailly's work is not unusual in this respect, and the theme is particularly relevant because of the central place given to the painter's own image. But the brilliance of the execution puts a common doubleness—the presentation of craft and its simultaneous undermining—into sharp relief. Despite the multiple references to mortality, neither revulsion nor despair intrudes upon this devoted display of the fruits of art. Far from condemning the pleasures offered by the practice of such craft—or, in the Horatian version of this theme favored by students of the arts, far from seeking to delight us with pleasures in order to teach or preach against them—images such as these instead offer us a mode through which to enjoy craft to the fullest. Acknowledging the fragility of his enterprise, the artist fully, steadily, and with loving care undertakes a version of Baconian experiments or what we have called experiential observation.

Once again English words and practice can help us to understand the pictures of the Dutch. Let us turn once more to Thomas Sprat, who addresses the problem of the legitimacy granted to experiments in a long passage of his history of the Royal Society. In a section entitled "Experiments useful for the cure of men's minds," Sprat writes:

What raptures can the most *voluptuous* men fancy to which these are not equal? Can they relish nothing but the *pleasures* of their *senses* ? They may here enjoy them without guilt or remors. . . . What *ambitious disquiets* can torment that man, who has so much glory before him, for which there are only requir'd the delightful *Works* of his *hands?* What dark, or melancholy passions can overshadow his *heart,* whose *senses* are always full of so many various *productions,* of which the least progress, and *success,* will affect him with an *innocent joy?* What anger, envy, hatred, or revenge can long torment his breast, whome not only the greatest and noblest objects, but every sand, every pible, every grass, every earth, every fly can divert?[63]

What agitates and excites Sprat is revealing. Experiments, he claims, offer raptures and sensuous pleasures without guilt or remorse. In the face of such delight in the pleasures of the senses and in handiwork, all evil passions can be dispelled. In the course of the argument, Sprat offers the industry of experiments as an antidote to idleness and vanity. But his logic is less important to us than the issue he raises: the competing claims of the passions that pull us between savoring pleasure and attendant guilt. This arena into which Sprat rushes with such verbal gusto is also the subject of Bailly's fine brush. And in each instance the devotion to experiments offers at least a temporary respite from conflict. God is never far from Sprat's mind in his overall defense of experimental learning. He invokes Him not as a guardian of behavior but, in a standard argument for the pursuit of natural knowledge at the time, as creator of the world:

> What anger, envy, hatred, or revenge can long torment his breast, whome not only the greatest, and noblest objects, but every sand, every pible, every grass, every earth, every fly can divert?

Sprat here implicitly locates God in the details of His creation. Experiment with those details is thus grounded in creation itself.

I hope that with the picture before us and Sprat's text at our side we can dispel the notion that Bailly's painting is intended as a doctrinal assault on human pleasures in general and on the pleasures of craft in particular. Yet it would surely be wrong to dispose in this way of the entire issue of mortality and transience that is raised by the painting. From the rendering of each object up to the ordering of the whole, Bailly keeps before our eyes the fact that this is but a picture—therein lies the ultimate fragility and transience. In a haunting way Bailly's art seems to vie with the very fragility that it courts and admits. The consummation of his art produces bubbles, but bubbles so crafted that they will never burst. Transience is invoked less by the presence of emblems of vanity than by their status as crafted representations. Art is thus not challenged by a moral view, but lies at the very heart of that view.

In saying this I am not making a modernist claim but one very much of the seventeenth century. We can see Bailly's *Still Life* as the pictorial version of a subtle yet powerful formulation of Bacon's. Let us consider the following passage about the accumulation of natural histories:

> But I contrive that the office of the sense shall be only to judge of the experiment, and that the experiment itself shall judge of the thing.[64]

Bacon is describing the mediating role of experiment: it is the link through which we are enabled to grasp and thus understand nature. If we replace the word experiment with "picture" or "representation" we find ourselves in familiar territory:

> I contrive the office of the sense shall be only to judge of the picture and that the picture itself shall judge of the thing.

We are back to the image on Kepler's retina, or Comenius's words, which like Dutch paintings themselves are located at that place where the world and human crafting of it meet. This conjunction defines representation, which is credited with giving us the capacity to comprehend the world.

Bacon's definition of art among the human arts gives an account of making consonant with the nature of the picture that we have been exploring. It is less valuable as a definition of art than as a program for art as the production of basic knowledge of the world. Although Bacon's somewhat hectoring and repetitious definitions are a far cry from the intimate views given us in Dutch paintings, his program for texts on natural history shares certain basic things with them. Bacon too manifests an intense interest in the minutiae of the world. This is combined with an anonymity or coolness (it is as if no human passions but only the love of truth led him on) that is also characteristic of the Dutch. The world is stilled, as in Dutch paintings, to be subjected to observation. Detailed descriptions, compiled almost without end and fitted into the table, displace time, since each observation is separate from the next. Indeed, despite its title, or, provocatively, in the very face of its title, Bacon's natural history displaces history—at least that history of civil life which admits human activites and time and depends on interpretation. It is, like the Dutch art with which we have linked it, description, not narration.

<div align="center">IV</div>

Bacon concluded his *Parasceve* with a note in which he said: "I care little about the mechanical arts themselves: only about those things which they contribute to the equipment of philosophy."[65] He was aware of the conflicting interests that adhered to the studies he proposed. To take two of his examples: the fact that meat must be salted earlier in winter than in summer is important for the cook's knowledge of pickling, but it is also important for a knowledge of coldness and its effect; and though the red appearance of a cooked crab is of no culinary interest, it is of great interest to a student of redness.[66] Bacon urges on us that the perfection of art—in this case the art of cookery—should not displace larger philosophical concerns such as the study of coldness or redness. But, indeed, the future of the project lay in just what he did not wish for it. A practical interest in trades, their products, and the related improvement of society was soon to replace Bacon's philosophical ambitions.

Petty's *The Advice of W.P.* of 1647 was one of the first statements in which the natural history of the mechanical arts was casually referred to as the history of trades—the phrase that was to become the common one. The project was taken up by John Evelyn, who in the 1650s embarked on the modern version of Bacon's project. In time this was institutionalized in the proceedings and publications of the Royal Society for the Improving of Natural Knowledge, one of whose stated aims was to reach an audience of tradesmen, who through the work of the Society would improve their products. It was Hooke, a Baconian of the second generation, who articulated this in the introduction to his *Micrographia* of 1655: "They do not wholly reject experiments . . . but they principally aim at such, whose Applications will improve and facilitate the present way of Manual Arts." Indeed, Sprat in his *History* feels that he has to argue once more for the value of experiments that do not bring immediate gain.[67]

It is curious for a student of the history of art to find that John Evelyn, whose *Sculptura* is a basic text for our knowledge of engraving at the time, produced his work out of a practical impulse. Far from entertaining a specific interest in the fine arts, Evelyn was engaged in a general project (for which he himself drew up a never realized plan) of a history of trades.[68] The three treatises that he did publish—the *Sculptura* of 1662, on engraving and etching, the *Sylva or Discourse of Forest Trees* of 1664 on gardening, and the translation of Fréart de Chambray's *Parallel of Ancient Architecture with Modern* on building—study three trades listed by Bacon. As it happens they correspond to the three instances of human craft included by Comenius in his *Opera Didactica*. Engraving and architecture are presented under the same rubric with gardening, and if we look further into the papers of the Society we find that these are joined by Evelyn's *Panificium* —or the Several Manners of Making Bread in France. An American who cooked through the 1970s, educated to it by Julia Child, would hardly be surprised by such a study. But it is perhaps surprising to discover that making bread in the French manner is considered basic to human understanding and to the well-being of society. Yet from engraving to bread, from glassmaking to oyster breeding to trying to make wine from sugar cane, the Sprat *History of the Society* turns to studies that are supported more, it would seem, for the good life than for good thoughts.[69]

Evelyn admires and encourages attempts that were made to extend such projects into one's life. In a prefatory essay to his *Sculptura* entitled "An Account of Signor Favi," he praises a new conception of the Grand Tour: an Italian made it his purpose to produce a cycle and history of trades as a result of his travels. It would surely be worthwhile to consider the reports of travelers such as Evelyn or the Frenchman Monconys (known primarily to art historians because of his visit to Vermeer) not simply as eyewitness journals of life abroad but in the context of knowledge as it was conceived, gathered, and codified at the time. Glass tears, the studios of Vermeer and Mieris, a collection of lenses, the pendulum, some beautiful shells and fine Arab

books—all these follow one another in quick succession as undifferentiated, valuable experiences in Monconys's account. The nature of this apparent jumble is clearer in the context of the concerns and categories of Baconian projects. In travelers' reports of the Netherlands, the particular riches of the individual collections merge with praise of Amsterdam as the center of world trade. The history of encyclopedic collections such as the *Kunstkammer* of Rudolf II have recently received a good deal of attention. Such princely collections, organized according to categories of nature and art and demonstrating a concern with artifice, have been shown to be antecedents of seventeenth-century Dutch collections. But it is clear that there are significant changes by the mid-seventeenth century. A major change, and one of interest to us here, is that the products of both nature and man once assembled to celebrate the glory and power of a monarch like Rudolf are now the possession, and decorate the lives and households, of the Dutch merchants.[70] We are no longer dealing with individual emissaries sent out to collect rarities for an emperor, but with the world of trade in Amsterdam. Bacon's project had been in some sense suspended or poised between the intellectual schemes of the sixteenth century and the technology and possessions of the seventeenth. In Holland, as with the second generation Baconians of the Royal Society, the intellectual ambitions of Bacon are transformed into commercial ventures. Craft is practiced less for knowledge than for possession. While the Royal Society planned and executed studies, the Dutch, it would appear, literally delivered the goods. They exceed us in riches and traffic, writes Sprat, and he considers this economic advantage a demonstration of what can result from following the Baconian program. Amsterdam as the queen of trade was at the center of the Dutch view of themselves. It was trade that was celebrated on the pedimentary sculpture of the new Town Hall, begun in 1648 after the signing of the Treat of Münster. Ports are, of course, normally celebrated in such terms—witness Rubens's despair about Antwerp's loss of trade in the designs for his 1635 entry of the archduke Ferdinand. This explains the illustrated frontispiece to Zesen's *Amsterdam,* which shows goods being brought from everywhere to the city, and it explains the title of the 1664 publication *Amsterdam: World Famous Commercial Center.*[71] The Dutch are celebrated as merchants and Amsterdam as the greatest trading center in the world. Perhaps no one put it better than Diderot in the account he wrote of his trip through Holland in 1772:

> The Dutch are human ants; they spread over all the regions of the earth, gather up everything they find that is scarce, useful, or precious, and carry it back to their storehouses. It is to Holland that the rest of Europe goes for everything it lacks. Holland is Europe's commercial hub. The Dutch have worked to such good purpose that, through their ingenuity, they have obtained all of life's necessities, in defiance of the elements. Wherever one goes in that country, one sees art grappling with nature, and always winning. There, wealth is without vanity, liberty is without insolence, levies are without vexation, and taxation is without misery.

[Les Hollandais sont des hommes-fourmis, qui se répandent sur toutes les contrées de la terre, ramassent tout ce qu'elles trouvent de rare, d'utile, de précieux, et le portent dans leurs magasins. C'est en Hollande qui le reste de l'Europe va chercher tout ce qui lui manque. La Hollande est la bourse commune de l'Europe. Les Hollandais ont tant fair par leur industrie, qu'ils en ont obtenu tout ce qu'exigent les besoins de la vie, et cela en dépit des quatre élémens. C'est là qu'on voit à chacque pas l'art aux prises avec la nature, et l'art toujours victorieux. La richesse y est sans vanité, la liberté sans insolence, la maltote sans vexation, et l'impôt sans misère.][72]

Where does the Dutch artist fit into this? My answers to this question are tentative ones. They are suggestions about the ways in which we might look at Dutch painting based on the connections between the crafting of nature, language, the trades, and images that we have been considering. The evidence is that in most towns the Dutch painter entered the seventeenth century institutionally bound to the other craftsmen in the craft guild of Saint Luke. The list of crafts involved in the Delft guild in 1611 gives us a sample of such a grouping: "all those earning their living here with the art of painting be it with the fine brushes or otherwise in oil or water colors, glassmakers, glass sellers, faïenciers, tapestry-makers, embroiderers, engravers, sculptors, working in wood or stone, scabbard makers, art printers, book sellers, sellers of prints or paintings."[73]

The Delft guild is, it is true, one of the few to survive so long. But it is remarkable that with the exception of the defunct scabbard-makers the group of craftsmen in the Delft guild of Saint Luke remained unchanged from 1550 to 1750. Various arguments have been put forth showing that the painters' identification with other craftsmen, rather than with a literate elite and a related elevated notion of art, characterizes them as well as the nature of their art through the seventeenth century.[74] Evidence to support this view has been adduced from the painters' membership in craft guilds, the low price paid for their products, their parentage, and their professional attitudes. To take the last two: artists were frequently sons of craftsmen. Jacob Ruisdael was the son of a frame-maker, Miereveld the son of a goldsmith, Ostade's father was a weaver, and Dou's a glassmaker and engraver. Being an artist was clearly a craft, not a calling in this society. Artists gave it up when better money was to be had by other means: the portrait painter Bol was one of a number of artists who stopped painting when he made a good marriage, and Hobbema, the landscape artist, stopped when he was installed as a city wine gauger.

Yet there is much evidence that the Dutch painters did distinguish themselves from other craftsmen in the course of the century. I have in mind the fact that they did so many self-portraits, some very elegant indeed, and that they struggled to change their guilds. At present the issue is dealt with in polarized terms: an Italian or academic notion of Dutch art coming of age in Europe is posited against an older and persistent northern craft tradition. But the issue is less clear-cut than this. The question would seem to be, Did the Dutch artists distinguish themselves *from* or *among* other craftsmen, and

what pictorial form did such a distinction take? Though there is no simple, all-inclusive answer to these questions, it seems that craft ties bind even as the artists insist on their own identity. There is, for example, a history of separatism—artists breaking away from the other craftsmen in the guild of Saint Luke. This happens in a group of Dutch cities around the time of the 1609 truce with Spain and again later with the formation of an association like Pictura in the Hague. We must, however, try to understand the reasons for such separatism. While the Pictura group seems to have had something to do with artistic ideals, the issue at the time of the truce was protectionism rather than the definition of art. The artists wanted to defend their market against the influx of foreign artists who were free to enter at the end of hostilities. The artists, in other words, continued to hold a guild notion; but they wanted to make themselves special in it.

Haarlem is an interesting case in point of the persisting links of artists with other craftsmen.[75] There, in 1631, certain artists pushed for innovations in the training of the artist that involved what have been termed "academic" assumptions about art. But even while doing this these artists insisted on remaining in the same guild with all the other craftsmen, objecting hotly when the goldsmiths and silversmiths decided to withdraw. The reform was pushed through by the sometime history painter Salomon de Bray, but it was attended to by the landscape painter Pieter de Molyn, the portrait painter Hendrik Pot, and still-life painter Willem Claesz. Heda, and by Pieter Saenredam, who helped with the remodeling of their quarters. The works of these artists do not offer much testimony to a general reform in pictorial practice. The articles of reform propose sessions in drawing and in anatomy, but they also reveal concerns that are still deeply imbedded in the established traditions that they nominally want to reform. It has been a leitmotiv of this study that given the conditions under which Dutch art was produced—an indigenous pictorial tradition matched to a foreign rhetorical tradition about art and its nature—we must be careful to consider the nature of the art separately from the claims made on its behalf. A major concern in Haarlem seems to have been the precise ordering of the various craft groups within the guild. This comes out in the new regulations about who properly offers prayers for whom on the occasion of members' funerals (complete with a schedule of fines for failing to perform), but also in the attention to the designing (by none other than De Bray himself) of new coats of arms and funerary cloths for various groups. It will not do to dismiss all of this as petty in contrast to the innovative proposals about artistic training, nor to ignore the evidence that the installation of a bust of Michelangelo (a tribute to high art) is all mixed up with the arrangements for a table for the secretary and eight fine chairs (the low). Indeed, we read that the access to the new guild quarters in the Pand (the building housing all the guilds of Haarlem) was gained by "climbing the stairs of the library above the fencing school and to the east of the attic above the breadweighers' room." Doctors, smiths, bakers, masons, beer transporters, and linen merchants were all housed together with the painters. We

have a sense of the kind of company painters still felt it comfortable to keep.

If we are to understand the relationship of the Dutch artist to the craft tradition, we might begin by considering the sense in which, far from repudiating it, the artist of the seventeenth century achieved what he did by asserting himself as the prime craftsman of all. I would argue this despite the support given even by Dutch texts for a more elevated art. My evidence is the kind of accomplishment Dutch images display. This analysis fits various aspects of the artistic scene quite well: first, there is the striking fact that painters working at mid-century—Dou, Mieris, Metsu, Kalf, Ter Borch, Vermeer, and even Ostade (whose peasants get neater in dress and more finely rendered)—all show an increased rather than a decreased attention to the crafted surface of their representations. The high finish and detailed rendering associated with the growing distinction between the *kladschilder* (rough painter) and the *fijnschilder* is a common feature of mid-century painting in Holland. [76] Cost was often calculated according to finish: time was devoted to execution, not to invention. It is the man-hours it takes to do it (not unlike the work of some New Realists today) that contributes to the great rise in the price of individual paintings. In their concentration on rendering crafted stuffs—the silks of Ter Borch, the tapestries and spinets of Dou, Metsu, Mieris, even bread in the case of Vermeer—these artists are clearly asserting their prowess as the supreme craftsmen of all they represent. The tapestry the weaver weaves, the glass the glassblower blows, the tiles of the tile maker, even the baker's bread—all this they can capture and reproduce in paint. The display of virtuosity so often found in these Dutch painters is a display of representational craft.

The positive nature of the artist's relationship to the established craft traditions and to their own traditions explains why Jan Vermeer, the greatest Dutch artist of the second half of the century, flourished in a city that boasted a tradition of fine craftsmanship as well as the most conservative guild structure. At mid-century, when all of this conscious crafting is going on in pictures, there is no evidence of any particularly new regard for the craftsman as such in Holland. There is no body of texts like that coming out of the Royal Society in England that praises craftsmanship and that encourages people to engage in it. (It is, of course, a theme of this chapter that the English had such texts, but they did not have the craftsmen.) It was the buyer, the possessor, and the goods possessed, not craft or production, that were important in the Netherlands. [77] In Delft, for example, the evidence is that craft becomes reconfirmed in painting even as there is a weakening of respect or interest in the craft traditions that we would today call the minor arts. In an industry like tile-making, production techniques were developed to cut cost, emphasizing speed at the expense of craft. The quality of tiles therefore noticeably declines. The painters seem more and more to mediate. It is they who now provide the designs for the other craftsmen as they did not in the previous century. [78] If we want to delight in finely crafted tiles, we look at them as they are represented in a painting by Vermeer. In taking on the responsibility for craft, the

59. WILLEM KALF, *Still Life with a Nautilus Goblet*. Thyssen-Bornemisza Collection, Lugano.

painters also increasingly become the purveyors of luxury goods to the rich. They claim what are complained about at the time as outrageously high prices for their works, prices they justify on the basis of the long hours spent on their execution. Six hundred guilders were asked for a single work by Dou or Vermeer, while cheap paintings were had in the past for well under ten. One could say that the concern with craft is thematized in the objects they choose to depict as well as in the manner in which they depict them. The objects in still lifes done by Kalf in Amsterdam in the 1650s and 1660s are often identifiable rarities—collectible pieces of great value (fig. 59).[79]

We have strayed far from the subject of Bacon, but not far from the problems he raises. How does one measure the relationship between the valuing of craft and its collection? Or between the aim of gaining knowledge and that of gaining possession? The problems raised in the texts of the Royal Society are displayed in the collectibles of the Dutch—perhaps nowhere more poignantly than in their paintings. And to say this leads us to a final point. There is a problematic aspect to the painter's relationship to a craft tradition that we touched on in our discussion of Bailly. The painter does not really weave tapestries, blow glass, work gold, or bake bread. He feigns all these things in paint. This is a source of pride, but it is also a source of a certain unease.

Dutch painters acknowledge this in various ways. Gerard Dou, in what is his largest and arguably his most ambitious painting, depicts himself as a painter, palette in hand, standing beside a quack who is hawking his false wares to a crowd (fig. 60). It has been shown that a number of the people and objects assembled around the quack are re-presentations of pictured proverbs or maxims commonly found in Dutch books at the time.[80] Dou culled and assembled a group of pictorial quotations with meanings roughly as follows: the seal hanging from a document on the quack's table says "what is sealed is true"; the mother wiping her child's behind, "life is but stink and shit"; and the mother in her role as pancake-seller, "the seller's prattle is meaningless, immoral talk"; the child vainly trying to trap a bird parallels the vain search for gold; and the two trees, one bare and one in bloom, the anguish of choice. In Dou's hands, the quack's performance becomes a pictorial occasion. But what kind of occasion and what kind of picture is this? The tone is witty and light. The execution is crisp and clear, making everything remarkably present to the eyes. The organization is that of an apparently casual assemblage of individual motifs. In the face of all this, the current argument for the picture as a doctrinal depiction of Aristotelian modes of living—the sensual quack versus the active farmer and the contemplative artist—is unpersuasive. Though it engages moral issues, the work is descriptive, not prescriptive. Dou's visual attentiveness to the individual maxims is the perfect counterpart to Beeckman's verbal attentiveness to proverbs, which we touched on earlier. Human nature is treated as something visible. And Dou's characteristic way of assembling instances of human behavior has a decidedly Baconian flavor, which we can call taxonomic. Each person does, or in the case of objects *is*, his own thing without any acknowledgment of his presence or, one might say, his narrative effect in the world. "People want to be deceived." As others have done, we might well apply this motto from a contemporary Dutch engraving of a quack to this picture. But if we do, a strange thing happens: Are we and is the artist himself not also party to deception? It is not clear from Dou's image than anyone is exempt. Leaning out his window, in the shadow of the quack, Dou catches the viewer's eye with his own. The picture alerts us not only to the duplicity of the quack but also to the painterly one. It is another case of the Dutch artist absorbed into his painted world. The canvas

60. GERARD DOU, *The Quack*, 1652. Museum Boymans-van Beuningen, Rotterdam.

61. JAN VERMEER, *Woman Playing a Guitar.* Courtesy of the Greater London Council as Trustees of the Iveagh Bequest, Kenwood.

is a mock-up of the world. Far from disowning it, Dou, in a kind of low and comic analogue to the high claims made by Velázquez in his *Las Meninas,* implicates himself and his making in it.

Dou does not question all that we see, he rather alerts us to its circumstances. His dust-free surfaces, most likely worked with the help of a lens and once covered, in many cases, by a protective panel, make the claim that beguiling surface is the stuff of which art and life are both made. Later, in the works of Kalf or Vermeer, this claim is lodged in the very handling of the paint (fig. 59). Kalf's mature works feature the finest and most precious objects of both foreign and native hands—finely wrought silver and gold, rare carpets, splendidly wrought nautilus shells, elegant glass of the Venetian type, chosen fruits, porcelain from the Orient. All of these objects catch beams of light cast from an undisclosed source, which make them if anything more beautiful in art than in life. Placed against a darkened background at the edge of a table of rare marble, the objects are in some sense creatures of light and of paint. But for the light they would not be visible at all. Looking through Kalf's lenses we see paint. The globules of paint that articulate the skin of the lemon or the shimmer of a glass are plainly visible to the eye. Even while celebrating possession, such works reveal that what we possess is crafted out of paint. This is not a modernist strategy that admits to and even makes a virtue out of the handling of paint. When Vermeer makes this admission (fig. 61) in the awkward, lozenge-like brushstrokes that destroy the looks and spoil the illusion of his last works, it marks the end of an old kind of painting, not the beginning of the new.

4

The Mapping Impulse
in Dutch Art

The two previous chapters have proceeded on the border line between art and its models (to put it strongly) or art and its analogies (to put it in a weaker form). We considered those models that seem relevant to the making, viewing, and understanding of images in seventeenth-century Holland. In addition to the visual self-consciousness shared with Kepler's study of the eye and the craft concerns shared with Hooke, Bacon, and Comenius, I want to consider now what I call the mapping impulse. Our starting place is the observation that there was perhaps at no other time or place such a coincidence between mapping and picturing. Given what we have found previously, it should come as no surprise that the basis of this coincidence is a common notion of knowledge and the belief that it is to be gained and asserted through pictures. But the congruity between pictures and maps does more than simply confirm what we have already seen. This time our model is itself an image. Those descriptive characteristics that we have so far reached by indirection—through analogies—we shall now be able to ground directly in the nature of attitudes toward, and the language applied to a particular kind of image.

I

Vermeer's *Art of Painting* (pl. 2), a work that illuminates the resemblance between pictures and maps, is a promising place to begin. In size and theme this is a unique and ambitious work that draws our attention to a splendid representation of a map. We are looking into a painter's studio. The artist has started to render the leaves of the wreath on the head of a young woman, one of Vermeer's familiar models, who here represents, so we have been told, Clio, the muse of history bedecked with her emblematic accoutrements as described by Ripa. The great map (fig. 62), hung so as to fill the back wall before which Vermeer has situated painter and model, has not gone unnoticed by art historians. It has been plumbed for its moral meanings: its presence interpreted as an image of human vanity, a literal rendering of worldly con-

62. Jan Vermeer, *The Art of Painting,* detail (map). Kunsthistorisches Museum, Vienna.

cerns; and its depiction of the northern and southern Netherlands interpreted as an image of a lost past when all the provinces were one country (a historical dimension borne out perhaps by the painter's old-fashioned dress and the Hapsburg eagles on the chandelier). Most recently the scrupulously careful rendering has enabled the map to be identified as a particular one preserved today in only a single copy in Paris. Seen this way, Vermeer's map, inadvertently, is a source for our knowledge of cartographic history.[1]

But these interpretations all overlook the obvious claim that the map makes on us as a piece of painting in its own right. There are, of course, many pictures of the time that remind us of the fact that the Dutch were the first who seriously produced maps as wall-hangings—this being only a part of the wide production, dissemination, and use of maps throughout the society. But nowhere else does a map have such a powerful pictorial presence. When compared with the maps in the works of other artists, Vermeer's maps might all be said to be distinctive. While Ochtervelt, for example (fig. 63), merely indicates that a map is on the wall, testified to by a faint outline on a tawny ground, Vermeer always suggests the material quality of varnished paper, paint, and something of the graphic means by which the land mass is set forth. It is hard to believe that the same map is represented by Ochtervelt and by Vermeer. Each of the maps in Vermeer's works can be precisely identified.

63. JACOB OCHTERVELT, *The Musicians.* Courtesy of the Art Institute of Chicago.

But the map in the *Art of Painting* is distinctive in other ways. It is the largest map and also the most complex assemblage of any in Vermeer's works. The Netherlands is at the edge of a ship-filled sea, framed by topographical views of her major cities, emblazoned with several cartouches, explained beneath by a text, and elegantly titled in clear letters set across its upper edge. (The orientation of printed maps was not yet fixed at the time, and the west coast rather than the northern border of Holland appears at the top of the map.) What is more, it is a map whose original combined the four kinds of printing

then available for use in maps—engraving, etching, woodcut, and moveable type for the letters. In size, scope, and graphic ambition it is a summa of the mapping art of the day, represented in paint by Vermeer.

And in this respect—as a representation—it is also different from other maps in Vermeer's paintings. In every other work by Vermeer where there is a map it is cut by the edge of the picture. But here we are meant to see it all because we are meant to see it in a different light. Although it is skimmed by a bit of the tapestry, and a small area is hidden by the chandelier, the entire extent of this huge map is made fully visible on the wall. Vermeer combines the richly painted surface of the map in his Frick painting with the weight of the varnished paper of the map behind the *Woman Reading a Letter* in Amsterdam to give this map an astonishing material presence. Other objects in the studio share this crafted presence—the tapestry, for example, with threads hanging loose from its back side. But the tapestry is located, as its position in the painting suggests, at the edge. It leads us in to the painting while the map is itself presented as a painting. (The red tip of the maulstick matches the red paint on the map—but then as if to caution us against making too much of the fact the artist's stockings share the shade.) Vermeer irrevocably binds the map to his art of painting by placing his name on it. *I Ver-Meer* (fig. 106) is inscribed in pale letters at the point where the map's inner border meets the blue cloth that stands out stiffly behind the model's neck. In no other painting does Vermeer claim that the map is of his own making. Vermeer's claim to the identity of mapmaker is powerfully confirmed elsewhere in his work. The only two male figures to whom he devoted entire paintings—the *Astronomer* in a private collection in Paris, and the *Geographer* in Frankfurt—were also by profession makers of maps and they encompassed the heavens and the earth between them.

The *Art of Painting* comes late in the day for Dutch painting and late in Vermeer's career. It stands as a kind of summary and assessment of what has been done. The poised yet intense relationship of man and woman, the conjunction of crafted surfaces, the domestic space—this is the stuff of Vermeer's art. But here it all has a paradigmatic status due not only to its historic title but to the formality of its presentation. If this map is presented like a painting, to what notion of painting does it correspond? Vermeer suggests an answer to this question in the form of the word *Descriptio* (fig. 64) prominently written on the upper border of the map just where it extends to the right of the chandelier over the easel. This was one of the most common terms used to designate the mapping enterprise. Mapmakers or publishers were referred to as "world describers" and their maps or atlases as the world described.[2] Though the term was never, as far as I know, applied to a painting, there is good reason to do so. The aim of Dutch painters was to capture on a surface a great range of knowledge and information about the world. They too employed words with their images. Like the mappers, they made additive works that could not be taken in from a single viewing point. Theirs was not a window on the Italian model of art but rather, like a map, a surface on which is laid out an assemblage of the world.

64. JAN VERMEER, *The Art of Painting*, detail (map). Kunsthistorisches Museum, Vienna.

65. JAN VERMEER, *View of Delft*.
Mauritshuis, The Hague.

But mapping is not only an analogue for the art of painting. It also suggested certain types of images and so engaged Dutch artists in certain tasks to be done. Vermeer confirms this kind of relationship between maps and pictures. Let us consider his *View of Delft* (fig. 65): a city is viewed as a profile, laid out on a surface seen across the water from a far shore with boats at anchor and small foreground figures. This was a common scheme invented for engraved topographical city views (fig. 95) in the sixteenth century. The *View of Delft* is an instance, the most brilliant of all, of the transformation

from map to paint that the mapping impulse engendered in Dutch art. And some years later in his *Art of Painting* Vermeer recapitulated the map-to-painting sequence, for the small but carefully executed city views (fig. 64) that border the map return his own *View of Delft* to its source. Vermeer puts the painted city view back into the mapping context from which it had emerged as if in acknowledgment of its nature.

Seen from our perspective, this mapping-picture relationship might seem unusual. In the study of images we are used to treating maps as one kind of a thing and pictures as something else. If we exclude the rare occasions when a landscape picture (fig. 66) is used to serve the mapping of a region—as when the U.S. Congress in the 1850's commissioned landscape lithographs of the West in preparation for choosing a route for the continental railroad—we can always tell maps and landscapes apart by their look.[3] Maps give us the measure of a place and the relationship between places, quantifiable data, while landscape pictures are evocative, and aim rather to give us some quality of a place or of the viewer's sense of it (fig. 67, 68). One is closer to science, the other is art. This general, though casually held view—casual because it does not normally seek out the possible philosophical grounding—is upheld professionally. Cartographers are clearly a group separate from artists even as students of cartography are separate from historians of art. Or at least that is how it was until recently. We are witnessing a certain weakening of these divisions and the attitudes that they represent. Art historians, less certain that they can stipulate which images count as art, are willing to include more kinds of human artifacts and makings in their field of study. A number have turned

66. John Mix Stanley, after RICHARD H. KERN, *View of Sangre de Cristo Pass* (lithograph), in *Reports of Explorations and Surveys to Ascertain the . . . Means for a Railroad from the Mississippi to the Pacific Ocean* (1853–54), vol. II, opp. p. 37. Courtesy, the Bancroft Library, Berkeley, California.

67. Map of the United States. © Rand McNally and Company, R.L. 82-S-32.

68. ALBERT BIERSTADT, *Yosemite Winter Scene*. University Art Museum, Berkeley, California. Gift of Henry D. Bacon.

69. JASPER JOHNS, *Map*, 1961. Collection, the Museum of Modern Art. Fractional gift of Mr. and Mrs. Robert C. Scull.

to maps.[4] Cartographers and geographers for their part, in keeping with a related intellectual revolution of our time, are newly conscious of the structure of maps and of their cognitive basis. A distinguished geographer put the change this way: while once it was said "that is not geography which cannot be mapped," now it is thought that "the geography of the land is in the last resort the geography of the mind."[5] Jasper Johns's *Map* (fig. 69) is a painter's version of this thought. Indeed, the meeting or at least approaching of the different fields is evident today in the work of a number of artists who are making maps.

Students of maps have never denied the artistic component of the maps themselves. It is a commonplace of cartographic literature that maps combine art and science, and the great age of Dutch seventeenth-century maps offers a prime example of this. This is illustrated in the cartouche pairing two female figures at the top left corner of the map represented in Vermeer's *Art of Painting* (fig. 70): one figure bears a cross-staff and compasses while the other has a palette, brush, and city view in hand. Decoration—whether in the form of cartouches and other materials such as portraits and city views or built into the use of a map as a domestic wall-hanging—is acknowledged and studied. "Decorative" maps constitute a specific body of cartographic material. But inevitably such decorative aspects or uses are considered to be secondary to the real (scientific) aims of mapmaking. There is assumed to be an inverse proportion between the amount of art displayed and the amount of information conveyed. Art and science, even when combined, are in some conflict. A recent and interesting study by a geographer of the historical links between cartography and art had this to say:

> Mapmaking as a form of decorative art belongs to the informal, pre-scientific phase of cartography. When cartographers had neither the geographical knowledge nor the cartographic skill to make accurate maps, fancy and artistry had free rein.[6]

There is of course some truth to this, but it is stated at the expense of understanding the prescientific cartography in its own appropriate terms, in the spirit in which it was done. While cartographers set aside the decorative or picturelike side of maps, art historians for their part have done the same with the documentary aspect of art. "Mere topography" (as contrasted with "mere decoration") is the term here. It is used by art historians to classify those landscape pictures or views that sacrifice art (or perhaps never rise to it) in the name of the recording of place. Cartographers and art historians have been in essential agreement in maintaining boundaries between maps and art, or between knowledge and decoration. They are boundaries that would have puzzled the Dutch. For at a time when maps were considered to be a kind of picture and when pictures challenged texts as a central way of understanding the world, the distinction was not firm. What should be of interest to students of maps and of pictures is not where the line was drawn between them, but precisely the nature of their overlap, the basis of their resemblance. Let us therefore consider the historical and pictorial conditions under which this mapping-picture relationship took place.

II

A great range of people took part in the explosion that geographical illustration underwent in the sixteenth century. A number of reasons can be given for the explosion—military operations and demand for news, trade, and water control among others. A general feature is the trust to maps as a form of knowledge and an interest in the particular kinds of knowledge to be gained

70. Map of the Seventeen Provinces, published by CLAES JANSZ. VISSCHER, detail. Courtesy of the Bibliothèque Nationale, Paris.

from maps. Mapping was a common, even a casually acquired skill at the time. Cornelis Drebbel, inventor and experimenter in natural knowledge, mapped his hometown of Alkmaar early in his career and Comenius is reputed to have made the first map of Bohemia before being forced to leave.[7] Each man made only a single map in a lifetime. It seems to have been an accepted way to pay one's respect to one's home while contributing to the knowledge of it.

I am understandably less concerned than a cartographic historian might be to distinguish between the act of surveying (which some draftsmen did themselves) and the act of drafting a map. For my aim is to call attention to the fact that mapping taken in its broad sense was a common pastime. On occasion it even offered the possibility of displacing deep human feelings onto the act of describing itself. So it was, for example, that early on the morning of 5 August 1676 just before, as we know from his diary, Constantijn Huygens the Younger was to start the search for the body of his great nephew, killed the day before in battle, he settled down with pen, ink, and paper to describe

the besieged city of Maastricht viewed across the river Meuse.[8] In the splendid drawing (fig. 71) that he made, Huygens dealt with human loss by turning to description, though we cannot with certainty call this drawing a commemoration.

It is often said that a fondness for topographical views and topographical details made maps more like what we think of as pictures. A horizon was not an uncommon thing on a map. But the connection is also demonstrated by the surprising number of northern artists who were engaged in some aspect of mapping. Pieter Pourbus (1510– 84), who eventually rose to become deacon of the guild of Saint Luke in Antwerp, was both a painter and a serious mapper who worked with surveyors and himself used the most modern surveying techniques to produce his essentially topographic maps.[9] In the seventeenth-century Netherlands, from Pieter Saenredam early in the century to Gaspar van Wittel toward the end, artists were employed in executing maps and plans of all kinds. These have tended to be included (though mostly passed over lightly) in the monographs of art historians rather than in the studies of cartographers.[10] An engraving after Saenredam's drawing the *Siege of Haarlem* (fig. 72) was designed for the commemorative publication on the city. And Gaspar van Wittel, later famous as Van Vitelli for his panoramic views of Rome, went to Italy originally to assist a leading Dutch hydraulic engineer by mapping the course of the Tiber as part of a scheme to make it navigable. There is a clear relationship between the format of the simple maps for the Tiber project (fig. 73) and his later painted views (fig. 74). Nowhere are the professional and the pictorial links between pictures and maps closer than in the activites of the Visscher family. Claesz Jansz. Visscher, himself responsible for a revival of interest in the topographical views attributed to the old Bruegel, also drew marvelous topographical views of his own in the first decade of the century.[11] A draftsman and engraver, Visscher became a publisher of engravings of landscapes, portraits, and maps and contributed some of the illustrations of towns and local life that appear on his maps. (It is common knowledge that maps in the Netherlands were often sold by the same dealers who sold other kinds of prints.) Visscher's son, Nicolas, was the map publisher responsible for the map represented in Vermeer's *Art of Painting*.

Journeys undertaken for mapping, among other descriptive purposes (including the study of foreign flora and fauna and costumes), were as much an impetus to travel abroad for northern artists in the sixteenth century as the desire to see Rome and to learn about antiquity. All attempts to ferret out some influence of Italy on Bruegel's subsequent figurative art miss the fact that his Italian trip was probably made for the world scene, not for Italian art. His famous drawing of the Ripa Grande is close enough in format to be considered among the type of the city views collected for Braun and Hogenberg's publication. A picture like his *Bay of Naples* (fig. 75) fits right into the category of topographical harbor views (fig. 76) which, like his painting, sometime also record naval battles. Mapping projects such as these would have been of interest to his friend Ortelius.

71. CONSTANTIJN HUYGENS III, *A View of Maastrich across the Meuse at Smeermaes* (drawing), 1676. Teylers Museum, Haarlem.

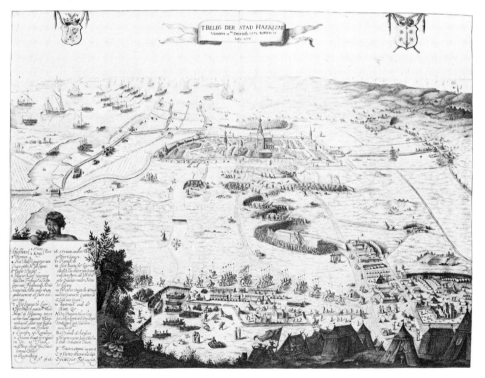

72. Anonymous, after PIETER SAENREDAM, *The Siege of Haarlem* (etching). Municipal Archives, Haarlem.

Oruicta

La qui delineata figura, rappresenta solamente, che quando la nauigatione del Jeuere fusse agguolata sino ad Oruieto, si potrebbe poi anche dar mano à fare nauigabile sino à quella Città il fiume Paglia: accio d'à questa potesse uenire per il Jeuere à Roma, con minor dispendio, e più breuità di tempo tutte le mercantie, e sostanze, ch'abbondano in quel paese.

73. GASPAR VAN WITTEL, *View of the Tiber at Orvieto* (drawing). Meyer Codex (MS nr. 23), Biblioteca Corsini, Rome.

74. GASPAR VAN WITTEL, *The Square and the Palace of Montecavallo.* Galleria Nazionale, Rome. Gabinetto Fotografico Nazionale, Roma. Neg. serie E, n. 36313.

75. PIETER BRUEGEL, *Bay of Naples*. Galleria Doria, Rome. Gabinetto Fotografico Nazionale, Roma. Neg. serie E, n. 41731.

76. Frontispiece in WILLEM BARENTSZ., *Caertboek Vande Midlandtsche Zee* (Amsterdam, 1595). Vereeniging Nederlandsch Historisch Scheepvart Museum, Amsterdam.

77. JAN VAN GOYEN, *Views of Brussels and Haeren,* in the Dresden Sketchbook. Staatliche Kunstsammlungen, Dresden.

The *Forschungsreisen,* as Ernst Kris called such trips,[12] should also be invoked when we consider excursions taken closer to home by certain Dutch artists in the seventeenth century. Pieter Saenredam's sometimes extended stays to record the churches in various Dutch towns obviously fit this mapping model, and so do those trips taken by the popular landscape artist Jan van Goyen, during which he filled pages of his sketchbook with profile views of various towns (fig. 77). The assimilation of these views into Van Goyen's painting, combining as they sometimes do elements from different sites, raises different questions. While the form is obviously still a mapped one, the pictures in such cases do not record specific places but rather what one might call possible ones. They are, however, still usefully placed under the rubric of the mapping mode as an application and an extension of its assumptions. They contrast, for example, with the radical changes wrought on a site combined with the affective handling of Jacob van Ruisdael's *Jewish Cemetery,* which nears, in this regard, his imaginary representation of swamps. On the other hand, from the point of view of the viewer they contrast with the sense of situating oneself so as to have a particularly picture-worthy view that we find in the nineteenth century. Pissarro reports in his letters to his son that he looked for a room to rent from whose window he could make a pleasing painting. But Dutch draftsmen, by contrast, when they do annotate a drawing (fig. 90), note with care the vantage place from which they take a view, because recording is inseparable for them from picturing. Distinguishing the

mapping impulse, as in the case of Ruisdael, is not to insist on a single mode but to mark the beginning of an attempt to come to terms with different Dutch modes of landscape representation.

In the case of maps it seems obvious that the intended function of the image had something to do with the kind of knowledge or information it conveyed and the kind of accuracy that was desirable. According to whether it was used to enable a ship to navigate the seas or enter ports, to enable an army to mount a siege, or to enable a state to tax, different kinds of things were demanded. But despite differences in kind it is important not to miss the aura of knowledge possessed by maps as such regardless of the nature or degree of their accuracy. This aura lent a prestige and power to maps as a kind of image. Their making involved possession of a particular kind which must not be underestimated in considering the relationship of art to mapping. We cannot help being amused at the claim made by Braun and Hogenberg that figures were included in their city views to prevent the Turks—whose religion forbade them to use an image with human figures—from using them for their own military ends. But there is no doubt of the jealous care with which the Dutch trading companies guarded their sea charts against competitors. There is a chilling account given to us by Isaac Massa—sometime Dutch contact in Russia—of the difficulty he had in obtaining a map of Moscow. Before giving him the map a Russian protested, "My life would be in danger if it were known that I had made a drawing of the town of Moscow and had given it to a foreigner. I would be killed as a traitor."[13] The fear speaks not only to an age-old Russian anxiety about foreigners, but to a seventeenth-century valuing of knowledge conveyed in map form. It puts great emphasis, in other words, on the value of a picture. Even for the person on the spot, for the traveler in Moscow, the map allowed one to see something that was otherwise invisible. To put it this way is to call attention to what maps have in common with other Dutch pictures at the time—pictures that were associated with, and used to record, what was seen in a microscope, something that was also otherwise invisible. Like lenses, maps were referred to as glasses to bring objects before the eye. To an artist like Jacques de Gheyn, who on occasion made both, the map was the obverse of the drawing of a fly.[14]

III

The link between maps and picture-making is an old one that dates back at least to Ptolemy's *Geography*. With the discovery, translation, and illustration of his text it became part of the Renaissance verbal and pictorial tradition. Though the first sentence of the *Geography* defines it as a picture of the world (the Greek phrase is, "Hē geōgraphia mimēsis esti dia graphēs tou kateilēmmenou tēs gēs merous holou," a Latin translation of which was, "Geographia imitatio est picturae totius partis terrae cognitae"), the point of the text that follows is to distinguish between the measuring or mathematical concerns of geography (concerned with the entire world) and the descriptive ones of chorography (concerned with particular places).[15] By way of clari-

fication Ptolemy invokes the analogy of making a picture: geography is concerned with the depiction of the entire head, chorography with individual features such as an eye or an ear. In his *Cosmographia*, a sixteenth-century adaptation of Ptolemy, the Flemish geographer and surveyor Apianus offers illustrations of these points (fig. 78). Ptolemy connects the training and skills of the mathematician to geography and those of the artist to chorography. Having made such a distinction, Ptolemy—who seems a modern in this respect—restricts his work to the first category. The maps that he produced were mathematical projections of various kinds of large areas of the world rather then detailed pictures of places or regions.

Ptolemy was as careful in his designation of the concerns proper to geography as he was in his designation of the role of the artist. In the Renaissance the situation was different. The explosion of geography in the sixteenth century involved not only a multiplication of images but also an extension of the field itself. One might say that the two were functions of one another. Mercator's projected five-part *Atlas* —the first to bear the name—was to have started with the Creation, and then have moved on to astronomy, geography, genealogy, and finally chronology. Meanwhile Braun and Hogenberg sent draftsman all over Europe to record views of cities for their *Civitates Orbis Terrarum*. The Dutch were surveying their old (and newly made) land and charting the routes overseas to lands such as the Indies and Brazil, which were, in turn, theirs to map. Astronomy, world history, city views, costumes, flora, and fauna came to be clustered in images and words around the center offered by the map (fig. 79). The reach of mapping was extended along

78. "Geographia" and "Chorographia" in PETRUS APIANUS, *Cosmographia* (Paris, 1551). Princeton University Library.

79. Map of Africa in WILLEM JANSZ. BLAEU, *World Atlas* (1630). Courtesy of the
Edward E. Ayer Collection, the Newberry Library, Chicago.

with the role of pictures, and time and again the distinctions between mea-
suring, recording, and picturing were blurred.

To what extent do we find this reflected in contemporary texts? In what
way was all of this activity proposed or accounted for? To answer this we
must go back to Ptolemy himself. The only Greek word available to Ptolemy
in referring to a maker of pictures was *graphikōs*. What is of particular interest
to us in the context in which Ptolemy used it is that the term (unlike the Latin
pictor) can suggest and indeed is etymologically related to the group of terms
ending in a form of *graphō*—geography, chorography, topography—which
in antiquity as in the later West were used to define his field of study. The
common meaning of this suffix is to write, draw, or record. It is impossible
for us today, as it was for the Renaissance, to tell with what examples in mind,
thus with what particular force, Ptolemy invoked a *graphikōs*. How the
Renaissance took it is however clear from the translations and adaptations of
his work. In general the word *picture* —*pictura*, *schilderij*, or the word appro-
priate for picture in the modern language—was used. [16] We shall postpone for
the moment a consideration of the pictorial presence that came to be sug-

gested by the pictorial reference to maps, the extent to which, in a most
unlikely sense, mapped images were said to make the world visually immedi-
ate. For now I want to consider the manner in which the Renaissance was not
content to invoke Ptoloemy's geographic records without also acknowl-
edging their specifically graphic nature. Though the word picture is intro-
duced it is inevitably modified, accompanied, or replaced by the term
description—*descriptio* in Latin, *description* in French, *beschryving* in
Dutch.[17] All of these words, of course, depend on the Latin *scribo,* the
equivalent of the Greek *graphō.*

To call a picture descriptive at the time was unusual, since description was
a term commonly applied to texts. From antiquity on the Greek term for
description, *ekphrasis,* was the rhetorical term used to refer to a verbal evo-
cation of people, places, buildings, or works of art.[18] As a rhetorical device
ekphrasis depended specifically on the power of words. It was this verbal
power that Italian artists in the Renaissance strove to equal in paint when they
rivaled the poets. But when the word description is used by Renaissance
geographers, it calls attention not to the power of words, but to the sense in
which images are drawn or inscribed like something written. It calls attention,
in short, not to the persuasive power of words but to a mode of pictorial
representation. The graphic implication of the term is distinguished from the
rhetorical one. When we look back at Ptolemy now we have to say that his
term *graphō* was opened up to suggest both picture and writing.

In the sixteenth and seventeenth centuries description is used equally to
title books that teach the new surveying techniques and to title the more
general kind of knowledge included in atlases or on maps such as the one in
Vermeer's *Art of Painting.* Similarly, the word *landschap* was used to refer to
both what the surveyor was to measure and the artist to render.[19] Seen from
the point of view of the later parting of the ways between maps and other
kinds of pictures, description might seem to be a hybrid term that brings
together things basically dissimilar in nature. Although the *only* pictorial
context in which the word was involved in this later period is in the literature
of mapping and surveying, I think it suggests a view of picturing that accepted
mapping as one of its modes. By employing the term description, the geo-
graphical texts accepted the graphic basis of their field while at the same time
they related their records to a notion of image making. The graphic use of the
term *descriptio* is not appropriate only to maps—which do inscribe the world
on a surface—but also to northern pictures that share this interest. With the
help of the words used about maps we can suggest that pictures in the north
were related to graphic description rather than to rhetorical persuasion, as
was the case with pictures in Italy.

Dutch art, like maps, was comfortable with its links to printing and to
writing. Not only were Dutch artists often printmakers accustomed to plac-
ing images on the surface of a printed page (often of a book), but they also
felt at home with inscriptions, with labels, and even with calligraphy. Artists
and geographers were related not only generally through their interest in

80. How to hold a pen, in GERARDUS
MERCATOR, *On the Lettering of
Maps* (1549). Courtesy of the John
M. Wing Collection, the Newberry
Library, Chicago.

describing the world but specifically through their interest in script. Mercator
(fig. 80) and Hondius, among others concerned with maps, wrote handbooks
for calligraphy as did members of the circles of Dutch artists.[20] (Indeed, the
extraordinary detail in which Mercator set forth the process of the cutting of
the quill, the way the hand rests on the surface, and the forming of the letters
analyzed in six moves reveals a graphic attention as great as we find in any
draftsmen of the time.) One thing that made this possible was that, in spite
of the Renaissance revolution in painting, northern mapmakers and artists
persisted in conceiving of a picture as a surface on which to set forth or
inscribe the world rather than as a stage for significant human actions.

We must return briefly to the issue of format, which we dealt with earlier
in our discussion of the Keplerian image. It is implicit in the comparison that
I am drawing between maps and northern pictures that I am taking issue with
recent work on Renaissance art and geography that has argued for a deter-
mining link between Albertian perspective and Ptolemaic recipes for map
projections.[21] In this view the picture in Ptolemy is understood to be like the
Albertian picture. But despite the great interest generated by Ptolemy all over
Europe, the evidence I think goes against this. Where European Renaissance
picturing is concerned, it is in the north, not in Italy, that maps and pictures
are reconciled, and the results are clear in the great and unprecedented pro-
duction of mapped pictures, the landscapes and city views with which we will
be concerned.

As I argued earlier, Alberti's great contribution to picture-making was not

just in binding the picture to vision but in what he chose to call a picture: it was not a surface like a map but a plane serving as a window that assumed a human observer, whose eye level and distance from the plane were essential. Though in his third projection Ptolemy did indeed give instructions for making an image based on a projection from a single eye point, he did not invent the Albertian picture. The question of whether he did is academic, since no one argues that the Renaissance ever actually took up Ptolemy's construction. To make a long and complicated story short, Ptolemy's third projection corresponded not to Alberti's vanishing-point perspective but to the so-called distance point method favored in the artists' workshops of the north. Let us recall the diagrams provided for us by Vignola (figs. 27, 28). While Albertian perspective posits a viewer at a certain distance looking through a framed window to a putative substitute world, Ptolemy and distance-point perspective conceived of the picture as a flat working surface, unframed, on which the world is inscribed. The difference is a matter of pictorial conception.

One might speak of the resulting image as being seen essentially from within or being surveyed. It is in a certain respect much like surveying, where the viewer's position or positions are included within the territory he has surveyed. We recall, for example, the eye positions marked by Saenredam in his church interiors. Surveying, however, takes us away from Ptolemy, who was concerned with geography or the mapping of large areas of the earth. There the issue was not that of surveying but rather how to project or, better, transform part of the spherical globe onto a flat surface. What is called a projection in this cartographic context is never visualized by placing a plane between the geographer and the earth, but rather by transforming, mathematically, from sphere to plane. Although the grid that Ptolemy proposed, and those that Mercator later imposed, share the mathematical uniformity of the Renaissance perspective grid, they do not share the positioned viewer, the frame, and the definition of the picture as a window through which an external viewer looks. On these accounts the Ptolemaic grid, indeed cartographic grids in general, must be distinguished from, not confused with, the perspectival grid. The projection is, one might say, viewed from nowhere. Nor is it to be looked through. It assumes a flat working surface. Before the intervention of mathematics its closest approximation had been the panoramic views of artists—Patenir's so-called world landscapes—which also lack a positioned viewer.

All this will come as nothing new to cartographers, but it can be of definitive importance for students of art. In discussions of mapping, distinctions are drawn between systems of projections for dealing with large areas of the globe and the surveying of small areas. But whichever case we take, northern painting is like the map as the Albertian picture is not. The presence on maps of individual structures—buildings, for example—that are "viewed in perspective" does not affect the basic nature of the image. It offered a surface on which to inscribe the world, and this fact permitted the

addition of views—those of cities, for example—as we have seen in the *Art of Painting*. Contrary to what is assumed, such mapped images have a potential flexibility in assembling different kinds of information about or knowledge of the world which are not offered by the Albertian picture.

To sum up: the circumstances were propitious for northern image-makers to pursue the pictorial aims that had long been implicit in geography. Their success in this was in turn made possible by a notion of a picture particular to northern Europe.[22] These are factors to bear in mind as we turn to the two major types of images which I think are inherently like mapping in source and nature: the panoramic or what I should prefer to call the mapped landscape view, and the cityscape or topographical city view.

<div align="center">IV</div>

What are commonly referred to as the first "realistic" Dutch landscape images are some drawings (fig. 81) done about 1603 by the great Dutch draftsman Hendrick Goltzius of the dunes near Haarlem. Rather than working from his mind or imagination, the artist goes out into nature and tries to capture the great sweep of the flat Dutch land, farms, towns, and church towers all marked out on this great expanse. The reason that such a description first appears in drawing rather than in paint, it is said, is the "after-life" aspect of pen and paper. It was a medium that, unlike brush, paint, and canvas, was taken outside in the seventeenth century. So, the account goes, Goltzius was the first to go out and draw what he saw. This realism is then contrasted with his previous imaginary or so-called "mannerist" landscapes (fig. 82). But indeed surveyors and mappers and artists engaged in such tasks had gone into the landscape and viewed it for descriptive purposes before. Their results differ. Those that are closest to Goltzius's feel for the surface and the outstretched land are the maps that have a high but articulated horizon— Braun and Hogenberg's *Den Briel* (fig. 83), or Saenredam's *Siege of Haarlem* (fig. 72). Goltzius's landscape does not mark the birth of realism (a slippery notion at best), but the transformation of a mapping mode into landscape representation. We see a new attitude toward the land. Both Goltzius's impetus to record landscape and his graphic mode of inscribing it on a surface are accounted for in this way. An entire genre of landscape paintings—a number by Van Goyen, some by Ruisdael, and almost all of Koninck's—commonly known as panoramic and often considered to be the most important contribution made by the Dutch painters to the image of landscape, is rooted in mapping habits.[23]

It is no discovery, particularly after Gombrich's engaging demonstrations, that even the most illusionistic art employs conventions. What is significant here is that the conventions are like those of some contemporary maps. The artist acknowledges and accepts the working surface—the two-dimensional surface of the page to be worked on. In this drawing, as in the entire tradition of panoramic landscapes that follows, surface and extent are emphasized at the expense of volume and solidity. We note that lack of the usual framing

81. HENDRICK GOLTZIUS, *Dune Landscape near Haarlem* (drawing), 1603. Museum Boymans-van Beuningen, Rotterdam.

82. HENDRICK GOLTZIUS, *Couple Viewing a Waterfall* (drawing). Nationalmuseum, Stockholm.

83. Map of Den Briel, in BRAUN AND HOGENBERG, *Civitates Orbis Terrarum* (Cologne, 1587–1617), vol. II, p. 27. Courtesy of the Edward E. Ayer Collection, the Newberry Library, Chicago.

devices familiar in landscape representations which serve to place us and lead us in, so to speak, to the space. We look on from what is normally (and somewhat misleadingly) referred to as a bird's-eye view—a phrase that describes not a real viewer's or artist's position but rather the manner in which the surface of the earth has been transformed onto a flat, two-dimensional surface. It does not suppose a located viewer. And despite the tiny figures just visible at the bottom edge, this landscape can virtually be said to be without people. Goltzius's earlier drawing is, on the other hand, peopled with a couple whose affection for each other is echoed in their joint attraction to the torrent cascading before them. Human wonder at nature, not the recording of the land, is the artist's concern.

"How wonderful a good map is," wrote Samuel van Hoogstraten in his treatise on art, "in which one views the world as from another world thanks to the art of drawing."[24] Hoogstraten's exclamation applies as well to what I have called mapped (panoramic) landscapes as to the maps that they transform. Goltzius *does* make us feel that we are situated apart from the land, but with a privileged view. It is precisely the curious mixture of distance pre-

served and access gained that is at the heart of Jacob van Ruisdael's best works in this mode. Hoogstraten concludes with thanks to the art of drawing for making maps possible. Although his words are usually quoted when maps and Dutch art are at issue, it has not struck anyone to ask why Hoogstraten discusses maps in a section about drawing. The answer lies in his notion of drawing. This is the same chapter of his treatise in which Hoogstraten speaks of drawing as a second kind of writing. It is a chapter dominated, in short, by the spirt of *descriptio*—to recall the word on Vermeer's map—that inscribing of the world to which Goltzius was heir.

Landscapes and mapping are linked in the Netherlands of the seventeenth century by the notion of what it is to draw. In the Italian-dominated theory of the late sixteenth century, drawing (*disegno*) had been exalted to the point where it was synonymous with the idea (*idea* in Italian) of art, and thus with the act of the imagination itself. Hoogstraten, by contrast, introduces drawing as linked to letters formed in writing, to planning war maneuvers, to medicine, astronomy, natural history, and geography. Drawing is treated as a craft with specific functions, among which are the description on a page of different phenomena observed in the world. A beautiful sheet by Saenredam (fig. 125; pl. 4), which juxtaposes views of Leiden and Haarlem with their names in a fine calligraphic hand above and with the imprinted silhouettes of two trees below to complete the page, is an example of drawing understood in this way. It is this impetus to describe that binds the Goltzius landscape drawing and maps. As time goes on this graphic mode is not jettisoned, but is in a characteristic Dutch way absorbed into paint. Color already informs the drawing by Saenredam we have just looked at. Paintings do what graphic media had done previously. This is one of the reasons, perhaps, why the relationship between maps and Dutch landscape painting has been easily missed.

In many mapped landscapes, as in small area maps, buildings, towns with their church towers, windmills, and clumps of trees appear as landmarks, literally marks on the land (as if to guide travelers), rather than as evocations of particular things. The sources for these are found in maps: in those coastal profiles that illustrate books of navigation (fig. 84) and in the notation common on maps of other kinds. Koninck (fig. 85) comes particularly close to such landmark notations in the summary nature of his description of the objects in his views.

Starting from mapping enables us to describe more justly the nature in format and interest in recording place of certain landscapes. An early seventeenth-century painting (fig. 87) by a provincial artist from Enkhuizen (possibly the teacher of Jan van Goyen) reveals a connection to maps in most direct ways—its extremely high horizon, the grid set forth by the polders, and the designation of the landmarks. The horizon alone recalls the mapping connection of many sixteenth-century works such as those by Bruegel, who was no stranger to the geographical activity of his day through his friendship with Ortelius. We might also want to use mapping terms to distinguish the

84. Landmarks, in WILLEM JANSZ. BLAEU, *Le flambeau de la navigation* (Amsterdam, 1625). Courtesy of the Edward E. Ayer Collection, the Newberry Library, Chicago.

85. PHILIPS KONINCK, *Landscape with a Hawking Party* (detail of fig. 86).

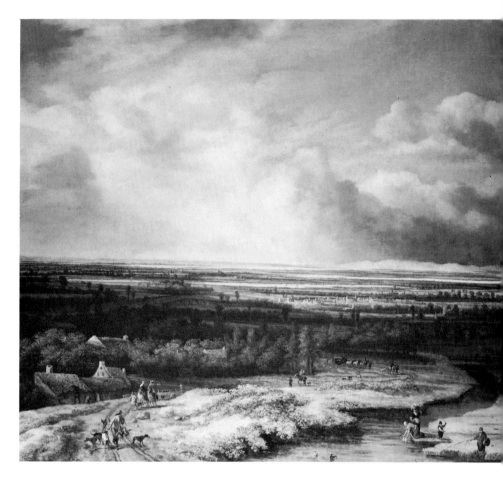

86. PHILIPS KONINCK, *Landscape with a Hawking Party.* By permission of the Trustees
of the National Gallery, London.

larger *geographical* ambitions of Bruegel's *Season* landscapes from the specific
chorographic concerns of his drawing of the Ripa Grande or the painting of
the Bay of Naples. Establishing Bruegel's engagement with mapping helps us
not only to distinguish between his works but also to understand them better.
By combining the traditional theme of the seasons with an extensive mapped
view of the earth, Bruegel gives the yearly cycle a world rather than a local
dimension. In works such as the engravings of the Vices and Virtues or the
paintings of the Proverbs and Children's Games the mapped view is also used.
Though individual proverbs had been represented in prints before as had
mapped landscapes in paintings, Bruegel's great invention was to combine the
two. The mapped view suggests an encompassing of the world, without,
however, asserting the order based on human measure that is offered by
perspective pictures. By depicting human behavior in this unlikely setting
(though the world is so mapped, people are never seen this way on maps),
Bruegel can suggest the endless repetitiveness of human behavior in an essen-

tially boundless (unframed) space. But the care he takes to distinguish between such essentially repetitious human actions is not dictated by the format. The human community seen under a mapped aspect but attended to with such care has a particular poignancy.

This is not the direction taken in Holland, where the land, not its inhabitants, continues as the major interest. The mapped horizon was not sustained, but was lowered first to let in more sky (the Van Goyen monochromatic works of the forties) and then clouds and effects of light (as we move on to Ruisdael in the fifties and sixties). Philips Koninck (fig. 86) is the artist who sustains the format of the mapped landscape the longest in the century. It is not clear to what extent he did or did not detach it from its recording aspect. The enormous size of some of his works, which are the largest of all Dutch painted landscapes, rivals the dimension of wall maps. Rather than picturing a geographic world view as Bruegel did, or the chorographic places of Goltzius, Van Goyen, and Ruisdael, Koninck aims at making the pieces of Holland he is describing seem a part of the larger world. By introducing a gentle curve to the horizon he lets the earth into what is a mapped view of an area of his native land. While Bruegel expands his neighborhood into the world, Koninck brings a world view to Holland.

Many of Jan van Goyen's views are examples of mapped landscapes. Although the horizon is lowered, the panel gives the impression of being a worked surface. The extent of the land is scattered with standard landmarks—church towers, hayricks, trees, even cows. A city, which is never far away in Holland and on which the country so depended, is the major landmark. This is true also of Ruisdael's views of Haarlem (fig. 88), called *Haarlempjes* at the time after the city. Ruisdael, perhaps following the example of the materials added to maps, depicts a major product and economic support of the city—the bleaching of linen in the fields. In these works the mapped landscape

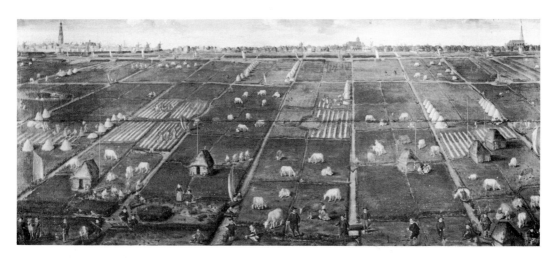

87. ANONYMOUS DUTCH PAINTER, *The Polder "Het Grootslag" near Enkhuizen.*
Zuiderzeemuseum, Enkhuizen.

88. JACOB VAN RUISDAEL, *View of Haarlem*. Gemäldegalerie, Staatliche Museen
Preussischer Kulturbesitz, Berlin (West).

89. AELBERT CUYP, *View of Amersfoort*. Von der Heyt-Museum, Wuppertal.

approaches the other genre obviously derived from mapping, the topographical city view.

People passing through the country, some inhabitants, some travelers presumably like the artist himself, stop sometimes to look out or, very rarely, to draw. Nothing ever happens. Only rarely is work being done. (Ruisdael's *Haarlempjes* are a signal exception.) The working of or bounty of the land is rarely illustrated. We do not to my knowledge see figures actually engaged in surveying. But the access to the land and the interest in it (people direct their gazes far out, not at things close by) is related to this. There was a tradition among mapmakers that one could turn to the natives—to the fisherman or the peasants—for assistance.[25] Those living on the land or sea share an interest in knowing it—that at least is the assumption. A Cuyp painting of two shepherds looking out and pointing toward Amersfoort (fig. 89) illustrates this. Representative peasants or fishermen turn up on the frontispiece of an atlas or the cartouche of a map. A fisherman with a surveyor's tool is on the Visscher map represented in Vermeer's *Art of Painting*—although here the mapmaker also intends a play on his own name.

We can, I think, distinguish a narrower and a broader use of the mapping designation. Used narrowly, mapping refers to a combination of pictorial format and descriptive interest that reveals a link between some landscapes and city views and those forms of geography that describe the world in maps and topographical views. Used broadly, mapping characterizes an impulse to record or describe the land in pictures that was shared at the time by surveyors, artists, printers, and the general public in the Netherlands. In the face of this I think we must supplement Gombrich's well-known solution to the problem of how to explain the invention or institution of landscape as a pictorial genre.[26] Gombrich refers us to a telling account from Edward Norgate's *Miniatura* (written ca. 1648–50). An art lover returning from a trip through the mountains, hills, and castles of the Ardennes calls on an artist friend in Antwerp and gives an account of his trip. In the course of the account the artist takes up his brushes and proceeds to paint: "describing his description in a more legible and lasting Character than the other's words" are Norgate's words.[27] Gombrich uses this anecdote to point to the idea or the words, the rhetoric to be more precise, concerning a landscape that preceded its invention as an image. Following this anecdote he refers us to passages from other contemporaries who also narrated their experience of landscape. This link to a prior human narrator stands us in a good stead for the birth of those kinds of landscape images in which expression or tone in the rhetorical sense is important. (Gombrich mentions the heroic and pastoral modes of Poussin and Claude as examples.) But mapped landscape images and the impetus for making them are not accounted for in this way. They were founded significantly by artists who were on the road looking, artists who were not staying at home listening to travelers' accounts. We can turn Norgate's words back on himself. These works are descriptions, but not in the rhetorical sense, for description in these cases is not a rhetorical but a graphic thing. It is description, not narration.

If the great landfill and water projects on the one hand and military activity and news on the other contribute to the demand for detailed maps, the natural features of the Netherlands—the flat, open, relatively treeless land—made it particularly suitable for mapping. But though its flatness is itself maplike, it was difficult to gain a vantage place from which to view it. The Dutch took every opportunity they could to climb their many towers or coastal dunes for this purpose. In fact these very aspects—the condition of its mapping—are some of the favorite motifs in the mapped images. We have many verbal accounts from the seventeenth century of people climbing towers in order to take in at least a visual measure of the land. Men such as the scholar-scientist Isaac Beeckman and the doctor Van Beverwyck had prospects from their own houses, but foreign visitors, like the Frenchman Monconys, are regularly taken up to get a prospect on the land. Views drawn from the vantage point of specific towers and annotated as such (fig. 90) form a special small subgenre of Dutch drawings.

But the mapping and related viewing of the Netherlands were surely also conditional on social and economic factors. All mapping is in some sense. And in the Netherlands the system of land ownership that permitted access to much land that was politically and socially untrammeled is a relevant consideration. The northern Netherlands were unique in the Europe of the time in that over fifty percent of the land was peasant owned. Unlike other countries, seigneurial power was weak to nonexistent.[28] Though I know of no historical account of the matter, it was in practice easy to survey the land in a situation that presented no threat to tenants or to any others. When we read the history of surveying in England, the social dimension is striking, by which I mean that because of the nature of land ownership the project of surveying was greeted with suspicion on the part of tenant farmers. The first leading seventeenth-century English handbook on the subject, John Norden's *Surveior's Dialogue* (1607), is presented in the form of a dialogue between the surveyor, a bailiff, a farmer, the lord of the manor, and a purchaser. It is the surveyor's task to allay the threat of higher rents that the survey presents to the farmer, while at the same time underlining the lord of the manor's obligations to his tenant. I have found nothing similar of Dutch origin. English poetry of the time reflects the sense that a landscape inevitably involved issues of authority and of possession. The prospect or view was itself seigneurial in its assumption and assertion of power. Pride in estate was real and was related to the order of the state. As Andrew Marvell said in a Latin poem on his patron's estates:

> See how the heights of Almscliff
> And of Bilbrough mark the plain with huge boundary.
> The former stands untamed with towering stones all about;
> The tall ash tree circles the pleasant summit of the other.
> On the former, the jutting stone stands erect in stiffened ridges:
> On the latter, the soft slopes shake their green manes.
> That cliff supports the heavens on its Atlantean peak:

90. CONSTANTIJN HUYGENS III, *View of the Waal from the Town Gate at Zaltbommel* (ink, brown wash, and some color wash), 1669. Fondation Custodia (coll. Frits Lugt), Institut Néerlandais, Paris.

> But this hill submits its Herculean shoulders.
> .
> Nature joined dissimilar things under one master;
> And they quake as equals under Fairfaxian sway.[29]

In the Netherlands, on the other hand, as the surveyors, travelers, and images testify, the land was there to be mapped and pictured with no issue over seigneurial possession. The informative views taken from Dutch towers contrast with the authority accruing to such views in English life and verse. Though mapping can serve to mark ownership, it does not, by its nature, display pictorial marks of authority. What maps present is not land possessed but land known in certain respects. What has been referred to as the social and political irrelevance of land ownership in the Netherlands was, then, an important enabling factor in the freedom to map as well as in the freedom to picture the land as in a map.

It is in this social context that Rembrandt's splendid etching of 1651 known as the *Goldweigher's Field* (fig. 91) becomes a particularly interesting example of the Dutch mapping mode. The work was done, we believe, on the occasion (or following upon the occasion from which a drawing is preserved) of Rembrandt's visit to the country house of one of his unpaid creditors just outside of Haarlem. Christoffel Thijsx's country estate, Saxenburg, is visible in the left middleground of the etching. Rembrandt renders a familiar type of

91. REMBRANDT VAN RIJN, *The Goldweigher's Field* (etching and drypoint), 1651.
Courtesy of the Art Institute of Chicago.

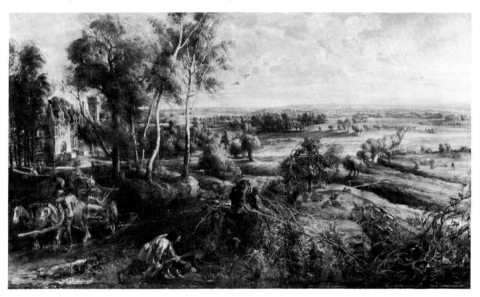

92. PETER PAUL RUBENS, *Landscape with Het Steen*. By permission of the Trustees of the
National Gallery, London.

mapped landscape, which, however, takes no particular notice of the estate.
True to the mode, he shows the great sweep of the land marked by the church
at Bloemendaal at the right and the huge Saint Bavo of Haarlem on the
horizon to the left. The extensive fields are peopled, as in Ruisdael's paint-
ings, by workers setting linen out to bleach.[30] Rembrandt records the lay of
the land, its churches, towns, trees, and grasses and to a much lesser extent
its product—the use being made of good air to set out the linen. Thijsx's
estate is incidental to this view. Rubens's depiction of Het Steen (fig. 92)
offers a fitting contrast to all this. Though its format could lead one to call it
a mapped view, it is a view determined by and engaged in the presence of a

seigneur. In buying this estate Rubens knew that he would inherit the title that it bore. The prospect of Flanders stretching out to the right is the view gained from his house. It is suitably graced by a golden light. It is the possession of such a house that gives one the authority of this prospect. The owner and family stand before it. Meanwhile the hunter aiming for a bird and the wagon piled with a trussed lamb on the way to market remind us of the uses to which nature is put by human society. Rubens, as always, acknowledges the conditions of our life—even its violence.

In the second half of the century more Dutch merchants wanted titles, and some acquired them with their manors. But the Dutch country villas with their small plots of land were not the actual seats of wealth or authority as were the English estates, nor were they seats to which such authority was attributed, as in the case of the new Flemish nobility, who escaped to the country to avoid the troubles of Antwerp. When Dutch merchants invested in country pleasure-houses it is their portraits and the portraits of their houses—the look of a good life—and not power over nature and the land that they wanted to have represented. Dead game and food turn up in portraits and in still lifes. Once again these are forms of description.

There is a further social determinant evident in Rembrandt's etching, which conveniently serves to turn our attention to a second major group of mapped images—the topographical city view. A close look at panoramic

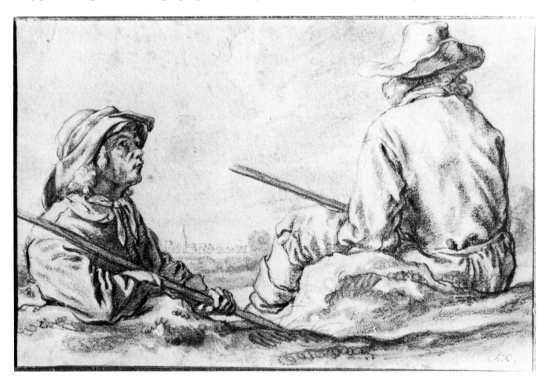

93. AELBERT CUYP, *Two Young Shepherds* (drawing). Fondation Custodia (coll. Frits Lugt), Institut Néerlandais, Paris.

views will frequently be rewarded with the discovery of a city with its prom-
inent church tower on the horizon. These cities mark not only the visual fact
that one was seldom far away from an urban center even in seventeenth-
century Holland, but also an economic one. The fact that such mapped
landscapes like Rembrandt's *Goldweigher's Field* are in a significant respect
cityscapes testifies to the importance of the city in the life of the society.
Dutch prospects, then, far from asserting the possession of land and property,
rather pay tribute to the cities of the land. And this leads to one further and
final point, for in paying tribute to the cities of the land, in depicting cities
seen in this way as part of the land, Dutch artists reveal that the contrast, even
the tension, between city and country that was such a traditional feature of
Western urban culture is not decisive in Holland. These pictures, like the
maps that they are close to, offer us instead images of continuity. A pair of
resting shepherds drawn by Cuyp, country dwellers like Potter's bull, are
juxtaposed before the dwarfed towers of a distant church and town (fig. 93).
Questions of place—of city and country—are subtly joined here with those
questions of measure or scale which we spoke of in an earlier chapter.[31]

<p style="text-align:center">V</p>

The genre of topographical city views is a classic example of the trans-
formation we find often in Dutch art from a graphic medium to the more
expensive medium of paint. And the nature of the transformation is of partic-
ular interest because Vermeer's *View of Delft* (fig. 94) belongs to this genre.

Art historians who, not mistakenly but certainly far too rigidly, assume
that every work must have a source in another have been stumped by Ver-
meer's *View of Delft.* The only picture that can be found to resemble it at all
is a view of Zierikzee (fig. 96) by Esias van de Velde painted forty years
earlier.[32] The comparison has always seemed reductive, as almost any attempt
to compare Vermeer's unique work with another image perhaps does. But
here too we find a city spread out in profile against the sky, with boats at
anchor and figures perched on a lip of land at the left foreground. A study of
map materials, in particular topographical town views (fig. 95), makes it clear
however that, rather than this being a case of influence, both of these works
belong to a common tradition.

The interest in city views and their basic models was first presented in
Braun and Hogenberg's ambitious *Civitates Orbis Terrarum,* published be-
tween 1572 and 1617. Their stated purpose was to offer the pleasure of travel
to those at home. This was travel, they cautioned, without an interest in
business or gain, but purely for the sake of knowledge.[33] Figures in native
dress, flora and fauna, and inscriptions add to the information presented in
the views. In the Netherlands the general European interest in cities was
supplemented by a civic pride in one's hometown. This is evident in prints of
individual cities that started appearing in the 1590s by Bast and others and also
in the series of books sponsored by cities in their own honor, often illustrated
by native artists. Saenredam designed a profile view of Haarlem for Amp-

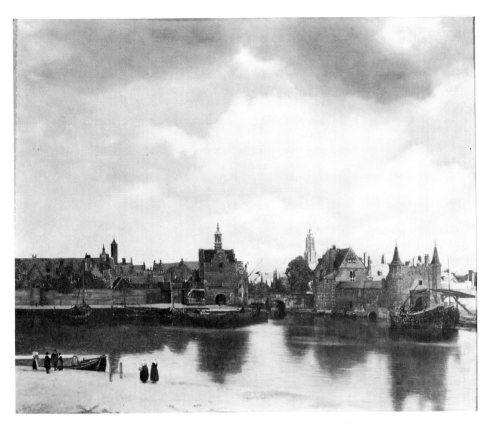

94. JAN VERMEER, *View of Delft*. Mauritshuis, The Hague.

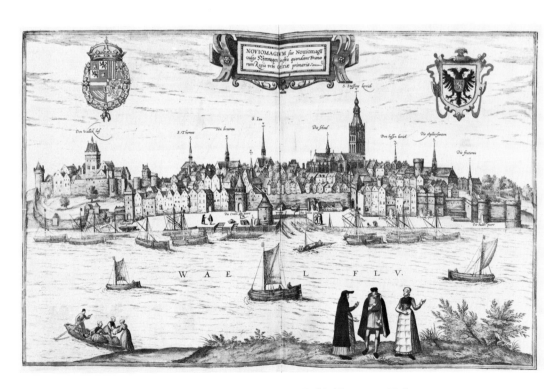

95. Nijmegen, in BRAUN AND HOGENBERG, *Civitates Orbis Terrarum* (Cologne, 1587–1617), vol. II, p. 29. Courtesy of the Edward E. Ayer Collection, the Newberry Library, Chicago.

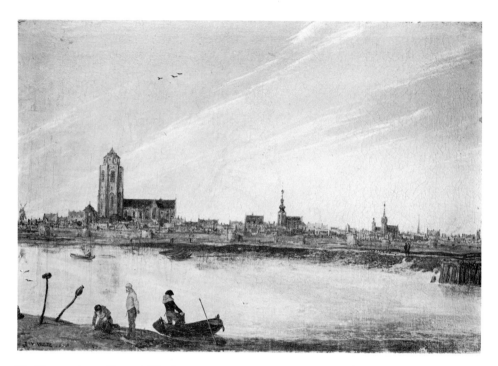

96. Esias van de Velde, *Zierikzee*, 1618. Gemäldegalerie, Staatliche Museen Preussischer Kulturbesitz, Berlin (West).

zing's *Description and Praise of the Town of Haarlem* of 1628. Individual buildings and squares were shown in formats that did not depend at all on Braun and Hogenberg. Trade and gain, contrary to their wish, were very much at issue. In 1606 Visscher had already borrowed Bast's profile view of Amsterdam, expanded it in size, and added four smaller scenes of trade in the city and a panegyric text. The 1649 publication by Blaeu of the first atlas of Netherlandish cities, divided between north and south to commemorate the political division confirmed in the 1648 Treaty of Munster, coincided with a new burst of interest in cities. The Blaeu Atlas, however, consistently uses the vertical or linear grid format for its cities—as far from a picture as it can be.

Of the various formats in which cities are presented by Braun and Hogenberg (four were distinguished by R. A. Skelton)[34] a number were popular in separate prints and paintings. One of these is the profile city view—in the case of Dutch cities often seen from across a body of water as in the *View of Nijmegen* or in Hendrik Vroom's 1615 view of the newly built Haarlem Gate at Amsterdam (fig. 97). This is the format used by Esias van de Velde and later by Vermeer. On occasion such views were commissioned in a painted form by the cities themselves—like Van Goyen's 1651 *View of the Hague* (fig. 98), Rembrandt's etched *View of Amsterdam* (fig. 99) from about 1643 was suggested by this established format.

Vermeer's *View of Delft*, then, is dependent on a tradition of topographical prints and is not the first painted view of a Dutch town to take over this

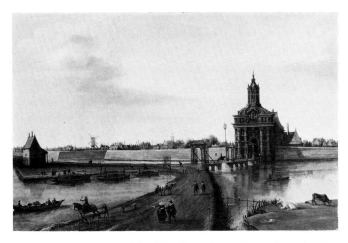

97. HENDRIK VROOM, *The Haarlem Gate, Amsterdam,* 1615.
Collection Amsterdam Historical Museum, Amsterdam.

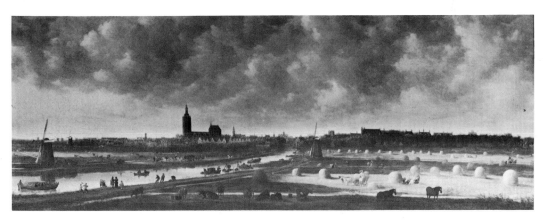

98. JAN VAN GOYEN, *View of the Hague,* 1653. Collection Haags Gemeentemuseum, The
Hague.

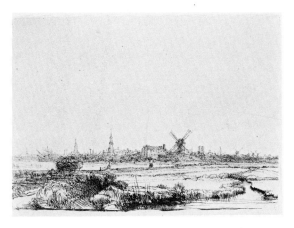

99. REMBRANDT VAN RIJN, *View of Amsterdam*
(etching). Courtesy of the Art Institute of
Chicago.

design. In the midst of the renewed interest in many kinds of depictions of cities at mid-century, Vermeer's seems essentially to be a traditional, even conservative way to view his hometown.

The accuracy of Vermeer's view has often been remarked. The linear or vertical map of Delft from Blaeu can be marked to indicate which buildings are seen. Vermeer even noted the time—7:10—on the tower clock. But still it seems mistaken to call this picture a topographical view. It is of a different order of rendering from the printed or even the other painted views. It is endowed with an uncommonly seen and felt presence. Vermeer changes the format by lifting the sky high over the strip of the town, which is held to the lower frame by the golden bank. The town so exposed turns in on itself. Embraced by its wall, which encloses trees and crowded roofs, it suggests the intimacy of human habitation—an intimacy preserved in the quiet talk of the figures outside it on the bank. (Vermeer painted out the one person, a man, who would have stood apart.) But the intimacy is internally differentiated. The threatening but protective shadow at the left, which extends the full length of the city wall, is played off against the brilliant light on the right part of the town. Each depends on the other to set it off. It is the contrast that is made between men and women in Vermeer's other works. This is a fact in the perception of the light, in the painter's art, but also in human experience. Vermeer transforms into this city view and its visual values the sense of human experience that informs all of his paintings. The two towers that reach into the sky—one in shadow and one in full sunlight—are pictorially linked by the small bridge, where masonry, leaves, sun, and shade all meet. In a final confirmation of the articulated resolution that this picture offers, Vermeer invites our eyes to dwell on the bridge as the only place where the canal and the world beyond is able to penetrate and thus link up with the town.

The transformation from graphic to painted medium was in one respect common in the mapping enterprise. Painters were regularly employed as colorists for maps. The map in Vermeer's *Art of Painting* is a colored one. At a first level such colors have a symbolic value: they distinguish between various aspects of the earth for our eye—sea is blue, land tan. Though they signify, they need not be descriptive. Vermeer's *Soldier and Laughing Girl* in the Frick Collection (fig. 14), with its pointed reversal of the actual colors of sea (here tan) and land (here blue) clearly makes this point.

But although color conventions were not necessarily descriptive, maps were thought of at the time as being descriptive, as were pictures. In the writings of geographers it was a commonplace to speak of a map as putting the world or a place in it before the viewer's eyes. Apianus calls on the image of the mirror. Cosmography, he says, mirrors the image and appearance of the universal world as a mirror does one's face. In other words, he continues, one sees the picture and image of the earth.[35] Braun and Hogenberg say of the chorographer:

[He] describes each section of the world individually with its cities, villages,

islands, rivers, lakes, mountains, springs, and so on, and tells its history, making everything so clear that the reader seems to be seeing the actual town or place before his eyes.[36]

(Those copies of the *Civitates* in which the views were hand-colored at the time confirm this intent.) Isaac Massa returning from Russia refers to the map of Moscow that he replicated for the Dutch as "done by pen with such exactitude that in truth you have the town before your eyes."[37] And Ortelius in the introduction to his *Theatrum Orbis Terrarum* (London, 1606) writes: "those chartes being placed as it were certaine glasses before our eyes, will the longer be kept in memory and make the deeper impression in us." We could multiply such statements, which occur in almost every geographical text. The terms "mirror," "before the eyes," and "glasses" were applied equally to maps and to pictures at the time. Norgate, for example, continues his passage on the invention of landscape painting with the following characterization:

> Lanscape is nothing but Deceptive visions, a kind of cousning or cheating your owne Eyes, by our owne consent and assitance, and by a plot of your owne contriving.[38]

To speak of maps in this way, however casually, is to assume more similarity between them and pictures than we have yet noted. Not only description but mirroring presence is held in common. It is not irrelevant that the word graphic, encompassing both the meaning "drawn with a pencil or pen" and the meaning "vividly descriptive or lifelike" is first in use at just this time.[39] And as I suggested earlier, it was also at this time that pictorial aims long implicit in geography were taken up by northern image-makers. But for all the implicit claims about the mirroring presence of a map, how can a map bring something to the eyes in the way a picture can?

We must pause a minute to appreciate the peculiarity of this claim. And the best way to do so is to look at a map—or is it a picture?—by the little known Dutch painter Jan Micker (fig. 100; pl. 3). Basing himself on the famous sixteenth-century painting (or perhaps even the woodcut) of Cornelis Anthonisz., Micker literally painted the mapped Amsterdam. In this idiosyncratic work he tries to bind the graphic nature of the map to the mirroring qualities of a painting: the list labeling landmarks at the lower right casts a shadow onto the sea, but, even more striking, the city is softly colored and grazed by scattered light and shade cast by unseen clouds. Micker reveals an ambition but poses a pictorial problem. In his *Haarlempjes* (fig. 88), Ruisdael provides a resolution that Micker could not find.[40] He lowers the horizon, and extends the sky to include the clouds, which leave their mark but have no presence in Micker's painted map. Haarlem is made the object of a pictorial celebration of a sort that no map or topographical view could offer. Vermeer's *View of Delft* is the consummate solution to the problem of placing a topographical view before the viewer's eyes. It cleaves close to the design of an engraved city view but it is hard to retrace the steps back to this design. The town of Delft is smaller in relation to the large, almost square canvas, but it

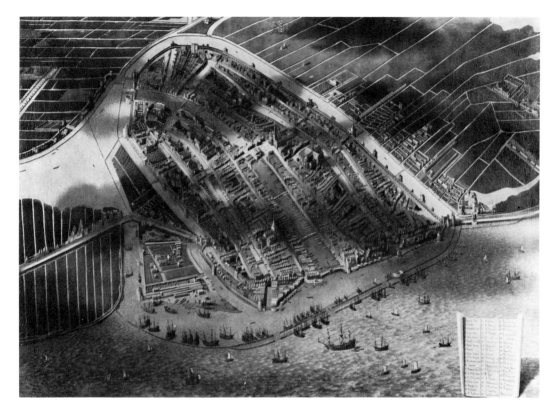

100. Jan Christaensz. Micker, *View of Amsterdam*. Collection Amsterdam Historical Museum, Amsterdam.

commands more: sky, water, light, and shade appear summoned to grace it. To recall our earlier analysis of the language used of maps: the epideictic eloquence of *descriptio* is transformed from a rhetorical figure to be given a uniquely pictorial form. In Vermeer's *View of Delft* mapping itself becomes a mode of praise.

A central element in the transformation from print to painting is the addition of color. Obviously color was not only used symbolically. Though maps were produced as prints, the application of color often made them hard, it is said, to distinguish from something originally executed in watercolor. Lines in painted maps were taken over by color. Watercolor itself had long been a favored drawing technique in northern Europe.[41] Dürer used it for his *Great Piece of Turf,* the *Rabbit,* and for landscapes. In seventeenth-century Holland many of De Gheyn's drawings of animals or flowers are also exe-cuted in watercolor (fig. 3). (If one looks at Dutch drawings rather than at reproductions of them it is surprising how many employ color.) Watercolor is a medium that effaces the distinction between drawing and painting, and it was primarily employed in the interest of immediacy of rendering. One might say, conversely, that it is a medium that allows drawings to display at once two normally contradictory aspects: drawing as inscription (the recording on

a surface) and drawing as picture (the evocation of something seen). Vermeer's *View of Delft,* though not executed in watercolor, is this kind of work. Whether or not it was painted with the assistance of a camera obscura, it inscribes the world directly in color as did that popular device. It took Vermeer to realize in paint what the geographers say they had in mind.

<div align="center">VI</div>

In 1663 Blaeu presented his new twelve-volume atlas of the world to Louis XIV accompanied with some words of introduction and explanation:

> Geography [is] the eye and the light of history . . . maps enable us to contemplate at home and right before our eyes things that are farthest away.[42]

We have seen that the notion of description was instrumental in tying geography to pictures and in the development of new modes of images. Geography's relationship to history gave it a special authority and encouraged its enlarged scope. Blaeu's remark is an appropriate introduction to an atlas of images recording wide travel and exploration. He wishes to make distant, unseeable things visible. He welcomes and encourages description and validates it as knowledge. The presentation of geography as the eye of history was a commonplace by this time. Apianus, a hundred years earlier, had recommended geography to those interested in the acts and lives of princes.[43] Mercator had imbedded history and chronology in his ambitious plans for the first atlas and his heirs Hondius and Janssonius (Amsterdam, 1636) quite casually introduce their atlas by writing of their concern with actions such as war and exploration, which are "described by Geographie and knowne to be true by Historie." History had long lent status to geography. But in the seventeenth century the balance between the pair (Castor and Pollux, as Mercator called them) was subtly changed. As in the realm of natural knowledge, the new testimony of the eye challenged the traditional authority of history. This happened in geography too. A traveler in Holland confirmed that even the houses of shoemakers and tailors displayed wall-maps of Dutch seafarers from which, he commented, they know the Indies and its history.[44] One kind of map informed the pilot at sea but another informed the tailor at home. In such a view history is largely based on visual evidence. It suggests the unprecedented ways in which images at the time were thought to contribute to knowledge.

The relation of images and history was hardly new to European culture, but it was not established in these terms. The highest form of art was history painting, by which was meant not current or even recent events as such but painting that dealt with significant human actions as they were narrated by the Bible, myth, the historians, and the poets. The great narrative works in the Renaissance tradition are history paintings in this sense. Nothing could be further from the idea of placing strange or distant things immediately before the eyes. The emphasis was on the mediation of tradition. The understanding

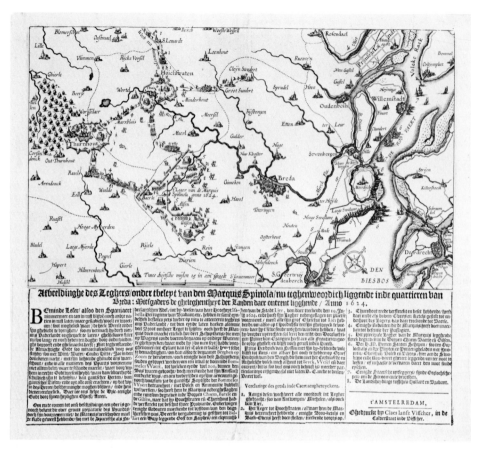

101. CLAES JANSZ. VISSCHER, *The Siege of Breda* (engraving), 1624. By courtesy of the Rijksmuseum-Stichting, Amsterdam.

of the mind, not immediacy to the eye, was the aim.

The record of history that we find on maps and in atlases of the seventeenth century is different in nature. First of all, places, not actions or events, are its basis, and space, not time, is what must be bridged. It is in this sense—if we limit ourselves to questions of historical representation—that Visscher's simple news map of the siege of Breda (fig. 101) can be usefully put beside the great painting by Velázquez (fig. 102). The power of the history painter's representation is partly derived from its relationship to a previous interpretation of a meeting. The surrender between gentlemen, which is surprising by its intimacy in the midst of a public occasion, was culled by Velázquez from Rubens's *Meeting of Jacob and Esau*. The gestures of greeting and also the famous lances reveal this. Despite the mapped background (Velázquez's art contained much of what I am considering as the northern mode), Velázquez presents a human relationship steeped in artistic tradition, which he further stages on the basis of the account of Breda given in a contemporary play. Visscher's map with accompanying text records the placing of Breda and the lineup of the army, and indicates relevant towns, churches, rivers, and

forests. He numbers with a verbal key below the places of interest. To record history in maps and their related illustrations is to emphasize certain aspects rather than others: history is pictured by putting before our eyes an enriched description of place rather than the drama of human events.

The belief that the historical enterprise should be terse, factual, and non-interpretive, in short descriptive in the way in which we have been using the term throughout this book, is not unlike Bacon's notion of natural history. But while Bacon clearly reserved this notion for what he called the "deeds and works of nature," the Dutch mapped history extends it also to the deeds and works of man. In the Netherlands of the time the humanist and rhetorical mode of historical narration was under assault from revisionists who wanted history to have a firm factual basis. References are made to the blind super-stitions of the past: the Catholic Church and monastic chronicles with their miracles were particularly suspect. Kampinga in his fine study of sixteenth- and seventeenth-century Dutch historiography offers numerous examples of this phenomenon.[45] As early as Dousa's *Hollandtsche Riim-Kroniik* of 1591 the plea is made for eyewitness reports or writings. In the preface to his *Short Description of Leyden* (1672) Van Leeuwen calls on historians to cast off old prejudices and to look with what he calls "antenna eyes" at the naked truth

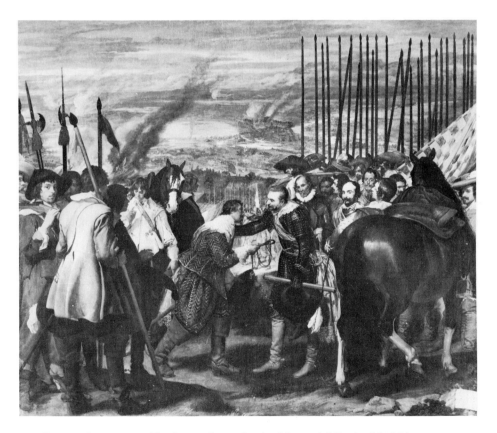

102. DIEGO VELÁZQUEZ, *The Surrender at Breda.* Museo del Prado, Madrid.

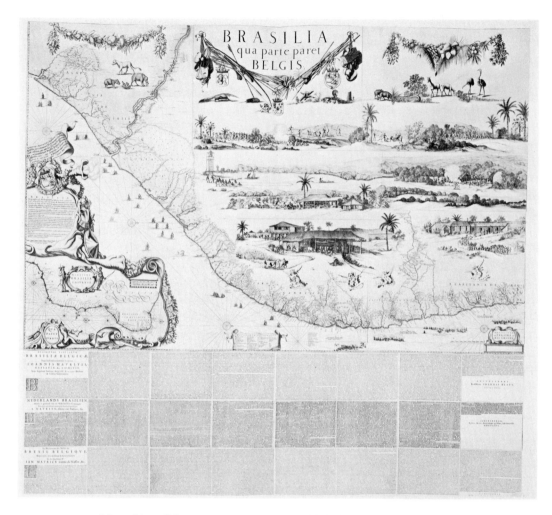

103. Map of Brazil by GEORG MARKGRAF, published by Johannes Blaeu (1647), Klencke
Atlas, pl. 38. By permission of the British Library.

seen in the clear and bright sun.[46] His words are interesting, for it is the same
tone and visual imagery that was invoked by Constantijn Huygens in his
Daghwerck. Huygens, as we saw in chapter 1, also pushed aside the historians
of the world in the interest instead of binding knowledge to the vivid appear-
ance of things seen. To the Dutch way of thinking, pictures, maps, history,
and natural history had common means and ends.

 This kind of descriptive, mapped history has two notable characteristics
(fig. 103). First, it presents a surface on which a great variety of information
can be collected: a map of the Netherlands features her cities at the side and
their coats of arms beneath with natives displaying their special regional dress
arranged above; Brazil is depicted with her settlements surrounding the land
on either side and views of natives at work that seem to extend into the paper.
Small items line up around the edges. Portraits appear on sheets layered onto

the original surface. Words and images mingle. The profile view of a harbor town, in a typical format, abuts the coastal land (of which it is part) viewed from above so that the page holds two contradictory views. Considered as images these maps are inventive and even playful and as such are conscious of their craft. It is a playfulness that is not unique. It is in fact almost a feature of Dutch art. The peep-box, for example, was a construction that also offered various views adding up to make a single world, as do the frequent mirrors or mirroring surfaces; still lifes obsessively topple containers and peel lemons, or cut pies or open watches to expose multiple aspects to view. One could go on. No single view dominates in the interest of this additive way of piecing together the world. There is in Dutch painting a pleasure taken in description that is akin to what we find in the world of maps.

Second, the mapped history can offer a detached or perhaps even a culturally unbiased view of what is to be known in the world. The Dutch record of their short-lived colony in Brazil is an extraordinary case in point. It is the pictorial, not the verbal records of the Dutch in Brazil that are memorable. They constitute "the most extensive and varied collection of its kind that was formed until the voyages of Captain Cook," as a recent writer pointed out.[47] The unprecedented team of observers or describers (if we may call them that) that Prince Maurits assembled included men trained in natural knowledge and mapping and also in draftsmanship and painting. The skills predictably overlapped and have not yet been sorted out to our satisfaction. They assembled a unique pictorial record of the Brazilian land, its inhabitants, the flora and fauna. The basic mode was portraiture of previously unknown or unprecedented things. Albert Eckhout produced the first full-length paintings of native Brazilians (fig. 104). They are unusual not only by virtue of their scale but also because of the care with which he records their bodily proportions, skin color, dress, accoutrements, and social and natural setting. An Eckhout portrait constitutes an ethnography or a human map, as a commentator has put it, and with good reason. Such an interest in description must be set against the fabulous accounts of the New World that were still in vogue. It was these, not the Dutch descriptions, that continued to fascinate Europe.

And therefore the story of Prince Maurits's descriptive enterprise ends sadly. Aside from Markgraf and Pies's basic handbook on the natural history of Brazil illustrated by new woodcuts, there was no dissemination or absorption of these materials. Maurits himself upon returning home quickly readapted to the international court world in which he had been raised. He devoted himself to building houses and designing gardens largely in the court mode of the day using his collection—both of images and objects—as gifts with which to enhance his social position. He did put some Brazilian natives on the frescoed walls of his new house in the Hague, but the assemblage seems to have been part of the indigenous and lofty European theme of the Four Parts of the World. Eckhout's portraits turn up in a painting entitled *America* by the Antwerp court painter Jan van Kessel (fig. 105). What Eckhout had described with such discretion, with such a sense of its difference from what

104. ALBERT ECKHOUT, *Tarairiu Man,* 1641. Department of Ethnography, National Museum of Denmark, Copenhagen.

he knew, is here possessed, triply so, by European culture: the interest in mapping the native is absorbed into the allegorical theme of the Four Parts of the World of which America is one—the world, in other words, as structured by European thought: the Brazilian Indian (a noble savage?) is reshaped in the image of the *David* of Michelangelo. All this in turn is presented in the form of the collectibles of a court because the room Van Kessel depicts is a *Kunst-kammer.*

There is much more to be said about Maurits's pictorial records of Brazil. But even a brief look at their nature and their fate helps us isolate some of the impulses that went in to the making of images in Holland—impulses which I think have deeply to do with mapping as a basic mode of Dutch picturing.

The images and explanations that crowded the surface of individual maps poured over onto further sheets, the sheets multiplied to fill the volumes of an atlas (which in the case of a wealthy private patron like Van der Hem could grow to as many as forty-eight volumes), and they finally extended so far that they could no longer be bound and so they constituted separate collections.[48] There is truly no end to such an encyclopedic gathering of knowledge. We

105. JAN VAN KESSEL, *America,* 1666. Alte Pinakothek, Munich.

find atlases catalogued under a number of headings in book inventories at the time—as mathematics, geography, art, or history. Though a careful study might suggest a historical sequence, the sum suggests that their nature made their designation at once flexible and uncertain. The historical atlas, as Frederick Muller (who collected a great one himself) remarked, is a Dutch invention.[49] No other culture assembled knowledge through images as did the Dutch. Even today the Muller collection in Amsterdam or the Atlas van Stolk in Rotterdam are unique sources for our knowledge of Dutch history and art. But the historians who so often go to Rotterdam to find illustrations for their texts have not stopped to ask why such useful illustrations are available in the Netherlands.

VII

We can now return with fuller understanding to the splendid wall-map to which Vermeer gave a central place in his *Art of Painting* (fig. 62; pl. 2). Blaeu's praise for the map that brings knowledge of history into the house is realized here before our eyes. This map, which we recognized before to be like a painting, is also a version of history. Vermeer confirms this for us in the female figure he placed just before it, the figure whose image he is beginning to enter on his canvas as the object of his art. Draped, wreathed with bay,

106. JAN VERMEER,
*The Art of
Painting*, detail
(model's head).
Kunsthistorisches
Museum, Vienna.

bearing a trumpet and book, the young woman is decked out as the figure of
History according to a recipe provided by Ripa. She serves as an emblematic
label placed diagonally across the map from the word "Descriptio": together
these two signs, the woman and the word, set forth the nature of the mapped
image.

We do not think of Vermeer as a history painter. After his first works he
turned away from the tradition of narrative subjects. The argument that this
depiction of history's Muse shows that, despite his own art, he still honored
the noblest art in the traditional sense is unpersuasive. His concentration on
the domestic world of women attended by men excludes the public stage on
which history in this sense takes place. The map in the *Art of Painting*
confirms this domesticity. Far from threatening the domestic world, this
pictured map takes history in to inform it. It is as if History raises her trumpet
to praise such descriptive painting.

But to conclude with the map alone is not to do full justice to its place in
Vermeer's *Art of Painting,* of which it is only a part, albeit a central one.
Consider how Vermeer not only relates but also compares Clio and the map.
He has juxtaposed two different kinds of pictorial images—one, the figure of
a young woman as Clio, an image replete with meaning calling for inter-
pretation; the other the map, an image that functions as a kind of description.
How does an image comprehend the world, Vermeer makes us ask, through
an association of meanings (art as emblem) or through description (art as
mapping)? As we step back from what is before the painter—the woman and

107. "Geographia" and "Chorographia" in PETRUS APIANUS, *Cosmographia* (Paris, 1551). Princeton University Library.

the map—to view the artist and the world of which he is part, we too are suspended between seeking meanings and savoring lifelike descriptions.[50]

The emblematic figure, Vermeer acknowledges, is but one of his familiar models dressed up to represent History. She poses, taking on a role. On the table the fabrics, books, and the mask—whatever they might be said to mean—are the very materials out of which an emblematic identity is composed. They are discarded or perhaps waiting to be assumed. Vermeer juxtaposes the face of the woman with the map (fig. 106). Her eyes, nose, mouth, her curls are placed beside the bridges, tower, and buildings of one of the small town views, while behind her head lies the Netherlands. The mapping of town and of country are compared to the delineation of a human visage. This may be the most extraordinary painterly transformation of all. For it recalls those simple woodcuts (fig. 107) with which Apianus illustrated Ptolemy's analogy between describing the world and picturing a face. But Vermeer disclaims any identity. In contrast to Ptolemy and Apianus, Vermeer distinguishes the human presence from map or city. He shows instead that inscription and craft, like emblematic accoutrements, give way before the flesh of a human presence.

But that is not final, for craft is richly present in this painting. A crafted world surrounds both artist and model, who are introduced by a tapestry, backed by a map, crowned by a splendid chandelier, and richly robed. Craft subtly transforms and shapes observation. Observation is in fact revealed to be inseparable from craft. The leaves resting on the model's head are both

reconstituted by the painter's brush and transformed in threads high on the foreground tapestry. There too they grace a female figure, though one woven in cloth—the only legible human form in the tapestry. The golden band on the woven woman's dark skirt recalls, though in reverse, the pattern and colors of the skirt of the artist's Muse. A woman too is subject to fabrication (fig. 108).

Vermeer signed the map and paints the woman. The eroticism of his earlier works—where men wait attentively upon women—is absorbed here into the pleasure of representation itself, which is displayed throughout the painting. Vermeer withdraws to celebrate the world seen. Like a surveyor, the painter is within the very world he represents. He disappears into his task, depicting himself as an anonymous, faceless figure, back turned to the viewer, his head topped by the black hole of his hat at the center of a world saturated with color and filled with light. We cannot tell where his attention is directed at this moment: is it to the model or to his canvas? Observation is not distinguished from the notation of what is observed. That is the grand illusion that the picture also creates. It represents an *Art of Painting* that contains within itself the impulse to map.

108. JAN VERMEER, *The Art of Painting*, detail (figure of woman in tapestry). Kunsthistorisches Museum, Vienna.

5

Looking at Words:
The Representation of Texts
in Dutch Art

Dutch paintings, surprisingly for such realistic images, are at ease with inscribed words. There are inscriptions in painted books whose pages are often quite legible, on papers, on maps, woven into cloth, on boards or tablets, on virginals, on walls (figs. 109, 111, 113, 116, 132). The words can have been previously inscribed on a surface that is depicted—as in books or virginals—or they may be presented as added labels, or frankly inscribed by the artist with his signature. But in each case a continuity is demonstrated between rendering the visible world and reading words. These inscribed texts, rather than existing prior to the work as motives for picturing—a story to be evoked, a theme to be presented—are themselves made part of the picture. Vermeer's *Art of Painting,* at which we have just been looking, is the supreme example of a common phenomenon.

I called this surprising because, with the exception of the painter's signature, we do not normally expect words to intrude on the picture itself.[1] Western art since the Renaissance differs in this from other major traditions, such as the art of China and Japan. A clear distinction is made between visual representation and verbal sign. It is not that texts are unimportant in Renaissance art, but they exist prior to and outside of the confines of the image itself. Images serve as a kind of mnemonic device.[2] A painting so conceived recalls a significant text and makes its substance—but not its surface—present to the eyes. Texts in this tradition are invoked by a picture, but words are not represented in it.

It has been a major theme of this study that the Dutch art of describing stood apart from this kind of verbal grounding. The appeal to the eye, to knowledge, and to craft suggests alternatives to a textual basis for the invention of and trust in images. Like so many aspects of Dutch art this phenomenon of looking at words has a modern ring about it. It is a recognized mark of the art of our own century that it disrupts the traditional Western distinction between text and image. Picasso's *Ma Jolie,* Klee's *Einst dem Grau der Nacht,* Magritte's *Ceci n'est pas un pipe,* and the *Alphabet* of Jasper Johns

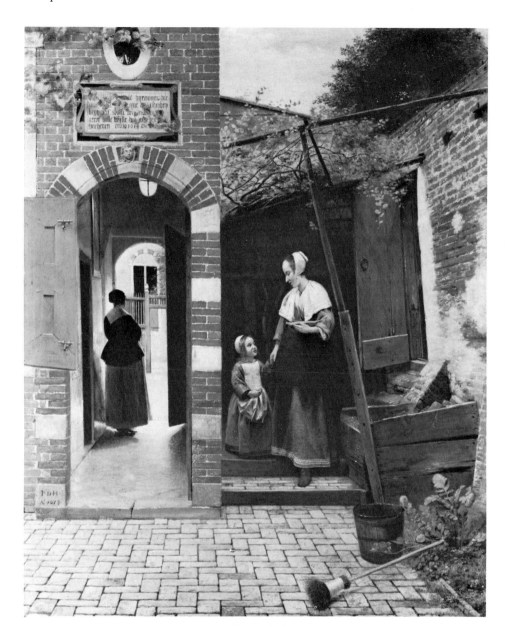

109. PIETER DE HOOCH,
*The Courtyard of a
House in Delft*, 1658.
By permission of the
Trustees of the
National Gallery,
London.

110. PIETER DE HOOCH,
detail of fig. 109
(tablet with
inscription).

111. BARTHOLOMEUS VAN
DER HELST, *The Four
Archers of the St.
Sebastian Guards*,
1653. By courtesy of
the Rijksmuseum-
Stichting, Amster-
dam.

112. BARTHOLOMEUS VAN
DER HELST, detail of
fig. 111 (blackboard
with inscription).

all call attention to the common representational status of word and image. What are we to make of this similarity? Its recognition, first of all, serves as a kind of warning. It can perhaps help to save us from the commonest and most misleading claim made by students of modernism, to the effect that there is a clear before and after: that art or texts as we know them now date from the nineteenth century. Yet on the other hand it will not do to claim the Dutch art of describing for modernism. In the modernist mode the inclusion of words with images has the function of celebrating the new and unprecedented making that is a picture, while at the same time, and often in the same work, acknowledging the ineluctable absence of what can only be present in signs. It is an ironic and decontructive pictorial mode. Dutch art, on the other hand, comes out of a tradition that had long permitted words and images to join and jostle each other on the surface of an illuminated manuscript and then a printed page. Far from mistrusting or deconstructing the making of pictures, the Dutch in the seventeenth century grant them a privileged place. Images are at the center of human making and constitute an attainment of true knowledge. The moral, then, is that we must be careful to make distinctions.

The question I want to address in this chapter is what happens to words and texts given the Dutch notion of a picture. I have divided the answer—which leads in unexpected directions—into three parts: inscriptions; the representation of texts as letters; and the captions implicit in narrative works.

I

A central figure in the use of inscriptions is Pieter Saenredam. His finely observed and meticulously rendered portraits of Dutch churches are richly and variously inscribed. He depicts the late Gothic church of Saint Odulphus at Assendelft, for example (fig. 113), stripped of its ecclesiastical art, not animated by human events, its white walls reflecting the daylight let in by windows of clear, uncolored glass. It is laid out before our eyes on the panel as an architectural panorama. We might contrast this portrait mode with Rubens's altarpiece of Saint Ignatius Loyola (fig. 115), in which the church instead becomes the setting for a miraculous theater. Except for the preacher just visible in the distance and the mourning tablets to the right, almost the only articulation is some inscriptions. On the choir pew at the left Saenredam, in the manner of his study drawings, notes the name of the church and the date of the painting. This documentation is not part of the depicted world but rather added, as on the surface of a drawing, though contained by the edges of the pew. To the right on a great stone structure an inscription in Gothic script identifies the tombs of the lords of Assendelft. Though styled to fit the Gothic church it also is clearly added by the artist. Finally, at the bottom of the panel, reversed to our view, a tombstone set into the pavement of the church reads "JOHANNIS SAENREDAM SCULPTORIS CELEBERRIMI . . ." (fig. 114). This is the tomb of the artist's father, an engraver who had died in 1607 when Pieter was only ten. The representation of the inscribed stone of the tomb in the church is Saenredam's curiously self-effacing manner of com-

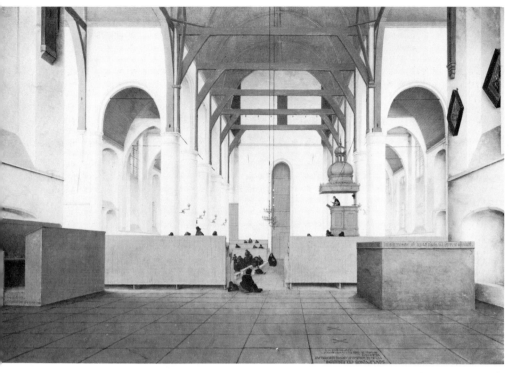

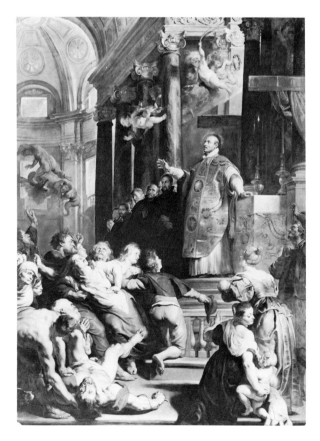

PIETER SAENREDAM, *Interior of the Church of St. Odulphus in Assendelft,* 1649. By courtesy of the Rijksmuseum-Stichting, Amsterdam.

PIETER SAENREDAM, detail of fig. 113 (tomb inscriptions).

PETER PAUL RUBENS, *The Miracles of St. Ignatius Loyola.* Kunsthistorisches Museum, Vienna.

memorating his dead father. The inscribed tomb commemorates by visibly naming. It does not attempt to recreate narratively or to present allegorically the events and concerns of a life lived or the relationship of the son to them. We find a similar use of inscribed words to commemorate the dead in Pieter Steenwyck's *Allegory on the Death of Admiral Tromp* (fig. 116). The late admiral's portrait and the title page of his funeral oration represent the life whose achievements are not rendered. In contrast we can look at Tromp's tomb itself in the Old Church in Delft (fig. 117). The recumbent Tromp is surrounded with images including sea deities and festoons of trophies. But we also find the sculptured relief of a naval battle that narrates a triumph of his life at sea. The still-life painting is clearly part of a vanitas tradition. The snuffed-out candle, books, sword, globe, and laurel wreath are all conventional references to the passing nature of achievements and possessions of this earth. But the normally anonymous theme is turned into a form of documentation by fixing the name and face of the hero in the company of transient things. In both commemorative inscriptions, that of the tomb and that of the title page, the pictured world instead of inviting further interpretation is inscribed with a meaning that is visible on the surface.

Saenredam is acutely aware of the status and role of the inscriptions within

116. PIETER STEENWYCK, *Allegory on the Death of Admiral Tromp.* Stedelijk Museum "de Lakenhal," Leiden.

117. The tomb of Admiral Tromp, Oude Kerk, Delft. Dutch State Service for the Preservation of Monuments.

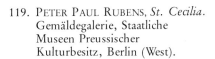

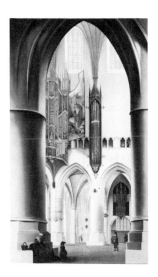

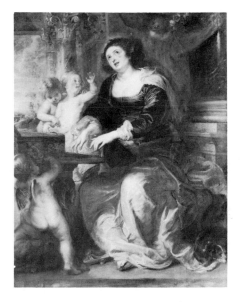

118. PIETER SAENREDAM, *Interior of the Church of St. Bavo in Haarlem*, 1636, detail (inscription on organ). By courtesy of the Rijksmuseum-Stichting, Amsterdam.

119. PETER PAUL RUBENS, *St. Cecilia*. Gemäldegalerie, Staatliche Museen Preussischer Kulturbesitz, Berlin (West).

his work. He calls attention to them by providing lookers. We recall the small figure of a man standing in a painting of Saint Bavo and raising his eyes to the organ above. His eyes direct ours to the image of the resurrected Christ on the shutter and to the golden words inscribed below (fig. 118) which invoke the music of the hymns: "nde zangen en geestelycke liedekens" is part of a longer biblical passage reading, "teach and admonish one another in psalms and hymns and spiritual songs." By means of his extraordinary passion for crafted description (the golden letters are fashioned out of gold leaf) Saenredam introduces the image and the organ music that the Protestant church had excluded from its worship in the form of a representation.[3] The worship of God through music is given a singularly nonnarrative and even, one might say, a disembodied form here. This point is brought home if we compare Saenredam's praise of hymns here to Rubens, who in rich colors and glowing flesh-tones presents an ecstatic Saint Cecilia playing the virginal with her eyes raised toward heaven (fig. 119).

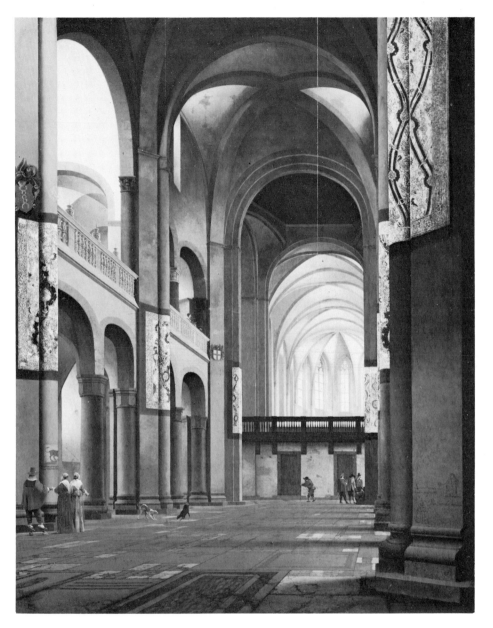

120. PIETER SAENREDAM, *Interior of the Mariakerk in Utrecht,* 1641. By courtesy of the Rijksmuseum-Stichting, Amsterdam.

We find something similar in the manner in which Saerendam identifies and places himself in his works through his signature. There are several instances in which his naming of the church, his name, and the date of his painting's execution are inscribed as graffiti on a church wall. In a painting of the Mariakerk, Utrecht (figs. 120, 121), the inscription is grouped with three small figures that are scrawled on the foreground pillar in the same ink or chalk. Like the figures to which it is bound, it is executed in three colors—

121. PIETER SAENREDAM, detail of fig. 120 (inscription on
 pillar, right foreground).

ochre, black, and white—and in three hands that divide it in such a way as
to suggest a series of graffiti done over time:

> Dit is de St Mariae kerck binnen uijttrecht [ochre]
> Pieter Saenredam ghemaeckt [black]
> ende voleijndicht den 20 Januarij int Jaer 1641 [white]

The effect of the different hands, the colors, and the division is to bind
Saenredam's writing of the inscription to drawings of the least tutored kind.
There is an anecdote told by Vasari that Michelangelo once demonstrated his
superior skill by being able to mimic the art of a child.[4] Saenredam's intent
is quite the opposite. Far from claiming special knowledge for himself, the
Dutchman instead exhibits the relatedness of all kinds of drawing—trained
and untrained, image and script. The form and position of the graffiti-
inscription also characterize or place the artist in another way. By locating
himself within the church as the one who has marked the wall with graffiti,
Saenredam subtly undercuts his priority as the creator of the picture. This
device is related to the designation of eye points and the positioning of
"lookers" in the picture, which we discussed in chapter 2. Saenredam's aim
in diminishing his role as creator is to give priority to the documentation of
the church seen and thus to present the picture itself as a document of a
particular kind.

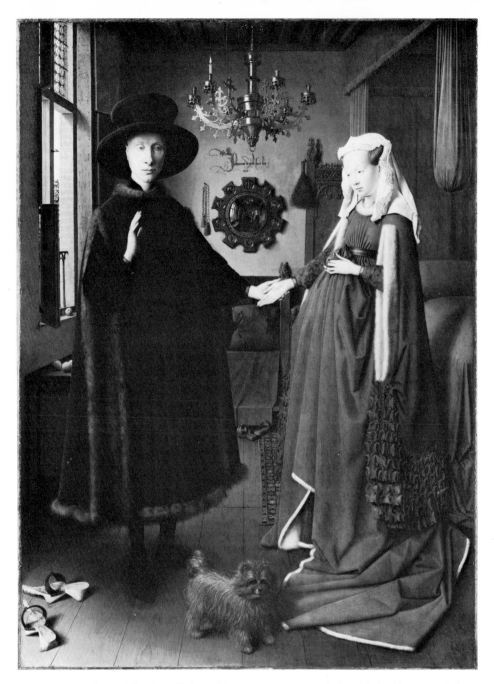

122. JAN VAN EYCK, *The Arnolfini Wedding*, 1434. By permission of the Trustees of the National Gallery, London.

The artist's use of the inscribed signature to establish his presence within the work and to turn the portrayal into a document is not Saenredam's invention. It dates back in northern art at least to Van Eyck's Arnolfini portrait (fig. 122). Van Eyck wrote "Johannes de eyck fuit hic" on the wall in a fine calligraphic hand to testify that he was there, a witness to the couple's marriage. This famous picture is unique as a marriage document. But with the help of Saenredam in particular and our sense of seventeenth-century Dutch

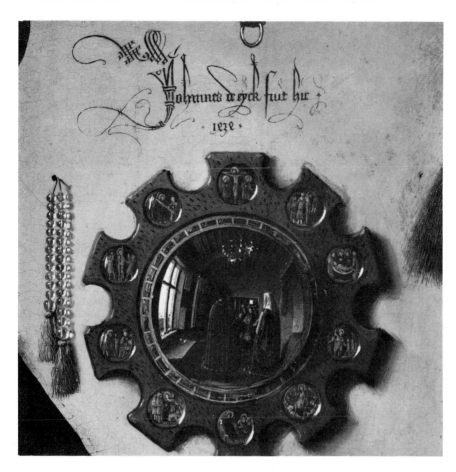

123. JAN VAN EYCK, detail of fig. 122 (inscribed name and reflected image of the artist).

art in general, we see that it is also paradigmatic of the nature of much northern picturing. For like the painters of landscapes and still lifes, Van Eyck bears witness to or documents a world that is prior to him rather than laying claim to be the creator of a new or second one. In Van Eyck's painting this is acknowledged not only by the inscription but also by the image of the artist reflected in the mirror on the wall just below it (fig. 123). It would take us too far afield from Saenredam and inscriptions to deal fully with this device. Suffice it to say that it too has an extensive history in the north. (The artist at his easel occurs as a reflection in the armor of Saint George in Van Eyck's Van der Paele altarpiece (fig. 11), in a jewel of God the Father's crown in his Ghent alterpiece, and in the surface of objects in a number of still lifes in the seventeenth century [figs. 9, 10].) But the juxtaposition by Van Eyck of mirrored image and inscribed name deserves some comment in a chapter devoted to the word in northern images. The mirror is a *tour de force* of illusionism that reveals the Arnolfini couple seen from behind greeted by the tiny painter and his companion at the door to their chamber. It also doubles the presence of the artist as an internal witness: he is present in word (the inscription) and in image (the mirror). Considered as self-presentations (for that is what they are), neither reveals anything to us about the nature of the human maker. The artist's presence as a witness to the world described is

more important to the picture than his own nature. But the juxtaposition of these two signs of the artist's presence calls attention to the common function of a verbal and a visual sign. It returns us to the remarkable and confident equivalence between word and image that is our subject.[5]

The referential or symbolic force of inscribed words is somewhat spent as they take their place in the seen surface of the iconic image. This transformation has the effect of emphasizing the iconic or representational status of the picture. In this sense the look of an inscription is an important part of its role in a Dutch picture. In a number of paintings the pleasure of the look of the texts and the distinction between them is emphasized by juxtapostion much as it is in the various typefaces displayed in the printed emblem books of the time. A *vanitas* still life by Anthony Leemans, for example (fig. 124), plays off a printed frontispiece against a broadsheet and a handwritten poem against a paper displaying a stave of musical notes and an even more informally inscribed paper enclosing some tobacco. To all of this the artist added his signature on a piece of paper tacked below. Here, as in Steenwyck's painting, the heroic exploits of Admiral Tromp are given an inscribed presence in the broadsheet. The diversity of rendered texts vies with the diversity of accumulated objects. And any question of the painter's performance is held off, as it were, by the prominently inscribed tale of Apelles and the shoemaker, whose motto "Let a shoemaker stick to his last" (and not criticize the art of Apelles, which he does not understand) makes a modest but firm stand for art.

The Saenredam drawing with profile views of Leiden and Haarlem (fig. 125; pl. 4) juxtaposes them with the description provided by his calligraphic inscription at the top of the page. Our attentiveness to the look of the words—in particular the flourish above Haarlem at the left—is drawn out in the delicate outlines of the tree trunks that spread to fill the lower portion of the page. As background to all this lettering, we must remember the popularity enjoyed by calligraphy in Holland at this time.[6] A calligraphic tribute to one Nicholas Verburch suspends letters, which are set among flowering branches and fashioned out of mother of pearl, on the borderline between naming and picturing (fig. 126). A unique example of such play is the odd genre known as *penschilderij* or pen-painting (fig. 127). A board prepared as if for a painting is worked in pen and ink so that the world is rendered as a kind of written picture. We considered this earlier as an instance of the lack of a clear boundary between drawing and painting, to which we can now add writing. *Penschilderij* was usually employed in a documentary capacity. Willem van de Velde used it to record sea battles. This medium actually permits the writing of what is drawn, so that the entire world might be seen as if it were rendered as an inscription. Matham's description of the brewery and country house of the burgomaster Van Loo of Haarlem, with its lengthy inscription beneath, does just that.[7]

Objects come with their own verbal documentation. They make themselves visible in image and in word and the picture documents them by visibly naming the object. A good number of Dutch images document natural won-

124. ANTHONY LEEMANS,
Still Life, 1655. By
courtesy of the
Rijksmuseum-
Stichting,
Amsterdam.

125. PIETER SAENREDAM, *Profile Views of Leiden and Haarlem and Two Trees* (pen,
wash, and watercolor), 1617 and 1625. Kupferstichkabinett, Staatliche Museen
Preussischer Kulturbesitz, Berlin (West).

126. DIRCK VAN RIJSWICK, *Tribute to Nicholas Verburch*. By courtesy of the Rijksmuseum-Stichting, Amsterdam.

127. JACOB MATHAM, *The Brewery and the Country House of Jan Claesz. Loo* (pen on panel), 1627, detail. Frans Halsmuseum, Haarlem.

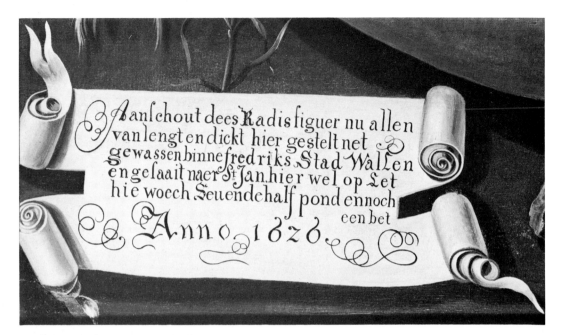

128. ANONYMOUS, Northern Netherlandish
School, *Radish*, 1626, detail (inscription).
By courtesy of the Rijksmuseum-Stichting,
Amsterdam.

ders or what Bacon would have called aberrations. One records a giant radish
found in Fredrickstaat (fig. 128). It was washed clean and weighed over seven
and a half *ponds*, as the inscription tells us. Another records two record-size
kidney stones whose date of removal is duly noted. A captured English ship
is portrayed with its history in battle set forth on a bit of paper illusionistically
stuck into its frame (fig. 129, 130). Though not a natural wonder, it is an
object worth special note. A herring is set forth for our delectation and
praised in an accompanying poem (fig. 131). In each instance word and image
combine to document the claim the object has on our attention without any
recourse to narrative entanglements: because of the instription the radish is
not dug up before our eyes, the ship is not embattled, the tasty herring is not
eaten.

Within this phenomenon of inscriptions we can also include the inscribed
virginals frequently found in the mid-century paintings of artists such as
Gabriel Metsu, Jan Steen, and Jan Vermeer (figs. 132, 133, 134). Even
instruments in Holland make themselves visible in words. It is a curious fact
of music history that it was particularly in the Netherlands (and I mean here
to include Antwerp) that instruments bore verbal inscriptions along with the

129. JERONIMUS VAN DIEST, *The Seizure of the English Flagship "Royal Charles."* By courtesy of the Rijksmuseum-Stichting, Amsterdam.

130. JERONIMUS VAN DIEST, detail of fig. 129 (inscribed document).

131. JOSEPH DE BRAY, *In Praise of Herring*, 1657. Städisches Suermont-Ludwig Museum, Aachen. Phot. Ann Münchow.

132. GABRIEL METSU, *Woman at the Virginal.* Museum Boymans-van Beuningen, Rotterdam.

normal decoration of scrolls and pastoral scenes.[8] They are represented in Dutch paintings as are other objects—maps, organ stalls, books—with their own verbal documentation. The range of inscriptions is limited. They either praise music as soothing or quote the psalmist's injunction to praise God with every breath. These suggest rather different attitudes toward music performed in the home, but they are used quite interchangeably. Metsu casually represents a virginal bearing the psalmist's words both in a work that seems to have no erotic overtones as well as in two that most obviously do (figs. 132, 133). The inscription, in other words, does not seem to be providing an interpretive key to the painting. This goes against the iconographers' assumption, but it should come as no surprise after what we have seen of the proliferation of words in Dutch images. In the fine Metsu in London (fig. 133) the young woman at her music lesson has turned to offer some music to the young man, who in turn offers her a drink. Does she want it? Should she? Should he offer it? The painting hardly seems to consider these questions. The relationship of the two is as unstated as is our relationship to the work. The inscription—"Praise God with every breath"—is placed just under the dimly visible picture, whose curtain drops in subtly to overlap and cast a shadow near the words. The picture on the wall, identified as an early work of Metsu's own rendered in reverse, depicts the Twelfth Night feast. Poised above the proffered drink we find a representation of the Bean King, who drinks raucously but with the sanction of a religious feast. The inscribed words to praise God with every breath seems to take their place not as an injunction but as one representation among others: the couple at their flirtatious play, the picture of the raucous feast, the landscape painting on the wall. They are

133. GABRIEL METSU, *Duet*. By permission of the Trustees of the
National Gallery, London.

interlocked, even overlapping, but without any clear hierarchy or ordering.
They add up to a world, but as we have seen in other cases of Dutch paintings
they do not presume to order the world.

I have been at some pains in the course of this brief survey to suggest the
conditions under which texts are given what we might call separate but equal
place in Dutch pictorial representations. Rather than supplying underlying
meanings, they give us more to look at. They extend without deepening the
reference of the works. Again and again the words stand for, or to put it
precisely, represent what would in another art and another culture be pic-
tured as dramatic enactments of self or society. Saenredam's devotion to his
father or the heroic escapades of Admiral Tromp are described, not narrated.
It is the artists themselves, and most particularly Vermeer and Rembrandt,
who are acutely aware of the insistence of this kind of visual presence and its
curious lack of meaningful depth.

Vermeer confronts the limitations of the art and learns to accept them. The circumscribed nature of any representation, the partiality of what we are given to see in an inscription, a face, a picture, or mirror is basic for him. In his *Music Lesson,* now in Buckingham Palace (fig. 134), a man is attendant on a woman, his pupil, who is standing at the virginal. A mirror beyond her on the wall reflects part of the room and the woman's face turned slightly, however, toward the man. On the wall to the right we see a piece of a picture, which depicts the scene known as the Roman Charity: a bound male prisoner, Cimon, leans forward to suck for sustenance at the breast of a charitable woman, his daughter Pero. This man, like the attendant teacher, is dependent on a woman. The inscription on the virginal reads "Music is the companion of joy, the medicine of sadness." The inscription is one of four ways of representing—but also one of four versions of—the relationship between the man and the woman at the virginal (fig. 135). Each one is presented as partial, not just in respect to the others but because each is cut off from total view: the "real" woman is visible only from the back; her face, held in a different position, is reflected in the mirror; the picture on the wall is severely cut by the frame; the words inscribed on the virginal are hard to make out (compared to the clarity of the Metsu) and are further interrupted by the figure of the woman. The words are hard to see because this painting creates distance, admits light and even paint. Representation here does not add up to and confirm a world, as did Metsu's picture. It rather renders the appearance of the world as ungraspable. Vermeer repeatedly thematized this truth in his works as the ungraspable presence a woman offers a man.

Vermeer presents the image as all we have. Rembrandt, deeply the iconoclast, rejects the very conditions of such knowledge. Books, for example, appear often in Rembrandt's painting and they are painted with loving care, as in the portrait of the preacher Anslo and his wife (figs. 136, 137). The books glow in a golden light with thick bindings and opened pages suggesting the riches contained within. We do not, however, see any inscribed words or pictures. We might contrast in this respect a pair of portraits, probably of Rembrandt's mother. Rembrandt and his pupil Gerrit Dou each depicted an old woman engaged in reading a book (figs. 138, 139). Dou's woman peers intently at the illustrated page of what has been identified as a Dutch *perikopenbuch* —a Catholic lectionary containing excerpts from the Gospels and Epistles. We are invited to look with her at what is clearly inscribed as Luke, chapter 19, intended for reading on the day of the consecration of the church (fig. 138).[9] The reader and the surface of the page are clearly and steadily lit. To see the text is to know it. And looking at the text is like looking at the image that illustrates it. In Rembrandt's version the emphasis is quite different. The text is not legible except for perhaps two letters, just enough to reveal the writing to be in Hebrew, the language of God (fig. 139). There are no illustrations and the reader, cast in shadow, seems to relate to the book more by the touch of her hand than with her eyes. To generalize the differences: while other Dutch artists offer us visible texts, Rembrandt insists that

134. JAN VERMEER, *The Music Lesson*. Buckingham Palace. By permission of Her Majesty the Queen.

135. JAN VERMEER, detail of fig. 134 (inscription, mirrored image, and picture).

136

137

136. REMBRANDT VAN RIJN, *Anslo and His Wife*, 1641.
Gemäldegalerie, Staatliche Museen Preussischer Kulturbesitz,
Berlin (West).

137. REMBRANDT VAN RIJN, detail of fig. 136 (books).

138. GERARD DOU, *Rembrandt's Mother*. By courtesy of the
Rijksmuseum-Stichting, Amsterdam.

139. REMBRANDT VAN RIJN, *An Old Woman* (perhaps
Rembrandt's mother as the prophetess Hanna). By courtesy
of the Rijksmuseum-Stichting, Amsterdam.

138

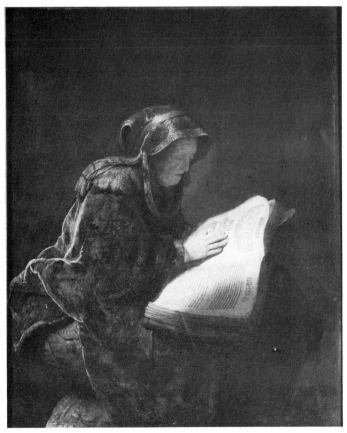

139

it is the Word within and not the surface of the texts that must be valued. Therefore, with the exception of the design for one uncompleted allegorical work, *The Concord of the State* (Rotterdam), and the superscription in Hebrew, Latin, and Greek placed above an early crucified Christ, the only words Rembrandt inscribed in a painting are the Hebrew words transmitted by God on the tables of the law held aloft in the *Moses* (Berlin), and the Hebrew characters written by the hand from heaven that appear in *Belshazzar's Feast* (London). His art shows a determination to define and deal with what texts, as conceived in Dutch painting, normally leave out.

II

Our initial question, we recall, was what happens to texts in Dutch pictures. Our second group of examples concerns one of the most unusual and popular kinds of painted texts in Holland—the letter. There is something strange and unpromising about paintings of people reading, writing, and receiving letters. The painter would seem to be invading the writer's territory with little hope of competing. And there is also something fugitive about considering letter paintings as the representation of texts, since the viewer of the painting is not permitted to read any of the words. But it is just this fugitive quality that makes them of interest. They place visual attention and absence of deeper meaning in a special light and can therefore profitably be seen as a special case of the inscriptions we have just looked at. The letters are commonly the object of attention within the painting, but we do not see the contents and those who do do not reflect it in their demeanor. For all the visual attentiveness required, an essential content remains inaccessible, enclosed in the privacy of the reader's or writer's absorption in the letter. As we shall see, this interpretation actually corresponds to the lore, the use, and the fascination with letters as we know it from a variety of sources at the time.

Letters had, of course, occurred as a motif in painting before. They were commonly delivered to or held by male sitters in portraits. We can take Thomas de Keyser's *Constantijn Huygens* of about 1627 (fig. 1) as an example. In Holland, in particular, a few letter paintings like Dirck Hals's 1631 *Lady Tearing a Letter* (fig. 140)[10] have been connected to a specific emblematic tradition concerning the joys and sorrows of love. But we are concerned here with a burst of interest in letter writers and readers of Gerard ter Borch, Metsu, and Vermeer. A man, or for the first time frequently a woman, often alone in an interior or with an accessory figure of the postman, a servant, or friend, writes, reads, or receives a letter. Starting as a social event, like that in Ter Borch's *Postman Delivering a Letter* in Leningrad, the works move to concentrate on the writing or reading of the letter. Ter Borch's single female writing figure dates from 1655 (fig. 141), a reader from perhaps 1662 (fig. 142). The theme culminates in the well-known letter readers by Vermeer of the late 1650s and 1660s.

Although we do not see their texts, it has convincingly been argued that their subject is love. What were considered entertaining anecdotes by

140. DIRCK HALS, *Lady Tearing a Letter,* 1631. Mittelrheinisches
Landesmuseum, Mainz.

nineteenth-century writers on art tend to be interpreted by scholars today as
cautionary tales. In the case of works like the Dirck Hals paintings, which are
connected with emblematic material, it has been suggested that they are
warnings against love. Several overlapping explanations have been offered of
the vogue for this love-letter theme. They bear on these images in a variety
of ways. A love emblem of Otto van Veen dating from the first decade of the
century shows cupid as a postman with an accompanying inscription to the
effect that he brings joy from an absent lover.[11] This connects letters with
love, although the image in no way looks like a Dutch painting. An illustra-
tion accompanying a printed play by Krul—one of a mélange of texts assem-
bled in his *Paper World* of 1644—comes closer in this respect: a man sits at
his desk to write a letter and is torn, so the text explains, between the urging
of love to write (Cupid is standing by) and the restraints brought on him by
jealousy.[12] The letter paintings also coincide almost exactly in date with a
fashion for epistolary manuals like *La Secrétaire à la Mode* of Jean Puget de
la Serre, which was printed nineteen times in Amsterdam between 1643 and
1664 and was also translated into Dutch.[13] The manuals had originated as a
method of teaching children to write through epistolary models. In the sev-
enteenth century they evolved into a kind of courtesy book for adults in
which the love letter was among the accepted categories. Training in the
composition of such letters was reinforced by the great interest in penmanship
in Holland. Both skills, the composing and the penning of letters, were often
under the direction of the ubiquitous French schools, frequent teachers of the
wealthier Dutch. The literary fad had a real-life counterpart in the popularity
of letter-writing itself. There is indeed a question as to whether the pictures

141. GERARD TER BORCH, *A Lady Writing a Letter.* Mauritshuis, The Hague.

document social behavior—the activities of a society actually engaged in the writing and reading of letters—or illustrate the literary fictions created in the manuals. There is perhaps no simple answer. In Dutch picture-making, certain themes tend to assume prominence when actual social rituals coincide with established fictional or artistic forms.[14]

Love, then, is in the air in these letter pictures. Or to be more precise, it is inscribed in the letters that are the center of attention. There is much that remains to be learned about the literary and social circumstances of such love play as this in Holland. But the particular question we want to address has to do with the pictures: How do they represent the letters? The answer to this question in not without its own social implications.

142. GERARD TER BORCH, *A Lady Reading a Letter.* Reproduced by permission of the Trustees, the Wallace Collection, London.

A man's letter on the subject of absence reads:

> I lead such a sad life since you departed. . . . So I must tell you, that after losing appetite and peace of mind, I pass whole days without eating and nights without sleeping.

> [Je meine une si triste vie depuis le jour de vostre depart. . . . Je vous dirai donc, qu'après avoir perdu l'appetit & le repos, je passe également les jours entiers sans manger & les nuits sans dormir.]

To which a lady might reply.

> If it were in my power to console you with my presence, for the ills my absence is making you suffer, you would see me now instead of this letter.

But as I am constrained by a father and mother who do not give me so much as the liberty to write you, it is all that I can do to take that liberty in order to console you with the expectation of my return. Please believe that I wish for it ardently.

[Si j'avois le pouvoir de vous consoler par ma presence, des maux que mon absence vous fait souffrir, vous me verriez maintenant au lieu de cette lettre. Mais estant sous la servitude d'un père at d'une mère, qui ne me donnent pas seulement la liberté de vous écrire, c'est tout ce que je puis faire que de la prendre pour vous consoler de l'esperance de mon retour, vous pouvey bien croire que je le souhaite avec passion. . . .][15]

Reading conventional narrations such as these of lovers' situations and feelings, one is struck by the absence of expression in the pictures. Ter Borch's women (and men) are calm, poised figures who look at their letters with no suggestion of inner unrest. While recognizing the link between these pictures and the epistolary manuals it is also necessary to distinguish the pictorial tradition from the textual one. The letters in the manuals provide the framework for narrative and initiate the literary tradition of the early epistolary form of the novel. The letters expand and eventually break through their epistolary frames to permit the progress of love to become the subject of extended narrative texts. The pictures depict the form that social intercourse took, but serve as a device that permits the Dutch artist to avoid its narrative dimensions. We know the subject is love only by the attention to the epistolary surface. Both representations—the letters in the manuals and the painted ones—define a private human space. But while the novel makes the world of private passions accessible, the Dutch painters depict women absorbed in the perusal of a correspondence that is closed to us. It is clearly represented as an isolating affair.

What is suggested in the pictures is not the content of the letters, the lovers' feelings, their plans to meet, or the practice and the experience of love, but rather the letter as an object of visual attention, a surface to be looked at. The attention that Ter Borch's woman directs at the letter's surface replicates the way in which we as viewers of the picture are invited to attend to various surfaces displayed: the pearl at her ear and its blue bow; the curls of hair; the fringe of the carpet; the pillow in the corner. The attention to all of this (a consistent concern as we have seen of the "fine" painters of the mid-century), is restated by the woman herself. This is another version of the visual attentiveness we have already seen bound to notions of education and leading to knowledge of the world. But here, since what is being attended to is a letter, or someone looking at a letter, there is a vacuum at the center. The letter stands in for or represents events and feelings that are not visible. Letters, as Otto van Veen put it neatly (quoting Seneca), are traces of love.[16]

In his Beit *Woman Reading a Letter* (fig. 144), Metsu frankly acknowledges and plays with the representational character of the letter by placing it among other representational surfaces. There is something of the air of a

demonstration piece about this painting. Any anecdotal interests the artist might have had are overwhelmed. The work is concerned with visual attention. It juxtaposes different ways of making present things that are absent: the letter, a picture on the wall, and a mirror. Metsu devises ways of emphasizing the act of looking. The lady turns her attention from the working of the embroidered surface on her lap to the letter. Her absorption is marked by her thimble, which has tumbled to the floor. She tilts the letter toward the light of the window to try to see it better; the maid lifts the curtain to get a look at the painting and is herself looked at by the little dog. The mirror, solipsistically, is enfolded into itself, reflecting only the grid of the adjacent window panes. The partial nature of what presents itself to view—the picture half-curtained, the letter turned to the light, the mirror reflecting its mirroring capacity—increases our attentiveness but seems in no way to call looking itself into question. Seeing is specifically related to representations of what is beyond this interior. It is related to the world from which the letter has come. Indeed, the envelope is still in the hand of the maid who delivered it. But Metsu resolutely concentrates on present surfaces. The letter is a surface looked at and it leaves the woman unmoved. This is in contrast to works such as the letter picture by Dirck Hals done earlier in the century (fig. 140). The stormy sea in the painting on the wall refers to the storms of love, which are in turn reflected in the behavior of the woman who is tearing up her letter. In Hals's handling of the letter theme, as in the painting itself, which displays none of Metsu's fine workmanship, surface is *not* what counts.

It is only outside the Beit *Woman Reading a Letter,* in its pendant depicting a man writing a letter to the woman (fig. 143), that Metsu admits to the problem of what is absent. This invention of the pendant is his. No other painter does it at the time. In his common-sense way, Metsu reminds us of the social circumstances, the parted correspondents, upon which the letter representation depends. Separated by their frames, in their separate rooms, these lovers can forever attend to the representation of love rather than engage in love itself.

This analysis of the treatment of the painted letters might seem idiosyncratic at best, and at worst perhaps simply unconvincing. But it finds surprising confirmation in the equally idiosyncratic perception of the letter as a cultural and even a technological phenomenon at the time. The prominence of the painted letters in Holland can of course be attributed partly to the level of literacy (Holland's was the highest in Europe), to the Dutch need to communicate with their far-flung trading posts, and to the improved postal service of the time.[17] Today, in the waning days of the public postal service, it is once again possible to imagine a time when the ability to communicate by letter was considered a notable accomplishment. But perhaps not to the extent or in the manner of the seventeenth century. Comenius, the Protestant theologian and educator whom we already used as an informant in our discussion of seeing and knowing in chapter 2, went so far as to list the letter

143. GABRIEL METSU, *Man Writing a Letter*. Reproduced by permission of Sir Alfred
Beit, Bart.

alongside the invention of printing, gunpowder, and Columbus's voyage as
previously unimaginable European accomplishments (needless to say, his aim
in making this claim was to find the proper rank for his own discoveries in
education):

> Nor could the American Indians comprehend how one man is able to
> communicate his thought to another without the use of speech, without a
> messenger, but by simply sending a piece of paper. Yet with us a man of
> the meanest intelligence can understand this.[18]

The event that Comenius might well have had in mind refines the point:
Garcilosa de la Vega reported that two Indians were sent by a nobleman's

144. GABRIEL METSU, *Woman Reading a Letter*. Reproduced by permission of Sir Alfred Beit, Bart.

steward from the country to deliver ten melons accompanied by a letter to his master in Lima. The Indians were warned that if they ate any on the way the letter would tell on them. Imagining the letter to have eyes, the Indians decided to hide it behind a wall so that it would not see them as they ate two melons. They were of course astounded at the end of the journey when they delivered the remaining melons with the letter and the nobleman knew, despite their caution, that two melons were missing. The Indians' astonishment at the Spaniards' ability to communicate by letter is bound up with their astonishment at the letter's ability to communicate a secret. This fascination with letters as both a secret way of communicating and a way of communicating secrets obtains also in seventeenth-century Europe.[19]

The distance between a letter sent in South America and Dutch pictures is closed for us by Karel van Mander. It seems at first rather curious that in his 1604 handbook for the young artist Van Mander introduces a similar story. In the section of his instructional poem devoted to color, Van Mander turns to the different glories of writing in black and white. It is in this context that he praises the letter:

> Indeed, though they be far apart, people speak to each other via silent messengers.
>
> [Jae, al zijn de Menschen wijdt van een ghevloden/Sy spreken malcander door stomme boden.][20]

We have already found evidence in our study of maps of a continuity between writing and drawing. What is notable here is that the form of writing that Van Mander specifically invokes is the letter. The letter for him bears on the making of an image. The evidence he offers, in much the same vein as Comenius was to do some years later, is the Indians' astonishment at how Spaniards communicated with each other by letter. Van Mander introduces the letter because of its ability to close distances, to make something present, to communicate secretly—all of which confirms what we have seen of the painted letter in Dutch paintings.

Second, and related to this, the letter was treated at the time as a prime object of vision. What was communicated was intended for the eyes alone. In our earlier discussion of the knowledge to be gained through attentive looking and its connection to the Dutch still life, we considered at some length Comenius's recipe for how to look at an object. We did not note there that having analyzed *how* to look, the first object that Comenius looks at is no other than a letter. Here is Comenius's description of how to look at a letter, or, in our terms, how to look at words:

> If any one wish to read a letter that has been sent him by a friend, it is necessary: (1) that it be presented to the eyes (for if it be not seen, how can it be read?); (2) that it be placed at a suitable distance from the eyes (for if it be too far off, the words cannot be distinguished); (3) that it be directly in front of the eyes (for if it be on one side, it will be confusedly seen); (4) that it be turned the right way up (for if a letter or a book be presented to the eyes upside down or on its side, it cannot be read); (5) the general characteristics of the letter, such as the address, the writer, and the date must be seen first (for unless these facts be known, the particular items of the letter cannot be properly understood); (6) then the remainder of the letter must be read, that nothing be omitted (otherwise the contents will not all be known, and perhaps the most important point will be missed); (7) it must be read in the right order (if one sentence be read here and another there, the sense will be confused); (8) each sentence must be mastered before the next is commenced (for if the whole be read hurriedly, some useful point may easily escape the mind); (9) finally, when the whole has been carefully perused, the reader may proceed to distinguish between those points that are necessary and those that are superfluous.[21]

We might compare this sense of a letter with the letters in the epistolary manuals. While the letters in the manuals provide examples of the rhetorical shaping of feelings, Comenius offers a letter as an object of sight. This extraordinary concentration on the act of reading as close looking reveals a mind bound up with visual representation in the manner of the Dutch pictures.

Both of the factors that we have just touched on—letters as objects of sight and letters as conveyors of secret messenges—are combined in a technical context at the time. I was originally led to look at sixteenth- and seventeenth-century treatises on natural knowledge to find experimental analogies for the interest Dutch artists had in attentive looking. We already considered this in chapter 4. It was with some surprise that I realized the frequency with which letters appear in reports of experiments done with the newly popular lenses and mirrors.

And lovers that are far asunder may so hold commerce with one another.

This passage from G. B. della Porta's *Natural Magick* does not describe letters but rather "merry sports" possible with an optical device—a set of mirrors by which words are cast onto a distant wall—that serves a function similar to that of a letter between lovers. Lenses or mirrors are like letters in that they also allow a man, as della Porta says, to "secretly see and without suspition what is done far off & in other places."[22]

Della Porta notes the secrecy involved in being enabled to see something in this manner. The viewer sees what he otherwise could not and is himself not seen. The lens in such studies not only functions as a letter does in sending messages, but is itself directed to seeing other people's messages. Secreted letters seem to have been on many minds. The English experimenter Thomas Digges, for example, prides himself on setting up an instrument enabling him to survey everything around him, from large to small. He specifies what he means: everything from the lay of the land of a whole region to the inside of houses where "you shall discerne any trifle or reade any letter lying there open."[23] And Robert Hooke in his 1665 *Micrographia,* the first English book on microscopy, does not choose living matter but a point, the tip of a needle, followed by the dot made by a pen, as the first things to view through his instrument. Hooke models himself on the common strategy of starting with a mathematical point, but proceeds to take the pen-point literally and goes on to discuss a miniaturized text. With a microscope at hand this small writing, so Hooke argues, "might be of very good use to convey *secret Intelligence* without any danger of *Discovery.* "[24] In this complex overlap of lenses and letters, of objects to improve sight with objects of sight, experimenters repeatedly testify to the situation of being unseen seers, eyes fixed to lenses or mirrors, catching sight of something otherwise unseeable that is unaware of their gaze. The fascination with a letter or message as the object in view reveals the guilt that was part of their adventure. They felt their attentive looking to be a kind of prying. And they experienced the unease of viewers who feel themselves to be voyeurs.

145. GABRIEL
 METSU, *The
 Letter Writer
 Surprised.*
 Reproduced by
 permisssion of
 the Trustees,
 the Wallace
 Collection,
 London.

As in the pursuit of knowledge, so in the pictures of the time. The outsider looking in at the letter is also a theme in Dutch painting. In at least one instance Metsu makes light of the situation of seeing as spying. His so-called *Letter Writer Surprised* (fig. 145) is really a letter-writer spied on. The woman with the letter does not realize that a gentleman is peering over her shoulder. But it is Vermeer who perceives that the artist's own eye looking into his work plays this very role. Vermeer in effect turns the relationship between the Metsu couple ninety degrees and puts himself in the position of the man. Vermeer discovers that the artist is a voyeur with a woman as his object in view.[25] In his *Woman Reading a Letter* (fig. 146), the painting now in Dresden, Vermeer represents the absence of the letter's content as an elusiveness. And unlike Ter Borch or Metsu, Vermeer draws our attention particularly to the elusiveness of the woman. She seems less to be looking at the letter, as Ter Borch's women do, than to be absorbed in it even as she is absorbed in herself. We note the distinctive angle of her head and her slightly parted lips. Her elusiveness is further played out by Vermeer in the invention of the reflection of her face, which is mirrored in the surface of the open window. This is a conflation of surfaces that Metsu would carefully distinguish. The window we expect to be able to look through instead reflects back. (In Metsu's painting of a man writing a letter [fig. 143] we look through the open window to catch sight of the world itself in the form of a globe.) Another surface of the woman's face is made visible without offering us any further insight into her. The carefully constructed foreground—a curtain partially drawn back, the barrier of rug, the table with its offering of fruit—bars our entry even as

146. JAN VERMEER, *Woman Reading a Letter.* Staatliche Kunstsammlungen, Dresden.

it confirms our presence. The relationship between surface presence and inner inaccessibility so characteristic of the letter pictures is acknowledged by Vermeer in these pictorial tensions and it is thematized in the viewer's relationship to the woman. While Metsu used pendants to classify the male and the female with a distinct space for each and the letter as the go-between, Vermeer deals instead with complex and uncertain relationship between a male observer and a female observed.

In the great *Woman Reading a Letter* (or *Woman in Blue*) in Amsterdam (fig. 147), a later work, Vermeer resolves the tensions of his Dresden picture. The monumental figure of the woman poised in her absorption in the letter now dominates. She assembles the world of the picture around her. Her ample figure reveals, by comparison, the slightness of the Dresden woman,

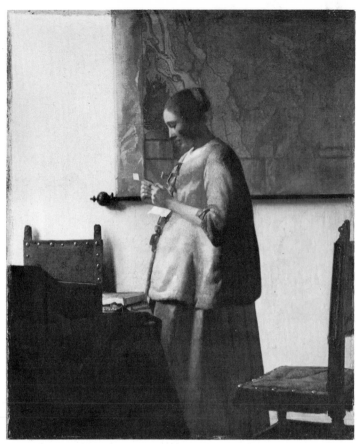

147

148

149

147. JAN VERMEER, *Woman Reading a Letter*. By courtesy of the Rijksmuseum-Stichting, Amsterdam.

148. REMBRANDT VAN RIJN, *Bathsheba*, 1654. Musée du Louvre. Cliché des Musées Nationaux, Paris.

149. JAN STEEN, *Bathsheba*. Private collection.

whose small figure was pressed in by objects from all sides. No longer a product of the tension between viewer and woman viewed, the woman's elusiveness is now simply granted her as her own. It is a sign of self-possession. In this resolution of his art, Vermeer still remains true to the presence of the letter as a text that absorbs attention while remaining inaccessible.

I began with the admission that there was something fugitive about considering letters as texts. The seriousness with which Dutch painting took this issue can be measured by the reactions of the two greatest talents. While Vermeer meditates and pursues the implications posited in the letters as representation, Rembrandt objects. The power and nature of Rembrandt's critique is stated in his *Bathsheba* in the Louvre (fig. 148). The work was painted in 1654 at the peak of the popularity of the epistolary manuals and just when Ter Borch was engaged in his paintings of the subject. I would not dispute the Italian connections that have been claimed for this picture.[26] The great, monumental female nude clearly reveals Rembrandt's ambition to rival the Italians by engaging in a central image of their art. But it should also be seen among the familiar women with letters of the north. This is, however, a letter painting with a difference. It is precisely the implications of the letter's contents that are at issue for Rembrandt. Bathsheba has read the letter in which David declares his love for her. It rests in hand as she turns from it, lost in her thoughts, ignoring both maid and viewer. What does she feel, graced by a beauty that has already made her beloved of a king who will send her husband off to death in battle? The letter is presented not as visible evidence of a social transaction, nor as the representation of feelings that are absent. Its contents are the object of Bathsheba's meditation and, by extension, of ours. It cannot be argued that this manner of depicting is given in the choice of the theme. Jan Steen, after all, produced a *Bathsheba* that easily accommodated the scene to the Dutch letter works that we have been looking at (fig. 149). If it were not for the words "Most beautiful Bathsheba—because" ("Alder-schonte Barsabe—omdat") inscribed on the letter, we would take this for another "genre" scene. It is important evidence for the way we perceive Rembrandt's Bathsheba with the letter. The painting by Steen proves that Rembrandt was not alone at the time in seeing a connection between the popular letter theme and Bathsheba.

Rembrandt's picture is not only a Dutch letter painting with a difference, it is also Italian painting with a difference. There were essentially two pictorial traditions connected with Bathsheba, neither of which Rembrandt draws on here.[27] One depicted her with her maid at her bath *before* David's letter arrived on the scene. This is the subject of Rembrandt's painting in New York. It was made in 1643 before the letter fad began. The other depicted David's letter being delivered. The bath scene enabled the artist to emphasize Bathsheba's beauty, while the letter scene added narrative interest to this. Rembrandt instead presents Bathsheba as a letter-reader. But he rejects the epistolary surface valued by the other letter painters for a characteristic emphasis on interiority. The setting is somber. Is it a bedspread or a robe that

lies beside her? Where is she, inside or out? Details of appearance are not recorded. The woman's body is exposed to our view. The firmly modeled flesh of the solid limbs and fine face is worked not to make appearance visible, as in other Dutch paintings, but to suggest thoughts and feelings. Interiority is here bound to Rembrandt's insistence on the contents of the letter. It is one more example of his disaffection from the Dutch way of looking at words.

<div style="text-align:center">III</div>

We have been considering the problem of what happens to words in a pictorial world that privileges sight. In Dutch pictures we frequently find texts assumed into pictures as inscriptions or as letters. They take their place among other objects represented in the pictorial world and like them are to be seen as representations rather than as objects for interpretation. Instead of interpretive depth we are offered a great and expansive attention to specificity of representation. An obvious question remains, however: What happens in such an art when it actually does present narratives? Must we not then speak of a prior text that is evoked in a picture and conversely of a picture that must be interpreted or read with reference to a prior text? The answer to this question is not an unqualified yes. To an extraordinary extent the Dutch artist did not evoke his text but believed he could carry it along with him in the picture. He often did this by means of a device that I call captioning.

The works we shall look at are by the best-known group of narrative painters, the so-called Amsterdam history painters. They are, somewhat awkwardly to my mind, also known as the pre-Rembrandtists, since Rembrandt studied with at least one of them and based individual works and much of the basic project of his early work on theirs. These artists painted small narrative works for the home, mostly biblical in subject matter, during the first three decades or so of the seventeenth century.[28] One of the first things to note about these works is the obscurity of their subject matter. It is notoriously hard in a number of cases to figure out what has been represented. This is true also of Rembrandt's works—most particularly his biblical drawings—and for similar reasons. The apparent obscurity results in both instances from the fact that it is not the canonical scenes of Catholic Church painting but rather the myriad printed illustrations accompanying Protestant readings of the Bible that lie behind them. The tendency to present unusual and therefore hard-to-identify subjects from the Old Testament as well as the format of individual scenes has been traced back to its roots in an illustrative sixteenth-century tradition. As examples of this kind of unusual scene consider the following works by Lastman and Venant: David giving Bathsheba's husband, Uriah, the letter to his commander in the field ordering his death in battle (fig. 150); the angel addressing Tobit and Tobias in departure (fig. 151); an angel conversing with Abraham about Sarah before their tent (fig. 152); David and Jonathan discussing Saul's attitude toward David (fig. 153). It is curious how many works by these artists present conversations. Once this feature is called to our attention, it is hard not to be aware of the number of figures in any image with heads bent, mouths open, hands flung out. The

150. PIETER LASTMAN, *David Giving the Letter to Uriah*, 1619. Dienst Verspreide
Rijkscollektie, The Hague.

151. PIETER LASTMAN, *The Angel Addressing the Family of Tobias in Departure*. Statens
Museum for Kunst, Copenhagen.

152. PIETER LASTMAN, *Abraham and the Angels*, 1616. Private collection.

153. FRANÇOIS VENANT, *David and Jonathan*. Fondation Custodia (coll. Frits Lugt), Institut Néerlandais, Paris.

154. PIETER LASTMAN, *Susanna and the Elders*, 1614. Gemäldegalerie, Staatliche Museen Preussischer Kulturbesitz, Berlin (West).

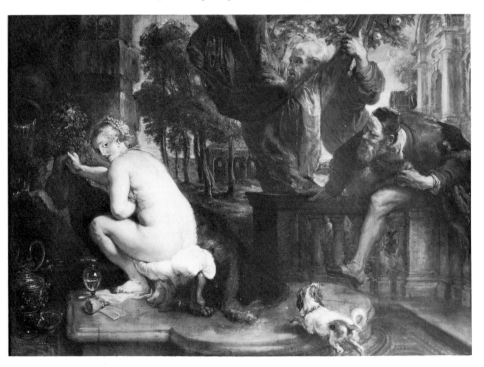

155. PETER PAUL RUBENS, *Susanna and the Elders*. Alte Pinakothek, Munich.

156. Frames from *Asterix en de Belgen* (1979, p. 33). © DARGAUD 1982 by Goscinny and Uderzo.

figures are not, in the accepted Italian manner, acting out inner feelings through their gestures. With arms characteristically and awkwardly flayed out they are busy gesturing in accompaniment to spoken words. A particularly striking example of this phenomenon is Lastman's *Susanna and the Elders* (fig. 154). Rather than sneaking up and leaping out at her with lust straining and tensing every limb, these elders stop to talk. We might compare this painting with a work by Rubens, whose Italianate bent can serve as a useful foil to the Dutch (fig. 155). In contrast to Lastman's conversing figures, a leap over the garden wall and a face thrust between the branches of the nearest tree dramatize the desires of the elders and the urgency of their demands. Susanna, for her part, rather than seeking to make a reply, cowers in fear. Rubens expects the viewer to interpret bodily gestures as signs of invisible feelings. Lastman, on the other hand, expects the viewer instead to supply the missing words, to imagine a caption or a visible text.

> Behold the garden doors are shut, that no man can see us and we are in love with thee; therefore consent unto us and lie with us. If thou wilt not, we will bear witness against thee, that a young man was with thee; and therefore thou didst send away thy maids with thee. Then Susanna sighed and said, I am straightened on every side: for if I do this thing it is death to me. . . .

The words spoken by the elders and Susanna in the biblical text implicitly exist as if in balloons over the heads in Lastman's picture. In its relating of word and image the painting is akin to that most familiar instance of inscribed words, the cartoon (fig. 156). Indeed, it is in comic strips such as *Asterix* that to this day we find gestures similar to those employed by Lastman to accompany speech.[30]

In making this comparison between Lastman and Rubens I chose a scene that is canonical. It should be remembered, however, that the majority of the scenes painted by these Dutch artists are not familiar through repeated, independent representations. They suppose a different relationship to the text on which they are based than would a canonical scene. Rather than serving as a mnemonic device to recall well-known texts, they come out of an illustrative tradition that assumes that a text in some form will accompany them on the page. The notion of what is representable is thus different. While in the Italian tradition artists assume that there are certain significant moments that call for representation, the northern artist assumes that the number of possible illustrations for any text is infinite. Bathsheba's bath exists in the midst of the rest of the things that happen in the Book of Samuel: David giving the letter to Uriah, the prophet Nathan admonishing King David over Uriah's death (drawn at least four times by Rembrandt [fig. 157]), and much else. The aim is to make the entire surface of the text visible. It is essentially an additive or serial notion that seeks to describe (or illustrate) everything that goes on rather than trying to narrate in depth a few significant events.

To make clear what I mean by the difference between descriptive surfaces and narrated depth let us contrast the Dutch illustrations with the Italian Renaissance recipe for pictorial narrations: through the *visible* actions of the body, through gesture and facial expression, the artist can present and the viewer can see the invisible feelings or passions of the soul. This notion of pictorial narration had its roots in the art of antiquity and drew in time on an established vocabulary of bodily movements and gestures familiar to artist and viewer. The massacre of the innocents was considered a showpiece for this kind of pictorial narrating. It gave the artist the opportunity to display the heightened feelings of multitudes: cruel soldiers, despairing mothers, and dying children. In his *Massacre of the Innocents* (fig. 158) Rubens calls on established figures—types such as the dying Laocoön (in the put-upon soldier at the left)—to assist him in the articulation of the passions. To "read" such a picture is to imagine the passions suggested by it. The use of expressive figure types, but more basically the very notion of the expression of invisible feelings, does not obtain in the north. It is important to recognize this factor when attempting to explain the frequent awkwardness displayed by figures in northern works. We should try to explain them not by making an appeal from art to nature, as is commonly done, but by an appeal to a different notion of art. Their awkwardness is not due to a naturalistic bent, or to the personal view of the artist (through this may play a part), but to a different notion of a picture and of its relationship to a text.[31]

As it happens, Rubens himself offers most interesting testimony to this. So far in this chapter, I have invoked Rubens as offering an alternative to the northern tradition. But his artistic strengths came as much from the traditions to which he was heir by birth as from the southern ones that he ambitiously took on. In works such as his Ovidian designs for a hunting lodge of Philip IV of Spain, he employs this northern illustrative mode.[32] If one comes to

157. REMBRANDT VAN RIJN, *Nathan Admonishing David* (drawing). Kupferstichkabinett, Staatliche Museen Preussischer Kulturbesitz, Berlin (West).

158. PETER PAUL RUBENS, *The Massacre of the Innocents*. Alte Pinakothek, Munich.

Rubens's Torre de la Parada sketches fresh from viewing the Dutch works it becomes clear that a number fit into our category of captioned conversations: Apollo answering Cupid's verbal challenge (fig. 159); Minerva chatting with Cadmus; or most surprising, given the precedent of Titian, Bacchus talking to Ariadne on the shore. The representation of such speaking figures introduces a particular tension into these works. Rubens's accustomed use of established figural motives is visibly disrupted. We see the graceful Apollo Belvedere, poised as he releases his arrow, appearing awkward as he turns to argue with Cupid. Developing my previous interpretation of these works further, I would now say that the comic (Ovidian) view of the gods in this series is achieved by combining a southern cast of characters with the illustrative mode of the north. If we ask why Rubens took up the northern mode on this occasion, the answer must surely lie in the demonstrable relationship between these works and the tradition of illustrated printed editions of Ovid. Though destined to hang in a hunting lodge, they were designed on the model of works made to accompany a printed text. These works by Rubens offer confirmation of the illustrative intent of the captioned narrative mode.

The idiosyncracies of the pre-Rembrandtists have not gone unnoticed. But their tendency to cleave to the surface of the text and their interest in conversation have until now been interpreted in other terms. It is, first of all, to religious rather than pictorial values that these phenomena have been related. I have no disagreement with the supposition that their attention to the surface of the text was reinforced by the sixteenth-century commitment—apparently shared by both Protestant and Catholics—to the literal interpretation of the Bible.[33] There are, however, many interpretive strategies toward texts that do not have a pictorial counterpart. The humanists, for example, were professional interpreters who were dead set against pictorial illustrations, since to them illustration was achieved in (and in fact meant) verbal rather than pictorial comentary.[34] The possibility of representing a text literally depends on a basic assumption about the nature of images and their relationship to texts. The fact that such pictorial handling extended to texts other than the Bible, to mythological themes for example, would seem to confirm this. I am less convinced by the argument that scenes of conversation are the result of a theological interest in gripping scenes of discourse and recognition. I find little that is gripping about the Lastman and Venant that we have looked at, and I think that here the attitude toward the pictorial representation of narrative is the cause.

Another prominent context in which the work of the Amsterdam history painters has been understood is the theater. These works, so it is argued, are essentially painted plays that share themes, talk, tableaux, and sometimes settings with the contemporary theater. There is something attractive about this point. Artists had long taken part in the theatrical and literary doings of Chambers of Rhetoric, and a certain amount of information has been gathered that relates particular artist among the pre-Rembrandtists to authors writing for the stage and to the Amsterdam theater itself. A few paintings have been identified as representations of characters in plays or as illustrations of

159. PETER PAUL RUBENS, *Apollo and the Python* (oil sketch). Museo del Prado, Madrid.

actual performances.[35] But what does this relationship alert us to about the painting or about the plays? And what does it say about precedent in this matter? Does illustrating a play mean making a *theatrical* image in the sense that we mean that word when we casually invoke the dramatic action on the stage? Our analysis of the essentially undramatic works of the pre-Rembrandtists suggests that this is not true. Did painters learn from the theater or, as has in fact been recently suggested, did the influence work the other way?[36] The appeal to the theater, like the appeal to matters of faith, should also take into account the strong and historic descriptive bias that made northern painters assume that there was a ceratin way to represent a text.

The penchant for what I have called captioned conversations continues in the next generation's painters, in particular among students of Rembrandt such as Ferdinand Bol. A sketch that Bol made for the work in the bur-gomaster's room in the Amsterdam Town Hall represents the Roman consul Fabritius gesturing in conversation as he tells King Pyrrhus that his elephant will not scare him into surrendering (fig. 160). And in a painting for the Leper's House in Amsterdam, Bol presents Elisha at the door explaining to Naaman that he cannot accept his gift (fig. 161).[37] A painting could, and in another tradition would, show Fabritius standing fast as he confronted the monstrous elephant, or Elisha (in the next scene) punishing his servant with the curse of leprosy because he had accepted Naaman's forbidden gift. Even in major works designed for public view such as these, the opportunity to depict a dramatic scene is not taken up. Instead, Bol has recourse once again

160. FERDINAND BOL, *The Intrepidity of Fabritius in
the Camp of King Pyrrhus* (oil sketch). Collection
Amsterdam Historical Museum, Amsterdam.

161. FERDINAND BOL, *Elisha Refuses Naaman's Gifts,* 1661. Collection Amsterdam
Historical Museum, Amsterdam.

Elck fpiegle hem felven.

Soo u de fpiegel feyt dat uwe wangen blofen,
En fris en jeugdich zijn, gelijck als verfe rofen,
V tanden als yvoir, u lippen t'eenemael
Gelijck het Indifch lack, of als het root corael;
Soo gaet van ftonden aen bereyden uwe finnen,
Om mede fchoone glans in uwen geeft te winnen;
Geeft u geheele kracht gants over aen de deugt,
Op dat ghy binnen felfs in fchoonheyt blincken meugt:
Spreeckt dus tot u gemoet : Sal't niet een fchande wefen
Soo maer dit buyte-vel in ons en wort geprefen :
Sal't niet een herten-leet aen al de vrienden zijn,
Indien wy maer alleen en hangen aen den fchijn ?
Neen, neen, mijn weerde ziel, wy moeten verder poogen;
Wy moeten hooger fien als op den luft der oogen ;
Wy moeten fchoone zijn, en dat aen alle kant,
Iae tot de gronden felfs, gelijck een diamant.
Zijn in het tegendeel u leden foo gefchapen,
Dat van u, door het oogh, geen luft en is te rapen ;
So fpreeckt met u gemoet, en maeckt een vaft verbondt,
Op dat ghy door den geeft u fchade boeten condt :
Gaet oeffent u verftant in alle goede feden,
Gaet oeffent uwen mont in alle wijfe reden,
Gaet çiert het innigh fchoon, dat is het befte deel,
Dat is voor alle dingh een edel hals-juweel.
Men vinter menighmael die fonder fchoone wangen ,
Die fonder witte verw, der menfchen herte vangen :
„ De deught, de reyne deught, is wonder lief-getal ,
„ De deught, de waere deught, is verre boven al.

De Ou- **G** Hy die het aerdigh glas, dat by de jonge vrouwen
de Mae fpreeckt Een fpiegel wort genaemt, zijt befich aen te fchouwe,
Let vry op u geftel, u hayr en gantfch gelaet,
Let vry hoe u het oogh, en al het wefen ftaet,
Doch geeft u niet alleen om uwen douck te fchicken,
Of om gekroont te zijn met bloemen ende ftricken,
Maer let op u gemoet, oock onder dit bellagh ;
En leert dat uwe jeught ten goeden dienen magh :

Soo

162. "Elck spiegelt hem selven," in JACOB CATS, *Spiegel van den Ouden en Nieuwen Tyt* (The Hague, 1632), pp. 12–13. Courtesy of the Royal Library, The Hague.

to depicted conversation, to a form of narration that does not dramatize an absent text but rather seeks to carry its word into the work in implied captions, much as a cartoon does.

The practice of captioning assumes a parity between image and text. We began this chapter by setting this notion of a visible text against the assumption that a text invokes depths beneath the surface offered by the image. It was a commonplace at the time to speak of the picture as the body, the text as the soul of an invention. This anatomy of an emblem was in effect a hermeneutic strategy for interpreting all images. But in Holland emblems also were different.

It has been noted that Dutch emblems differ—not the least in their domestic settings—from the tradition in other countries. But the particular way in which some of them depart from the assumed relationship of word to image has not been noted. It provides an appropriate coda to our discussion of the captioned picture. As far as I can discover, Cats is alone among European emblematists in presenting the text accompanying the image as if it were spoken by one of the figures in the image. Let us take the emblem with the motto "Elck spiegelt hem selven," meaning each one mirrors himself (fig. 162).[38] A woman is pictured seated in her room at a dressing table, her face

reflected in the mirror, with an old man standing at her side. The motto is above the image. Underneath, extending onto the next page, is a lengthy text explicating the meaning. But the text underneath is introduced in the margin by the words "De Oude Man spreeckt." And if we look back at the image we see that the man is indeed represented in the now familiar stance of one speaking. The words of the explanatory text are being spoken by the man represented in the image. In other words, the picture within the emblem is also captioned. It is not a unique case in Cats's book. The implications of this for the parity assumed between a text and an image are no different from what we found in the biblical paintings. However, it does make a difference that this parity is inserted into an emblem, because emblems served as a model for the relationship of word and image. Rather than treating the text as the soul of the emblem, implying that the text contributes a deeper level of meaning than the superficial image, Cats treats the text as a caption to the image. Even in the case of emblems, the text and image are treated as equals.

We are far from accounting for the nature of all Dutch history painting in this discussion of those paintings I have called captioned. There were, however, enough such pictures assembled in the recent international exhibition of Dutch history paintings to make the staff of the sponsoring museum stage a witty (and appropriate) contest to see who could provide the best caption for each painting.[39] The penchant for captioned words engages a number of further issues, including not only the relationship of word and image but also the notion of depicted gesture or actions. Rather than being expressive of inner feelings—*affetti*, as the Italians called them—many northern figures tend to be what I would call *performative*. By this I mean that a figure is described in terms of an action performed, be it speaking, dancing, playing, or whatever. This tradition dates back at least to the old Pieter Bruegel. This ease with described figures, with what indeed is a particular view of human nature, is basic to the northern fascination with depicted proverbs. This also dates back at least to Bruegel. By their nature proverbs define people in performative terms—he who hits his head against the wall, he who wears a blue cloak, and so forth. And proverbs bring us back again to word and image. For proverb paintings assume and, as in the case of a number of works by Jan Steen (figs. 163, 164), can display captions. It is a category into which many of the Dutch emblems also fit.

I would like to let Rembrandt have the last word, or perhaps better, the last picture. Rembrandt was a student and follower of the Amsterdam history painters. But he disputed their trust in visibility, their trust that the world and its texts were known by the eye. Julius Held has argued in a powerful essay that Rembrandt introduced a new way to represent the spoken word in art.[40] Common practice had been to show either two people speaking at once or a subsequent action taking place even as words were spoken. Rembrandt characteristically represents someone speaking and being listened to. Held's prime example among many is Rembrandt's etching *Abraham and Isaac*, which shows them stopping on their journey to the mountain (fig. 165). Isaac has

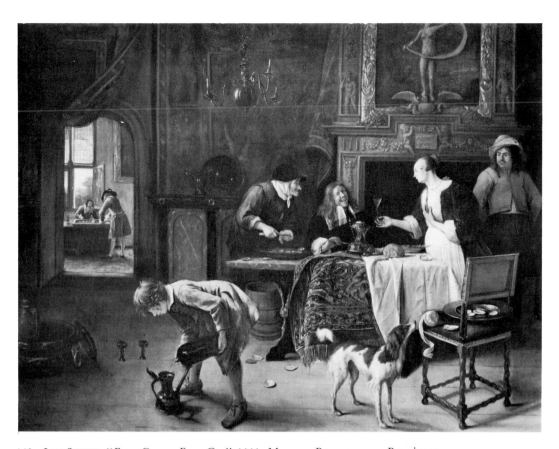

163. JAN STEEN, *"Easy Come, Easy Go,"* 1661. Museum Boymans-van Beuningen, Rotterdam.

164. JAN STEEN, detail of fig. 163 (inscription).

asked his father a question and is listening attentively, unmoving, as his father, with his hand raised in address, speaks to him. Held is surely right that Rembrandt is trying to represent an actual conversation. What is at stake for him is his deep respect for the power of words and the privilege that he gives to the sense of hearing. Rembrandt shows the spoken word to be a prime way of bringing or binding people together.

In view of what we have seen of the captioned conversations of Rembrandt's predecessors and followers, we could put this in slightly different terms. Rembrandt's interest in represented conversations follows from the works of his teacher Lastman. But Rembrandt in effect takes our eyes off the captions. He effectively does away with them. He dwells on the human relationship before us by suggesting words that cannot be seen. Rather than depicting gestures used in accompaniment of speech, "speaking people" who focus our attention on *what* is being said, Rembrandt in the *Abraham and Isaac* etching focuses our attention on the relationship between speaker and listener.[41] This interplay between speaker and listener is studied in an extraordinary number of his works. Even when the subject of the conversation remains unidentifiable (Rembrandt also followed his teachers in this), we can make out the intricacy and complexity of a human exchange. Indeed, one can measure Rembrandt's distance from the captioned conversations of the other artists by looking at those scenes of instruction or preaching in which it is the aura of the word rather than any particular wisdom imported that Rembrandt represents. We shall never know what is being said by Anslo to his wife in the portrait in Berlin (fig. 136), nor what is being said by Christ to the small circle of assembled listeners in the etching known (for want of a specific occasion) as *Christ Preaching* (fig. 166). These preaching figures, with their hands in motion and their heads turned to attendant listeners, speak out of the fullness of a knowledge that we must trust without its being visible. Rembrandt accepts neither the high Catholic miracle of the Word made flesh nor the low Dutch trust to the look of the world. His obsession with the nature of the invisible Word that related God to man plays a major role in his understanding of both the nature of faith and the nature of pictures. In keeping with his dismissal of inscribed words and epistolary surface, it represents a rejection of the Dutch trust to looking at words.[42]

165. REMBRANDT VAN RIJN, *Abraham and Isaac*
(etching), 1645. Teylers Museum, Haarlem.

166. REMBRANDT VAN RIJN, *Christ Preaching* (etching). By courtesy of the
Rijksmuseum-Stichting, Amsterdam.

Epilogue:
Vermeer and Rembrandt

M y account of Dutch art in the seventeenth century has concentrated on defining the distinctive system of conventions, governing metaphors, intellectual assumptions, and cultural practices in which that art was grounded. Though I have not attempted to deal with all the artists considered to be major, nor with all the genres considered essential, the success of my effort must lie in what it can help us to see throughout the range of the art. Any interpretation of Dutch art that makes such claims should, I think, be able to offer a persuasive account of the works of the two greatest Dutch artists of the time, Rembrandt and Vermeer. That the issues raised here should have made a difference to *their* art is in turn some confirmation of the interpretation. Rembrandt and Vermeer are polar opposites in this respect: Rembrandt rejects the notion of knowledge and of human experience that dominates Dutch images, while Vermeer makes a meditation on its nature the center of his work. Thus if Rembrandt's art provides a critique of the art of describing from without, the art of Vermeer takes its measure from within.

I shall do no more here by way of an epilogue than outline some of those elements in the works of Rembrandt and Vermeer that are illuminated by this way of understanding them. The place that Vermeer's works have had in this book leaves no doubt about what I take to be their exemplary role in the definition of the art of describing. What might not be clear, and what I want to conclude with, is the manner in which Vermeer refined and defined this sense of image-making and of knowledge.

Let me introduce this point by offering a correction to the viewing of his *Art of Painting* I presented in chapter 4. It is undeniable that the great map of the Netherlands, which is claimed by Vermeer to be of his own making, presents and makes central a mapping mode of picturing. And Vermeer further confirms the relationship between picture-maker and maker of maps in his two paintings of professional men, the *Astronomer* and the *Geographer*. However, while it is *like* a map, it would be wrong to conclude that Vermeer

shows that a picture *is* a map and hence that he is really a cartographer. An obvious resistance to this conclusion is provided by the fact that the theme of the great majority of his paintings is far from a mapmaker's concerns. Vermeer effectively determines the woman observed, woman as the object of male attention, to be the painter's subject. In a sense there is nothing so astonishing about this. What was true in Italy is given a different life in the domestic context of Dutch art. But the rigor with which Vermeer defines the theme is singular. The total absence of children in his works, for example, is astonishing when his fellow painters presumed children to be an essential part of a woman's domestic sphere—an essential sign of her virtue one might say. In isolating woman observed as his subject, Vermeer thematizes something essential about the nature of such a descriptive art.

To show what I mean, let us look once more at the passage attributed by Francisco de Hollanda to Michelangelo and give special attention to its reference to women:

> Flemish painting . . . will . . . please the devout better than any painting of Italy. It will appeal to women, especially to the very old and the very young, and also to monks and nuns and to certain noblemen who have no sense of true harmony. In Flanders they paint with a view to external exactness or such things as may cheer you and of which you cannot speak ill, as for example saints and prophets. They paint stuffs and masonry, the green grass of the fields, and shadow of trees, and rivers and bridges, which they call landscapes, with many figures on this side and many figures on that. And all this, though it please some persons, is done without reason or art, without symmetry or proportion, without skilful choice or boldness and, finally, without substance or vigour.[1]

Northern art, it is argued here, is an art for women because it is concerned to represent everything in nature exactly and unselectively. It thus lacks all reason and proportion. The assumption, clearly, is that this contrasts with Italian art, which is for men because it is reasoned and proportioned. But why cite women? As a gloss we can turn to a fifteenth-century Italian handbook on painting written by Cennino Cennini:

> Before going any farther I will give you the exact proportion of a man. Those of a woman I will disregard for she does not have any set proportion. . . . I will not tell you about irrational animals because you will never discover any system of proportion in them. Copy them and draw as much as you can from nature.[2]

To say an art is for women is to reiterate that it displays not measure or order, but rather a flood of observed, unmediated details drawn from nature. The lack of female order or proportion in a moral sense is a familiar sentiment from this time. What is suggested by de Hollanda is its analogue in a particular mode of art—an art that is not like ideal, beautiful women, but like ordinary immeasurable ones.

It is fitting, given such a view, that Vermeer presents the ungraspable nature of the world seen and poses the basic problem of a descriptive art in

the form of repeated images of women. How do we relate to the presence of the prior world seen? In his depiction of women, Vermeer thematizes this problem and turns it to extraordinary psychological account. For all their presence, Vermeer's women are a world apart, inviolate, self-contained, but, more significantly, self-possessed. This is why they are freed even of children. In a mature work such as the Amsterdam *Woman Reading a Letter* (fig. 147), the quality of the paint and the quality of the rendering engage human implications that are rare in Dutch art. Vermeer recognizes the world present in these women as something that is other than himself and with a kind of passionate detachment he lets it, through them, be.

Lawrence Gowing in his fine study of Vermeer has put the central quality of his art in the following way:

> Vermeer stands outside our convention [of art, he means, for which we can read of Italian art] because he cannot share its great sustaining fantasy, the illusion that the power of style over life is real. However an artist love the world, however seize on it, in truth he can never make it his own. Whatever bold show his eye may make of subduing and devouring, the real forms of life remain untouched.[3]

Vermeer, writes Gowing—voicing what has been a major theme of this book—rejects the claims on which the dominant mode of Western art is based. Dürer's representation of the draftsman at work can serve to remind us of those claims (fig. 19). And in the end Vermeer's art did give way to the world: the lozenge-like brushstrokes that patch together his last works signal the rift between the image and the world it describes that Dutch art had almost managed to hide (fig. 61).

A reader might well ask, when then do you do with Rembrandt? Surely his art, which deserts the surface of things in this world to plumb human depths, cannot be accounted for as an art of describing? Certainly not. As I suggested in the first chapter while discussing the camera obscura and the *portrait historié*, Rembrandt's art does not fit this model. As we have seen in the juxtaposition of his *Bathsheba* with the letter paintings of the other Dutch, or in his representation of conversation, our attention to this dominant pictorial mode can help us to see Rembrandt's works precisely by suggesting the depth of his estrangement from it. The idiosyncratic appearance and curious power of his images are, I think, bound up with his profound reaction to the native tradition. The question is not, as it used to be put, was Rembrandt or was he not a representative Dutch artist, but rather how or in what respects was he such? With the rise in interest in Dutch history painting, the current fashion is to see Rembrandt as fitting comfortably into the native scene. In many ways I, on the contrary, tend to agree with Kenneth Clark's remark about the surprising nature of Rembrandt's power given the artistic world into which he was born. But I think that Lord Clark's Italian solution to the problem— his suggestion that it was the deep affection for Italian art that proved the making of Rembrandt—is at best a partial truth. Fully as important as his attraction for Italy was his engagement with, and to my mind his deep

ambivalence toward, his own tradition. Rembrandt's idiosyncracy is that he not only turned away from the Dutch art of describing, but also from the Italian notion of narrative painting.[4]

We might start with the characteristic technique, the handling of paint in Rembrandt's mature works. Rembrandt resolutely refuses to produce the transparent mirror of the world of the Dutch *fijnschilderkunst*. The thick surfaces of paint that we find in mature works such as the *Jewish Bride* (fig. 5), the *Prodigal Son,* or the *Oath of Julius Civilis* (fig. 167) obfuscate the world seen while offering a rare entry into invisible human depths. At one level what concerns Rembrandt is a matter of craft. In his later drawings and etchings, as in his paintings, Rembrandt rejects the established practice of good craftmanship appropriate to each medium: in his paintings, figure and ground are bound together and thus elided through the medium of paint; in the graphic works the broad strokes of the reed pen, and the burr he leaves on the plate to soak up the ink, obscure linear definition in a striving for tonal effects.[5]

It is not commonly noted that in choosing to associate himself with members of the group of artists known today as the Amsterdam history painters, Rembrandt chose as his models precisely those Dutch artists who were *least* concerned with the craft of representation. Far from aiming to fool and thus win the eye of the observer, Lastman leaves his surfaces rough, undescriptive and, by comparison with other Dutch artists, even ugly. For him it is the tale that counts. In choosing to work in this illustrative tradition with its significant themes, Rembrandt also rejected the crafted surfaces of a De Gheyn or a Saenredam.[6]

Notwithstanding the traditional representational skills that Rembrandt does display in a number of works (his portraits of the 1630s, for example, and his landscape drawings), over his career as a whole he was true to his chosen path. But the scumbled paint and worked surfaces of the mature works make something totally unexpected out of the awkward laying on of the paint and the denial of craft common in the work of his teachers. Rembrandt shows, by transforming, what can be done with a facture that is not primarily descriptive in intent. His engagement with the working of the paint is an alternative to the crafting of descriptive surfaces.

Rembrandt shared the Dutch artist's avid taste for finery: every viewer can recall the glimmer of his helmets and swords, the glow of jewels, the density of robes woven, it would seem, with threads of gold. In his art, as in his life, Rembrandt was a proud possessor. But though this taste continues in his later works, Rembrandt gives us to understand it differently. If we compare his painted garments to the silks of Ter Borch, or his goblet to those of Kalf (fig. 168), it appears that Rembrandt has forsaken that competition among craftsmen which was so enabling to other artists. There is no confusing his stuffs or his crystal with crafted objects seen. Rembrandt, instead, settles for the materiality of his medium itself. His paint is something worked as with the bare hands—a material to grasp, perhaps, as much as to see. It, not the world

167. REMBRANDT VAN RIJN, *The Oath of Julius Civilis*, 1661, Nationalmuseum, Stockholm.

168. REMBRANDT VAN RIJN, detail of fig. 167 (goblet).

169. REMBRANDT VAN RIJN, detail of fig. 167 (sword and blinded eye).

170. Rembrandt van
Rijn, *Homer
Dictating*, 1663.
Mauritshuis, The
Hague.

seen, becomes his frame of reference. In the *Jewish Bride, Prodigal Son,* or *Julius Civilis,* paint is acknowledged as that common matter, like the very earth itself in the biblical phrase, out of which the figures emerge and to which they are bound to return.[7]

In turning away from the craft of representation, Rembrandt also turns away from the certainty and knowledge attributed by Dutch culture and its art to the world seen and to sight itself. The surfaces of Rembrandt's late works, as we have just noted, do not enable one to see better on the model of sight embraced by the culture. They are the surfaces of a maker of pictures who profoundly mistrusted the evidence of sight. This point becomes the very subject of Rembrandt's art in his fascination with blindness. Loss of sight was by no means an uncommon topic in Dutch art of the time. We find innumerable renderings of the apocryphal story of Tobit and some even of the blinding of Argus. But Rembrandt's images are memorable in the authority they attribute to those who lack sight. One thinks in particular of his attention to the blind Homer in the fragment that remains of one of his late paintings (fig. 170). The aged Homer is represented dictating to a young scribe: an unseeing speaker speaking words that remain unseen. Paradoxical though it may seem, Rembrandt makes images that show us that it is the word (or the Word) rather than the world seen that conveys truth.

Rembrandt, finally, turned from the art of describing in order to evoke time past. Some kind of historical interest must have been part of the appeal for him for the stories illustrated by the Amsterdam history painters. Placed

beside the instantanous nature of making suggested by Hals's brushwork, and the effacement of time suggested in the imprinted effect of Vermeer's *View of Delft*, the working and reworking recorded in the layers of paint of Rembrandt's late works is an admission of work done through and thus even against time. But the depth of Rembrandt's historical commitment, and what is more, the sense he had of challenging the authority of his fellow artists and their culture, is most clearly revealed in his rejected painting for the new Amsterdam Town Hall. Rembrandt's *Oath of Julius Civilis* depicts the early Batavians' commitment to revolt against their Roman rulers. The event was commonly seen at the time as a parallel to the modern revolt of the Netherlands against Spain. Rembrandt represented the ancestors of the Dutch engaged in a tribal blood oath: swearing on a sword held by a leader, Civilis, whose hideously blinded eye reveals that he himself had lived by the sword (fig. 169).[8] It is true that Tacitus in his account of the incident refers to these as barbarous rites. But Rembrandt was moved by more than a desire to be faithful to the text. For a leading contemporary painter like Caesar van Everdingen, the historical is that which the artist can put illusionistically before our eyes (fig. 171). (Note the work's extraordinary clarity, and the foreground fringe on the rug.) The *Civilis* shows how far Rembrandt felt he had to go—back even before civilized times—to counter the Dutch insistence on accommodating the past to what is present to the eyes.

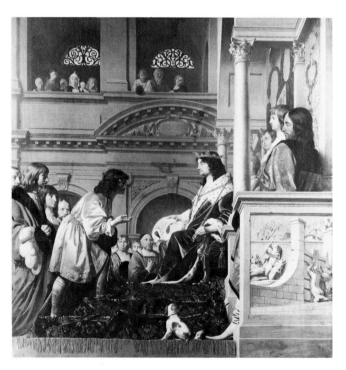

171. Caesar van Everdingen, *Duke Willem II Granting Privileges to the High Office of the Dike-Reeve of Rijnland in 1255*, 1655. Copyright Stichting Lichtbeeldeninstitut, Amsterdam.

Appendix:
On the Emblematic Interpretation
of Dutch Art

In proposing to view Dutch art as descriptive, I have implicitly chosen not to follow the lead currently offered by the emblematic interpretation of Dutch art. I want briefly to explain why. The discovery of the similarity between the illustrations printed in emblem books and Dutch paintings is an important one: objects, figural actions, and the domestic settings of Dutch paintings had their counterparts on the pages of the popular emblem books. The question is not whether there is a connection, but what that connection tells us about the art; how we see and interpret the art in the light of it.

The argument of the emblematic interpretation has been put forth repeatedly and most powerfully in the work of the pioneer in this field in Holland, E. de Jongh.[1] Referring to an established explanation for the pleasure and power of emblems, De Jongh argues that the objects and realistic scenes placed before our eyes in Dutch paintings serve as veils that conceal meaning. What appears as one thing yields to unexpected hidden meanings. De Jongh offers the emblematic connection as a challenge to what he takes to be the nineteenth-century view of Dutch art as a realistic mirroring of the world. Dutch art, he claims, is only apparently realistic, and he offers us instead the formula (surprising in view of the look of the art) that Dutch art is a realized abstraction.

Rejecting the radically reductive view that Dutch art is a mirror of reality, De Jongh moves to embrace a polar opposite, which is to my mind equally reductive. This view is that meaning is paramount and that the pictures are the means by which it is made visible. Neither net, it seems to me, is suitable to catch Dutch art, which slips through because time and time again it suggests that meaning resides in the careful *representation* of the world.

As a basic rule of thumb De Jongh's emblematic view seems to me to be misleading both about Dutch pictures and about the emblems to which they are often related. Let me take the emblems first. The notion of a veiled verbal meaning that is to be sought out by the viewer of the image with the help of the caption or motto (usually above) and the epigram or commentary (below)

on the printed page is central to the tradition of emblem-making in Europe. The emblem, it has been shown, started as a verbal description or epigram to which publishers began to add illustrations and captions.[2] In its developed form it offered a way to make the visible intelligible and the intelligible visible through a complex and richly organized conceit. It encouraged a play of mind and a delight in indirectness, and appealed to the viewer's wits, reaching its most arcane achievement in the subcategory of imprese or devices.[3]

There are several important respects in which Dutch emblems in general do not fit the principles on which the Italians meant them to stand. Though the tradition is rich, it is not misleading to focus on Jacob Cats as being the most prominent author of emblem books and the one most prominently connected to Dutch painting. The great majority of Cats's emblems are illustrated proverbs with commentary attached. They are by their very nature commonplaces, examples of shared rather than of arcane wisdom. Far from being totally unintelligible without an exercise of wit, the images are easily grasped, couched as they are in the actions, dress, and domestic settings of Dutch society. Though Cats's prefaces refer to the delights of uncovering veiled meanings, he actually offers his reader or viewer little to puzzle over. Indeed, in his rambling prefatory remarks the formula of uncovering hidden meanings is only one of a number of explanations that Cats offers for proverbial emblems.[4] His appeal to proverbs as offering knowledge of the behavior and even displaying the dress of different peoples is borne out in the examples of Dutch mores that illustrate his books. Far from being a world of hieroglyphs, alchemy, and other such assertions of unexpected correspondances, this is more like an early ethnography. And though he did not go on to *picture* the proverbs of other peoples, Cats in his later editions multiplied equivalent sayings in Spanish, French, Italian, and other languages across the bottom of his pages as evidence of the persistence of a common wisdom among different peoples. Though the proverbs individually constitute moral wisdom and offer moral guidance, their assemblage in a Cats volume presents us with a catalogue of human behavior that is a successor in this respect to a painting like Pieter Bruegel's *Proverbs*. The total effect, it might be argued, is more descriptive than prescriptive, as much taxonomic as didactic.

It will certainly be countered that this way of putting it ignores the fact that Cats, like the other Dutch, took his moral views very seriously indeed. It would be foolhardy to deny this. But I wish to draw attention to the effect that the Dutch mode of emblematic presentation has on the way one takes these views. It *cannot* be argued that Dutch emblems or the paintings related to them are curious and inventive in respect to their consideration of our moral existence. What they *are* curious and inventive about is representation. My emphasis on this does not question the moral concerns of the culture as much as it draws attention to the particular way in which those concerns were expressed.

De Jongh has explained the distinctive look of Dutch emblems with reference to the Dutch preference for realism. He assumes that this preference

does not affect the nature or function of the emblem. Mario Praz, however, pointed out long ago that while the Italians strove to outdo themselves in pedantic definitions of the emblem, in other countries the word took on vague meanings. Far from conforming to certain precepts, an emblem was almost synonymous with an illustration, or with an illustration accompanied by words.[5]

Rather than appealing to the tradition of the image as the body and the textual meaning as the soul of an emblem, which De Jongh in effect does, I think we should try to give a more ample account of the nature of Dutch emblems.[6] On the basis of Cats's books alone, I want to offer a few preliminary suggestions in this direction. First of all, they can be said to display the same easy relationship between word and image that we have already found in Dutch paintings. Rather than posing a puzzle to be solved, motto and image are unproblematic. Verbal and pictorial sign are equated in a manner similar to the way Comenius related word and image in his *Orbis Pictus*. We have in short something more like a picture language than like hidden meanings.[7] Furthermore, as we have just seen in the course of our discussion of captioning, Cats is unique in often presenting the legend below as spoken by a figure within the image. Meaning is not to be sought beneath or behind the surface of the page but is made visible on it. This view of the relationship between meaning and the surface of the page is literally built into the extraordinary plan of his earliest emblem book. Cats's *Silenus Alcibiades* of 1618 is the only example I know in the whole of Europe of an emblem book in which the three traditional levels of meaning—amorous, moral, and religious—are represented through the device of replicating the entire set of illustrations three times over with different mottos and legends each time (figs. 172, 173, 174).

Other problems with the emblematic interpretation arise when we turn to the paintings themselves. The devotion to the crafting of the painted surface can only serve, in the current view, to lead us to a hidden, textual meaning, usually a moral injunction. This represents too simple a view of what seems to have been a Dutch obsession with behavior or possessions that they both loved and feared, celebrated and condemned.[8] It effectively insists on a gap between the surface and the meaning of works. Further, in those cases in which a textual meaning cannot be found, as in a recent study of *The Sentry* by Fabritius or some late works by De Hooch, scholars find themselves in the awkward position of claiming that powerful and accomplished pictures probably had no intended meaning.[9]

By adjusting what we think a Dutch emblem is like and how it means, we can profitably see Dutch paintings as being like painted emblems even as De Jongh's work suggests. In the painted form, the working surface gains a new kind of articulation through the display of the painter's craft. The great effort that Dou, for example, put into making his brushless, clear surfaces is one version of the painterly transformation of attention to the surface of the page. He was wont, on occasion, to use the triptych format to differentiate between

172. JACOB CATS, *Silenus Alcibiades* (Middelburg, 1618), book I, pp. 24–25. Courtesy of the Royal Library, The Hague.

173. JACOB CATS, *Silenus Alcibiades* (Middelburg, 1618), book II, pp. 26–27. Courtesy of the Royal Library, The Hague.

174. JACOB CATS, *Silenus Alcibiades* (Middelburg, 1618), book III, pp. 26–27. Courtesy of the Royal Library, The Hague.

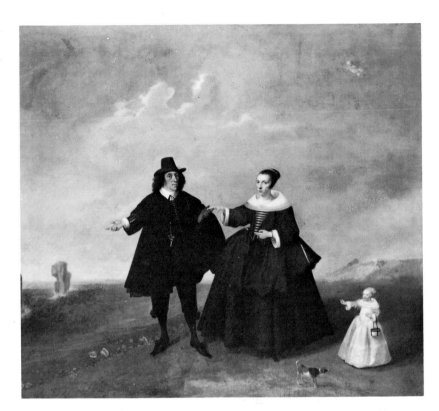

175. ANONYMOUS, Northern Netherlandish School, *Couple with Child*. By
courtesy of the Rijksmuseum-Stichting, Amsterdam.

meanings that Cats articulated in the three reprintings of his emblems. The
use of this pictorial language the meaning of which is visible can lead to very
idiosyncratic images indeed: the scattering of objects on a Steen floor or table
and the pointed yet disconnected gestures of the people gathered in his inns;
the accumulation of human motifs in the street before Dou's quack; or the
placing of a married couple and their child beside the ocean from which
protrude two most unlikely rocks (figs. 60, 175). It is not a notion of hidden
meanings that produces such works, but rather the notion of a world that is
understood in terms of an assemblage of visibly accessible meanings. Steen's
display of the pleasures and dangers of festivity, Dou's catalogue of human
behavior, or the description of a sturdy marriage as a rock are presented under
the aspect of describing the world even though they contradict the look of
actual situations in the world.

To return to a theme of this book: if there is any veil between image and
meaning, if there is any indirection in these works, it is, as acknowledged by
Dou in his *Quack*, in the deceptiveness of the representation itself. This is
more the work of a skilled hand addressing an attentive eye than the work of
a learned mind. Approached in this spirit, a study of the deployment of the
emblematic mode has much to tell us about the order and presentation and,
yes, the meaning of Dutch images.

Notes

Introduction

1. Joshua Reynolds, *The Works . . . containing his Discourses . . . [and] A Journey to Flanders and Holland . . .* , 4th ed., 3 vols. (London, 1809), 2:359, 360; 361–62; 363–64.

2. Ibid., p. 369.

3. Eugène Fromentin, *The Masters of Past Time*, trans. Andrew Boyle, ed. Horst Gerson (London and New York: Phaidon, 1948), p. 97.

4. Ibid., p. 115.

5. Ibid., p. 101.

6. Ibid., p. 103.

7. Ibid., p. 128.

8. For an extended discussion of this point, see Svetlana Alpers, "Style is What You Make It: The Visual Arts Once Again," in *The Concept of Style,* ed. Berel Lang (University of Pennsylvania Press, 1979), pp. 95–117.

9. See Alois Riegl, *Stilfragen* (Berlin, 1893), *Spätrömische Kunstindustrie* (Vienna, 1901), *Das holländische Gruppenporträt* (Vienna, 1931; originally published in 1902), and *Die Entstehung der Barockkunst in Rom* (Vienna, 1908), published posthumously; Otto Pächt, *Methodisches zur kunsthistorischen Praxis: Ausgewählte Schriften* (Munich: Prestel-Verlag, 1977); Laurence Gowing, *Vermeer* (London: Faber and Faber, 1952); Michael Baxandall, *The Limewood Sculptors of Renaissance Germany* (New Haven: Yale University Press, 1980); Michael Fried, *Absorption and Theatricality: Painting and Beholder in the Age of Diderot* (Berkeley and Los Angeles: University of California Press, 1980).

10. Erwin Panofsky, *Early Netherlandish Painting*, 2 vols. (Cambridge: Harvard University Press, 1953), 1:182.

11. "We still operate very much within the Aristotelian concept of action, which suggests that description be viewed as secondary, and purely functional, or merely decorative." This introductory sentence to a recent issue of *Yale French Studies,* subtitled "Towards a Theory of Description" (1981, no. 61), reveals a general awareness of the problem. I argued at greater length for the importance of the distinction between description and narration to Renaissance painting in general and to seventeenth-century painting in particular in my "Describe or Narrate?: A Problem in Realistic Representation," *New Literary History* 8 (1976–77):15–41. In the study of literary texts recent work has distinguished between narrative and descriptive modes with the suggestion that the interplay between the two is built into the very nature of (our) culture. Be it termed utopian by Louis Marin, or "l'effet de réel" by Roland Barthes, or displaced violence by Leo Bersani, the pleasurable effect of the suspension of narrative action in the name of delight in representational presence is often considered to be essential to the nature of images. The nature and status of

images is, however, somewhat more complicated than this view implies, as a circumstantial study of seventeenth-century Dutch art will show. First, because a similar distinction between description and narrative can be made *within* the tradition of Western images, and second, because far from being the ideal suspension of a restless narrative mode, descriptive images, in the seventeenth century at least, were central to the society's active comprehension of the world.

12. J. Q. van Regteren Altena, "The Drawings by Pieter Saenredam," in *Catalogue Raisonné of the Works of Pieter Jansz. Saenredam* (Utrecht: Centraal Museum, 1961) p. 18. Though the reference to Sunday might be owed to Hegel, Van Regteren Altena's short essay contains some of the most original and acute writing ever done on the nature of Dutch art. For the "Sunday of life" characterization in Hegel, see G. W. F. Hegel, *Aesthetics: Lectures on Fine Art,* trans. T. M. Knox (Oxford: Clarendon Press, 1975), 1:887.

13. The standard work is G. J. Hoogewerff, *De Bentvueghels* (The Hague: Martinus Nijhoff, 1952), and some additional representations of their satiric goings-on are given by Thomas Kren, "Chi non vuol Baccho: Roeland van Laer's Burlesque Painting about Dutch Artists in Rome," *Simiolus* 11 (1980):63–80.

14. Francisco de Hollanda, *Four Dialogues on Painting,* trans. Aubrey F. G. Bell (London: Oxford University Press, 1928), pp. 15–16.

15. The famous epitaph written by Abraham Ortelius for his friend Pieter Bruegel refers to "works I used to speak [of] as hardly works of art, but as of works of Nature" ("picturas ego minime artificiosas, at naturales appellare soleam"). See Wolfgang Stechow, ed., *Northern Renaissance Art 1400–1600,* Sources and Documents in the History of Art (Englewood Cliffs, N.J.: Prentice Hall, 1966), p. 37.

16. The pioneering work demonstrating the relationship between Dutch images and contemporary emblems has been done by E. de Jongh. See his "Realisme en schijnrealisme in de hollandse schilderkunst van de zeventiende eeuw," in *Rembrandt en zijn tijd* (Brussels: Paleis voor Schone Kunsten, 1971), pp. 143–94, for a succint statement of this interpretive stance. The catalogue and De Jongh's essay are also available in a French edition.

17. What I am questioning is the basic art-historical notion of meaning. Its cornerstone is iconography—so named by Erwin Panofsky, who was its founding father in our time. Its great achievement was to demonstrate that representational pictures are not intended solely for perception, but can be read as having a secondary or deeper level of meaning. What then do we make of the pictorial surface itself? In his seminal essay on iconography and iconology Panofsky clearly evades this question. He introduces his subject with the simple example of meeting a friend on the street who lifts his hat in greeting. The blur of shapes and colors identified as a man and the sense that he is in a certain humor are called by Panofsky the primary or natural meaning, but the understanding that to raise the hat is a greeting is a secondary, conventional, or iconographic meaning. So far we are dealing only with life. Panofsky's strategy is then simply to recommend transferring the results of this analysis from everyday life to a work of art. So now we have a *picture* of a man lifting his hat. What Panofsky chooses to ignore is that the man is not present but is *represented* in the picture. In what manner, under what conditions is the man represented in paint on the surface of the canvas? What is needed, and what art historians lack, is a notion of representation. For Richard Wollheim, see his trenchant review of Anthony Blunt's major study of Poussin in *The Listener* 80, no. 2056, 22 August 1968, pp. 246–47; Erwin Panofsky, "Iconography and Iconology: An Introduction to the Study of Renais-

sance Art," in *Meaning in the Visual Arts* (Garden City, N.Y.: Doubleday Anchor Books, 1955), pp. 26–30; for an earlier attempt of my own to deal with this issue see my "Seeing as Knowing: A Dutch Connection," *Humanities in Society* 1 (1978):147–73.

18. See particularly Michel Foucault, *The Order of Things* (New York: Random House, Vintage Books, 1973).

19. E. Jane Connell, "The Romanization of the Gothic Arch in Some Paintings by Pieter Saenredam: Catholic and Protestant Implications," *The Rutgers Art Review* 1 (1980):17–35. The fact that it was artists of the Catholic faith (the so-called pre-Rembrandtists) who established what is considered to be a Protestant kind of narrative biblical painting is another example of the fluidity of boundaries and the difficulty of sustaining confessional categories in the interpretation of Dutch art.

Chapter One

1. For a solid and detailed study of the words used to refer to painters and their paintings in Netherlandish handbooks and inventories of the time, see Lydia de Pauw-de Veen, "De begrippen 'schilder', 'schilderij' en 'schilderen' in de zeventiende eeuw," *Verhandelingen van de Koninklijke Vlaamse Academie voor Wetenschappen, Letteren en Schone Kunsten van Belgie, Klasse der Schone Kunsten* 31, no. 22 (1969). The researches of the economist J. M. Montias into the production and consumption of art in Holland are adding much to our understanding of the operation of the art market. But students of art must still consider how the function of images as commodities affected their appearance and the way they were regarded at the time. See J. M. Montias, *Artists and Artisans in Delft in the Seventeenth Century: A Socio-Economic Analysis* (Princeton University Press, 1982).

2. The most intelligent general study of Constantijn Huygens is still Rosalie L. Colie, *'Some Thankfulnesse to Constantine'* (The Hague: Martinus Nijhoff, 1956). For Huygens's early days in England, see A. G. H. Bachrach, *Sir Constantine Huygens and Britain: 1596–1687: A Pattern of Cultural Exchange,* vol. 1, 1596–1619 (Leiden: at the University Press, 1962; London: Oxford University Press, 1962). Bachrach has continued to work on Huygens and a foretaste of his forthcoming book is included in the publication of the recent symposium on Huygens's son, Christian. See A. G. H. Bachrach, "The Role of the Huygens Family in Seventeenth-Century Dutch Culture," *Studies on Christiaan Huygens* (Lisse: Swets and Zeitlinger B. V., 1980), pp. 27–52. For modern editions of Constantijn Huygens's poems and letters, see *De gedichten van Constantijn Huygens,* ed. J. A. Worp, 8 vols. (Groningen: Wolters, 1892–98) and *De briefwisseling van Constantijn Huygens,* ed. J. A. Worp, 6 vols. (The Hague: Martinus Nijhoff, 1911–18).

3. The Latin manuscript, which was written between 11 May 1629 and April, 1631, is now in the Royal Library, The Hague. The complete text was published by J. A. Worp, "Fragment eener Autobiographie van Constantijn Huygens," in *Bijdragen en Mededeelingen van het historisch Genootschap* (Utrecht) 18 (1897):1–122. My references will be to this transcription. For a Dutch translation that was first published in 1946 and recently reissued, see A. H. Kan, *De Jeugd van Constantijn Huygens door hemzelf beschreven* (Rotterdam: Ad. Donker, 1971).

4. For the nature of autobiographical writings at the time, see Paul Delany, *British Autobiography in the Seventeenth Century* (London: Routledge and Kegan Paul, 1969).

5. "Fragment eener Autobiographie," p. 63ff.

6. The excerpted section on art was first published by J. A. Worp, "Constantijn Huygens over de schilders van zijn tijd," *Oud Holland* 9 (1891):106–36. A. J. Kan, *De Jeugd van Constantijn Huygens,* pp. 141–47, includes an essay by G. Kamphuis, "Constantijn Huygens als kunstcriticus." For a considered commentary on this section of Huygens's text, see Seymour S. Slive, *Rembrandt and his Critics* (The Hague: Martinus Nijhoff, 1953), pp. 9–26.

7. Worp, "Fragment eener Autobiographie," p. 112.

8. On Drebbel, see Gerrit Tierie, *Cornelis Drebbel* (Amsterdam: H. J. Paris, 1932) and L. E. Harris, *The Two Netherlanders: Humphrey Bradley and Cornelis Drebbel* (Leiden: E. J. Brill, 1961).

9. Charles Ruelens and Max Rooses, *Correspondance de Rubens et documents épistolaires concernant sa vie et ses oeuvres,* 6 vols. (Antwerp, 1887–1909), 5:153. The letter appears in translation in Ruth Magurn, trans. and ed., *The Letters of Peter Paul Rubens* (Cambridge, Mass.: Harvard University Press, 1955), pp. 322–23.

10. Worp, "Fragment eener Autobiographie," p. 120.

11. Clifford Geertz, "Art as a Cultural System," *Modern Language Notes* 91 (1976):1475–76.

12. Worp, "Fragment eener Autobiographie," p. 120.

13. Ibid., p. 113.

14. For Huygens's digression on eyeglasses, see Worp, "Fragment eener Autobiographie," p. 100ff. On the problem of who actually invented eyeglasses, see the exhaustive study by Edward Rosen, "The Invention of Eyeglasses," *Journal of the History of Medicine and Allied Sciences* 11 (1956): 13–306. The argument that lenses, although known, were previously mistrusted has been made by Vasco Ronchi in a number of his many publications. See, for example, his *New Optics* (Florence: Leo S. Olschki, 1971), p. 25ff.

15. The ruling group in Amsterdam was unusual in Europe at the time for its interest in the natural sciences. For a brief but informative account of its interest in novelty, which the author acutely dubs an "entrepreneurial virtue," see Peter Burke, *Venice and Amsterdam: A Study of Seventeenth Century Elites* (London: Temple Smith, 1974), pp. 76–78. It has been suggested that even Christian Huygens shared the practical leanings of his countrymen. In his summary of the recent international conference, A. R. Hall made the point that "of the major figures in seventeenth-century physical science, Galileo, Gassendi, Pascal, Descartes, Huygens, Leibniz and Newton, the Netherlander is the only one who is not markedly a philosopher. To apply to him such a term as 'positivist' would of course be anachronistic, so that I will simply say that his mind seems to have preferred what was concrete and factual and to have avoided metaphysics and broad speculations." A. R. Hall in *Studies on Christiaan Huygens* (Lisse: Swets and Zeitlinger B.V., 1980), p. 304.

16. A. G. H. Bachrach, *Sir Constantine Huygens and Britain: 1596–1687* (Leiden: at the University Press, 1962; London: Oxford University Press, 1962), p. 7. In his more recent work, Bachrach seems to have significantly developed his understanding of Huygens to include also his attraction toward Bacon and Drebbel. However, in his emphasis on the emblematic, theatrical, and philosophical play of these men's minds, Bachrach once again, I think, mistakes the basis of Huygens's attraction to them. See his contribution to *Studies on Christiaan Huygens,* pp. 46–48.

17. A. J. Worp's publication of this poem in *De gedichten* has been superseded by a new annotated edition, *Dagh-werck van Constantijn Huygens,* ed. F. L. Zwaan

(Assen: Van Gorcum and Comp. B.V., 1973). My references will be to the line numbers and related Huygens commentary that are common to both editions.

18. *Daghwerck,* Huygens's prose commentary on lines 550–58.

19. Ibid., ll. 562–65.

20. Huygens, *De briefwisseling* 1:94. This praise for the device is not contradicted, as it is sometimes said, by Huygens's lengthy and infamous criticism of the use of the camera obscura by the Dutch artist Torrentius. Huygens objects to the secrecy of the operation, not to the use of the device itself.

21. The passage is quoted, in translation, by Rosalie L. Colie, *'Some Thankfulnesse to Constantine'* (The Hague: Martinus Nijhoff, 1956), p. 97.

22. The first modern study devoted to this kind of work is R. Wishnevsky, "Studien zum 'portrait historié' in den Niederlanden," (Ph.D. dissertation, Munich, 1967). See also Alison McNeil Kettering, "The Batavian Arcadia: Pastoral Themes in Seventeenth Century Dutch Art" (Ph.D. dissertation, University of California, Berkeley, 1974).

23. Christian Tümpel has argued that the painting is Rembrandt's particular way of representing the biblical scene of Isaac and Rebecca by making a selection ("Herauslösung") of central figures from the narrative. R. H. Fuchs, arguing from a formal or rhetorical (what he terms a "voordracht") instead of an iconographic point of view, proposes that Rembrandt allows the biblical story to heighten what is in fact a portrait. See Christian Tümpel, "Studien zur Ikonographie der Historien Rembrandts: Deutung und Interpretation der Bildinhalte," *Nederlands Kunsthistorisch Jaarboek* 20 (1969): 107–98, R. H. Fuchs, "Het zogenaamde Joodse bruitje en het probleem van de 'voordracht' in Rembrandts werk," *Tijdschrift voor Geschiedenis* 82 (1969):482–93.

24. *Daghwerck,* ll. 250–53.

25. Ibid., commentary to ll. 1140–57.

26. Ibid., commentary to ll. 1192–95.

27. Huygens, *De gedichten* 2:236.

28. Ibid.

29. Worp, "Fragment eener Autobiographie," p. 120. Colie further substantiates Huygens's rationalist attitudes in her short study of his attack on the omens read into the appearance of the Great Comet of 1681. See Rosalie L. Colie, "Constantijn Huygens and the Rationalist Revolution," *Tijdschrift voor Nederlandse Taal en Letterkunde* 73 (1955): 193–209.

30. *Daghwerck,* commentary to ll. 1198–200.

31. Francisco de Hollanda, *Four Dialogues on Painting,* trans. Aubrey F. G. Bell (London: Oxford University Press, 1928), p. 16.

32. Leon Battista Alberti, *On Painting and Sculpture,* ed. and trans. Cecil Grayson (London: Phaidon Press, 1972), p. 53.

33. Ibid.

34. Worp, "Fragment eener Autobiographia," p. 75.

35. Tacitus, *Annals* 4.58.3.

36. *Daghwerck,* ll. 560ff.

37. For a discussion of Huygens's interest in natural knowledge, see Ignaz Matthey, "De Betekenis van de Natuur en de Natuurwetenschappen voor Constantijn Huygens," in *Constantijn Huygens: Zijn Plaats in Geleerd Europa,* ed. Hans Bots (Amsterdam: University Press, 1973), pp. 334–459.

38. Artists today who make maps, photographic records, and earth-works chal-

lenge this distinction and force the issue of art and its nature in ways unimaginable in the seventeenth century.

39. Thomas S. Kuhn, "Mathematical versus Experimental Traditions in the Development of Physical Science," in *The Essential Tension: Selected Studies in Scientific Tradition and Change* (Chicago: University of Chicago Press, 1977), pp. 31–65. For the Merton thesis, see R. K. Merton, *Science, Technology and Society in Seventeenth Century England* (Bruges: St. Catherine Press, 1938).

40. Erwin Panofsky, *Early Netherlandish Painting*, 2 vols. (Cambridge, Mass.: Harvard University Press, 1953), 1:182.

Chapter Two

1. Henry James, "In Holland," in *Transatlantic Sketches*, 4th ed. (Boston: Houghton, Mifflin and Company, 1868), pp. 382–83.

2. Kenneth Clark, *Landscape into Art*, new ed. (New York: Harper and Row, 1976), p. 65.

3. Samuel van Hoogstraten, "Een recht natuerlijke Schildery," *Inleyding tot de Hooge Schoole der Schilderkonst: Anders de Zichtbaere Werelt* (Rotterdam, 1678), p. 263.

4. In general, studies on the camera obscura and Dutch art have considered the device as a technical aid for making pictures and as a model for the desired "look" of pictures. Arthur Wheelock, Jr., for example, writes: "For Dutch artists, intent upon exploring the world about them, the camera obscura offered a unique means for judging what a truly natural painting should look like." "Constantijn Huygens and Early Attitudes towards the Camera Obscura," in *History of Photography* 1, no. 2 (1977):101. But why did such a model of the "natural" picture prevail in the first place? And what is its nature?

5. Joshua Reynolds, *The Works . . . containing his Discourses . . . [and] A Journey to Flanders and Holland . . .* , 4th ed., 3 vols. (London 1809), 2:360.

6. Eugène Fromentin, *The Masters of Past Time*, trans. Andrew Boyle and ed. Horst Gerson (London and New York: Phaidon, 1948), p. 142.

7. Ibid., p. 141.

8. Ibid., p. 128.

9. Ibid., p. 131.

10. Claudel and Pennell are quoted in the article by Heinrich Schwarz, itself prompted by an earlier study by Charles Seymour, which was the first major attempt to put together an argument for Vermeer's use of the camera obscura. See Heinrich S. Schwarz, "Vermeer and the Camera Obscura," *Pantheon* 24 (1966):170, 171 and Charles Seymour, "Dark Chamber and Light-Filled Room: Vermeer and the Camera Obscura," *The Art Bulletin* 46 (1964):323–31.

11. Daniel Fink, "Vermeer's Use of the Camera Obscura—A Comparative Study," *The Art Bulletin* 53 (1971):493–505, made the most comprehensive claims for the visible effect of copying after the device in Vermeer's art. The most careful critique of Fink is by Arthur Wheelock, Jr., *Perspective, Optics, and Delft Artists Around 1650,* Outstanding Dissertations in the Fine Arts (New York and London: Garland Publishing, 1977), pp. 185–95.

12. Whatever view one might hold in the debate about the nature of linear perspective (whether it is the only *exact* representation of the uniocular field of vision or one convention for *representing* such a view) the contrast implicit in such state-

ments between culture and nature, or art and vision, effectively puts Dutch images beyond the reach of art. For the two quotations, as well as for a useful bibliography of the current literature on linear perspective, see Walter A. Liedtke's review of Wheelock, *Perspective, Optics and Delft Artists* in *The Art Bulletin* 51 (1979):494, n.15; 492.

13. On the pinhole camera, see David C. Lindberg, "The Theory of Pinhole Images from Antiquity to the Thirteenth Century," *Archive for History of Exact Sciences* 6 (1970); 299–325. I have found the most helpful study of Kepler to be Stephen M. Straker, "Kepler's Optics: A Study in the Development of Seventeenth-Century Natural Philosophy" (Ph.D. dissertation, Indiana University, 1970). Following the lead of earlier work by Vasco Ronchi and Alistair C. Crombie, Straker views Kepler as a revolutionary figure who transformed the very nature of visual theory. See the imaginative Vasco Ronchi, *Optics, The Science of Vision*, trans. Edward Rosen (New York: New York University Press, 1957) and *The Nature of Light: An Historical Survey*, trans. V. Barocas (London: Heinemann, 1970); or the more careful Alistair C. Crombie, "The Mechanistic Hypothesis and the Scientific Study of Vision: Some Optical Ideas as a Background to the Invention of the Microscope," in *Historical Aspects of Microscopy*, ed. S. Bradbury and G. L. E. Turner (Cambridge: W. Heffer and Sons Ltd., 1967), pp. 3–112. For a different view that places Kepler squarely in the tradition of thought coming out of Allhazen in the eleventh century, see David C. Lindberg, *Theories of Vision from Al-Kindi to Kepler* (Chicago and London: University of Chicago Press, 1976).

14. Johannes Kepler, *Ad Vitellionem paralipomena, quibus astronomiae pars optica traditur*, in *Gesammelte Werke*, ed. Walther van Dyck and Max Caspar, 18 vols. (Munich: C. H. Beck'sche Verlagsbuchhandlung, 1937–), 2:153 (hereafter cited as *G. W.*). I have used the English translation with commentary "Kepler: De Modo Visionis: A Translation from the Latin of *Ad Vitellionem Paralipomena*, V, 2, and related passages on the formation of the retinal image," Alistair C. Crombie in *Mélanges Alexander Koyré*, vol. 1 (Paris: Hermann, 1964), pp. 135–72.

15. Kepler, *Ad Vitellionem, G. W.* 2, p. 143. The translation is by Straker, p. 415.

16. Ibid., p. 151. The translation is by Crombie, pp. 147–48.

17. Ibid., p. 153. The translation is by Crombie, p. 150.

18. Ibid., p. 186.

19. David C. Lindberg, *Theories of Vision*, p. 202. In this matter there is no disagreement between the medievalists' and the modernists' understanding of Kepler.

20. Laurence Gowing, *Vermeer* (London: Faber and Faber, 1952), p. 19.

21. Kepler, *Dioptrice, G. W.*, 4, p. 368.

22. Ibid., p. 372.

23. "Datmen zich gewenne de dingen, eeven alsze zijn, nae te bootsen." Samuel van Hoogstraten, *Inleyding tot de Hooge Schoole der Schilderkonst: Anders de Zichtbaare Werelt* (Rotterdam, 1678), p. 36 (hereafter cited as Hoogstraten, *Inleyding*). A word is in order here about the nature of the contemporary texts available to us on Dutch art. We have seen how, in unexpected ways, the writings of Constantijn Huygens can begin to make up for the absence of other texts. This is also true of a small number of handbooks on art from Van Mander's compendium of 1604 to Van Hoogstraten in 1678. Though these works accept the rhetoric and most of the categories first established by the Italian writers, a careful and attentive reading reveals a constant interplay between Italian assumptions about the nature of arts and northern practice. Samuel van Hoogstraten, to whom we shall return more than

once, is a major source of Dutch notions of art in just this way. And the passage on drawing reveals the complex interplay between Italian assumptions and Dutch practice to which I just referred. For a detailed and comprehensive consideration of Samuel van Hoogstraten's writings on art and their relationship to his works and those by other Dutch artists, we shall have to await the completion of the current research of Celeste Brusati.

24. Fromentin, *The Masters of Past Time*, p. 128.

25. "Sullen wy het soo maecken dat yder een kan sien om dat het op sodanige maniere gemaect is, dat het van die, of die *Meester* zy? neen geensins." ("Should we do it in such a way that everyone can see that a work is done in a certain manner, that it is done by this or that Master? no, by no means") Philips Angels, *Lof der Schilder-Const* (Leiden, 1642), p. 53. Angels's praise of painting was delivered as an address to the artists in Leiden, where in 1642 they were still denied their own guild. It reveals much the same interplay between southern ideals and northern practices that we find in Hoogstraten. This point seems to me suggested, though not in these terms, by the commentary on Angels's text offered by Hessel Miedema in the December 1973 issue of *Proef*, a small mimeographed publication of work in progress at the University of Amsterdam.

26. I think it can fairly be said that the notions about the nature of the invention of images that Panofsky assembled under the term "idea" were never central to thinking about or making art in the north. See Erwin Panofsky, *Idea: A Concept in Art Theory*, trans. Joseph J. S. Peake (New York: Harper and Row, Icon Editions, 1958).

27. "Een dito [boeckie] vol Statuen van Rembrant nae't leven geteckent." C. Hofstede de Groot, *Die Urkunden über Rembrandt* (1575–1721) (The Hague: Martinus Nijhoff, 1906), p. 204, no. 261.

28. "Goltzius comende uyt Italien, hadde de fraey Italische schilderijen als in eenen spieghel soo vast in zijn ghedacht ghedruckt, dat hyse waer hy was noch altijts ghestadich sagh." Karel van Mander, *Het Schilder-Boeck . . .* (Haarlem, 1604), fol. 285ᵛ. E. K. J. Reznicek was misleading when, in a brief but influential essay, he translated the word "geest" as meaning "imagination" and then distinguished between working "uit den geest" and "naer het leven" as two paths in Dutch art around 1600, one manneristic, the other realistic. It is the combination of the two sources of visual perception that is consistently praised by Dutch writers on art. Van Mander says De Gheyn found it necessary to work "veel nae t'leven, en met eenen uyt de gheest te doen, om also alle redenen der Const te leeren verstaen" (*Schilder-Boeck*, fol. 294ᵛ). Indeed, far from distinguishing clearly between two different ways of working or two different kinds of art, the Dutch tend to blur and combine them as the means to one representational end. This is similar to the blurring (from the Italian point of view) inherent in Van Hoogstraen's use of the word "teykenkunst."

29. Like his art, Goltzius's life as set forth by Van Mander is a model of this curious sense of self as self-effacement and absorption into one's art. Goltzius is not only complemented for being a Proteus or Vertumnus in his works in the Dürer manner, but during his trip to Italy he actually delights in traveling incognito by exhanging roles with his servant and even assumes the clothes, name, and identity of a German peasant (*Schilder-Boeck*, fols. 285; 282ᵛ, 283). Vermeer's representation of the anonymous artist absorbed in his craft in the *Art of Painting* culminates this notion of self and of image-making.

30. See Karel van Mander, *Den Grondt der edel-vry schilderconst*, ed. and trans.

Hessel Miedema, 2 vols. (Utrecht: Haentkjens Dekker and Gumbert, 1973), 2: 437–38 for a commentary on the phrase *uit zijn selven doen*. Though Miedema relates this Dutch notion of memory to the Italian *maniera*, we must not thereby draw the conclusion that the Dutch and the Italians were in essential agreement with each other either in their verbal usage or in their art. (See Hessel Miedema, "On Mannerism and *maniera*," *Simiolus* 10 [1978–79]:19–45.) The premise of Miedema's important commentary on Van Mander, which is to ground Dutch rhetoric on art in the tradition of writing coming out of Italy, seems to me misleading. An alternative reading of Van Mander will be forthcoming from the research currently being done on his writings and on his art by Walter Melion. Again and again the evidence is that though the Dutch do borrow terms from the Italians, they use them in quite different ways. To cite a relevant example, the Dutch characteristically lack a strong sense of the fantasy that shapes memory. Hence the extraordinary image of Pieter Bruegel spitting the mountains up onto his canvas invoked by Van Mander.

31. On this important point I differ with the literature on Kepler. Whether they are of what one might call the modernist (Straker) or medievalist (Lindberg) persuasion, students of Kepler stress the continuities between Kepler's model of the eye and Albertian perspective. Some even attribute Kepler's invocation of the metaphor of the picture to this connection. In my analysis, the question is not a matter of geometry— where a similarity does indeed exist—but rather of the nature of the picture where it does not.

32. Johan van Beverwyck, *Schat der Ongesontheyt*, p. 87 in *Wercken der Genees-Konste* (Amsterdam, 1664).

33. G. B. della Porta, *Natural Magick*, trans. (London, 1658), p. 364.

34. Leon Battista Alberti, *On Painting and Sculpture*, ed. and trans. Cecil Grayson (London: Phaidon Press, 1972), p. 67. I chose Dürer's woodcut to contrast with the illustration to Van Beverwyck because it illustrates the framed intersection of the visual pyramid and, tellingly, a female nude as the object in view (of which more later). However, admittedly, this woodcut does not illustrate perspective practice as such because the net or grid insures correctness by mechanical rather than by mathematical means.

35. Ibid., p. 55.

36. James Ackerman, "Alberti's Light," in *Studies in Late Medieval Painting in Honor of Millard Meiss*, eds. Irving Lavin and John Plummer, 2 vols. (New York: New York University Press, 1977), 1:19.

37. The similiarity of the photograph to the Dutch descriptive mode that we have been analyzing—a similarity that Kenneth Clark voiced when he wrote that the *View of Delft* was like a colored photograph—has a bearing on current thinking about the nature and status of photography. To state my conclusion at the start: photography, I shall argue, is properly seen as being part of this descriptive mode, rather than as the logical culmination of the Albertian tradition of picture-making.

The question of whether photography is or is not an art seems quite out of date today. But the issues it raises continue to be posed by the medium. While most writers on photography take the affirmative position, a few still insist on the negative and these two positions subdivide further in interesting ways. On the negative side there are two voices: one says photography is not art in order to condemn it (Sontag, Scruton); the other says it is not in order to celebrate it (Krauss). On the affirmative side, one group says that photography is not different from other pictures (Snyder) and the other position refines this to say that not only is photography *like* other

pictures, but it is indeed dependent upon them, a creature really of the history of painting (Varnedoe, Galassi). What all the debaters without exception have in common is the notion that by *art* is meant the Albertian picture: it is this that the photograph is meant to be, or not to be, like.

In this situation it is, ironically, those denying photography the status of art, those who agree with Krauss that "the photograph is generically different from painting, or sculpture or drawing" who come closest to the mark. The next step is to recognize that the difference from art means a difference from the Albertian picture. It is a difference, in other words, that allies the photograph to what we can, I think, establish as an alternative mode of art, to the descriptive mode that we have found in Dutch works. Indeed, the much heralded thesis of Galassi's catalogue essay for the recent MOMA exhibition entitled "Before Photography" makes just this pictorial point without knowing it. Peter Galassi has proposed that the invention of the photographic image is properly seen as part of the history of art. In the name of this he exhibited a host of eighteenth-century and early nineteenth-century studies of paintings done "after nature" that are characterized by their fragmentary, unframed, uncomposed recording of the world seen. He backed up these works by illustrating works by Dürer, Ruisdael, Saenredam, and Van Wittel in his catalogue essay. Galassi is correct in the materials that he is relating but incorrect in the terms on which he relates them. His claim, that these works are a branch or offshoot of the linear perspective picture, seems wrong. For as this assemblage of backup works reveals, the ultimate origins of photography do not lie in the fifteenth-century invention of perspective (Galassi, p. 12), but rather in the alternative mode of the north. Seen this way, one might say that the photographic image, the Dutch art of describing and (*pace*, Varnedoe) Impressionist painting are all examples of a constant artistic option in the art of the West. It is an option or a pictorial mode that has been taken up at different times for different reasons and it remains unclear to what extent it should be considered to constitute, in and of itself, a historical development. But it is only when it is distinguished from the central tradition of the Albertian picture that its particular nature becomes clear. See Susan Sontag, *On Photography* (New York: Farrar, Straus and Giroux, 1977); Roger Scruton, "Photography and Representation," *Critical Inquiry* 7 (1981):577–603; Rosalind Krauss, "The Photographic Conditions of Surrealism," *October* 19 (1981):26; Joel Snyder, "Picturing Vision," *Critical Inquiry* 6 (1980):499–526, Kirk Varnedoe, "The Artifice of Candor: Impressionism and Photography Reconsidered," *Art in America* (January 1980):66–78; and Peter Galassi, *Before Photography: Painting and the Invention of Photography* (New York: The Museum of Modern Art, 1981).

38. In terms of the analysis of light, we might say that the southern artist is concerned with *lux* (light emitted by the eyes to explore the world) and the northerners with *lumen* (light given off by objects). Gombrich has offered us Leonardo's *lume* and *lustro* with just this force. (See E. H. Gombrich, "Light, Form and Texture in Fifteenth Century Painting North and South of the Alps," *The Heritage of Apelles* (Oxford: Phaidon Press, 1976), pp. 19–35.) But it appears from recent studies that a distinction between the two theories of vision—the so-called extramission and the intromission accounts of light of which Ronchi made so much—was not basic to notions of vision even in the Middle Ages. (See Lindberg, *Theories of Vision*, pp. 143–46.)

39. Panofsky's seminal paper on perspective as symbolic form, which argued that the system is but one possible convention among many, has often been disputed. The

art historian Gombrich and the physiologist Pirenne are among a number of scholars to argue that linear perspective is the correct way to represent the world on a picture plane. Samuel Edgerton (p. 163), who describes perspective as a "relatively non-subjective way to make pictorial images," tries to take a stand somewhere in between the two views. T. Kaori Kitao has recently shown that the root of this dispute lies in the fact that Alberti's text, paradoxically, supports both what he calls the illusionist and the constructivist claims. See Erwin Panofsky, 'Die Perspektive als 'Symbolische Form,' " *Vorträge der Bibliothek Warburg: 1924–25* (Leipzig-Berlin, 1927), pp. 258–330; E. H. Gombrich, "The 'What' and the 'How': Persepctive Representation and the Phenomenal World," *Logic and Art: Essays in Honor of Nelson Goodman,* eds. R. Rudner and I. Scheffler (Indianapolis: Bobbs-Merrill, 1972), pp. 129- 49; M. H. Pirenne, "The Scientific Basic of Leonardo da Vinci's Theory of Perspective," *The British Journal for the Philosophy of Science* 3 (1952–53):169–85; Samuel Y. Edgerton, Jr., *The Renaissance Rediscovery of Linear Perspective* (New York: Harper and Row, Icon Editions, 1976); and T. Kaori Kitao, "*Imago* and *Pictura:* Perspective, Camera Obscura and Kepler's Optics," *La Prospettiva Rinascimentale,* ed. Marisa Dalai Emiliani (Florence: Centro Di, 1980), 1:499–510.

40. James Ackerman, "Alberti's Light," p. 20, n. 50.

41. Walter A. Liedtke, "Saenredam's New Church in Haarlem Series," *Simiolus* 8 (1975–76):154, and Liedtke, review of Wheelock, *The Art Bulletin* 51 (1979):492.

42. The Albertian picture has been so dominant in the Western tradition ever since the Renaissance that exceptions to it are rarely granted and attempts to analyze these exceptions to it are even rarer, In recent times, Leo Steinberg's definition of Rauschenberg's flat-bed picture plane, "in which the painted surface is no longer the analogue of a visual experience of nature but of operational processes," and Michael Fried's interest in the absorptive and antitheatrical (for which read anti-Albertian) images in France are rare examples of pictorial analyses that recognize such "difference" to be a problem. They do so in each case in an attempt to deal with images that, so they claim, challenge what so much Western art specifically confirms: our orientation as upright figures looking out through a frame to a (second) world. See the title essay in Leo Steinberg, *Other Criteria* (London and New York: Oxford University Press, 1972), pp. 82–91; and Michael Fried, *Absorption and Theatricality* (Berkeley and Los Angeles: University of California Press, 1980).

43. For a powerful critique of this tradition, see Richard Rorty, *Philosophy and the Mirror of Nature* (Princeton: Princeton University Press, 1979).

44. Leonardo da Vinci, *Treatise on Painting,* trans. A. Philip McMahon, 2 vols. (Princeton: Princeton University Press, 1956, 1:23, par. 34.

45. Ibid., p. 48 par. 71.

46. The clearest account of the profound dilemma about the status of the observer, which is built into both Albertian perspective and Leonardo's (or the northern) alternative, was that by the late Robert Klein, who wrote: "Zenale and Piero [for whom we could substitute Alberti] counted on a spectator 'placed in proper conditions' by the distance which he adopts; Leonardo's specatator is nowhere . . . but he is also everywhere, for the work takes the place of the eye. The question cannot be resolved for each party necessarily tumbles into the adversary's camp. The objective and scientific attitude, which refuses to reproduce the aberrations and weaknesses of vision, is obliged to count upon them for the perception of the work; the analytical attitude which incorporates them into the work must deny the existence of the spectators." "Pomponius Gauricus on Perspective," *The Art Bulletin* 43 (1961):228.

The distinction is between the painting considered as a *substitute* for the world (Albertian) and the painting considered as a *replica* of the world (northern). This point is in fact made by Pirenne himself (who, however, in effect denies the possibility of the second option). See M. H. Pirenne, *Optics, Painting and Photography* (Cambridge: University Press, 1970), p. 138.

47. *The Notebooks of Leonardo da Vinci,* ed. Jean Paul Richter, 2 vols. (New York: Dover Publications, 1970), 1:18, par. 20.

48. Leonardo da Vinci, *Treatise on Painting* 2:49, par. 72.

49. I owe the reference to Prospero to a marvelous essay on Leonardo by E. H. Gombrich, "The Grotesque Heads," *The Heritage of Apelles* (Oxford: Phaidon Press, 1976), p. 75.

50. *Correspondance de Nicolas Poussin,* ed. C. Jouanny (Paris, 1911), p. 143. For an analysis of this letter, see Carl Goldstein, "The Meaning of Poussin's Letter to De Noyers," *The Burlington Magazine* 108 (1966):233–39.

51. I want to thank Gerald Holton for calling my attention to this drawing when I was first thinking about these problems. He suggested to me the revolutionary nature of Kepler's notion of sight and anticipated its possible relevance to a study of Dutch pictures. This drawing, Holton advises me, was probably not drawn by Kepler himself. It is based on a design by Christoph Scheiner and was most likely sent to Kepler by Melchior Stöltzle in September 1615, when Kepler was himself working on this kind of device.

52. *The Life and Letters of Sir Henry Wotton,* ed. Logan Pearsall Smith, 2 vols. (Oxford: Clarendon Press, 1907), 2:206.

53. "Hoe de zichtbaere Natuer zich bepaelt vertoont." Hoogstraten, *Inleyding,* p. 33.

54. Pieter Saenredam (1597–1665), the son of an accomplished engraver, apprenticed in Haarlem with the history painter Frans Pietersz. de Grebber. His first important commission was to illustrate Ampzing's history of the city of Haarlem (1628). Almost all of his works are portraits of Dutch church interiors. He recorded them in drawings made on trips taken for the purpose and then, sometimes years later, he would take paintings from the drawings, often annotating the drawings when he did so. Saenredam's works have been admired by writers as different in purpose and tone as J. Q. van Regteren Altena, "The Drawings by Pieter Saenredam," in *Catalogue Raisonné of the Works of Pieter Jansz. Saenredam* (Utrecht, 1961), pp. 17–28, and Roland Barthes, "The World as Object," in *Critical Essays,* trans. Richard Howard (Evanston: Northwestern University Press, 1972), pp. 3–12.

55. Vredeman's contemporaries, in particular Karel van Mander in his life of Vredeman, acknowledge this representation of views viewed in the very way they describe his works. A group of twenty-six engravings is described as "views into palaces from points without and within" ("26 stucken, insiende en van boven siende Paleysen, uytwendigh en inwendigh"), and a little gallery painted for a gentleman in Hamburg depicts a "view into a little green garden. Opposite the gallery . . . a wooden fence with a view through an open door to a pond and swans" ("een doorsien van groenicheyt: recht tegen over de Galerije . . . een houten schutsel, een Prospect van een opstaende deur, toonende eenen Vijver met Swanen"). Karel van Mander, *Schilder-Boeck,* fols. 266, 266ᵛ.

56. See Ann Banfield, "Where Epistemology, Style, and Grammar Meet Literary History: The Development of Represented Speech and Thought," *New Literary History* 9 (1978):417–54. The distinction Banfield makes between the properties of

represented thought and speech (known also as *style indirect libre* or *erlebte Rede*) and those of narration per se has interesting analogies to the distinction I am drawing between descriptive and narrative pictorial modes. As if to confirm this, Banfield concludes her forthcoming book by drawing an analogy between represented discourse and those lenses and mirrors that are so closely connected with Dutch picturing. What Banfield says of lenses supports not only her definition of represented thought but also my definition of the descriptive picture: "the lens is witness to the fact that representation, even a representation of the mind, need not imply a represented mind." *Unspeakable Sentences: Narration and Representation in the Language of Fiction* (London: Routledge and Kegan Paul, 1982).

57. Van Regeren Altena, "The Drawings by Pieter Saenredam," p. 25.

58. See L. Brion-Guerry, *Jean Pélerin Viator: Sa Place dans l'Histoire de la Perspective* (Paris: Société d'Edition Les Belles Lettres, 1962), pp. 219–20 for the passages with which I am principally concerned. Viator's text, originally published in Latin and French in 1505, 1506, and 1521, remained popular enough to warrant a fourth edition in 1635. Discussion of Viator's construction has stressed that it gives final results that are identical to Alberti's, while admitting that it is much more abstract in nature. See William M. Ivins, Jr., *On the Realization of Sight* (New York: Da Capo Press, 1975) for the established view.

59. See Timothy K. Kitao, "Prejudice in Perspective: A Study of Vignola's Perspective Treatise," *The Art Bulletin* 44 (1962):173–94. Kitao points out that Vignola completely rejects a perspective construction that features two or more eyepoints (the *prejudice* of the article's title), and suggests, I think correctly, that this can be explained in part "as an instance of culturally conditioned preconception" (p. 185).

60. Brion-Guerry, *Viator*, pp. 221, 218.

61. Jan Vredeman de Vries, *Perspective: Id est Celeberrima ars inspicientis aut transpicientis oculcrum aciei, in pariete, tabula aut tela depicta . . .* (The Hague and Leiden: 1604–5).

62. Hoogstraten, *Inleyding*, pp. 273–75.

63. Giorgio Vasari, *Le Vite de Più Eccellenti Pittori Scultori ed Architettori*, in *Le Opere*, ed. G. Milanesi, 9 vols. (Florence: Sansoni, 1878–85), 4:98.

64. See David Summers, "*Figure come Fratelli:* A Transformation of Symmetry in Renaissance Painting," *The Art Quarterly* n.s. 1 (1977):59–88, and "*Maniera* and Movement: *The Figura Serpentinata*," *The Art Quarterly* 35 (1972):269–301, and Leo Steinberg, "Picasso: Drawing as if to Possess," *Artforum* (October, 1971):44–53. The point is further developed by Steinberg in his *Other Criteria*, pp. 174–92. As Summers correctly points out ("Figure come Fratelli," p. 86 n. 19), Giorgione's work has a decidedly northern flavor.

65. Kepler, *Ad Vitellionem, G. W.*, 2:143.

66. Hoogstraten, *Inleyding*, p. 274.

67. See Gary Schwartz, "Saenredam, Huygens and the Utrecht Bull," *Simiolus* 1 (1966–67):90–99 for a full discussion of the meaning and the commission of this picture. Although the figures in his paintings were not normally executed by the artist himself, he was clearly responsible for establishing their positions and, in a number of cases, the direction of their gazes.

68. It turns out that even this image is not the linear perspective construction that it at first appears to be. Only after this chapter was completed did I discover a recent study of this particular etching that demonstrates that it, too, must be distinguished from Albertian perspective. In a masterful essay—the best that I have ever read on

Saenredam's representation of space—Bob Ruurs shows that even this work is constructed by means of a mixture of central perspective and the *unconscious* use of what he calls *proportional notation*. (Ruurs proposes that we use this term instead of the usual curvilinear perspective to refer to a notation that requires that the distance between any given two points of the picture be always directly proportional to the angle under which a particular observer would see the two points.) Proportional notation, as Ruurs points out, cannot be achieved on a flat plane. I would argue, however, that in making the attempt Saenredam, like the cartographers to whom Ruurs correctly compares him, confirms that he accepts the image as a flat surface rather than conceiving of it as a framed window through which we look, as did the practitioners of linear perspective. The question is not only what's *in* a picture, but what *is* a picture. See Bob Ruurs, "Drawing from Nature: The Principle of Proportional Notation," *La Prospettiva Rinascimentale,* ed. Marisa Dalai Emiliani (Florence: Centro Di, 1980), pp. 511–21.

69. As my interpretation suggests, I think that the long-held view of the intrinscially puzzling nature of *Las Meninas* is justified. The question is why and in what respect we take it to be puzzling. A powerful study by the philosopher John Searle posits some of the same contradictions of which I have written. His conclusion differs from mine because Searle assumes that there is a single canon of classical pictorial representation with which the Velázquez picture is not consistent. The correction I offer to his reading is to identify the inconsistency with the presence of two identifiable and incompatible modes of pictorial representation. It is, then, not the exception to a *single* representational canon but the tension between the *two* that is at the heart of the picture. Velázquez is engaged in a testing and questioning of the nature of the artist's relationship to his work and to the world that is central in Western art. The refutation of Searle's position by Snyder and Cohen accommodates the picture on the narrowest of grounds to what they (and Searle) would call the classical canon of pictorial representation. By arguing that the vanishing point is at the far, open door and that the mirror on the wall cannot be reflecting the king and queen standing before the picture but must represent the king and queen as they are depicted on the hidden canvas, they think that they have ruled out the paradoxical nature of Velázquez's work. My sense of the paradoxical nature of Velázquez's representation is not dependent on these arguments, which seem well taken. By identifying the painting's point of view as a geometrically defined point *outside* the picture, Snyder and Cohen ignore the contradictory view from *within,* which is what Velázquez has presented by the artist looking out. See "Las Meninas," in Michel Foucault, *The Order of Things* (New York: Random House, Vintage Books, 1973), pp. 3–16; John Searle, "Las Meninas and Representation," *Critical Inquiry* 6 (1980):477–88; and Joel Snyder and Ted Cohen, "Reflections on *Las Meninas:* Paradox Lost," *Critical Inquiry* 7 (1980):429–47.

70. Crombie, "The Mechanistic Hypothesis," p. 85.

71. Art historians have, understandably, been alert to those junctures when artists and their spokesmen assumed that there was a virtue to being at the forefront of natural knowledge. The Renaissance artist-engineers who studied anatomy and employed the perspective system, and the interest shared in the nineteenth century between painters, photographers, and students of light are two examples that have been studied. Until recently, the seventeenth century has been seen in the art-historical literature as a time when art was no longer significantly tied to such knowledge. In two well-known essays, Panofsky and Ackerman argue that the new

compartmentalization of knowlege displaced art from its central place in the system of knowledge. It is no accident that this analysis was made by students of Italian Renaissance art, for if one looks to the north, one finds that this compartmentalization (which is, to use Foucault's term, the classical episteme) has the effect of distinguishing the image from other forms of knowledge and thus gives it its own particular access to a different kind of knowledge. The nature of this is what the present chapter and the next are about. See Erwin Panofsky, "Artist, Scientist, Genius: Notes on the Renaissance Dämmerung," in *The Renaissance: Six Essays* (New York: Harper Torchbooks, 1962), pp. 123–82; James Ackerman, "Science and Visual Art," in *Seventeenth Century Science and the Arts*, ed. Hedly Howell Rhys (Princeton: Princeton University Press, 1961), pp. 63–90; and Aaron Sheon, "French Art and Science in the Mid-Nineteenth Century: Some Points of Contact," *The Art Quarterly* 34 (1971):434–55.

72. E. H. Gombrich, "Light, Form and Texture," p. 20.

73. In proposing this "storage" model for the relationship between northern art and science, I am struck by its similarity to a recent study of the relationship between psychology, psychoanalysis, and literature that suggests that literary texts were the storage places for insights that were only much later made central to Freud's psychoanalytic studies. See Wolf Lepenies, "Transformation and Storage of Scientific Traditions in Literature" (paper delivered at the Institute for Advanced Study, Princeton, New Jersey, 1980).

Chapter Three

1. Hegel, in a short passage in his lectures on aesthetics, already characterized Dutch painting in terms close to these. He argued that the Dutch replaced an interest in significant subject matter with an interest in the means of representation as an end in itself ("die Mittel der Darstellung werden für sich selber Zweck"). More recently, Meyer Schapiro developed a similar point in reference to still lifes by Cézanne and also suggestively related the entire genre of still life to Western bourgeois society. My purpose in this chapter is to try to relate such pictorial phenomena to notions of knowledge current in the seventeenth century. See G. W. F. Hegel, *Aesthetics: Lectures on Fine Art*, trans. T. M. Knox (Oxford: Clarendon Press, 1975), 1:599; Meyer Schapiro, "The Apples of Cézanne: An Essay on the Meaning of Still-life," *Selected Papers: Modern Art, 19th and 20th Centuries* (New York: George Braziller, 1978), pp. 1–38. In her current research on Jan Bruegel, Anita Joplin is dealing in detail with the background and earlier history of the notions of art, nature, artifice, and knowledge with which I shall be concerned in this chapter.

2. Robert Hooke, *Micrographia* (London, 1665), A2v; reprinted as vol. 13 of *Early Science in Oxford*, ed. R. T. Gunther (Oxford, 1938).

3. Robert Hooke, "An instrument of Use to take the Draught, or Picture of a Thing," in *Philosophical Experiments and Observations* (London, 1721), pp. 292–96.

4. Hooke, *Micrographia*, Gv.

5. Thomas Sprat, *The History of the Royal Society of London for the Improving of Natural Knowledge* (London, 1667; reprint, eds. Jackson I. Cope and Harold Whitmore Jones [St. Louis: Washington University 1958]), p. 89. Hereafter cited as Sprat, *History*.

6. Ibid., p. 401.

7. For a relevant account of the success of Bacon in Holland, see Rosalie L. Colie, *'Some Thankfulnesse to Constantine,'* (The Hague: Martinus Nijhoff, 1956), pp. 73–91. See R. W. Gibson, *Francis Bacon: A Bibliography* (Oxford: Scrivener Press, 1950), for a record of the many editions of his works published in Holland.

8. R. Hooykaas, "Science and Religion in the Seventeenth Century: Isaac Beeckman (1588–1637)," *Free University Quarterly* 1 (1952):169–83.

9. *Journal tenu par Isaac Beeckman de 1604 à 1634,* ed. C. de Waard, 4 vols. (The Hague: Martinus Nijhoff, 1939–53), 3:317–18.

10. Ibid., 1:321; 3:265; 2:382; 2:315–16; 1:xviii.

11. Ibid., 1:322; 2:248.

12. Hoogstraten, *Inleyding,* pp. 24–25.

13. Ibid., p. 34.

14. Hooke, *Micrographia,* p. 153.

15. Hoogstraten, *Inleyding,* p. 140.

16. "Van de gelijkheyt en ongelijkheyt der zweeming" (roughly, "On likeness and difference in resemblance"), Hoogstraten, *Inleyding,* pp. 38–40.

17. Hoogstraten, *Inleyding,* p. 39.

18. *The Works of Francis Bacon,* ed. James Spedding, Robert Leslie Ellis, Douglas Denon Heath, 14 vols. (London, 1857–64), 4:55. Hereafter cited as Bacon, *Works.*

19. Michel Foucault, *The Order of Thing* (New York: Vintage Books, 1973), pp. 54–56.

20. Abraham Cowley, "To the Royal Society," in Sprat, *History,* p. 62.

21. The relevant passages of the long inscription reads as follows: "Waerchtige Afteykeninge der Beelden, . . . in eenen Appel boom gewassen . . . tot bestraffinge, beschaminge, ende overtuyginge van sekere onlangsche valsche Afbeeldinge, ende onder halinge ende wederlegginge van den gestroyden Landleugen tot onderrichtinge vande bedrogene Wereld uyt liefde der waerheid uyt gegeven . . . en sijn de beelden geene andere als dese ende konter oock anders niet in merken al ist schoon dat ghyse met eenen Kristalijnen Bril wel te degen besiet." *Catalogue Raisonné of the Works of Pieter Jansz. Saenredam* (Utrecht, 1971), pp. 267–68.

22. Charles Ruelens and Max Rooses, *Correspondance de Rubens,* 6 vols. (Antwerp, 1887–1909), 4:381. The translation is by Ruth Magurn, trans. and ed., *The Letters of Peter Paul Rubens* (Cambridge, Mass.: Harvard University Press, 1955), p. 247.

23. Bacon, *Works* 4:32–33. Confirmation that the Dutch microscopists long thought of themselves as Baconian in this sense is offered by Boerhaave's introduction to an edition of Swammerdam: "He affirmed nothing but what he saw, and was able to demonstrate everything he affirmed. He in good earnest followed Lord Bacon's advice." Herman Boerhaave, "The Life of the Author," in John Swammerdam, *The Book of Nature ; or the History of Insects,* trans. Thomas Flloyd (London, 1758), p. xvi.

24. *Alle de Brieven van Antoni van Leeuwenhoek,* 10 vols. (Amsterdam: Swets and Zeitlinger, 1939–79), 2:390–94. For general studies of Leeuwenhoek, see Clifford Dobell, *Antony van Leeuwenhoek and his "Little Animals"* (New York: Dover Publications, 1960); A. Schierbeek, *Antoni van Leeuwenhoek: zijn leven en zijn werken* (Lochem, 1950), and *Measuring the Invisible World* (London and New York: Abelard Schuman, 1959).

25. "santgens . . . diemen up een swartsijde taff soude mogen werpen." Ibid., 1:212.

26. Ibid., 2:79.

27. Ibid., 10:126.

28. Quoted in Dobell, *Leeuwenhoek*, pp. 314–16.

29. Hooke, *Micrographia*, p. 153.

30. Jacques (or Jacob) de Gheyn II (1556–1629), as we saw in the first chapter, was admired and beloved by Constantijn Huygens. A student of Hendrick Goltzius, he was an extraordinary draftsman—and in later life a painter—whose prodigious skill in representation was matched by a great breadth of interests: animals and people both alive and dead, flowers, landscapes, witches' rites, and more are described with remarkable care and with affection. His relative obscurity is due to the fact that so many of his works are drawings that are inaccessible to the general public. In manner and subject, De Gheyn heralds many things that matter most to the Dutch artists of his day. The fine, basic study is J. Q. van Regteren Altena, *Jacques de Gheyn: An Introduction to the Study of His Drawings* 1 (no further volumes) (Amsterdam: Swets and Zeitlinger, 1935). Just before his recent death, Van Regteren Altena completed his long-awaited book on all of De Gheyn's works. For good reproductions of the drawings, see J. Richard Judson, *The Drawings of Jacques de Gheyn II* (New York: Grossman, 1973).

31. For Plutarch's brief account of Caesar's dictation of letters, see *Fall of the Roman Empire: Six Lives by Plutarch*, trans. Rex Warner and intro. Robin Seager (Harmondsworth, Middlesex: Penguin Books, 1972), p. 261.

32. William James, *The Principles of Psychology*, 2 vols. (New York: Dover, 1959), 1:409.

33. Riegl pointed out the distinctiveness of the kind of composition, or rather the lack of composition in the traditional sense, evident in a painting like De Gheyn's *Caesar Dictating*. Realizing that it was characteristic of a large number of northern works, Riegl defined it as a *coordinated* composition of *attentive* individuals to distinguish it from the *subordinated* ordering of *acting* figures favored in Italy, and he thought that its epitome was to be found in the Dutch genre of group portraits. Despite its dated psychological terminology, Riegl's analysis still rings true. For a convenient translation of his central arguments, see the selection from *Das holländische Gruppenporträt* in *Modern Perspectives in Art History*, ed. W. Eugene Kleinbauer (New York: Holt, Rhinehart, and Winston, 1971), pp. 126–38.

Description of attentive behavior has a long history in the north, where it often served as a mode of pictorial narration. The apostles in Hugo van der Goes's *Death of the Virgin* (Bruges) who are attentive to her death are the forebears of De Gheyn's scribes. Such figures are not actors in a dramatic event; they rather bear witness to the event from within the picture. The ordering of a picture through witnesses was employed by many seventeenth-century Dutch history painters and was recommended by Van Mander. Rembrandt's *Denial of St. Peter* and his etching of Christ preaching known as *La Petite Tombe* are composed in this way. Van Mander wrote, "One introduces the witnesses of an event on hills, in trees, on stone stairways, or clinging to the pillars of a building, together with others, in the foreground, on the ground below." Van Mander, curiously, compares the painter of such a work to a market seller displaying his wares, which suggests that it is in fact attentive witnesses rather than the event itself, and in turn *our* visual interest in them as in objects to possess, that are central to such pictures. See B. P. J. Broos, "Rembrandt and Lastman's *Coriolanus*: The History Piece in 17th Century Theory and Practice," *Simiolus* 8 (1975–76):203.

34. One might say that Dutch still lifes present the anatomical view of the lemon. As an example of the kind of sentiment with which I do not agree: "It is hard to feel chastized by images of such beauty. And yet the sumptuous repasts, their luminous peeled lemons left to shrivel and their opened oysters to rot, warn of gluttony and and moral aftermath of human appetite." Leon Wieseltier, review of the Chardin exhibition in *The New Republic,* 24 November 1979, p. 25. A broadly revisionist view of still-life painting in general is presented in the many essays that constitute the exhibition catalogue *Stilleben in Europa* (Münster: Westfälisches Landesmuseum für Kunst und Kulturgeschichte and Baden-Baden: Staaliche Kunsthalle, 1979–80).

35. Bacon, *Works,* 4:58.

36. John Locke, *An Essay Concerning Human Understanding,* ed. Alexander Campbell Fraser (1894, reprint, New York: Dover, 1959), 1:403.

37. Johann Comenius, *The Gate of Languages Unlocked,* trans. Thomas Horn (London, 1643), D.

38. Robert Hooke, *Micrographia,* p. 154.

39. *Die Ausgaben des Orbis Sensualium Pictus,* ed. Kurt Pilz, *Beiträge zur Geschichte und Kultur der Stadt Nürnberg,* 14 (Nürnberg: Stadtbibliothek, 1967). Pilz lists 244 editions of the *Orbis Pictus* between 1658 and 1964. There is a handy reprint of the 1658 edition in the series "Die bibliophilen Taschenbücher."

40. The literature on Comenius is vast because he is of interest to Protestant thinkers as well as to students of education. For a good general survey of his life and writings, see part 1, M. W. Keatinge, trans. and ed., *The Great Didactic of John Amos Comenius,* 2nd rev. ed. (New York: Russell and Russell, 1910; reprint 1967). For Comenius in England, see G. H. Turnbull, *Hartlib, Dury and Comenius* (London: University Press of Liverpool, 1947) and Robert Fitzgibbon Young, *Comenius in England* (Oxford: Oxford University Press, 1932); for Comenius in the Netherlands see Wilhelmus Rood, "Comenius and the Low Countries," (Ph.D. dissertation, Rijksuniversiteit, Utrecht, 1970); Jean Piaget, intro. to *John Amos Comenius on Education,* Classics in Education no. 33 (New York: Teachers College Press, 1967).

41. Comenius, *The Great Didactic,* p. 186.

42. Ibid., p. 188.

43. *Evelyn's Sculptura,* ed. C. F. Bell (Oxford: Clarendon Press, 1906), p. 140. See Benjamin DeMott, "Comenius and the Real Character in England," *PMLA* 70 (1955):1068–81; Clark Emery, "John Wilkins' Universal Language," *Isis* 38 (1948):174–85; Murray Cohen, *Sensible Words: Linguistic Practice in England, 1640–1785* (Baltimore: The Johns Hopkins University Press, 1977); and Vivian Salmon, *The Study of Language in 17th Century England* (Amsterdam: John Benjamins, 1979). A convenient edition to refer to is Johann Amos Comenius, *Visible World,* trans. Charles Hoole (London, 1659; reprint ed. John Sadler [New York: Oxford University Press, 1968]).

44. Cost was an important factor in the restricted use of illustrated books for classroom purposes at the time. For the way in which education was conducted, see Pieter Antonie de Planque, *Valcoogh's 'Regel der Duytsche Schoolmeesters'* (Groningen: Noordhoff, 1929), and J. ter Gouw, *Kijkjes in de Oude Schoolwereld,* 2 vols. (Leiden, 1872). For children's books, see G. D. H. Schotel, *Vaderlandsche Volksboeken en Volkssprookjes,* 2 vols. (Haarlem, 1873), and William Sloane, *Children's Books in England and America in the Seventeenth Century* (New York: Columbia

University, King's Crown Press, 1955). We shall touch again on the subject of education when we deal with the culture of letter-writing in chapter 5.

45. My reference here is specific: I am taking issue with a previous interpretation of this drawing. De Gheyn's mother and child looking at the pictures in the book have been offered as prime evidence that the so-called realism of seventeenth-century Dutch art is really not realism at all. It is nonhistorical, so it has been argued, to see this work as realistic. The alternative we are offered is to see it as an allegory drawing on contemporary notions of knowledge. It illustrates the middle term of the Aristotelian tripartite division of learning: *natura, exercitatio,* and *ars.* In this view, De Gheyn's drawing, like other Dutch works, belies its surface to call attention to deeper meanings. Its message is: "It is not enough just to look at what exists on earth. That only enables one to 'picture' things, not to understand their true essence" (p. 17). I have three objections to this: (1) not only does this work display a concern for observation common to De Gheyn's works, it may even be said to thematize that concern in the boy's attention to the pictures on the page; (2) the relevant context is not a notion of knowledge or understanding that *denies* the visible world and eludes pictorial representation, but one that is identified with the representation of the visible world; (3) the interpretive stance that contrasts realism and allegory is misleading, since there is no such thing as simple realism. This stance is particularly misleading in the case of an art that locates knowledge in the represented surfaces of the world and replaces the established figures of Nature or Learning (Natura or Minerva, let us say) with a child, seated beside his mother, engrossed in learning through the pictures in his book. See Hessel Miedema, "Over het realism in de Nederlandse schilderkunst van de zeventiende eeuw," *Oud Holland* 89 (1975):2–18. Miedema's interpretation of the De Gheyn drawing is related to J. A. Emmens's earlier study of a triptych by Dou. There, too, the author invoked the Aristotelian model of learning as the key to the work. And there, too, the interpretation seems to me to insist wrongly that the meaning of the picture is at odds with the pictorial surface—and one must remember how attentive to surfaces Dou was—rather than being at one with that surface. See J. A. Emmens, "Natuur, onderwijzung en oefening; bij een drieluik van Gerrit Dou," in *Album discipulorum aangeboden aan professor Dr. J. G. van Gelder ter gelegenheid van zijn zestige verjaardag 27 februari 1963* (Utrecht, 1963), pp. 125–36.

46. Comenius, *The Great Didactic,* pp. 114, 115.

47. See Walter E. Houghton, Jr., "The History of Trades: Its Relation to Seventeenth-Century Thought," in *Roots of Scientific Thought: A Cultural Perspective,* eds. Philip P. Wiener and Aaron Noland (New York: Basic Books, 1957), pp. 354–81, and Paolo Rossi, *Philosophy, Technology and the Arts in the Early Modern Era,* trans. Salvator Attanasio and ed. Benjamin Nelson (New York, Evanston, and London: Harper and Row Torchbook, 1970). Marin Mersenne and Pierre Gassendi shared Bacon's engagement with the practical arts and, related to this, Gassendi was fascinated with the knowledge gained through sight. Though these thinkers take us far from Dutch painting, they are nevertheless justifiably cited as part of the larger seventeenth-century culture of which Dutch images are part. See Tullio Gregory, *Scetticismo ed empirismo: Studio su Gassendi* (Bari: Editori Laterza, 1961), and Olivier René Bloch, *La Philosophie de Gassendi: Nominalisme, Matérialisme et Métaphysique* (The Hague: Martinus Nijhoff, 1971).

48. Bacon, *Works,* 4:13.

49. Ibid., p. 28.

50. For Bacon's notion of natural histories and their distinction from civil histories, see Lisa Jardine, *Francis Bacon: Discovery and the Art of Discourse* (Cambridge: Cambridge University Press, 1974), pp. 135–49; 151–56.

51. There is a body of literature by historians of science that debates the contribution of the scholar and the craftsman to natural knowledge in the seventeenth century. The diplomatic solution to this problem of the relationship between theoretical and practical activities is to say that both played their role. For this view, see Rupert Hall, "The Scholar and the Craftsman in the Scientific Revolution," *Critical Problems in the History of Science,* ed. Marshall Clagett (Madison: University of Wisconsin Press, 1959), pp. 2–23. Thomas Kuhn offers a more nuanced interpretation, which tries to distinguish between the *kind* of contributions that were made by the classical and the Baconian sciences, as well as between their practitioners: scholars versus craftsmen, and academicians versus amateurs.

52. I owe knowledge of this to Wolf Lepenies, who suggested its relevance to Dutch art. See Wolf Lepenies, *Das Ende der Naturgeschichte,* Suhrkamp Taschenbuch der Wissenschaft no. 227 (Baden-Baden: Suhrkamp, 1978), p. 51.

53. *Goethe's Theory of Colours,* trans. Charles Lock Eastlake (Cambridge: M.I.T. Press, 1970), p. 254. Gerald Holton called my attention to this passage. It seems most appropriate that the scientist responsible for the discovery of the visual (versus behavioral) phenomenon of patterns on a butterfly's wings was a Dutchman called Oudermans, after whom the phenomenon is named. See Adolf Portmann, *New Paths in Biology,* trans. Arnold J. Pomerans (New York, Evanston, and London: Harper and Row, 1964), p. 77.

54. The interest today in the whole problem of the distinction between art and craft has the effect of calling into question the boundaries between them that we in the West usually assume. See Howard S. Becker, "Arts and Crafts," *American Journal of Sociology* 83 (1978):862–89. Kristeller has carefully traced the original notion of the fine arts to the eighteenth century, before which time the classification system of the different kinds of human makings was significantly different. It is to an aspect of the difference that I am pointing here. See Paul Oskar Kristeller, "The Modern System of the Arts," in *Renaissance Thought II: Papers on Humanism and the Arts* (New York, Evanston, and London: Harper Torchbooks, 1965), pp. 163–227.

55. This is the masterpiece, one of only a small number of works that we have, by the Leiden painter of portraits and still lifes, David Bailly (1584–1657). He ended his life as a servant at the university. See J. Bruyn, "David Bailly," *Oud Holland* 66 (1951):148–64; 212–27; and on this painting, M. L. Wurfbain, "Vanitas-stilleven David Bailly (1584–1657)," *Openbaar Kunstbezit* 13 (1969):7a–7b. I want to thank Dr. Wurfbain for sharing with me his further thoughts about Bailly and this picture.

56. Bacon, *Works* 4:29.

57. Joseph Moxon, *Mechanick Exercises or The Doctrine of Handy-Works,* 2 vols. (London, 1677–83), 1:A4.

58. It is only modern usage that clearly distinguishes between the double sense of craft as (1) a human making and (2) deceit. See *The Oxford English Dictionary,* s.v. "craft."

59. Bacon, *Works* 4:30.

60. Ibid., p. 26.

61. See Charles B. Schmitt, "Experience and Experiment: A Comparison of Za-

barella's View with Galileo's in *De Motu,* " in *Studies in the Renaissance* 16 (New York: The Renaissance Society of America, 1959):80–137. The tradition of appealing to experience and above all to the eye had a long life in Holland. s'Gravesande, who was named professor of mathematics and astronomy at The Hague in 1717, wrote that "il faut observer d'un oeil attentif toutes les opérations de la nature." Pierre Brunet, *Les Physiciens Hollandais et la Méthode Expérimentale en France au XVII*^e *Siecle* (Paris: Librarie Scientifique Albert Blanchard, 1926), p. 49.

62. M. L. Wurfbain, "Vanitas-stilleven David Bailly," p. 7b.

63. Sprat, *History,* pp. 344–45.

64. Bacon, *Works* 4:26.

65. Ibid., p. 271.

66. Ibid., p. 258.

67. Hooke, *Micrographia,* G; Sprat, *History,* p. 245.

68. For Evelyn's projects, see Walter E. Houghton, Jr., "The History of the Trades," pp. 367–81.

69. Sprat, *History,* pp. 258, 307, 193. Bread-making was one of the crafts illustrated by Comenius in his *Orbis Pictus.*

70. See [Balthasar] de Monconys, *Journal des voyages,* 3 vols. (Lyon: 1665–66):2. Visits to such collections were a major entertainment for travelers to Holland at the time. The most useful publications of these materials are those that are topically arranged. See, for example, the sections on private collections in Julia Bientjes, *Holland und der Holländer im Urteil Deutscher Reisender 1400–1800* (Groningen: J. B. Wolters, 1967), pp. 72–80. In England natural knowledge was already encouraged under royal patronage in the seventeenth century. In Holland the organization of societies for such pursuits depended on private and civic resources and did not get under way until the later eighteenth century. One of the oldest Dutch societies of this kind was founded by the Haarlem burghers only in 1752, while the Teyler Stichting in the same town dates from 1778.

71. Filips von Zesen, *Beschreibung der Stadt Amsterdam* (Amsterdam, 1664); *Beschrijvingh Der wijdt-vermaarde Koops-stadt Amsterdam* (Amsterdam, 1664).

72. Denis Diderot, "Voyage en Hollande," in *Supplément aux Oeuvres de Diderot,* (Paris, 1818), p. 68.

73. I am quoting from the translation of the ordinance of 11 May 1611 by J. M. Montias, *Artists and Artisans in Delft in the Seventeenth Century: A Socio-Economic Analysis* (Princeton: Princeton University Press, 1982). The basic, general study on the guilds of Saint Luke in Holland remains G. J. Hoogewerff, *De Geschiedenis van de St. Lucasgilden in Nederland* (Amsterdam: P. N. van Kampen and Zoon, 1947). For the art market in general, see H. Floerke, *Studien zur niederländischen Kunst- und Kulturgeschichte, Die Formen des Kunsthandels, das Atelier und die Sammler in den Niederlanden von 15.–18. Jahrhundert* (Munich-Leipzig, 1905).

74. The most popular and often quoted account of this kind is "Painting—The Artist as Craftsman," chapter 6 of J. L. Price, *Culture and Society in the Dutch Republic During the 17th Century* (New York: Charles Scribner's Sons, 1974). In recent years the history and sociology of science has gone much farther in the direction of studying the boundaries between science and other forms of knowledge—thus considering science as a social construct—than historians and sociologists of art have done with art. The issues in these different fields bear an interesting resemblance in the seventeenth century, and art historians might do well to get

some hints about how to proceed from students of science. For a study that bears on the relationship between cognative systems, which is of relevance to the relationship between artists and craftsmen that I am proposing, see Peter Wright, "Astrology and Science in Seventeenth-Century England," *Social Studies of Science* 5 (1975): 399–422. For the politics involved in the success of a particular form of knowledge—an important question I have not considered—see Peter Wright, "On the Boundaries of Science in Seventeenth Century England," *Sociology of the Sciences Yearbook* 4 (1980).

75. See E. Taverne, "Salomon de Bray and the Reorganization of the Haarlem Guild of St. Luke in 1631," *Simiolus* 6 (1972–73):50–66. Taverne, who prizes a conceptual framework as essential to the serious practice of art, emphasizes the theory rather than, as I do, the practice of the artists in Haarlem.

76. It is true that the term *fijnschilder,* which is more commonly used in the middle of the century than it is earlier, was not used to distinguish a particular *kind* of picture but rather to distinguish the painting of pictures from rougher forms, such as the painting of signs or houses. However, the increased use of the term reflects a consciousness of difference, which the crafted surfaces of the painters also testify to. See Lydia de Pauw-de Veen, "De begrippen 'schilder,' 'schilderij' en 'schilderen' in de zeventiende eeuw," *Verhandelingen van de Koninklijke Vlaamse Academie voor Wetenschappen, Letteren en Schone Kunsten van Belgie, Klasse der Schone Kunsten* 31, no. 22 (1969), pp. 16–54.

77. I owe this point to a conversation with Prof. Th. H. Leunsingh Scheurleer, to whom I am most grateful.

78. J. M. Montias has substantiated the declining quality of tiles in the eleventh chapter of his book *Artists and Artisans.* In answer to my query, Montias suggested in a letter that the evidence is that as the position of the craftsmen declined, the painters replaced them in supplying the designs for the "applied" arts.

79. For an account of the collectible objects in Kalf's works, see Lucius Grisebach, *William Kalf* (Berlin: Gebr. Mann, 1974), pp. 113ff.

80. J. A. Emmens, "*De Kwakzaler:* Gerrit Dou (1613–1675)," *Openbaar Kunstbezit* 15 (1971):4a–4b.

Chapter Four

1. On Vermeer's map as a source for cartographic history, see James Welu, "Vermeer: His Cartographic Sources," *The Art Bulletin* 57 (1975):529–47 and "The Map in Vermeer's *Art of Painting,*" *Imago Mundi* 30 (1978):9–30. Footnotes 54 and 56 in the first article list the major studies of the map and of the interpretation of the painting itself. In a brief and perceptive footnote to a study by J. G. van Gelder, J. A. Emmens connects the map to the topographic and geographic ambitions of the art of painting. See J. G. van Gelder, *De Schilderkunst van Jan Vermeer* (Utrecht: Kunsthistorisch Instituut, 1958), p. 23, n. 14.

2. To cite but a few from a great number of examples: Gemma Frisius titled his 1533 treatise on triangulation *Libellus de locorum describendorum ratione . . . ,* the Dutch rendering of which was *Die maniere om te beschrijven de plaetsen ende Landtschappen* (Amsterdam, 1609); Petrus Montanus refers to Jodocus Hondius as "De alder-vermaerste en best-geoffende Cosmagraphus ofte Wereltbeschrijver van onse eeuw" in his introduction to the first Dutch edition of the Mercator-Hondius Atlas (1634).

3. Alfred Frankenstein, "The Great Trans-Mississippi Railway Survey," *Art in America* 64 (1976):55–58.

4. The major examples in the field of Dutch art are the several studies by James Welu (cited below) and the exhibition catalogue *The Dutch Cityscape in the 17th Century and its Sources* (Amsterdam: Amsterdams Historisch Museum, 1977). For a general study of cartographical material published in Amsterdam during the seventeenth century with a fine eye for its cultural place and relationship to art and artists, see *The World on Paper* (Amsterdam: Theatrum Orbis Terrarum, 1967), compiled on the occasion of the International Conference on Cartography by Marijke de Vrij. Both exhibitions were held under the suspices of the Amsterdam Historical Museum, which has been in the forefront of showing the ties that bind art to society.

5. J. Wreford Watson, "Mental Distance in Geography: Its Identification and Representation," unpublished MS of a paper delivered at the twenty-second International Geographical Congress, Montreal, 1972.

6. Ronald Rees, "Historical Links between Cartography and Art," *Geographical Review* 70 (1980):62. See also P. D. A. Harvey, *The History of Topographical Maps* (London: Thames and Hudson, 1980). This book, which appeared after I had completed my own research, is interested in some of the same material but differs because it still approaches it from what I would call a cartographic point of view.

7. Kurt Pilz has argued against the attribution of the map of Bohemia to Comenius. See Kurt Pilz, "Die Ausgaben der Orbis Sensualism Pictus," (Nürnberg: Stadtbibliothek Nürnberg, 1967), pp. 35–37. For the previous attribution of the map to Comenius, see L. E. Harris, *The Two Netherlanders: Humphrey Bradley and Cornelis Drebbel* (Leiden: E. J. Brill, 1961), p. 130 and Josef Šmaha, *Comenius als Kartograph seines Vaterlandes* (Znaim, 1892).

8. The circumstances of the making of this drawing were noted by J. Q. van Regteren Altena in London, Victoria and Albert Museum, *Drawings from the Teyler Museum, Haarlem* (London: Her Majesty's Stationery Office 1970), no. 39.

9. Antoine de Smet, "A Note on the Cartographic Work of Pierre Pourbus," *Imago Mundi* 4 (1947):33–36, and Paul Huvenne, "Pieter Pourbus als Tekenaar," *Oud Holland* 94 (1980):11–31. For more general studies, see S. J. Fockema Andreae, *Geschiedenis der Kartografie van Nederland* (The Hague: Martinus Nijhoff, 1947) and Johannes Keuning, "XVIth Century Cartography in the Netherlands (mainly in the Northern Provinces)," *Imago Mundi* 9 (1952):35–63.

10. *Catalogue Raisonné of the works by Pieter Jansz. Saenrendam* (Utrecht: Centraal Museum, 1961). Giuliano Briganti, *Gaspar van Wittel e l'origine della veduta settecentesca* (Rome: U. Bozzi, 1966).

11. Maria Simon, "Claesz Jansz. Visscher," dissertation, Albert-Ludwig Universität (Freiburg, 1958).

12. Ernst Kris, "Georg Hoefnagel und der Wissenschaftliche Naturalismus," in *Festschrift für Julius Schlosser* (Zürich, Leipzig, Vienna: Amalthea Verlag, n.d.), pp. 243–53.

13. Quoted (in translation) in Johannes Keuning, "Issac Massa, 1586–1643," *Imago Mundi* 10 (1953):67.

14. A recent study of the nature and use of maps in mural cycles in Renaissance Italy reveals how differently they were perceived. For all the interest in maps in Italy, they remained distinct from pictures both in execution and in format. See Juergen Schulz, "The Use of Maps in Italian Mural Decoration," unpublished Nebenzahl

lecture, Newberry Library, Chicago, 1980.

15. For the Greek I have used Claudius Ptolemaeus, *Geographia,* ed. Karl Müller (Paris, 1883); for the Latin the *Geographia,* trans. Bilibaldus Pirckheymer (Basel, 1552).

16. Evidence for this tradition of interpretation is readily available in the various translations of Apianus's *Cosmographia,* the text of which is based on Ptolemy. *Picture* is invoked in the subsection of chapter 1 entitled "Geographia Quid." The editions consulted were in Latin (Antwerp, 1545), in French (Paris, 1553), and in Dutch (Amsterdam, 1609), all in the British Library.

17. Apianus's rendering of Ptolemy's introductory words is "Cosmographia (ut ex etymo vocabuli patet) est mundi . . . descriptio," (Antwerp, 1545). The Dutch edition reads: "Cosmografie is een Conste daer-men de gheheele Wereldt mede beschrijft," (Amsterdam, 1609). The casual identity assumed between a description and a picture in this mapping context is best brought out in Gemma Frisius's own French translation of a passage from Apianus, in which geography is referred to as "une description ou paincture & imitation," (Paris, 1545), chapter 1, p. 3ᵛ. The Latin so translated reads: "Geographia [est] . . . formula quaedam ac picturae imitatio."

18. See Ernst Robert Curtius, *European Literature in the Latin Middle Ages,* trans. Willard K. Trask (New York: Bollingen Foundation, Pantheon Books, 1953), pp. 68ff., for a succinct summary of the system of ancient rhetoric of which *ekphrasis* is part.

19. See the title of Frisius's treatise on triangulation above, n. 2.

20. A. S. Osley, *Mercator: A Monograph on the Lettering of Maps . . .* (New York: Watson-Gupthill Publications, 1969).

21. Samuel Y. Edgerton, Jr., *The Renaissance Rediscovery of Linear Perspective* (New York: Harper and Row, Icon Editions, 1976), chapters 7 and 8. John Pinto, on the other hand, has distinguished a nonperspectival mode of city representation— a vertical plan—which he also associates with Italy. This view, which specifically lacks a located viewer and instead assumes a plurality of views, is closer to the northern pictorial mode that I am defining. See John A. Pinto, "Origins and Development of the Iconographic City Plan," *Journal of the Society of Architectural Historians* 35 (1976):35–50.

22. A subtle and original attempt to argue the mapping nature of northern images is found in Robert Harbison, *Eccentric Spaces* (New York: Alfred A. Knopf, 1977), chapter 7, "The Mind's Miniatures: Maps."

23. The modern Dutch artist Piet Mondrian offers this map-to-landscape sequence in reverse. In the series of studies entitled *Pier and Ocean,* started upon his return to Holland in 1914, Mondrian gradually turned a landscape (a seascape, really) into a map. He withdrew from depth and upended the pier until it was resolved into a surface articulation of a most determined and single-minded kind. Mondrian first revealed his relationship to this native tradition in some early landscapes such as the 1902 *Landscape near Amsterdam* (Michel Seuphor, Paris), which lies on the border-line between mapping and landscape like some Dutch paintings of the seventeenth century (fig. 176). We might see Mondrian's so-called abstractions not as *breaking* with tradition but as heir to the mapping tradition that we are defining.

24. Samuel van Hoogstraten, *Inleyding tot de Hooge Schoole der Schilderkonst* (Rotterdam, 1678), p. 7.

25. Kepler is quoted as commenting on the use of peasants as informants in mapmaking. See Egon Klemp, *Commentary on the Atlas of the Great Elector*

176. PIET MONDRIAN, *Landscape near Amsterdam.* Collection Michel Seuphor. Phot. Giraudon.

(Stuttgart-Berlin-Zürich; Belser Verlag, 1971), p. 19. Antoine de Smet, "A Note on the Work," n. 9, refers to Pourbus's use of fishermen and pilots.

26. Ernst Gombrich, "The Renaissance Theory of Art and the Rise of Landscape," in *Norm and Form* (London: Phaidon Press, 1966), pp. 107–21.

27. Edward Norgate, *Miniatura or the Art of Limning (1648–58)* (Oxford: Clarendon Press 1919), pp. 45–46.

28. Jan de Vries, *The Dutch Rural Economy in the Golden Age, 1500–1700* (New Haven: Yale University Press, 1974) provides the fullest evidence. See especially chapter 2.

29. Translated from the Latin *Epigramma in Duos Montes* in *Andrew Marvell: The Complete Poems,* ed. Elizabeth Story Donno (Harmondsworth: Penguin Books, 1972), pp. 74–75. For a discussion of this problem in English poetry, see James Turner, *The Politics of Landscape* (Cambridge, Mass.: Harvard University Press, 1979); for the term "landscape" see the same author, "Landscape and the 'Art Prospective' in England, 1584–1660,' " *Journal of the Warburg and Courtauld Institutes* 42 (1979):290–93.

30. I owe this point to Linda Stone who came upon it in the course of her extensive study of the representation of textiles and their production in Dutch art.

31. The distinctively urban direction taken, both economically and socially, by Dutch life on the land seems to inform these works. As the economic historian Van der Woude put it in an important article, "It was the city, the citizens and urban institutions which had to be reckoned with by village people." See A. M. van der Woude, "Variations in the Size and Structure of the Household in the United Provinces of the Netherlands in the Seventeenth and Eighteenth Centuries," Peter Laslett, ed., *Household and Family in Past Time* (Cambridge: Cambridge University Press, 1972), p. 304.

32. Wolfgang Stechow *Dutch Landscape Painting of the Seventeenth Century (London:* Phaidon Press, 1966) gives the standard account.

33. Georg Braun and Franz Hogenberg, *Civitates Orbis Terrarum* (Cologne, 1572–1617), 3, A^v.

34. R. A. Skelton in his introduction to the reprint of Braun and Hogenberg, *Civitates* (Cleveland and New York, 1966).

35. Petrus Apianus, *Cosmographia* (Antwerp, 1545), chapter 19.

36. Braun and Hogenberg, *Civitates,* 3, A^v, B.

37. Keuning, "Isaac Massa," p. 67.

38. Norgate, *Miniatura,* p. 51.

39. *The Oxford English Dictionary,* s.v. "graphic."

40. The Jacob van Ruisdael exhibition of 1981–82 brought to light that Ruisdael himself had provided another link between maps and landscapes. Ruisdael's extraordinary *Panorama of Amsterdam, Its Harbor and the IJ,* now in a private collection, is the true successor to Micker's painted map of Amsterdam. See Seymour Slive and H. R. Hoetinck, *Jacob van Ruisdael* (New York: Abbeville Press, 1981), no. 46.

41. Münich, Haus der Kunst, *Das Aquarell, 1400–1950,* 1973.

42. Johan Blaeu, *Le Grand Atlas* (Amsterdam, 1663), introduction, pp. 1, 3.

43. Petrus Apianus, *Cosmographia* (Antwerp, 1545), chapter 1.

44. Kurt Schottmüller, "Reiseindrücke aus Danzig, Lübeck, Hamburg and Holland 1636," *Zeitschrift des westpreussischen Geschichtsverein* 52 (1910):260.

45. Herman Kampinga, *De Opvattingen over onze Oudere Vaderlandsche Geschiedenis bij de Hollandsche Historici der XVI^e en XVII^e Eeuw* (The Hague: Martinus Nijhoff, 1917).

46. The phrase in Dutch is "tot een klare ende heldere sonne der onbedekte waarheyt, te spriet-oogen. . . ." It is quoted by Kampinga, *De Opvattingen,* p. 47, and Dousa's *Riim-Kroniik* is discussed on p. 29.

47. R. Joppien, "The Dutch Vision of Brazil," in *Johann Maurits van Nassau-Siegen 1604–1679* (The Hague: The Johan Maurits van Nassau Stichting, 1979), p. 296. This publication on Prince Maurits includes thorough studies of the Dutch pictorial records (including their maps) of Brazil.

48. Dr. I. C. Koeman, *Collections of Maps and Atlases in the Netherlands* (Leiden, 1961).

49. F. Muller, *De Nederlandsche Geschiedenis in Platen* (Amsterdam: Frederik Muller, 1863–70), 1, xiii–xviii.

50. It is perhaps not surprising that a modern interpretation of Vermeer's *Art of Painting* attempts to accommodate it also to the Aristotelian triad of *natura, ars, exercitatio.* But to see this painting as a rhetorical exercise seems to me to be a misrepresentation. See Hessel Miedema, "Johannes Vermeers 'Schilderkunst,' *Proef* (September, 1972).

Chapter Five

1. Though there is a growing literature on letters and words in cubism, there have been only a few attempts to deal with earlier art: Mieczyslaw Wallis, "Inscriptions in Paintings," *Semiotica* 9 (1973):1–28; "L'Art de la signature," the title of the entire issue of *Revue de l'Art* no. 26 (1974); and a small exhibition, "Just Looking at Words: Words in Painting," at the Rijksmuseum, Amsterdam, 7 July to 7 October 1979, which focused on the phenomenon but did not note its peculiar role in Dutch art.

2. An instructive, though admittedly rather extreme, instance of the mnemonic function of Renaissance paintings was built into a project for explaining art to the blind that was recently devised by a leading scholar of Italian art. When I asked how he meant to go about this apparently impossible task, he told me that he was going to set down (on tape, or in braille) the story narrated by each picture. That, he explained, (meaning the story) is what you take away or remember from a painting after looking at it. Of course Italian art was not devised for the blind, but it certainly intended to illuminate and recall texts in a way that this project suggests.

3. I am indebted to Gary Schwartz's fine study for the identification of the inscription (which is from a version of Colossians 3:16) and discussion of its place in the debate over the use of the organ in churches. It is very likely, as Schwartz argues, that this painting of Saint Bavo, like that of the Mariakerk to which we shall turn in a moment, was commissioned by Constantijn Huygens. He was the author of a short book that argued for the reintroduction of the organ into sacred use in Dutch churches: see Constantijn Huygens, *Use and Nonuse of the Organ in the Churches of the United Netherlands*, trans. and ed. Ericka E. Smit-Vanrotte, Musical Theorists in Translation 4 (Brooklyn, N.Y.: Institute of Mediaeval music, 1964). See also Gary Schwartz, "Saenredam, Huygens and the Utrecht Bull," *Simiolus* 1 (1966–67):68–93.

4. Giorgio Vasari, *Le vite de' più eccellenti pittori scultori ed architetti* in *Le Opere*, ed. G. Milanesi, 9 vols. (Florence: Sansoni, 1878–85), 7:277–78.

5. I am not disputing previous interpretations that identify the mirror framed by scenes from the Passion as the *speculum sine macula* or a symbol of the Virgin's purity. But I think it would be wrong to insist on this as its only explanation in the painting. I do, however, dispute the tendency, common in studies of seventeenth-century art, to insist on transience as the prime concern and thus to undermine the interest in representation that is so basic to the culture. For this view of the *Arnolfini Wedding* mirror, see Heinrich Schwarz, "The Mirror in Art," *The Art Quarterly* 25 (1952):97–118. Jan Bialostocki concludes an otherwise interesting essay by relating mirrors in the Baroque to transience in "The Mirror in Painting: Reality and Transcience," *Studies in Late Medieval and Renaissance Painting in Honor of Millard Meiss*, eds. Irving Lavin and John Plummer, 2 vols. (New York: New York University Press, 1977), 1:71.

6. See B. P. J. Broos, "The O's of Rembrandt," *Simiolus* 4 (1971):150–84. Broos's emphasis on the admiration with which calligraphy was regarded in Holland is I think justified. This chapter offers evidence of a different kind to add to his. Hessel Miedema's response to Broos, in which he tried to redress the balance between painting and calligraphy to give the former its due, is I think based on the mistaken assumption that the Dutch agreed with the Italian view of such things. See Hessel Miedema, "The O's of Broos," *Simiolus* 5 (1971–74):185–86.

7. The relation of letters and things inscribed in such a work puts one in mind of Saul Steinberg. Letters, as a review of a show of his work put it, present themselves to him as things. Or as Steinberg put it (quite in keeping with the Dutch), "I have always had a theory that things represent themselves." Quoted in *Time Magazine*, 17 April 1978, p. 95.

8. Of course Latin inscriptions did occur on the lids of keyboard instruments outside the Lowlands. But, as Alan Curtis kindly confirmed, among all the preserved instruments with original decoration there is none with a Latin inscription that is not Dutch or Flemish.

9. For the identification of the book that Dou's figure is looking at, see H. M. Rotermund, "Rembrandt's Bibel," *Nederlands Kunsthistorisch Jaarboek* 8 (1971):134. Tümpel has argued that Rembrandt's old woman is Hanna. The importance of this contrast between Dou and Rembrandt was brought to my attention by Mary Vidal, "Representations of the Book in Rembrandt's Art," (M.A. dissertation, University of California, Berkeley, 1978).

10. E. de Jongh, *Zinne- en minnebeelden in de schilderkunst van de zeventiende eeuw* (Amsterdam: Nederlandse Stichting Openbaar Kunstbezit en Openbaar Kunstbezit in Vlaanderen, 1976), pp. 49–55.

11. Otto Vaenius, *Amorum Emblemata . . .* (Antwerp, 1608), pp. 132–33.

12. J. H. Krul, *Pampiere Wereld* (Amsterdam, 1644), p. 81. The connection between such an image and paintings by Ter Borch was suggested by S. J. Gudlaugsson, *Gerard Ter Borch,* 2 vols. (The Hague: Martinus Nijhoff, 1959).

13. The basic study dealing with letter manuals in general and the Dutch scene in particular is Bernard Bray, *L'Art de la Lettre Amoureuse: des Manuals aux Romans* (The Hague: Mouton, 1967). For the French schoolmasters in Holland, see K. J. Riemens, *Esquisse historique de l'enseignement du Français en Hollande de XVI^e au XIX siecle* (Leiden, 1919).

14. I mean by this to suggest that the motif for Dutch "genre" scenes is less moral teaching than engagement with social ritual at the point where pictorial tradition and contemporary social custom meet. Another example is the so-called Gay Company or Gezelschap scenes of festivity and drinking in garden settings, which are related to the pictorial theme of the Garden of Love and to actual premarital or May-day celebrations. (I have touched on this point at greater length in my "Realism as a Comic Mode: Low-life Painting Seen through Bredero's Eyes," *Simiolus* 8 (1975–76):115–43, see esp. nn. 18 and 45.)

15. Jean Puget de la Serre, *Secrétaire à la Mode* (Rouen, 1671), pp. 188–89; 194.

16. "Litterae quae vera amantis vestigia," *Amorum Emblemata* (Antwerp, 1608), p. 132.

17. For the growth of the postal service at this time, see J. C. Hemmeon, *The History of the British Post Office* (Cambridge: Harvard University Press, 1912); Eugène Vaillé, *Histoire Général des Poste Françaises* (Paris: Presses Universitaires de France, 1950), vols. 2 and 3. A curious picture by Pieter de Wit in the Rijksmuseum testifies to the importance of the postal service for the Dutch in far-flung parts of the world. Dirck Wilre, a Dutch representative in Elmina, West Africa, clothed in the latest fashion, and standing in an interior decorated as it would be back home, looks on as a native stoops to show him a landscape painting of the region. On the table beyond lies a letter, plainly addressed to his wife, which serves to recall his distant home. See the *Bulletin van het Rijksmuseum* 27 (1979):7–29 on this painting.

18. *The Great Didactic of John Amos Comenius,* p. 84.

19. See Garcilosa de la Vega, El Inca, *Royal Commentaries of the Incas,* trans. Harold V. Livermore (Austin and London: University of Texas Press, 1966), 1:603–5. J. H. Elliott suggested to me that de la Vega, who was known in Europe at this time, is the probable source of Comenius's remark.

20. Karel van Mander, *Schilder-boeck,* 1, fol. 51b.

21. *The Great Didactic of John Amos Comenius,* pp. 188–89.

22. G. B. della Porta, *Natural Magick,* pp. 356, 357.

23. Thomas Digges, *A Geometrical Practical Treatize Named Pantometria* (London, 1591), p. 28. Cornelis Drebbel also claimed to have invented an optical device

that enabled him to read letters at the distance of an English mile. To further close the tight circle of friends engaged in natural knowledge at the time, the letter to the English king in which Drebbel makes this claim found its way into Beeckman's journal. For this, see L. E. Harris, *The Two Netherlanders: Humphrey Bradley and Cornelis Drebbel* (Leiden: E. J. Brill, 1961), pp. 146–48.

24. Robert Hooke, *Micrographia*, p. 3.

25. There is not, nor perhaps could there be, any textual equivalent to this pictorial admission on Vermeer's part. But it is not irrelevant that Van Hoogstraten, in the title-print to book 1 of his *Inleyding,* depicts the artist, spyglass in hand, perched on the shoulder of his teacher in order to see further: to learn to be an artist is literally to peer beyond the rest—like the users of the spying-lenses that we have been citing. The text accompanying the print reads, "Maer die op's meesters nek getilt zijn, zien licht verder," Hoogstraten, *Inleyding,* p. 1.

26. To pin down the classical mode of Rembrandt's presentation of this nude, a relationship has been suggested between it and an engraving by François Perrier after the antique. See Hendrik Bramsen, "The Classicism of Rembrandt's *Bathsheba,*" *The Burlington Magazine* 92 (1950):128–31.

27. For a study of the representation of Bathsheba in art, see Elizabeth Kunoth-Leifels, *Über die Darstellungen der "Bathseba im Bade": Studien zur Geschichte des Bildthemas 4. bis 17 Jahrundert* (Essen: Richard Bacht, 1962).

28. For the current state of research and thinking about the pre-Rembrandtists, see Astrid and Christian Tümpel, *The Pre-Rembrandtists* (Sacramento: E. B. Crocker Art Gallery, 1974) and Astrid Tümpel, "Claes Cornelisz. Moeyaert," *Oud Holland* 88 (1974):1–163.

29. The History of Susanna, 20–22, Apocrypha, King James Version.

30. This strain seems to run long and deep. The comic strip that appears at the end of the catalogue of the 1979 Vondel anniversary exhibit at the Theatermuseum in Amsterdam is not, as a recent reviewer put it, the sign of a student's book, or a "naive attempt to reach a more general audience" (Peter King, "Commemorating Vondel and Hooft," *The Times Literary Supplement,* 7 August 1981, p. 905). It is a long established Dutch mode of setting forth a story.

31. Terms such as "down-to-earth" are often applied to Dutch narrative paintings by way of explaining what I think is more properly seen as a specific narrative mode. See, for example, the description of the *Dance of Salome,* by the little-known Jacob Hogers, in the exhibition catalogue *Gods, Saints and Heroes in Dutch Painting in the Age of Rembrandt* (Washington: National Gallery of Art, 1980), p. 264.

32. See Svetlana Alpers, *The Decoration of the Torre de la Parada,* Corpus Rubenianum Ludwig Burchard 9 (Brussels: Arcade Press; London: Phaidon Press, 1971).

33. For this explanation of the pre-Rembrandtists' narrative mode, see Christian Tümpel, *The Pre-Rembrandtists,* pp. 132–47.

34. Heckscher made this point in the course of pointing out the objections to illustrated texts that had to be overcome by the progressive anatomists of the time. See William S. Heckscher, *Rembrandt's Anatomy of Dr. Nicolaas Tulp* (New York: New York University Press, 1958), pp. 62–64.

35. For an overview of the current state of knowledge in this area, see Pieter J. J. van Thiel, "Moeyaert and Bredero: A Curious Case of Dutch Theatre as Depicted in Art," *Simiolus* 6 (1972–73):29–49. Van Thiel is cautious about insisting on the stage as the source of the "look" of Dutch pictures. Indeed, in the case of the Moeyaert

painting with which he is concerned, he comes to the conclusion that the painting is based on the reading of the text, not on a performance of the play. See also Kurt Bauch, *Der frühe Rembrandt and seine Zeit,* (Berlin: Gebr. Mann, 1960), pp. 68–73, and Christian Tümpel, *The Pre-Rembrandtists,* p. 164.

36. An interesting example of the relationship between Vondel's biblical play *Joseph in Egypt* of 1640 and a painting by Jan Pynas suggests the complexity of this matter. In his introduction to the published play, Vondel acknowledges that he followed Pynas's painting of the "Discovery of the Bloody Coat" and goes on to say how much pictures can help playwrights. If we read the play we find, curiously, that rather than *dramatizing* the scene that is represented by Pynas in the painting, Vondel instead *describes* it in the form of a monologue put into the mouth of Ruben. The picture, in other words, becomes a caption on the stage. Bauch concluded from this that Vondel was less of a dramatic playwright in the manner of the contemporary English or Spanish stage than he was a painter! On the basis of what I have said about the pre-Rembrandtists' narrative mode, I would add that what Vondel and the pre-Rembrandtists shared was a commitment to description. In this instance the playwright took a lesson in it from the painter. For the passage from the Vondel play based on Pynas, and an illustration of the Pynas painting, see Bauch, *Der frühe Rembrandt,* pp. 71–73.

37. I chose these two particular examples because I was struck by them when they were both hung in the exhibition "Gods, Saints and Heroes: Dutch Painting in the Age of Rembrandt," which originated at the National Gallery in Washington in 1980–81. Though it is true as Albert Blankert points out in the catalogue (p. 170), that Bol expands and develops his composition through a series of preparatory sketches, the conversation between Fabritius and Pyrrhus remains its central feature.

38. J. Cats, *Spiegel van den Ouden en Nieuwen Tyt* (The Hague, 1632) pp. 12–13.

39. I was told of this contest by members of the staff of the Detroit Institute of Arts.

40. Julius S. Held, "Das gesprochene Wort bei Rembrandt," in *Neue Beiträge zur Rembrandt-Forschung,* eds. Otto von Simson and Jan Kelch (Berlin: Gebr. Mann, 1973), pp. 111–25.

41. Another case in point is Rembrandt's handling of *Christ and the Woman taken in Adultery.* The subject offered the opportunity, often taken up by artists, of representing Christ's words inscribed in the dust. Rembrandt eschews these written words. But in one drawing he adds some of his own: across the bottom of a sheet in Munich (Benesch 1047) Rembrandt has written "so eager to ensnare Christ in his reply, the scribes could not wait for the answer" (fig. 177). More like the humanists of the preceding century than the artists of his own, Rembrandt does not seek to put the wisdom of Christ into visible words; instead he comments on the *response* to those words.

42. In this consideration of the Dutch narrative mode, as in my book as a whole, I am in disagreement with an influential essay by J. A. Emmens which argues that in seventeenth-century Holland the word was valued over the image, or hearing over sight. Though this might seem to be the predictable attitude of a Protestant culture, it seems distinctly *not* to have been the case for the Dutch. Rembrandt, however, is the exception. In making him the central example, Emmens treats the exception as the rule. See J. A. Emmens, "Ay Rembrandt, Maal *Cornelis* Stem," *Nederlands Kunsthistorisch Jaarboek 7* (1956):133–65.

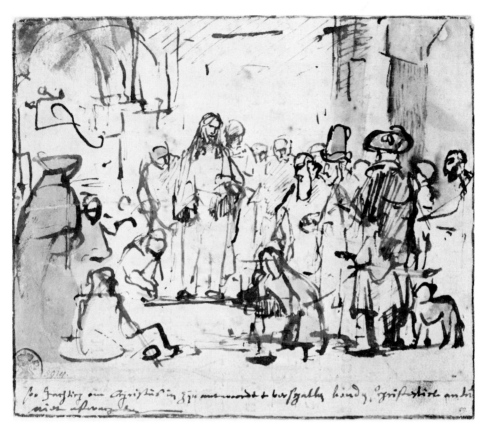

177. REMBRANDT VAN RIJN, *The Adulterous Woman before Christ* (drawing).
Staatliche Graphische Sammlung, Munich.

Epilogue

1. Francisco de Hollanda, *Four Dialogues on Painting*, trans. Aubrey. F. G. Bell (London: Oxford University Press, 1928), pp. 15–16.

2. Cennino d'Andrea Cennini, *The Craftsman's Handbook,* trans. Daniel V. Thompson, Jr. (New York: Dover Publications, n.d.,), pp. 48–49.

3. Lawrence Gowing, *Vermeer* (London: Faber and Faber, 1952), p. 66.

4. It was Rembrandt's distance from the Italian narrative mode that dominated my interpretation of his works on an earlier occasion and led me to group him with descriptive artists. I am now more conscious of the deep ambivalence of his art: it draws on, yet is profoundly other than, each of these established modes. For Lord Clark's remark, see Kenneth Clark, *Rembrandt and the Italian Renaissance* (New York: New York University Press, 1966), p. 2. My earlier characterization of Rembrandt as a descriptive artist is found in my 'Describe or Narrate?: A Problem in Realistic Representation," *New Literary History* 8 (1976–77):23–25.

5. Rembrandt's establishment of his own program in which he trained young artists as he wanted them trained is further evidence of his renegade relationship to the traditional craft of the Dutch painter.

6. With the exception of the works of a painter like Hendrick ter Brugghen in Utrecht and the history paintings painted on occasion by painters of domestic scenes

such as Metsu, there is a sense in which these two traditions—illustrative works on the one hand and crafted representations on the other—remain separate in Holland until late in the century. It was Jan Steen's unique achievement to be able to combine them both: he produced works that illustrate historical themes while deploying the highest level of skill of the descriptive mode.

7. One might, however, argue that Rembrandt shares his Dutch compatriates' notion of an attentive viewer but that he assumes different and more demanding work to be done on our part. Contrary, then, to what I have been suggesting, his art too can be seen as an art of describing, but of a most unprecedented kind. He locates that practice in the very material of the paint surface itself, with results that are as idiosyncratic as, and comparable to, what Picasso did in 1906 and 1907 with the pictorial tradition of representing objects in space. The germ of this thought, which occurred to me only after I completed the book, I owe to Michael Baxandall.

8. I owe much of this account of Rembrandt's *Julius Civilis* to a fascinating and persuasive unpublished paper by Margaret Carroll, which I want to thank her for letting me read. There is, of course, more to the painting than what I can say here. A full account of it would have to consider also the role of the model provided by Leonardo's *Last Supper* for the group at the table. Such reaching out to a hallowed Italian work is also a way of admitting a historical, in the sense of a temporal, dimension to the work. Rather than resolving history into one—as Poussin aimed to do—Rembrandt would seem to have been trying to complicate the Dutch sense of their present rebellion by relating it to both a Catholic and to a pagan oath of fealty.

Rembrandt was not alone after the mid-century mark in striving to create a Dutch past that would situate what were generally perceived as present truths in a temporal framework. In his two well-known views of *The Jewish Cemetery*, and more subtly in certain landscapes of the 1660s that display primeval trees and undrained swamps that admit of natural rot, decay, death, and new growth, Jacob Ruisdael offered a historiated alternative to the mapped histories of his *Haarlempjes*. It is very likely that the signs of political and economic troubles that surfaced even as the newly built Amsterdam Town Hall proclaimed the achievements of the Dutch Republic had something to do with this common historical concern.

Appendix

1. E. de Jongh has published a series of essay and supervised an exhibition presenting the emblematic interpretation of Dutch pictures. See his *Zinne-en min-nebeelden in de schilderkunst van de zeventiende eeuw* (Amsterdam: Nederlands Openbaar Kunstbezit, 1967); "Realisme en schijnrealisme in de hollandse schil-derkunst van de zeventiende eeuw," in *Rembrandt en zijn tijd* (Brussels: Paleis voor Schone Kunsten, 1971), pp. 143–94 (also available in a French edition); *Tot Leering en Vermaak* (Amsterdam: Rijksmuseum, 1976), an exhibition catalogue organized by De Jongh and assistants; for a brief example of the approach in English see E. de Jongh, "Grape Symbolism in Paintings of the 16th and 17th Centuries," *Simiolus* 7 (1974):166–91.

2. Hessel Miedema, "The term *Emblema* in Alciati," *Journal of the Warburg and Courtauld Institutes* 31 (1968):234–50.

3. Robert Klein, "The Theory of Figurative Expression in Italian Treatises on the *Impresa*," trans. Madeline Jay and Leon Wieseltier, in *Form and Meaning: Essays on the Renaissance and Modern Art* (New York: The Viking Press, 1979), pp. 3–24.

4. See, for example, the "Voor-reden" to J. Cats, *Spiegel van den Ouden en Nieuwen Tyt* in *Alle de Wercken* (Amsterdam, 1712), 2:479–82. Cats's presentation is rather like Hoogstraten's insofar as he does not proceed by developing a single line of argument, but rather by setting forth a series of separate proposals about the nature of emblems.

5. Mario Praz came to this conclusion in his *Studies in Seventeenth-Century Imagery*, 2nd. ed. (Rome: Edizioni di Storia e Letteratura, 1964), p. 170. It is a rare Dutch emblem that features the eccentric and puzzling assemblage of objects and abbreviated actions so common in the Italian tradition. While Roemer Visscher's *Sinnepoppen* of 1614 does feature some hands extending puzzling objects from the sky, in general the images in his book depict actions or objects in common use.

6. De Jongh's recent work has pointed out the multivalent nature of emblems: a pearl can represent virtue in one context but vice in another. This emphasis on multivalence does not, however, alter the basic notion of how Dutch pictures mean that is assumed by the emblematic interpretation. See E. de Jongh, "Pearls of Virtue and Pearls of Vice," *Simiolus* 8 (1974–76):69–97.

7. The popularity of this pictorial mode has lasted into modern times. It is amusing that in Holland the frequent warning to dogs and their owners against fouling the public footpaths are posted not in the form of the text of an ordinance threatening a fine, but as an emblem: brightly colored images of unmannerly dogs are stencilled onto the sidewalks with an inscription above reading "In de Goot" or "in the gutter."

8. The most suggestive interpretation of Dutch art and society along more complex lines is found in two articles by the historian Simon Schama: "The Unruly Realm: Appetite and Restraint in Seventeenth Century Holland," *Daedalus* 108 no. 3 (1979):103–23 and "Wives and Wantons: Versions of Womanhood in 17th Century Dutch Art," *Oxford Art Journal* (April 1980):5–13. On the evidence of their images of themselves, I tend to find the Dutch in the seventeenth century to be less ridden with anxiety than does Schama.

9. See Christopher Brown, *Carel Fabritius* (Oxford: Phaidon, 1981), p. 48, and Peter Sutton, *Pieter de Hooch* (Oxford: Phaidon, 1980), pp. 44–51. The problem of interpretation that these instances reveal is not, of course, unique to the study of Dutch art. But, to come full circle to where this book began, it is endemic to the discipline of art history, which has confined itself too long to a single theory of interpretation.

Index

References to illustrations are printed in italic type.